Portrait with Background

ALEXANDRA HASLUCK

Portrait

with

Background

A LIFE OF

Georgiana Molloy

MELBOURNE

OXFORD UNIVERSITY PRESS

LONDON WELLINGTON NEW YORK

Oxford University Press

OXFORD LONDON GLASGOW

NEW YORK TORONTO MELBOURNE WELLINGTON

NAIROBI DAR ES SALAAM CAPE TOWN

KUALA LUMPUR SINGAPORE JAKARTA HONG KONG TOKYO

DELHI BOMBAY CALCUTTA MADRAS KARACHI

First published 1955
Reprinted 1960
First paperback edition 1966
Reprinted 1976
Reprinted 1979

NATIONAL LIBRARY OF AUSTRALIA CATALOGUING IN PUBLICATION DATA

Hasluck, Alexandra, Lady
 Portrait with background.

 Index.
 First published, Melbourne: Oxford University Press, 1955.
 Bibliography.

 1. Molloy, Georgiana, 1805-1843. 2. Pioneers— Western Australia. I. Title.

 994.102

PRINTED IN HONG KONG BY BRIGHTER PRINTING PRESS LTD.

Contents

List of Plates

(between pp 84 and 85)

Introduction

OVER a quarter of a century ago the letters of Georgiana Molloy were printed in the *Western Australian Historical Society Journal*. A desire to find out more about the writer of those letters caused me to undertake a search for her descendants extending to the opposite ends of the earth—from England to Tasmania. It became apparent that the originals of the letters were not to be found, but that copies, much fuller than those of the *Historical Society Journal*, were in the hands of relatives in England. Mrs Pullan of Oxford kindly allowed the copies of her grandmother's letters to the Dunlop family to be microfilmed, and Mrs E. A. DuCane of Bideford, Devon, generously donated the Letter-Books of Captain Mangles (two bound volumes) to the Perth Archives. Both these collections of letters were of immense value in adding to the knowledge of Georgiana Molloy, filling in the gaps of the *Historical Society Journal* letters (which proved to be only extracts), and in correcting dates and spelling in the latter, especially the spelling of the name 'Georgiana' which is spelt 'Georgina' throughout them. Not only are the signatures plain as 'Georgiana', but Captain Molloy in his 'Application for Land', and in the registration of his wife's death, spelt her name thus.

As I read the full copies of the original writings, I became convinced that justice had not been done to Georgiana Molloy for her work as a pioneer botanist of Western Australia. The present book has been designed to show her contributions to the knowledge of the flora of the colony.

I have also tried to show the ordinary life of the colonists in the first decade or so of the colony—from 1829 to 1843. It should not be forgotten that Western Australia was a Crown colony which in its foundations and settlement had an existence linked with London, not Sydney, and was quite separate from the other Australian colonies. Too many novels and accounts of the first days of the colony show it as disastrous and tragic. Diaries and letters on the contrary show a picture of pleasant social life with a background of hard work, mostly unaccustomed but not wholly unexpected, with periods of depression offset by the achievement of a certain comfort which was to become

the Australian way of life. The outstanding fact in most of the manu-
scripts of the first two decades is the evident faith of the writers in
the country of their adoption. The path of progress has not gone
exactly in the way they thought it would, but in a mere century or
so the changes have been so vast and the growth in settlement so
extensive as to justify all their hopes.

Very little work has been done before on the mass of material (all
hand-written) contained in the files of the Colonial Secretary's Office,
Perth, and now in the Archives Branch of the Perth Public Library,
which relates to the early history of the south-western corner of Aus-
tralia. It is hoped that some of the sources referred to in the notes of
this work may be of use to others, and that the work itself will remove
some of the misconceptions about the early history of Busselton and
Augusta.

Besides the most grateful acknowledgments to Mrs DuCane, and to
Mrs Pullan, since deceased, I wish to thank other descendants of
Georgiana Molloy for their assistance, notably Mrs A. M. R. Bunbury
of Busselton, for photographs in this book which were taken by her,
for information, and for showing me other pictures of early Busselton
identities; also Mrs V. M. R. Bunbury of 'Marybrook', for showing
me portraits, medals, miniatures, and for information; Dr and Mrs
Elkington of Perth for diaries, letters and pictures, and Mr Pickering,
since deceased.

Mr John Taylor of 'Westbrook', Busselton, was of great assistance in
collecting information about Busselton and its early identities, from old
Busselton inhabitants with whom it was difficult for me to come into
touch; and Miss Stella Layman of 'Wonnerup House' was also of great
help in providing photographs, letters and general information. Other
Busselton inhabitants to whom thanks must be made are: Mr A. R.
Walker, the present owner of 'Fair Lawn', for showing me over the
house during its alterations, and for providing the warrant and sum-
mons of Captain Molloy; Mrs Willmott for a photograph of Captain
Molloy; Mr Hastwell, editor of the *South-Western News*, for a photo-
graph of 'Cattle Chosen', and Mr F. Eggleston for other photographs;
Mrs Piers Brockman, Mrs Carter, Miss Prinsep, Miss Jarvis and Mr
Edward Dawson for much information. I wish also to thank Miss
Dawson of Manjimup, Mr William Turner of Williamstown, Victoria,
and Mrs de Castilla (née Bussell) of Perth.

Mr David Elder deserves my most grateful thanks for advice on

military detail, also Captain L. S. Challis, London; Mrs Dorothy Forsaith, for making inquiries at the Horticultural Society, London; and Mr G. G. Smith, of the Botany Department, University of Western Australia, for checking botanical terms. I must also acknowledge the great help given by Miss M. Lukis, B.A. and Miss C. Cammilleri of the Archives Branch of the Perth Public Library; by members of the staff of the National Library, Canberra, and members of the Lands Department, Perth.

Last, but not least, I must thank my own family for their forbearance with me when I forgot them, as often happened, while this work was proceeding.

A. H.

CLAREMONT, W.A.
August 1954

Human beings are the stuff of history. Their social activities, whether political or otherwise, are the result of environment and personal qualities, in which I include personal interests. And to these two I would add that third, strange factor, group behaviour. . . .

Professor J. E. Neale

Chapter

I

Georgiana's Youth

In the year that Georgiana Kennedy was born, the threat of invasion which had hung over England for a decade was lifted. While she lay gurgling fat and pink in her cradle, the French and Spanish fleets were being annihilated by a smaller British fleet in a severe action off Cape Trafalgar. She was too young to know the grief that England felt at the death of Nelson in that battle; nor would she know till years later that her future husband had been in the thick of it as a midshipman. The significance of Trafalgar to the young Georgiana was simply that there was less and less basis for her nurse to make the threat: 'Boney will get you if you're not a good girl'.

England was not immediately aware that the danger of invasion by the French had passed. Though Trafalgar was the last of the great sea battles, and a victory for the English, Napoleon Bonaparte was yet supreme in Europe and had just gained a decisive victory over the Austrians while the guns of Trafalgar were still belching. He had become such a force that there was no knowing when he might get a fleet together again. So Georgiana's youth resounded to the marching of Volunteer bands with fife and drum, and to the singing of patriotic songs, which were distributed as handbills and broadsheets, to arouse patriotic fervour in the people of England.

> *Britons, rouse; with Speed advance;*
> *Seize the Musket, grasp the Lance;*
> *See the hell-born Sons of France!*
>
> *Now Murder, Lust and Rapine reign.*
> *Hark! the Shriek o'er Infants slain!*
> *See the desolated Plain.*

Now's the Day and now's the Hour,
See the front of Battle lower!
See curs'd Buonaparte's Power!

Who will be a Traitor Knave?
Who can fill a Coward's grave?
Who so base as live a Slave?

Rush indignant on the Foe!
Lay the Fiend Invader low!
Vengeance is on every Blow!

Forward! lo, the Dastards flee;
Drive them headlong to the Sea;
Britons ever will be free!
Huzza, Huzza, Huzza![1]

In every county of England the Volunteers drilled and marched, ready to defend it to the last man. Nor was it only the peasantry who volunteered. Many wealthy landowners commanded their own tenantry, provided colourful uniforms and caps, and marched and trained with them. It was a matter of pride in all classes of people to be a Volunteer. Country districts were organized. Posters headed 'Invasion', tacked on to village oak and church lych-gate, told what to do if the French landed. Precautions which had been thought out the last time England was threatened with invasion—two-hundred-odd years before when the Spanish Armada sailed up the Channel—were re-issued, with regard to destroying bridges, burning crops and herding cattle away from the coast. Round Martello towers were erected for defence, bonfires for alarm, and quite a few queer high wooden structures with moving arms and shutters, called semaphore telegraphs, which could signal messages very swiftly from one to the other all the way to the final one on the roof of the Admiralty Office. The sea, which had a hundred years or so more to be England's protection, was well watched.

The echoes of war sounded rather faintly in the remote Border country where Georgiana Kennedy was born. She entered the world on 23 May 1805,[2] at 'Crosby Lodge' near Carlisle in Cumberland. 'Crosby Lodge' was a comfortable country residence with ivy-clad walls, standing in spacious grounds. On both her father's and her mother's side she was connected with old Border families, Mrs Kennedy being descended from the Grahams of Netherby.

Mr David Kennedy lived the comfortable life of a country gentleman in the midst of his family, which, as the years went on, grew to consist of three girls, Georgiana, Elizabeth and Mary, and two boys, Dalton and the baby, George. Then suddenly, when Georgiana was about sixteen, Mr Kennedy was killed by a fall from his horse. This meant a great change for the family. After due consideration, Mrs Kennedy decided to transfer their home to Rugby for the sake of her sons' education. As for her daughters' education, no doubt that was the typical female education of their day, which was a thorough grounding in the art of pleasing men. They would have been taught singing, dancing and playing the pianoforte and harp; embroidery, fine sewing and sampler-work, drawing and painting. A certain amount of history, geography and literature would have been learnt in the form of question and answer, and a great deal of Scripture got by heart. The influence of Rousseau, remaining from the mid-eighteenth century, would have caused an interest to be taken in Nature study. It was part of the education of all young females to botanize. The Queen of England, Charlotte, wife of George III, liked to botanize in the grounds of Kew House or Windsor Castle, and set an example to the ladies of her realm. Botanizing involved recognizing plants and their families, and setting the Latin name to them. Georgiana must have had a natural aptitude for this, as later events were to show.

Unfortunately, as they advanced towards womanhood, the three sisters do not seem to have got on well together. The reasons for this are unknown. In after years, when writing to her sister Elizabeth, Georgiana said: 'Perhaps had we the time to spend together again we should be more harmonious than we used to be, dear Eliza. I know in my eventful life, past circumstances appear very trivial to the forbearance every day's experience demands. . . .'[3] At the time, the discord and unhappiness in the home were very real, and had the effect of making Georgiana seize every chance of going away on long visits to her friends.

Her dearest friends were the Dunlops of 'Keppoch House', Dunbartonshire. The Dunlop family was a large one, three of the daughters —Mary, Margaret and Helen—being Georgiana's especial friends. She regarded them as sisters more than her own flesh and blood. What they liked, she liked. The family at 'Keppoch' had a background of scholarly learning in both law and divinity. As Georgiana's three friends grew up they became interested in the religious revival that was sweep-

ing Scotland at the time. From the early years of the century the Church of Scotland had been undergoing a period of transition, and a revival of interest in matters of faith was being brought about by the inspired preaching of a remarkable young man named Edward Irving.

Irving had become impatient with the conventional utterances from the pulpits of the day. His own preaching won the recognition of Dr Chalmers, the most noted divine in Scotland, who invited him to become his assistant at Glasgow. Here Irving made a great impression. He had a striking appearance—he was six feet four inches in height, swarthy of complexion, with dark eyes, one of which had a cast in it, and long hair. He preached with a power and emotion that carried away his audience. In 1821 he was called to the Caledonian Church in London. Here again he was a great success, people such as Brougham, Canning, Lady Jersey and others coming to hear him, while the crowded little church listened spellbound for as much as two and a half hours to his sermons. He was next installed in a new church in Regent's Square, leaving it from time to time to make preaching tours through Scotland.

It would have been at this time that Georgiana heard him. Her friend Helen Dunlop had become betrothed to the Reverend Robert Story, the minister of Rosneath, a parish not far away from her home at 'Keppoch'. Robert Story and Edward Irving had been students together at Edinburgh University, which they had entered at the respective ages of fifteen and thirteen. On leaving the University, Story had gone to Rosneath as assistant minister, while Irving had become a teacher at a school at Haddington, where he had as a pupil an interesting small girl named Jane Baillie Welsh. He also acquired a new friend, one Thomas Carlyle, with whom he went on walking tours. They would sometimes call in on Robert Story at Rosneath. The years passed and Irving went to London, but before he left he introduced his friend Carlyle to this erstwhile pupil, Jane Welsh. Jane was a connexion of the Dunlops. She married Thomas Carlyle two years before Helen Dunlop married Robert Story.

It was in 1829 that Helen Story married and went to live at Rosneath. In due course she invited Georgiana to stay with her. Life was very pleasant in the little Scottish manse, set among trees on the edge of one of the loveliest and softest lochs of Clyde. Georgiana loved the pretty countryside and was often to recall its scenes with an aching nostalgia when far away.

This district had become a centre of religious fervour. Near by had lived a young girl, Isabella Campbell of Fernicarry, whose whole life had been so devout that in another religion she might have been canonized as a saint. After her death Mr Story wrote a memoir of her, called *Peace in Believing*, which went into three editions in several weeks. There were others: McLeod Campbell of Row, a saintly and admirable man whose unorthodox teachings had brought him on trial before his Presbytery; Mary Campbell, later Mrs Caird, a sister of Isabella Campbell, who was a disciple of Edward Irving's and, inspired by him, was to be seized with the 'Gift of Tongues'; Sandy Scott, another preacher, was also well-known at the time. It would be un-necessary to mention these names except that they occur in Georgiana Kennedy's letters, showing that she knew and revered them, and came under their influence. She and Helen Story, and Mary and Maggie Dunlop would spend hours discussing the 'Nature of Belief', and the need for conversion. Georgiana's early letters are full of her conversations with almost total strangers on the questions of Belief and Faith. She wrote to Helen Story in September 1829:

On Friday I accidentally found out that a person from whom I bought some Thread, needles etc. was Jewish, and I immediately began a conversation with her, and told her how much I felt our obligations to the Jews. I questioned her nearly about Christ. She said she believed he would come, but that he had not yet come. I told her he would not come again as a Saviour but as a Judge on those who did not believe in him as a Redeemer, and told her that Jesus was the only Jew who had never committed sin or broke the law, and that this partook of a divine nature. I said, How do you expect salvation by works when you know it is impossible (to keep things) and that now it is no longer a covenant of works but of Grace. She said, The Almighty can never make a law and break it, and that when Messiah came it would be seen which was the true Religion, and that she trusted she would die in that belief and faith. I said, My dear woman, I devoutly pray the Light of the Gospel may break in upon your hardness of heart and enable you to see you are one of Christ's Redeemed sinners. . . . After some longer conversation she began to weep and she said, Miss, do you really believe Christ has come and can you die in peace of going to Heaven? I said, Yes, that if I could not, it would be Hell to me to think of the danger I am every moment in. She was deeply interested and this being Friday I promised to call again on Monday.[4]

This religiosity of Georgiana's may have added to the friction between herself and her sisters Elizabeth and Mary. There is reason to believe that Elizabeth and Mary were just normally religious and quite normally interested in the frivolous ways of the world. 'Oh!

pray write to Mary and urge the folly of remaining so long buried in this world's wiles,' Georgiana was to write to Helen Story after Elizabeth's death. It is hard to reconcile the tone of Georgiana's letters with the miniature of her painted about that time, which shows her as a round-faced girl, elegantly dressed in the fashion of her day (Plate 1).

In making the move from Carlisle to Rugby, Mrs Kennedy may have considered that urban surroundings were better for her daughters' chances of matrimony. It is not known where Georgiana met her future husband, Captain John Molloy, but in a letter of 11 December 1828, written to him at Gosport while she was staying with friends at Wroxeter, she speaks as if she had known him a long time.

> Many thanks, my kind friend, for your letter, the perusal of which was, however, not wholly unmixed with pain—but what is, in this Vale of Tears? I saw in some of the papers that the Rifle Corps was not to go abroad and I hope that the report is correct, for whatever you may say of the nothingness of so long a voyage, I cannot bring my untravelled mind to regard it so lightly, and as I always have and always shall consider you are one of my greatest friends, I should be glad to retain you on this side of the Atlantic. . . .[5]

The same letter mentions that 'Besley has got the situation of sub-librarian at the Bodleian, which however is not lucrative enough to allow of our telling at present'. Since her sister Elizabeth eventually married a Mr Besley, a clergyman, this seems to indicate that there was an understanding between the two at this time. It may not have prevented Elizabeth from asking herself, however, why Georgy, who doted on religion, should appeal to the handsome captain, while she herself attracted the parson. This would obviously not improve the relationship between the two sisters, or the atmosphere in the Kennedy home. Whatever the true state of things was, and though the tone of Georgiana's letter to Captain Molloy is only that of friendship, by the next year the situation had changed. Georgiana was staying with the Storys at Rosneath when she received a letter from him asking her to be his wife.

As if this were not enough of a question for a young lady to consider, the gallant captain also asked her to venture out with him to the shores of New Holland—half a world away from friends and family—to the newly-founded colony at Swan River, where he proposed to take up land and make his home.

❧

Captain John Molloy (Plate 2)—'Handsome Jack', as he was known

among his friends in the army—would have made an impression on any female eye. The dark green braided jacket of the Rifle Brigade well became his erect figure; its upstanding black collar raised a haughty chin a little higher. Arched and arrogant eyebrows rose above heavy-lidded grey eyes and a Roman nose. His hair was combed with careful carelessness high on the brow in the classical mode. It was not a face to be easily forgotten; in fact, the most striking thing about it was that it reminded the observer of some face very well-known—but whose? Gossip had it that he was of royal parentage. Though the name was Irish, and the Molloys owned a country place, 'Millicent', near Sallins, in County Kildare, John Molloy was born in London on 5 September 1780.[6]

Nothing is known of his early youth, except that he was educated at Harrow.[7] It is asserted on not entirely reliable authority that

> he never knew his father nor his mother, that while at Oxford he received £200 per annum as pocket money and upon attaining his majority he was instructed to call upon a firm of London solicitors, who handed him a cheque for £20,000 and purchased for him a commission in the Royal Navy. . . . At the outbreak of war on the continent a commission was purchased for him in the army.[8]

Another account asserts that 'he began life as a midshipman in His Majesty's Navy and nearly died of fever off the African coast. He exchanged into the army and obtained a commission in the old 95th in 1807.'[9] The War Office confirms that he joined the 2nd battalion, 95th Foot (Rifle Brigade) on 17 December 1807 as a 2nd Lieutenant, and became a 1st Lieutenant on 5 June 1809. As he was then twenty-nine years of age and his friends in the army of his own rank or higher—Harry Smith, John Kincaid, John Bell and others—were younger than he by as much as ten years, it would seem to confirm the dubious authority quoted above that he did not enter the services till after attaining his majority; not, as was usual, as a lad in his teens. Whatever his parentage, it must be said for those who reared him that they laid the foundations of an upright and honourable character. Dashing and gallant in his youth, in his middle age a little high-handed and arrogant, though the soul of justice as a magistrate, he reached a great old age to have it recorded on his tombstone that he 'died as he had lived, a Christian gentleman'.

This element of mystery about the handsome young soldier may well have attracted the romantic interest of young females, but he

deserved interest no less for his exploits in the wars. There is, fortunately, plenty of evidence of this. Not only did Molloy himself recount his memories in after years to a son-in-law,[10] but several of his friends wrote their reminiscences in which he is mentioned; and there are references to him in other works.

Less than a year after he had joined the army, Lieutenant Molloy found himself on the way to Spain, to take part in what was to become known as the Peninsular War. When the Emperor Napoleon decided to make his brother Joseph King of Spain in place of the decadent Charles IV who had abdicated, he did not foresee, or perhaps did not care about, the revolt that this would cause among the states of Spain. They called upon England for help, and a small expeditionary force was sent to their aid. It disembarked at Figueira on the coast of Portugal on 1 August 1808. Among those who sailed with Molloy in this force was Rifleman Harris, one of the rank and file. Harris had had little education; a shepherd boy, he had joined the army young; but some of the best accounts of the Peninsular War are contained in his *Recollections*, and one of the officers he described was 'Lieutenant Molly [Molloy]—as fine a soldier as ever stepped, and full of life in the midst of death'.[11] They were together for most of the campaign. After landing, 'the Rifles were the first out of the ships,' said Harris proudly. 'We were, indeed, always in the front in an advance and in the rear in a retreat.'[12] They marched to Lisbon, and from thence to Roliça where they engaged the French. Several days later another battle was fought at Vimiera, both being fields of bloody carnage. Lieutenant Molloy was wounded at Vimiera. The future Duke of Wellington, Wellesley as he was then, commanded both of these battles, and particularly noted in despatches the valour and discipline of the 2nd battalion Rifles. As he was constantly with the advanced posts Lieutenant Molloy saw a great deal of him, and later always went to the dinner which the Duke gave on 21 August each year, to celebrate the first pitched battle he had fought against the French.

In September, through intrigue in high places at home, Wellesley returned to England and Sir John Moore was in command of the army. The army crossed from Portugal into Spain and made a lightning stroke at French communications. Stung by this, Napoleon himself led his army against Moore and forced him to retreat to thē sea. But the sea was 220 miles away. The country was mountainous, the weather bitter and snowy. The army coming from Salamanca had been joined at

Sahagun by new forces from England, the worn and sunburnt appearance of those who had fought at Roliça and Vimiera contrasting with the trim, neat look of the others. At Sahagun the army divided, Moore's forces making their way to the sea-port of Corunna, and the 2nd battalion, in which were Lieutenant Molloy and Rifleman Harris, going to Vigo under the command of General Craufurd. Craufurd was a severe disciplinarian and his men suffered great privations from lack of food and bitter weather on the difficult mountain roads. When what remained of the army was picked up by English ships and transported to Portsmouth, the men were so worn with fatigue and hunger, their clothing ragged and their weapons rusted, that as they limped on shore, Harris remarked that they looked 'more like the rakings of hell than the fragments of an army'.[13]

After disembarking at Portsmouth on 1 February 1809, the regiment marched to its old quarters at Hythe barracks, but they did not remain long in England to recover before they were off to Portugal again. Molloy was made a 1st Lieutenant in June 1809, and transferred to the 1st battalion, 95th Foot. Re-formed to a strength of 1,010 rank and file, the 1st battalion arrived at Lisbon on 28 June, to take part in the famous march to Talavera, where they arrived the day after the battle. Molloy now had for a comrade-in-arms Lieutenant Harry Smith, who was to become one of England's most famous soldiers, and to remain his friend and correspondent throughout their lives.

After Talavera they were nearly starved. The army retired into quarters, and Harry Smith was stationed at Campo Mayor. He was in charge of a fortress on the Spanish border and Molloy and other friends in Campo Mayor used to come out to breakfast with him and shoot both for sport and for food. This was the lighter side of a particularly grim and bloody war. Hunting was quite a feature of the campaign; Smith often used to supply the officers' mess of every company with hares for soup when the commissariat was low, as it usually was. Molloy's own recollection of this time is of being stationed with a company of Rifles in the village of Barba del Puerco, not far from Cuidad Rodrigo. The officers used to dance with the village girls, while an old woman sang a song about the celebrated guerilla fighter:

> *Don Julian Sanchez*
> *Con sus lanceros*
> *Yban a Rodrigo*
> *Tomar los Franceses.*

Forty years later, telling his reminiscences to his son-in-law, Molloy could still recall this song. It may have had a catchy tune and he may have sung it to his children. Another popular tune of his youth, to which the 1/95 often marched, was 'The Downfall of Paris'.

Soon after this, two companies and officers returned to England, Lieutenant Molloy among them. He joined the military college at Great Marlow in April 1810. This college had been established for the training of junior officers by the Duke of York, then Commander-in-Chief of the army; it later became known as the Royal Military College, Sandhurst.

Molloy remained at Great Marlow for nearly two years. By March 1812, he was back in Spain taking part in the siege of Badajos, which was held by the French. Badajos eventually fell to the English, and to the utter disgrace of the English soldiery, dreadful excesses and atrocities were committed by them while plundering the inhabitants. The men had got out of hand and their officers could do nothing with them. It was during this terrible day that two young Spanish girls were brought to Captain Harry Smith for protection. Both were weeping and their ears bleeding where the ear-rings had been torn off. The younger was only fourteen years old and of a freshness and beauty that caused Harry Smith to fall in love with her and marry her forthwith. He recorded in his autobiography, 'All my dearest friends—Charlie Beckwith, John Bell, Jack Molloy—were saying to themselves, "Alas! poor Harry Smith is lost . . . it is only natural he must neglect duty now." '[14] But he did not, for his girl wife, Juana Maria de los Dolores de Leon, moved with the army. This was not in the least unusual. John Kincaid humorously recorded the capture of an officer of the French army and his wife, 'who was dressed in a splendid hussar uniform. He was a Portuguese and a traitor, and looked very like a man who would be hanged. She was a Spaniard and very handsome, and looked very like a woman who would get married again.'[15] Rifleman Harris showed the other side of the picture—the wives of the common soldiers, who also used to follow the army on foot. It was their business to feed their men on whatever food they could procure; bear their children, even if on the march from one battle to another, seek for their dead on the field of battle, and generally form some sort of domesticity for soldiers who might be campaigning year after year. Only four women were officially permitted to accompany each company of a regiment, but many others managed to elude the eye of

officialdom. It was a hard life but it was their choice, rather than fending for themselves and their families alone at home.

Badajos was followed by the battle of Salamanca and the rout of the French at Vittoria. Molloy took part in these and in the long battle of the Pyrenees, the bitter ones of the Nivelle and the Nive, and in the attack on Toulouse. Wellington entered the city of Toulouse on 12 April 1814, and the same evening amid scenes of great excitement, received the news that the Emperor Napoleon had abdicated at Fontainebleau six days before. The war was over.

After the taking of Toulouse in April, it was occupied by the English till June. Molloy and another young officer shared a delightful chateau with Harry Smith and his wife Juana. They had a French cook, and after the rigours of the campaign it was good to live well for a time. Many years later, when Harry Smith was Governor of Cape Colony, he was to remind Molloy of this time and say, 'Juanita is very well, but very stout, but her ankles are as beautiful as ever.'[16] In July the regiment returned to England quietly and without acclamation. In after years Molloy remembered 'that when they returned to Dover at the end of the Peninsular War after so many years of fighting and glorious victories, nobody took any particular notice of them'.

Two months later Smith was sent to America where he participated in the capture of Washington. Returning to England briefly, he was then despatched to New Orleans, but here the English were routed and Smith and his men had to make their way over the bare flat Gulf territory to the sea-port of Mobile, where H.M.S. *Brazen* lay at anchor waiting to take them on board. The commander of the *Brazen* was a Captain James Stirling, to whom Smith took a great liking. 'A more perfect gentleman or active sailor never existed; we have been faithful friends ever since,'[17] he said. This meeting with Captain Stirling and the subsequent friendship of the two men is of importance for it provides the link with Molloy and the future. At a critical time in Molloy's career, Smith's recommendation of his friend Stirling as a man whose judgment and leadership was to be trusted may have had considerable influence.

At present, however, the alarums of war were not over. Smith and Stirling sailed back from the New World to find the Old World in a fever. The English people had been right in not celebrating the end of the Peninsular War and of the Emperor Napoleon too soon. Smith narrates how 'as we neared the mouth of the British Channel . . .

strange sail was reported . . . Stirling hailed as we shot past. "Where are you from?" "Portsmouth." "Any news?" "No, none." The ship was almost out of sight when we heard, "Ho! Bonaparter's back again on the throne of France." '

The General with them did not believe it, but Stirling did, and so did Smith. As they arrived at Spithead, 'all the men-of-war, the bustle, the general appearance, told us, before we could either see* telegraphic communication or speak any one, where "Bonaparter" was'.[18]

A month later an army was assembling at Brussels under the Duke of Wellington. The Peninsular veterans were scattered, but those who could rejoined their leader. Rifleman Harris was disqualified as medically unfit for service, to his great disgust. Lieutenant Kincaid was shooting woodcocks in Scotland when the summons to rejoin his regiment came. He had transferred to the 1st battalion, as the shipping list of those who sailed for Ostend shows, and so was together with Molloy in their last great battle. Captain Smith paused only to gather up his wife, who had not gone to America, before he departed for Brussels. It is not known where Lieutenant Molloy was when the news came, but he was not slow to reach Brussels, for the famous Rifles were one of the first regiments to embark.

There are many accounts of the battle of Waterloo which was to prove the downfall of Napoleon and the end of the Napoleonic Wars. John Kincaid's *Adventures in the Rifle Brigade* is one of the most graphic and was to be the occasion of great interest to Molloy, and of raised eyebrows to Mrs Molloy, in after years. Harry Smith also gave his account of that great battle in his autobiography. Molloy's own recollections, written for the *Cornhill Magazine* by a son-in-law long after Molloy's death, are mostly anecdotal, after the manner of old soldiers who fight old battles again over the dinner table, and tell old tales that are scintillating with wit for themselves, but for no others. They do, nevertheless, have the ring of truth.

The casualties of Waterloo were appalling—French killed and wounded amounted to between thirty and forty thousand, while the Allied casualties were twenty-three thousand. Among these was John Molloy, so badly wounded that he was left for dead and lay all night on the field of battle among the slain. His wound was to give him many a twinge in later years and remind him of that day.

In the years after Waterloo, Lieutenant Molloy, recovered from his

* 'See' it, because it was not wireless telegraphy, but semaphore telegraphy.

wound, remained on active duty with the Rifles and was stationed at different points in the kingdom. From 1819 to 1820 the 1st battalion, 95th Foot, was at Glasgow, and left there for Belfast. In Ireland, headquarters were at first at Fermoy and later at Rathkeale. At this time, 1823, Molloy was in charge of a company at Glandoff, County Limerick. A letter from a friend, G. H. Hewitt, an officer of the 22nd Regiment, was addressed to him there.[19] English soldiers were stationed in Ireland because of the agrarian riots. Hewitt alluded to the 'Whiteboys', an illegal association that wore white smocks at its meetings and night attacks. The troubles in Ireland at this time were caused by disputes between landlords and tenants; the distress and starvation caused by eviction of small tenants made the peasantry band together to try to enforce a wild justice by lawlessness. Military duty there can have been no sinecure. There is no indication that Molloy ever thought of Ireland as his own country, which lends colour to the rumour that whoever his mother may have been, no Irish Molloy was his father. He seems simply to have regarded himself as an English officer on duty there.

On 5 August 1824, Lieutenant Molloy was promoted to the rank of Captain, as was his friend John Kincaid. They were comparatively slow in gaining their promotion; their friend Harry Smith had gained his captaincy in 1812 and became a Major in 1826.

It was a time of uneasy peace in Europe. Before Molloy left Ireland, his friend Hewitt was writing to him fearing the inevitability of war in the near future, and saying that the life of a soldier was no life for a happily married man. He warned Molloy not to marry if he wished to continue in the army. No doubt this was good advice, but Molloy was not getting any younger. He was now forty-three, an age when a family man's life begins to present some advantages and comforts to a bachelor. For him, too, the attractions of military life were receding.

It was now ten years since Waterloo. How did England seem to those men who had fought for their country against the French? Most of the ordinary soldiers had been discharged in 1819; those remaining, like Molloy, being professional soldiers. No doubt, as after any great war, the men were glad at first to be home, but after a while, as conditions remained unstable, they began to see the England about them with new eyes.

Chapter
2

A Colony for Capitalists

SUPERFICIALLY, the Regency period both during the war with France and after it was one of gaiety and extravagance. The accent was on fine clothes, fine houses, fine living. The Prince Regent, or King George IV as he became in 1820, set the tone with his extravagant ways. The dandies with their exquisite notions of dress, the great ladies with their balls and routs, the visits of foreign notables such as the Czar of Russia after the war, the goings on of the various Royal Dukes and their mistresses, all add to the idea of the period as one of great elegance and sophistication. But the returned soldiers would notice other things besides the elegance of life around them—chiefly the change in ways of earning a living.

England, which had always been an agrarian state, had for the last forty years been changing in character. At first imperceptibly, but with a gradually increasing rhythm, the process of industrialization had gone on. An industry such as spinning, which workers had carried on in their own homes, changed entirely when in 1785 the first steam machines were installed in mills. The workers had to leave their homes to work at the mills. Because mills and factories were in or near large towns, an influx of people from the country to the towns began. Numbers were swelled by many rural workers who had lost their mode of livelihood when, during the last decades of the eighteenth century, large landowners resumed the common lands and amalgamated small farms into larger ones.

Soldiers and sailors as they were demobilized, found that there was no demand for their labour. Their pensions were small; food was dear. Bread was scarce and made dear by the actions of middle-men, or 'fore-stallers' as they were then called, in buying up harvests and

holding the corn for sale till the price was very high. There was much poverty and consequently much crime. Punishments were extreme—death for many trivial crimes, and transportation to Botany Bay for others. The case of the poor, and even of the lower middle-class, was so desperate that as many as could left England. In 1815, emigrants numbered two thousand. Four years later the numbers had risen to thirty-four thousand. These emigrants for the most part went to America and Canada; a few went to New South Wales, but as that was mostly thought of as a penal settlement, it did not attract many people of their own free will. In the next ten years, however, more people began to trickle out to the colonies of New South Wales and Van Diemen's Land, and when news of a new settlement on the shores of New Holland, on the western coasts of Australia, began to spread, it was received enthusiastically, particularly when it became known that no convicts were to be sent there.

Among those officers who at the end of the Napoleonic War had found themselves relegated to dull garrison duty, or—even duller—placed on half pay, was Captain James Stirling. Like a greater sailor, Nelson, before him, he was left on shore for eight years, eating his heart out for a ship, and wondering whether he had been forgotten at the Admiralty. To his delight, in 1825 he was given command of H.M.S. *Success*, twenty-eight guns, and ordered to Sydney. In this year a French expedition consisting of the *Thétis* and the *Espérance*, commanded by Bougainville and Camper, was cruising along the southern coasts of Australia. The presence of these vessels again made the British Government suspect that France was contemplating the establishment of a colony in the vast southern land. Despite the fact that French voyages of exploration had been taking place for the last twenty odd years, distrust of an enemy so old and so recent caused the Colonial Office in London to accede to requests from Sydney Town for settlements to the north and south-west, to prove Britain's ownership of the whole continent of Australia. So a small convict settlement was formed on Melville Island to the extreme north of Australia, and the commission of the Governor of New South Wales was extended to the 129th parallel so as to take in the island, though it still did not take in the western coasts. Unhappily the settlement, Fort Dundas, did not flourish, and Captain Stirling's orders on arrival at Sydney were to proceed to Melville Island and remove the settlement to a more suitable spot. Stirling, however, discovering that he would have to

wait until after the monsoonal rains to do so, suggested to Governor Darling that he should make use of the delay to explore the western coast of the continent. He pointed out that there was no settlement in that region beyond a small military outpost in the south. The French might easily forestall Britain there. They had explored the coast around Swan River twenty years earlier, and it was this particular part that Captain Stirling proposed to examine.

Three months later he returned to Sydney and gave glowing accounts of Swan River as an 'eligible spot for a settlement'. After sailing north and removing the Melville Island settlement to Raffles Bay (which was abandoned eighteen months later) Stirling returned to London with his report on Swan River, together with a despatch from Governor Darling warmly seconding his recommendations. These documents then had to pass to and fro between the Colonial Office and the Admiralty; they had to be read by Secretaries and Under-Secretaries and by the Lords of the Admiralty. These cautious gentlemen foresaw great expense to the Government in the founding of a colony, and the proposal was shelved.

Stirling was a sick man when he reached London and the disappointment of having his plan rejected when he was so sure of its merits must have been a blow. No doubt he talked about Swan River and its potentialities among his friends, and they persuaded him not to give up the attempt to interest the Government. Through some friend or acquaintance, he met with several gentlemen of means who were willing to invest capital in the place if they were sure of the Government's intentions. At all events, from August to November of 1828, Stirling communicated with the Colonial Office, his task made easier by the fact that the new Under-Secretary for the Colonies, Mr Horace Twiss, was a friend of his. By emphasizing the colonizing designs of the French Government and by showing that there were men of capital willing to risk its investment in a new country in the form of a syndicate for financing migrants, Stirling at last had the triumph of stirring the Colonial Office to direct the Admiralty to send a ship of war to take formal possession of the west coast of Australia in the name of His Majesty, King George IV. H.M.S. *Challenger* under Captain Fremantle left Spithead in December 1828 for that purpose, and in the same month Stirling was informed that he was appointed to the command of the new settlement.

The newspapers of January 1829 all carried articles about the

proposed new settlement at Swan River. In the ensuing months the *London Quarterly Review*, the *Gentleman's Magazine and Historical Chronicle*, the *Dublin Satirist*, the *Manchester Guardian*, the *Devonshire Chronicle*, and provincial papers in Worcester, Cheshire, Derbyshire— in fact, all over England—published articles on the advantages of Swan River. Interest was widespread through all classes of the population. To all those officers on half pay and soldiers on pensions too small to be of much use, the new land offered a challenge again in a life that had grown difficult and dull after the excitements of war. The agrarian revolution and the land enclosures had forced a great number of small yeomen to become no more than farm labourers; to these the prospect of owning their own land again was alluring. The industrial revolution had produced a state of poverty and depression from which numbers wished to escape. The crowded slums of manufacturing cities made an uninhabited and savage wilderness seem infinitely preferable. Gentleman, soldier, farmer, tradesman, poor man, adventurer—the vast empty new land attracted them all.

When His Majesty's Government had reluctantly been persuaded by the enthusiastic Captain Stirling to found a colony at Swan River, it was determined that the colony was not going to be a liability. In drafting regulations for the new colony, it expressly stated that only persons possessing capital were required as settlers. The terms were set forth as follows:

Although it is the intention of His Majesty's Government to form a settlement on the western coast of Australia, the Government do not intend to incur any *expense* in conveying settlers or in supplying them with necessaries after their arrival.

Such persons, however, as may be prepared to proceed to that country, at their own cost, before the end of the year 1829, in parties comprehending a proportion of not less than five female to six male settlers, will receive grants of land in fee simple (free of quit rent) proportioned to the capital which they may invest upon public or private objects in the colony to the satisfaction of His Majesty's Government at home, certified by the Superintendent or officer administering the Colonial Government, at the rate of 40 acres for every sum of £3 so invested, provided they give previous security; first, that all supplies sent to the colony, whether of provisions, stores, or other articles which may be purchased by the capitalists there, or which shall have been sent out for the use of them or their parties on the requisition of the Secretary of State, if not paid for on delivery in the colony, shall be paid for at home, each capitalist being held liable in his proportion; and, secondly, that in the event of the establishment being broken up by the Government or

Superintendent, all persons desirous of returning to the British Islands shall be conveyed to their own home at the expense of the capitalists by whom they may have been taken out. The passages of labouring persons, whether paid for by themselves or others, and whether they be male or female, provided the proportions of the sexes before mentioned be preserved, will be considered as an investment of capital, entitling the party by whom any such payment may have been made to an allowance of land at the rate of £15—that is, of 200 acres of land for the passage of every such labouring person over and above any other investment of capital.

Any land thus granted which shall not have been brought into cultivation or otherwise improved or reclaimed from its wild state, to the satisfaction of the Government within twenty one years from the date of the grant, shall, at the end of the twenty one years, revert absolutely to the Crown.

All these conditions with respect to *free* grants of land, and all contracts of labouring persons and others who shall have bound themselves for a stipulated term of service, will be strictly maintained.

It is not intended that any convicts or other description of prisoners be sent to this new settlement.

The government will be administered by Captain Stirling, of the Royal Navy, as Civil Superintendent of the settlement; and a Bill, in the nature of a civil charter, will be submitted to Parliament in the commencement of its next session.[1]

These regulations were issued as a circular, and the April 1829 issue of the *London Quarterly Review* in its article on the new colony made reference to 'the Colonial Office Circular', which caused many people to write in to ask for a copy of it. Not many of the other papers in which articles had appeared were so explicit, however, with the result that the Colonial Office was flooded with letters from intending emigrants asking for particulars. The harassed Colonial Office was obliged to have printed a stock letter setting out the conditions for emigration, which could be sent out with appropriate endorsements.

These letters of inquiry range in style from the lordly, 'Sir, Have the goodness to send me whatever information etc.', to the obsequious (and tangled), 'Sir, With condescendant humility I solicit your honor and regret that being under the necessity of so doing I should trespass too much on your valuable time, yet I hope your Benign consideration will pardon my liberty, and feel not offended at an anxious Enquirer. . . .' Some letters are almost wholly illiterate, some have had to be written for the inquirer because he could not write at all. Some are signed with ancient titles, inquiring on behalf of relations and friends. All are urgent with the desire to get to the new country to make their fortunes.[2]

Some were unaware that capital was needed and asked if free passage would be granted to desirable workmen. There are inquiries from all types of tradesmen—from an 'Upholsterer and Cabinetmaker from Bond Street', who 'flatters himself he should be able to cut your carpets and draperies'; from 'an Overlooker of Power Looms' from Manchester; and from a 'mechanick' of Cornwall, 'acquainted with building' and wanting to bring with him a number of builders, carpenters and shipbuilders. This 'mechanick' received 'the usual printed letter' with the postcript: 'I am further directed to inform you that H.M. Government are not in want of mechanics for the service of the settlement of Swan River.' Time was to show how wrong H.M. Government was, for the first thing that struck new arrivals in the colony was the want of workmen, both skilled and unskilled. Many capitalists who brought out their own workmen were to find that they often deserted their masters for any who would offer higher pay, and that such was the demand for labourers' services that they could always find work.

There were many inquiries, too, from officers of the army and navy asking whether they would receive advantages beyond those allowed to private settlers, but their letters were always endorsed: 'Officers only get the same terms as ordinary settlers.' Many intending emigrants asked if they would be granted land in proportion to capital which for one reason or another would follow them later. All requests for special treatment, or grants of land before capital entered the colony were endorsed: 'Persons are only allowed to receive grants of land upon their arrival.'

Among the earliest letters received by the Colonial Office was a formal request from one H. C. Sempill for a copy of the regulations for settlement. With it in hand, and doubtless with a copy of Captain Stirling's original report, he then compiled the following glowing description of the new colony, designed to attract prospective emigrants to ships of his chartering.

SWAN RIVER SETTLEMENT

in

WESTERN AUSTRALIA

The new Settlement on Swan River is in one of the finest climates of the Universe, about three months sail from England, highly suited for the production of cotton, silk, tallow, provisions, linseed, hemp, flax, and corn and the culture of the vine.

The country is of an open and undulating character, with excellent soil beautifully but not too much wooded; well adapted for wool-growing and the raising of stock. The coast and river literally teem with fish.

The shortness of distance between Swan River and the Cape of Good Hope, the Mauritius, the Indian Peninsula, Timor, Batavia, New South Wales, and many other important places, must open a door for commercial enterprise of a vast magnitude.

It has been calculated that rice, at one penny per pound, sugar at threepence per pound, coffee at fourpence per pound, tea at two shillings and sixpence per pound, and many other commodities and live stock at equally low prices can be imported from Java in five weeks.

The harmless Kangaroo seems to be the only wild animal in the occupation of this immense and beautiful country; while the splendid river and neighbouring lagoons are covered with myriads of swans and wild duck.

The fine teak-built ship *Lady Campbell*, Henry Murphy, Commander, burden 800 tons, possessing all the safe, splendid and roomy accommodation which a first-rate Indiaman is capable of affording, with more than half her cargo of goods and passengers already engaged, will sail for Swan River, Cockburn Sound, Port Vasse, and Port Leschenault on the 15th June next.

A Commissioner, furnished with the Government information, which includes the knowledge of the seat and situation of Swan Town, *the exact position* of all grants already made, the conditions of location, the regulations of the new Colony, its capabilities, woods, soils, fisheries and advantages, will sail in the *Lady Campbell* and accompany emigrants to their destination for the sole purpose of assisting in their settlement, and otherwise affording them the benefit of his information *on the spot*.

Engagements with young, stout and healthy labourers and mechanics of good character, are in the course of arrangements; and settlers sailing by this ship may be supplied with such labourers and mechanics on very advantageous terms.

Settlers will have no purchase money to pay for their lands, nor will they be chargeable *for any rent whatever;* their Grants will be conveyed to them in fee simple and will descend to their assignees or heirs for ever, in the same manner and way as any Freehold in England; thereby affording them the satisfaction of knowing that their labour will be wholly expended on their own property, and that the results of their patient endeavours will be enjoyed by their children, and their names transmitted with such estates to distant posterity.

The Emigrant will not have to wage hopeless and ruinous war with interminable forests and impenetrable jungle, as he will find prepared by the hand of Nature extensive plains ready for the ploughshare. He will not be frightened from his purpose by beasts of prey and loathsome reptiles. He will not be scorched by tropical heat nor chilled by the rigours of a Canadian winter. He will not be separated from the lofty protection of his native country, nor hardened in his heart by the debasing influence of being obliged to mingle with, and employ those bearing the brand of crime and punishment; and as no convict or any description of prisoner will be admitted into

the Colony, those who establish property and families will feel that their names and fortunes cannot be mixed hereafter with any dubious ideas as to their origin.

Settlers will be provided at the Settlement with live stock and all kinds of agricultural implements on the lowest possible terms. Credit will be afforded to respectable Persons for a part of their passage money, should they require it, that they may not be crippled in providing themselves with necessaries for their location and the immediate commencement of cultivation.

Land so situated, *without tythes, taxes or rent*, under the special care and protection of His Majesty's Government, and where the British laws will be rigidly and uprightly administered, cannot fail being worth the attention of every industrious and discerning Briton.

Apply personally, or by letters post paid, to

H. C. SEMPILL
East India Chambers
Leadenhall Street.[3]

This advertisement was designed to have the effect of making many would-be emigrants feel that all would be easy for them if they were in the right hands, and although there is no record of the *Lady Campbell* ever arriving at Swan River, Mr Sempill was the charterer of another ship, the *Warrior*, which sailed in 1829. Apart from the physical attractions of the place which his advertisement vaunted, it also put into words the feeling that many people had, that in coming to this free settlement, they would indeed become the progenitors of honourable families bearing their names with no taint of convict blood.

Mr Sempill, in advertising that engagements between settlers and labourers could be arranged, was doing a service not only to the capitalists but also to the numbers of young workmen whose longings to get to the new country had been frustrated by the Government's refusal of free passages. Some of them would have had a little money of their own though not enough to pay their fare and support themselves for a year or more in the colony. Once there, this type of man was not long in taking up land of his own and becoming in time a man of substance. He was valuable in the new land because he knew how to work and use his hands. The case of the poor labourer with a family was not so easy to arrange. The Government's allowance of land on the basis of £15 per servant taken out did not equal the actual cost of their passage money. From £25 to £30 was the charge for a steerage passage. 'The usual charge for a cabin passenger is £60. For a man and his wife, £110, who mess at the Captain's table and have a liberal allowance of wine and spirits. For a steerage passenger £25, who have

the same ration as the crew. Children are taken at half price,'[4] stated a
traveller who had made the voyage. Nevertheless, many capitalists
preferred to take out as servants men with large families, for they could
then claim two hundred acres of land for every £15 of passage money.
They thought, too, that the children would ensure a supply of labour
for them in later years. There were not, however, obliging capitalists
in sufficient numbers to accommodate the many labourers with families
who wished to emigrate. These had to rely on land settlement schemes.

There were several land settlement schemes which, though promising
at first, came to nothing. On 24 January 1829, Mr J. Matthey and Mr
G. Leake wrote to Mr Horace Twiss announcing that

> We have it in contemplation to form an extensive establishment in the Swan
> River settlement and to take out with us a considerable number of settlers,
> for which purpose in addition to our own private capital a number of Gentle-
> men are desirous of embarking each a certain sum in aid of the object pro-
> posed . . .

Letters passed to and fro between them for the next month or so while
they sought information on such subjects as whether a portion of
capital invested in the purchase and cargo would entitle the owners to
land; whether any doubts existed in the minds of the Government of
the ultimate success of the settlement; and whether any provision
would be made to enable the Governor to enforce the fulfilment of the
contracts or agreements entered into between the capitalist and the
labourers he brought out. By March, Matthey had heard a report of an
enormous grant of land being made to another syndicate 'comprising
the whole of the exclusive frontage of the Swan and Canning Rivers,
with the exception of a small portion to the west of the former river,
besides including the whole of the land in the immediate vicinity of
Cockburn Sound'. While this report was not correct, it caused Matthey
and Leake to abandon their plans.[5]

Another proposal came from Mr Nathaniel Ogle who wished to
bring out about a thousand people in a ship which was to be used in
the service of the colony. As the ship was foreign-built, he was refused
permission to use it, and his scheme had to be abandoned.

Two other schemes reached at least some kind of fruition. The
syndicate which had caused the abandonment of Matthey and Leake's
venture was that which had been formed by the group of city financiers
that Captain Stirling had been in touch with. They were Sir Francis
Vincent, Mr E. W. H. Schenley, Mr Thomas Potter Macqueen, M.P.

and Mr Thomas Peel, a gentleman of independent means who was a relative of the then Home Secretary. They had proposed a scheme for sending out a large number of emigrants whom they would provision and settle, in return for a large grant of land. This scheme had been put up to the Government and was probably one of the determining factors in deciding the Government that a colony could be established without undue Government expenditure. The amount of land the syndicate claimed was four million acres. The Government in considering the scheme cut the grant to one million acres and refused priority in the choice of land. The syndicate did not care for the terms offered in their detailed form and withdrew their offer, with the exception of Mr Thomas Peel. Peel informed the Government that he would accept their terms and continue with the venture. He was allowed priority of choice for two hundred and fifty thousand acres, the remaining seven hundred and fifty thousand to be granted after he had landed settlers and capital in a required period.

The newspapers seized upon the Peel scheme. Unable to conceive the vastness of the new land, they tried to give the public the impression that after Peel's two hundred and fifty thousand acres had been granted there would be very little good land left, and that it was all a matter of favouritism on the part of Sir Robert Peel for his relative. Questions were asked in Parliament and the Secretary of State was obliged to give a detailed history of the negotiations between Peel and the Government.

Peel did not prosecute his scheme very efficiently. He failed to land his settlers and capital in the time required by the Government and his priority of choice lapsed. About three hundred people were brought out by him.

A grant of a hundred thousand acres of land for a settlement scheme was also made to a Colonel P. A. Lautour who did not go to the colony in person but sent out an agent with eighty-five settlers together with stock and provisions.

❦

Whilst all this interest was being exhibited in the new colony, H.M.S. *Challenger*, Captain Fremantle, which had slipped quietly away from Spithead in December, had reached the shores of New Holland in April 1829. She had waited there, anchored in Cockburn Sound till the *Parmelia*, bearing the Lieutenant Governor, Captain Stirling, his

wife, various officials of the Civil Service and their wives and servants, arrived at the end of May. A week later, H.M.S. *Sulphur* with a detachment of the 63rd Regiment commanded by Captain F. C. Irwin, arrived. On 18 June 1829, a proclamation was read announcing that the Territory of Western Australia had been taken possession of in the name of His Majesty King George IV.

Chapter

3

Preparations for Emigrating

CAPTAIN JOHN MOLLOY was one of those Englishmen who, in the New Year of 1829, were interested in accounts of the new colony in Western Australia. He must have heard of Captain Stirling through their mutual friend, Major Harry Smith, so would be prepared to accept his recommendation of New Holland as a place for settlement. Major Smith himself had just departed in January for another British colony, the Cape of Good Hope, and Molloy's other friends in the Rifle Brigade were turning to civil life.

About this time Molloy had discussions with Captain Marshall MacDermott of the 8th Foot, Captain Francis Byrne of the Rifle Brigade and Mr George Cheyne, a Scottish merchant, about the prospects of Swan River and the advantages of taking up land there. They had the idea of purchasing a ship, to be loaded with wooden houses and boats, which would be sailed out to the new colony with its owners on board; its cargo would then be sold and the ship employed in plying for trade there.[1] These discussions must have taken place in the first three months of 1829, and at that point something must have gone wrong with their plans, for in April Cheyne was writing to the Colonial Office: 'I intend to emigrate to the New Settlement at the Swan River, New South Wales, and I beg to be informed whether a friend who is about to sail to that quarter will be allowed to secure a portion of land for me adjoining the grant he may fix upon for himself.' He received the reply: 'Persons are only allowed to receive grants of land upon their arrival, and his request is therefore inadmissible.'[2]

The friend in question would appear to have been Molloy, for in a letter of the following year, written in the colony, Molloy mentions Mr Cheyne as 'a person of most honourable conduct who suffered

much inconvenience by my defection from our original plans by my taking a passage in the *Warrior*'.

Captain Marshall MacDermott was not able to get his discharge from the army quickly enough and may have been the cause of the delay, while Captains Molloy and Byrne may have wished to sail at once to be among the first-comers, who would have an advantage in the choice of land. By May, these two must have decided to take the first ship they could, which proved to be the *Warrior*, due to sail in August, for on 4 May Mr Cheyne was inquiring of the Colonial Office:

> May I beg the favour of being informed whether there will be any duty levied on articles imported into the new settlement on the Swan River from a foreign country in a foreign vessel? If so, how these duties are regulated? And if the vessel may afterwards be employed in the trade of the Swan River in any way it may appear advantageous to the owner, he being a British subject and a settler in the new Colony?[3]

Advice was given, as it had been to Nathaniel Ogle, that no foreign vessel would be allowed to trade and that foreign goods would be subject to a levy. Nevertheless, Captain MacDermott and Mr Cheyne proceeded with their plan to buy a Swedish ship at Gothenburg and a cargo of wooden houses. MacDermott was some time in getting his discharge from the army and then took a little more time to get married, so that it was June 1831 before he and Cheyne arrived at Fremantle in their Swedish ship (tactfully christened the *Stirling*). They then had an acrimonious dispute over the value that each had put into the ship and the cargo,[4] which may have been the reason why Marshall MacDermott in his reminiscences, skims lightly over the negotiations for coming to the colony between himself, Molloy and Byrne, and does not mention Cheyne at all.

Captain John Molloy was now aged forty-eight. It was indeed time to settle down. With a suitable wife he could establish a home in the new colony and found a family to inherit the numerous acres which as a capitalist he could claim. Miss Georgiana Kennedy must have seemed just the right person. She was a gentlewoman, well connected, of a serious nature and used to living in the country, and of just the right age. Though she was twenty-four to his forty-eight, it was not too young. He was well set up for his age, and it was right for a man to have a certain superiority of years over his wife. He wrote to her, relying on his years of friendship with her.

Georgiana had gone to spend the summer with her friends the

Dunlops at 'Keppoch'. What a flutter must she and the Dunlop girls have been thrown into when Captain Molloy's letter arrived! It was a tremendous decision to make—not only to resign her maiden life, but all her friends and the places she loved, perhaps never to see them again. On the other hand, she had long held Captain Molloy in affection. She was now twenty-four, past her first youth as it was then regarded, and a home of her own would give her that happiness which she had lacked in her mother's home. After considerable heart-searching, she wrote accepting his proposal.

Molloy's first move, on receiving Georgiana's letter, was to make further inquiries about the ship *Warrior* from its charterer, Mr H. C. Sempill. He visited Mr Sempill at East India Chambers and found that he and his household could all be accommodated, and that the ship would sail for Swan River about the end of August. A letter was at once despatched to Georgiana warning her how near was the date of departure and perhaps suggesting, for ease in travelling, that he should come to Scotland to wed her and bring her back to London as his bride. Perhaps, on the other hand, as it is suggested by descendants that her family was not in favour of the marriage, she herself thought it would be a happier wedding if it took place in the home of her friends the Dunlops.

By the last week in July Captain Molloy had engaged sixteen servants, and had purchased horses, pigs, sheep and cattle. He had made comprehensive lists of all the requirements for farming, for seeding and planting, and for provisioning for a twelvemonth or more. Much of this had been bought and ordered to be boxed when he left London to journey north. He had tried to leave as little as possible to the last days before sailing.

He was accompanied in his journey to Scotland by Lieutenant Dalton Kennedy, Georgiana's brother. Lieutenant Kennedy had just returned from duty at the Rock of Gibraltar. He had taken a fever there and had been seriously ill. He was now on leave; he had just come of age, and after an unpleasant interview with his guardian on the subject of his pecuniary affairs, he was glad to get away with Jack Molloy and make the trip north to his sister's wedding. He was very fond of his sister, and Georgiana had a great affection for both her brothers—Dalton, the smart young officer, and George, the scrubby schoolboy, still at Rugby.

Unfortunately, letters or diary which might describe the wedding

are missing. All that is known is that the ceremony was performed according to the service of the Church of Scotland, by the Reverend Robert Story, the husband of Georgiana's friend Helen Dunlop, in the little church at Rosneath. Perhaps there were some simple celebrations afterwards—a glass of wine and a piece of bride cake—at the manse or at 'Keppoch', the Dunlops' home. The same evening, they took leave of their friends, for ever as it proved, and went to Glasgow.

The next day they went to Greenock, and took a small packet boat there for Liverpool. From thence they journeyed to Coventry by coach, and at Coventry they were met by Mrs Kennedy's carriage, in which they drove to Rugby. Here the next three days were spent in packing, saying farewell to friends, and listening to Mrs Kennedy's lamentations. There was some kind of reconciliation between the sisters, for, writing from Western Australia several years later, after Elizabeth's death, Georgiana said: 'I feel great consolation that we were good friends on leaving England and even better since I was out here.' Notwithstanding this, the two letters to Elizabeth that are preserved reveal a stiffness and distance that show she was still not quite sure where she stood with Elizabeth. Elizabeth remains a rather elusive figure. None of her own letters are extant to give a clue to her character. The one hint is conveyed in Georgiana's first letter to her: 'Mama told me in some fussy letter you had become an Authoress, but the name and subject or extent of your work was omitted. Do send us a specimen or tell me something about it. . . .'[5] Perhaps Elizabeth was a writer *manqué*, unsympathetic both with Georgiana's religious interests and the social interests of her Mama. This can only be speculation, but the sisters were evidently opposites.

As soon as they had arrived in London, the newly-wed couple went to lodgings at No. $7\frac{1}{2}$ Princes Street, Cavendish Square. Georgiana's first consideration was her wardrobe which would have to last her for several years at least. She may have been astounded with the new expensive shops in Regent Street, whose graceful curve of buildings had not long been erected; she may have visited the cheaper shops in Oxford Street. Both had the new plate glass windows which made shopping so much more interesting, for one could see merchandise attractively displayed. In spite of so much temptation—for, religious and serious-minded as she was, Georgiana was feminine enough to like pretty clothes—she was very sensible. The sphere to which she was going would be no fashion centre: she looked for things that would

be useful and lasting. It was unfortunate that no one knew exactly the kind of climate of the place, though it was said to be 'salubrious'. The materials of the day included light fabrics such as batiste, watered muslin, and embroidered organdie, and it can only be hoped that several of these were included in Georgiana's purchases. 'My gowns,' she stated in a letter to Mary Dunlop from London, 'are all very plain without anything but hems and tucks . . . and my bonnets cottage shape with X ribbons.'

At this period, gowns had reached an extreme of taste. The long graceful lines of the Empire style had gone. The high waistline had descended to the natural waist, which now required to be tight-laced. Skirts sprang out wide and full. They were excessively ornamented with flounces, loops of material, flowers and ruching, and were short enough to reveal the foot and ankle. Sleeves were immense and as laden with ornament as the skirts. The effect was to make a woman look as wide as she was long. Wide hats and bonnets were loaded with trimming, swaying and frothing with feathers, flowers and ribbons.

Coming from the provinces, Georgiana found she had to bring her ideas up-to-date. By the end of August, she had completed her outfit to her own satisfaction. The miniature painted before she left London shows her in a dark, tight-waisted gown, low-cut, with the fashionable wide full sleeves, her thick fair hair dressed high with pink and blue flowers, and a ringlet on each side of the face. The low hair-line on the forehead, and the heavy-lidded, very long-lashed eyes might be considered a trick of the painter, except that they occur in photographs of the next generation, and therefore, being passed on, must be an exact representation. In spite of her advanced age of twenty-four years, it is a young, proud and comely face.

Molloy, who liked to tease his serious young wife, referred to this portrait in a letter to Mary Dunlop, written across Georgiana's for the sake of saving paper and postage.

My dear Mary,

We are not yet off and from all appearance I think we shall be here or within the bounds of the kingdom until the 10th of the month. I do not regret our detention as it has afforded a *house painter* whom I employed, time to give a lively representation of her visage which may be the means of bringing us both to your recollection when we are far away.

She is a very dear creature, Mary, and really seems happy although she is

separated from her dear friends at Keppoch. She is quite notable in the way
of equipping herself and has accomplished the whole of her affairs in as quiet
and easy a manner as if she had been a wife of two years' standing. The Bell
man is ringing and I have only time to commend myself to all your family,
which I do without entering into a Catalogue of names, in the most cordial
and affectionate manner. Mind, I include all far and near.

> Ever yours most fraternally and truly,
>
> J. Molloy.[6]

Besides shopping for gowns and bonnets, Georgiana had to make
lists of household stores and other things to be bought. When Molloy
was ordering his seeds for planting, he headed the items—'Tobacco
seed, wheat, oats, barley, Indian corn, potatoes and fruit trees'—
'Garden seeds various'. This was Georgiana's demand and from later
accounts of her garden, she took with her all the hardy and well-
loved English flower seeds. She also chose garden tools suitable to a
lady's hands—a light rake, trowels and a watering-pot and rose. She
could not be without flowers even in a wilderness, and she had no idea
whether the wilderness had flowers of its own.

The days passed swiftly. There were calls to pay on friends, and to
receive and return on the wives of Molloy's brother officers of the
Rifle Brigade. It was fortunate that they could hire a carriage at a
livery stables. They had to visit Mr Sempill at East India Chambers in
the City to find out more about their quarters on the *Warrior*. As was
customary, they would furnish their cabin themselves, and as much as
possible of the furniture that they would use in their new home had to
be crowded into it, bedding and linen being provided by them as well.
Mr Sempill was impressed by the elegance and good breeding of
Mrs Molloy. He found they had mutual friends in Scotland. He
promised them the best cabin in the ship—one of the stern cabins
under the poop deck. He assured them that they would be very
comfortable.

This was Georgiana's first visit to London. Their lodgings in Caven-
dish Square were very comfortable, although to one accustomed as she
was to the fresh Scottish breezes, the air of the neighbourhood would
seem rather odoriferous. The sewers under the buildings were among
the most ancient and rotten in London, but no one paid any attention
to that. It was a very select neighbourhood. There was so much of
interest for Georgiana to see that she must have felt quite bewildered.
The portly King George IV no longer drove through the streets, for

he was aging and ill, and never left Windsor now, but the Duke of Wellington could frequently be met riding out from Apsley House, doffing his cocked hat to those who saluted him. Molloy was full of stories about him and would tease Georgiana that the only time he had missed the Duke's dinner to his Peninsular officers on the anniversary of Vimiera was this August, when he was otherwise engaged—to wit, getting married. There were the fashionable crowds to be seen parading in Hyde Park; and a sight new to both Georgiana and to Londoners were the Peelers, or Bobbies as they were called, patrolling the streets in twos. They were Sir Robert Peel's newly-formed police force, who wore blue tail-coats and tall hats.

There were places of amusement to visit: Madame Tussaud's Chamber of Horrors in Baker Street, where the little, beady-eyed Frenchwoman exhibited most realistic effigies of notorieties taken from life, and some of them even more realistically taken from death— death masks she had made herself from prominent personalities of the Reign of Terror during the Revolution in France. There was the Opera at Covent Garden (Georgiana was passionately fond of music) and theatres, such as the Haymarket and Drury Lane, if she was not too strict a Presbyterian to go to such places. She was certainly troubled by much of what she saw, the frivolity and carelessness of the fashionable world which gave no thought to the world to come, and the squalor and misery of the poor, whose only relief was found in the taverns and gin shops. 'I have not given way to the vanities,' she wrote to Mary Dunlop, 'in this truly depressing London where I never dreamt of such dreadful vice and search after unsatisfactory things as I cannot turn myself from beholding.'[7]

The Molloys had brought with them from Scotland a note to Edward Irving, then at the height of his fame. Irving made no attempt to see them at first, and Georgiana was a little piqued. She had been such an admirer of his. Irving had come a long way since his early days in Glasgow. On first coming to London he had accepted the offer of a decaying little Scottish church at Hatton Garden. His powerful sermons had rapidly made an impression and brought crowds to hear him. His first books, the *Orations*, and the *Argument for Judgement to Come*, had gone into three editions very quickly. He was called from Hatton Garden to a large church in Regent's Square, and it was here that the Molloys went to hear him. A meeting did eventually take place between them and Irving showed great interest in their venture,

their 'promised land'. He prayed publicly for their success there, for Georgiana recorded with pleasure on 12 September that:

> Irving prayed last Sunday week for the new Settlement and for those two lately joined in Wedlock by God and man, that we might be like Abraham and Sarah in the land God had allotted us—and that we might finally reach that other promised shore which had been ordained to us for Eternity.[8]

The need for haste in their preparations had lessened as it became evident that the *Warrior* would not be ready to sail in August and probably not till the middle of September. Georgiana had laid in all her stores and was busy supervising their packing. Life at $7\frac{1}{2}$ Princes Street went on very happily. Georgiana had instituted the custom of morning and evening prayers. This was an innovation for Molloy, but he accepted it as part of his life with Georgiana. She related with pride to Mary Dunlop:

> Dawson, Molloy's valet, is reading Isabella's* 'Life', the copy dear Maggie gave me, and was so delighted with it he begged to lend it to a friend in the Regiment, which I granted. He said to his wife after they had been to prayers the first evening, 'Oh! it's a beautiful thing to hear Mistress say, "Come to prayers", and Master seems to like it for he takes the books from her and begins reading so pleasantly. We ought all to be with God the last thing at night when He has preserved us through all dangers by day.' This his nice little wife told me with much heartfelt satisfaction that I know not how grateful I am, and wish you to assist me in esteeming thanks to Whom alone they are due, and to beg for an increase of light to aid me in the direction of these poor people. Anne says she does not feel happy for she doubts of being accepted of God, therefore she does not think she can be accepted. What an opening this would be for some of you and I certainly believe that you be yet among us.[9]

Dawson—Corporal Elijah Dawson—was a Kentish man, born at Birchington in the Isle of Thanet on 29 September 1794. He had joined the army at the age of seventeen. Five of his brothers were already in it, and all fought at Waterloo. Corporal Dawson had served under Captain Molloy and remained with him in the years after Waterloo. They had been together in Ireland, and afterwards at Gosport. When the idea had come to Captain Molloy to try his luck as a settler in Western Australia, he put it to Corporal Dawson and the faithful Dawson decided to follow his Captain there. He even followed his example in deciding to marry, and was considerably more prompt

* *Peace in Believing*. A Memoir of Isabella Campbell, by the Reverend Robert Story. Published 1829.

about it. Elijah Dawson* was married on 11 May 1829, to Anne
Wakeham, at Alverstoke in Hampshire. As this is near to Gosport, it
would seem that Corporal Dawson was unable to get leave, and so
had to be married close to barracks. Having turned in his papers,
Dawson and his wife came to London to make their own preparations
for the voyage, and to await the arrival of the Molloys.

The *Warrior's* delay in sailing caused much inconvenience to its
passengers. London was an expensive place to live in, and the Molloys
were glad to move to Brockhurst House near Gosport, there to await
the arrival of the *Warrior* at Portsmouth, where they would embark.
'It is no jest,' wrote Georgiana, 'keeping sixteen servants, horses, pigs,
sheep and cattle from July to the present time on hand.'

Two of their fellow passengers were already in residence at Brock-
hurst House—Captain and Mrs Byrne. Georgiana had written from
London to Mrs Byrne and must have expressed some doubts as to how
their religious life would be served in the new colony. The reply she
received caused her to comment to Mary Dunlop:

> Hear Mrs Byrne is much the woman of the world. In a letter just received
> from her, she says, 'I trust we shall be able to preserve that reverence which
> creates happiness when Vice is unknown and to attend properly to the
> salvation of our souls',—and this after declaring a Piano is indispensable to
> our comfort and pleasure. However, I shall be better able to judge from her
> own acquaintance.[10]

Five days after making her acquaintance, Georgiana was still critical.

> I found Mrs Byrne something in manner like Mrs Abney, but much more
> unquiet with a bustle—her petticoats in the air and two very pretty legs and
> feet protruding beyond them. However, she has much subsided and Molloy
> thinks when she sees more of me, she will change that quick and abrupt
> manner for my more steady and sedate aspect. She is very good-natured and
> I cannot wonder that having been born and bred in the Rifle Brigade, she
> is fond of those 'Oeils'† so often practised in and by military persons. She
> acceded instantly to my wish of having Prayers morning and evening, so
> accordingly Molloy reads a Psalm . . . also the Gospel of St. John and *reads*
> Prayers, which I wish would be done away with, and that we might have
> them extempore.[11]

* Corporal Elijah Dawson's Pay Book is still in the possession of the family and gives
the following particulars: No. 8 Company, 1 batn. Rifles. Where born: Birchington,
Kent. When: 1794. Height: 5ft. 7 in. Complexion: fresh. Hair: dark brown. Eyes: grey.
Face: round. Marks: none. Former Service in other Corps: none. Bounty: 16 Guineas.
His Waterloo medal is also to be seen.

† Flirtatious glances.

Georgiana found that she and Mrs Byrne had mutual friends in the Buchanans at Glasgow, and told Helen Story that Mrs Byrne was 'Matilda Harriet, a daughter of Colonel Westcott's, Rifle Brigade'.

Little Mrs Byrne, with her short skirts and worldly ways, was in for several weeks' discomfort, for Georgiana was in a crusading mood.

> On Thursday last after I arrived, Captain Byrne and I had a long conversation about Belief in what it consisted and why so much stress should be laid upon it. This led to how we are to ascertain our having the right Belief, which I showed him by 4.1.St. John, 1.2.3. and 2.1.St. John, 3, and 5.1.St. John 9-15, and also by telling him that if we were not assured of Christ being an all-sufficient atonement, our Belief was not the true one. Since this conversation we have spoken on no other subject, and this morning Mrs Byrne arose between five and six—her usual hour is nine—and began to commit to paper the state of her feelings, as she has just told me she has not got any rest these last two nights and especially last night. The poor thing has been weeping copiously these last three days and her eyes are now quite swollen. . . .[12]

Whether Matilda Byrne's diary received the state of her feelings, or whether she wrote to someone else is not known. Whether too much religion impaired the gaiety of life which was essential to her, or whether she considered the Captain's interest was less in St. John than in the blond hair and long downward sweeping lashes beside him, cannot be said. But she had had all she could stand. The situation became tense as the last days in England spent themselves. The *Warrior* did not arrive at Spithead till 16 October and by that time the two ladies were barely on speaking terms, while even their husbands had been drawn into it. On board the *Warrior*, one of their fellow passengers noted in his diary:

> The report that Mary heard of the rupture which had taken place between the two Captains appears to be quite true. It originated, I believe, in a mis-understanding on the part of the ladies but of the facts I am entirely ignorant. A marked stiffness, however, which is visible in the behaviour of each to each is an evident proof that something of the kind has been the case.[13]

This episode marked the end of Georgiana's proselytizing. As the shores of England receded, so did the influence of the Dunlops. It was an old and pagan land to which she was going, and though it never turned her from her faith, the terms of cant fell away and became mean and inadequate in the face of its boundless forests, its limitless space and its loneliness.

Voyage in the 'Warrior'

GEORGIANA'S two existing letters written before she left England unfortunately have little description of those last days. They are full of personalities known to her and to the Dunlops; it seems as if by mentioning their names she tightened the link with all she knew. The only name of any particular interest is in the allusion: 'I should much have liked to hear from dear Mrs Welsh and should have considered his book a very great compliment.'[1] Mrs Welsh was the mother-in-law of Thomas Carlyle, and this sentence may refer to *Sartor Resartus*, which would be known to his friends, though it was not actually published as a book until 1838. It would have been more interesting if Mrs Molloy had described instead those last days at Brockhurst House, when it seemed as if the *Warrior* would never come. She must have felt, as would anyone on the brink of such a journey, the tugging of the bonds that held her to her own country, and at the same time the urge to get under way, to begin the life to which she was committed, to start the adventure, to find out what lay ahead. The impatience with each shortening Autumn day, the soul-reproaching caused by the coolness at Brockhurst House, that went on until at last Captain Molloy returned from Portsmouth on Friday, 16 October 1829, with the news that the *Warrior* had arrived that morning, can only be imagined.

Mrs Molloy was not the only one who longed for the advent of the *Warrior*. There was in Portsmouth a London builder and surveyor of considerable affluence, Mr James Woodward Turner, and his sixteen-year-old son, Thomas, who had posted down from London by coach, leaving on 13 October and arriving the next day.[2] As Mr Turner had a large and growing family, and business was bad in London, he had decided to emigrate, and had written to the Under-Secretary for

Colonies to know if he could obtain employment with the Government. Although the answer was in the negative, he had been provided with a copy of the conditions of settlement and had resolved to sell up his business and go out to Western Australia. This had all been done very hurriedly, in order to take advantage of the *Warrior's* sailing. His wife had gone to Chichester to take leave of her parents; six of his children under the charge of Ann, the eldest, had sailed from London in the *Warrior*, a friend of their father's, a Mr Graves, making the short journey to Portsmouth especially to look after them, while Mr Turner and his eldest son had remained until the last minute in London winding up their affairs.

Even so they reached Portsmouth two days ahead of the *Warrior*, which took a week to reach there from London. Mrs Turner joined them and together they viewed the town. The second day they spent seeing over the dockyard. Portsmouth was the chief naval depot in England and had the latest modern equipment. Thomas was particularly impressed with the mechanical side, while Mr and Mrs Turner enjoyed a visit to the *Victory*, the flagship in which Nelson had lost his life at Trafalgar. This was tied up at Portsmouth and was a great attraction to visitors. However, the sights of Portsmouth were exhausted by the second day, and no one, not even Mrs Molloy, was more pleased than Mr Turner to see the *Warrior* at last standing out from shore. He and his wife decided to go on board at once and see the family. But the family had come on shore and Mr Turner, meeting them, advised them to visit the dockyard and the *Victory* while he and his wife Maria went to see their cabins and also how their employees were. Mr Turner had by far the largest establishment of any settler on the ship.

The *Warrior* lay about half a mile out, riding at anchor on the racing waves, her canvas furled. There were many other ships about and the small boat the Turners were in, together with the Captain of the *Warrior* returning to his ship, had to thread its way among them. An accident occurred, which though unpleasant enough at the time, reads amusingly in Mr Turner's diary.

The man in the bow of our boat did not see another boat of the same description as ours bearing down from another direction, and the sails were so low down that none of us saw her until about a minute before she struck us. The Captain was the first that saw her and he hollowed out as loud as he could, but I did not know what it was about, and in an instant I felt a shock,

saw the bow of the boat in ours, and the side of ours broken like a chip box and half full of water. . . . I pushed Maria forward and told her to hold tight to the boat, the other men humanely adjusted her and I thought her safe. . . .

They all attempted to jump into the other boat, Mr Turner being hampered by a great-coat. When he looked for Maria he could not see her. Glancing wildly around, he found she had fallen overboard.

I looked towards the bow of the boat and saw her bonnet just above the top of it, I ran to her and caught tight hold of her arms, but was so overpowered with joy that I could not lift her in. A little boy had got hold of her and managed to get her to hold tight and not be alarmed, and by the assistance of one of the men she was soon in safety, but in appearance more dead than alive. . . . Maria escaped all injury except fright and a wetting nearly up to her shoulders. The Captain hurt his hand and grazed the skin off his leg. I got a black eye and five bruises on my legs. . . .

They were not far from the *Warrior*, so they sailed on, went on board, changed their wet clothes and returned to shore.

Maria recovered her spirits very much and after having dinner I put her into the Chichester coach. . . . All my single men had left the ship in the morning and I heard they were seen about the town drunk. Saturday being a very fine day I paid my bill at the Inn and to save expenses went on board with my baggage. I found all my people on board except young Lany and I was then informed he intended to run away. . . .[3]

Saturday was a busy day for the Molloys and Byrnes. While the ladies wrote letters of final farewell, the two Captains superintended the rounding up of their cattle and livestock, which were then embarked in boats belonging to the Marine Artillery and taken out to the *Warrior*.

'On Sunday,' Captain Molloy noted in his diary, 'Dawson took my luggage on board. . . . Monday we all embarked, men, women and children.'[4] The sixteen servants Georgiana had mentioned earlier had dwindled to five adults and three children. They had probably lost enthusiasm for emigrating during the long wait since July. The same loss of staff may have happened to the Byrnes, as they only brought six adults.

Leaving his wife to reflect, as she unpacked her possessions in the small cabin, that this was to be her home for the next four or five months, Captain Molloy went to inspect the situations of his servants and his cattle. He was not pleased with what he found. The charterer of the vessel had filled up the stalls specially erected for the cattle in

the hold. The cattle were now on deck, exposed to the weather, uncomfortable, noisy and smelly. Steerage passengers complained that 'huge drops of the effusions of swine and cattle' leaked through to the cabins below.[5] The animals took up most of the deck space so that there was little room for the steerage passengers to move about; the better-class passengers were lucky in the possession of the poop deck, but they could not escape the smell of the animals borne on the wind. The general clutter made the ship look like a Noah's ark.

The *Warrior's* delay in leaving London had greatly inconvenienced the less well-off passengers, many of whom had taken up their quarters on the ship while waiting for her to sail. On 5 October 1829, the Colonial Office received a letter from one Thomas Habgood whose son and several friends were passengers, protesting against the conditions on the ship.

> It is doubted by many of the passengers whether it will be possible to keep the ship's crew in perfect health. The whole of the steerage is literally choked with Berths and nearly dark. Poor men who have paid from 25 to 50 pounds for their passage cannot find their berth but with a lighted candle. . . . There is no current of air to ventilate. His avarice has been so great that he has not even left a table or a space for the steerage passengers to mess or take their scanty allowance of food but are compelled to take it on their knees. . . .[6]

The person charged with avarice was the charterer, Mr Sempill. Nothing was done about the complaint.

The *Warrior*, Captain J. Stone, (479 tons, Owners Wm. Bushell & Co., 27 men, 4 guns, 166 passengers, from London and Cape of Good Hope to Swan River, Hobart Town and Sydney) was the average size of the ships that brought emigrants to Swan River in the first years of settlement.[7] The best cabins were those in the stern under the poop deck. The Captain and officers usually had their quarters in a round house on top of the poop deck. The steerage passengers were carried below in dormitories of berths ranged end to end. There were sometimes some separate steerage cabins.

The first class passengers messed with the Captain, who usually kept a fair table, including wines. The steerage, however, were only served with water, and little enough of that. They had to get their meals themselves, and so had to come on board provided with all the food they were likely to require. They learnt by experience which were the best sorts of provisions to take and were able to send advice on this to friends and relations who followed them.

As to provisions for his own use, we recommend his taking out a few sacks of potatoes. We miss Ireland's lazy root more than any other article whatever. Secondly, pickles, biscuits, gingerbread, arrowroot, wine. In fact, almost everything which your providence supplied he will find very grateful, but I think nothing more so than the gingerbread. . . . The pickles we have found super-excellent. . . . Let him lay in a good stock of coffee; it is the only thing that will render the water palatable.[8]

Pickles were necessary to counteract scurvy, and to lend zest to the hard salt meat which often went maggoty. Although fresh fruit was laid in at whatever ports they touched, it did not keep long. Gingerbread was a change from the hard biscuit that took the place of bread. Fresh bread was very rarely baked on board. The children particularly yearned for bread and butter or a nice hot roll. 'Today at tea time we got a little bread which has been baked on the ship,' Mr Turner noted in his diary. 'By great difficulty I got two slices. . . . Several times there has been bread of the same kind made by the steward, but it is generally smuggled up or given to favorites, for I believe we are not free from bribery . . . in our little kingdom.'[9]

But the article of diet whose provisioning—or lack of it—really upset them all was the wine. Before they left Portsmouth Turner gloomily reported that there were only two sorts of wine on board— a light Tenerifi [sic] and a mixed Cape Madeira. The lack of choice might not have been so bad if the quantity had been there. The provisioning had been done by Mr Sempill, the charterer, and from the very beginning it was apparent that it had been done on a mean scale. At Portsmouth, Turner referred to 'the Captain having the management of the water and provisions instead of Mr Sempill whom everyone I believe is dissatisfied with, excepting some of his own party and country-men for they are all Scotch'. Mr Sempill might have been thought rather unwise in travelling in a ship that he had stocked so badly, but it does not seem to have affected him. When, three weeks out from land, supplies of wine began to run short, one passenger indignantly remarked:

The rascality of Sempill has at length arrived at a crisis altogether intolerable. He had promised a pint a day and it has already given out. He has no more except what is under twenty tons of goods. The consequence is that every day after dinner he is treated in a manner that to a gentleman would be intolerable. He, however, with the greatest 'magnanimity' sits and hears and bears every insult which the irritated feelings of people not at all particular are inclined to level at him.[10]

The matter was one for some concern, as it was the custom then to drink wine rather than water. Water was often so impure as to carry many diseases; also on these small immigrant ships the storing of water was a real problem. The great amount of livestock on board meant that most of the water was for their use, and what remained was for washing purposes. Mr Turner had cause to mention that it was 'difficult to get sufficient to keep our flesh clean', and that even the small amount of filtered water for drinking 'stinks abominably'.

> Since we left Portsmouth the allowance served out to us is only one pint a day for each grown person and half a pint for each child, and from that we are obliged to squeeze a little extra to drink and they talk of even curtailing that allowance, and when rain occurs they object to allow water for washing.[11]

The *Warrior* remained at Spithead from Saturday 17 to Thursday 22 October. By then all the passengers were on board busy accustoming themselves to their quarters. 'Everything is so crowded and such a confusion we have scarcely room to stir. My own cabins are nearly in total darkness and filth and dirt in every hole and corner. . . . I really now begin to find a great advantage in being a very little fellow with a very small wife and children, and yet our principal cabin is nearly three times the size of several of the others,' remarked Mr Turner. 'We cut but a solitary figure amongst our Beaus and Belles on the Quarter Deck Parade,' he went on, referring to the several families of military men on board. By reason of his wealth Mr Turner enjoyed the same advantages as they did, but at the same time felt excluded by the strong class attitudes of the day. His later observations, though quite good-tempered, make this plain. When strong words occurred between him and an Irish passenger, the latter could not fight Turner because, to quote Turner himself who was rather amused about it, Turner was 'not a gentleman'.

By late afternoon of 22 October, the Blue Peter was seen flying from the masthead and the Captain announced that they would sail within two hours. This at once brought to mind, on the part of four young men who were setting out for the new colony, a host of last minute purchases they wished to make. Leaving the youngest of them, Alfred, in the charge of their one servant, Pearce, a youth of fourteen, the other three got into a boat and were rowed furiously to shore.

After making their purchases, they went to their home at Portsea and had dinner. There were a number of relations there to say farewell to them, as well as their mother and three sisters. Healths were drunk, tears and kisses exchanged, and all in all the proceedings took more than two hours. In considerable trepidation lest the ship should have sailed with only young Alfred on board, they reached the harbour. But all was well. There lay the *Warrior*. As they neared it, they could hear the strains of music and see figures dancing on the poop deck, while others stood at the sides shooting at seagulls. It appeared that the wind was not yet favourable and that they would not sail before daybreak. They spent the rest of the evening arranging the cramped quarters of their cabin.

These young men were named Bussell. Their father, a clergyman of the Church of England, had died nine years before, leaving their mother with six sons and three daughters to rear (Plate 3). John Bussell, the eldest son, had been to Winchester and had won an exhibition to Trinity College, Oxford. William was a medical student and Lenox in the navy. Charles was at the Bluecoat School, Vernon and Alfred at Winchester. It was through the generosity of friends and relatives that a small income was provided to enable the widow to bring up her family until each came of age. Their father had taken out an insurance policy of £500 for each of them, payable at the age of twenty-one. The most rigorous economy had to be practised. John, on graduating from Oxford, had intended to take Holy Orders. While waiting to be ordained, he had spent his time tutoring the sons of a member of Parliament, Mr John Fleming, on the Isle of Wight. By chance, he had gone to a ball at Southampton and there met Captain Molloy. Molloy told Bussell of his intention to emigrate to Swan River and interested him in the colony. It is likely that he heard more about the place from his employer, Mr Fleming, who was a friend of Mr Potter Macqueen, M.P. Macqueen had been one of the original Peel syndicate and was acquainted with all the facts about the colony. Thinking of the three younger brothers nearing manhood for whom professions would have to be found, John Bussell considered that the new colony with its generous land grants would hold good prospects for them. The Bussell family talked the matter over, and if their powers of discussion as a family were equal to their powers as letter-writers and diarists, they would have gone into every detail of the venture quite exhaustively. They decided fairly quickly

that John, Charles, Vernon, and Alfred should go out to Swan River first, and that when they had seen conditions there for themselves and had made a home, their mother and the rest of the family should follow. Accordingly they embarked on the *Warrior*, travelling steerage to save money. They took only one servant, Edward Pearce, while their capital goods included, besides cabin furniture, three dogs, a bloodhound valued at £25, a lurcher, and a retriever; six ducks, eight fowls, coops and kennels; a corn mill, a washing mill, tools, soap, foodstuffs, an *Encyclopaedia Britannica*, compasses, a perspective glass and a thermometer.[12]

At last on Friday 23 October, a good breeze sprang up at about six o'clock in the afternoon, and the *Warrior* rounded the Isle of Wight and set off down the coast. Passing Plymouth they fell in with the ship *Protector* which had accompanied them from London. It too was on its way to Swan River, eventually arriving the week before them. As Land's End faded out of sight the ship began to roll a good deal. The ladies kept to their cabins in the first agonies of seasickness, and the gentlemen fortified themselves against the same complaint with stiff glasses of brandy and water, mixed with a little nutmeg and ginger, as recommended.

Not all the ladies were prostrated, however. Matilda Byrne, who was just twenty-two years old, was a good sailor and felt impelled to organize the social life of the ship. On the Monday after they had sailed, Charles Bussell wrote:

> While in the midst of our breakfast this morning we received an invitation from Mrs Byrne to come to a dance which she had been forming upon the poop. We did not of course throw cold water upon the invitation, although we none of us had any predilection for the proposed amusement. Partners were chosen and an attempt was made, but it was only an attempt for there was a lack of those two most essential requisites in such cases—ladies and music. Of the one I think four formed the outside and of the other there was only a small hand organ of which none of the tunes were at all calculated for the dance.[13]

That she asked the young Bussells up to the poop deck from the steerage seems to indicate that Mrs Byrne had met them socially, probably when their mother and sisters had come on board to examine and arrange and exclaim over their cabin. They were all personable young men though John was perhaps a little austere, and Charles, tall, good-looking and highly-strung, had an affliction that prevented

him from being the best of company. He stammered. He said of himself:

> My society is found not only a bore, but insupportable, thanks to the mimicking propensities of my earlier years. I sometimes endeavour to think what kind of a character I should have been if I had not stammered, for I can imagine nothing that would tend more to alter a man than this defect. To feel upon occasions that you could afford the very information that parties in conversation are seeking, and to be obliged to hold your peace; to feel, at all events in your own conceit, that you could be witty, and to be compelled to preserve the stiff and rigid features of a mere listener. . . .[14]

Because of this defect his descriptive pen relieved his mind of what his tongue could not utter, and his diary and letters reveal his lively personality. In referring to his hostess, Mrs Byrne, he said: 'We found Mrs Byrne extremely affable and very good-natured, and her husband an agreeable gentlemanly man,' and slyly added later: 'Of Mrs Byrne I have nothing to add . . . except that I might be inclined to put "too" before the word "affable".' He finished his account of the dancing on the poop deck by saying: 'We understood that Mrs Molloy was suffering dreadfully from seasickness and that she had scarcely made her appearance on deck since she had been on board.'[15]

Georgiana had indeed been suffering dreadfully, not only from seasickness but from the first stages of pregnancy. She could expect no assistance from Anne Dawson, who was in the same state, but more advanced. Captain Molloy, with a soldier's brevity, merely recorded: 'The ship rolling and the ladies rather affected with the motion. My own household in particular.' He showed more concern with his stallion horse in a stall on the deck. It had been troublesome from the outset. Now it had fallen over with sickness. It had to be raised and supported in slings. The stalls were no more than 'gingerbread erections'. The sheep in pens had begun to die, and the pigs too were going, one after the other. The cows, whose milk the Captain had been distributing at first amongst fellow passengers, now began to fall off in amount. He was very preoccupied.

In between the attacks of nausea Georgiana had much to think about and to enter in her journal. 'I often regretted my promise to keep a journal, as for some days I was unable to hold a pen,' she wrote to Helen Story from Cape Town. Unfortunately this journal has been lost. It might have cast more light on Captain Molloy's entry in his own diary for 27 October: 'On this day B. and E. are to be married.

I wish them most cordially every happiness that state can afford.'
No doubt this referred to Georgiana's sister Elizabeth Kennedy, and
the clergyman, Mr Besley. As there is no mention of the matter in
Georgiana's letters after her own marriage before she left England,
perhaps the decision was only made and communicated to her just
before she quitted Portsmouth.

While she thus lay, occupied with sickness and thoughts of home,
there was much excitement on deck.

> A schooner was visible at an early hour this morning apparently bearing
> down directly upon us. All the telescopes were immediately directed toward
> her and she was universally pronounced to be an armed vessel and a pirate.
> All hands immediately set themselves about preparing their arms, ammu-
> nition etc., but long before they had transacted their weighing matter the
> cause of their alarm was 6 or 8 miles astern.[16]

This incident caused some trepidation among the more timid
passengers. Allusions to it in Captain Molloy's diary show that they
thought the Captain of their ship should have had more protection
for them against pirates. The *Warrior* carried four guns but only
twenty-seven crew who would be fully occupied in sailing the ship.
The fear of pirates was a real one as they were nearing the coasts of
Morocco from which pirate vessels often made sorties.

Mr Turner noted:

> Today had a muster of all our Rifles, Guns and Pistols to see what a respectable
> or rather formidable appearance we could make in case of any Pirates coming
> to visit us, and each suggested his plan of attack and defence and talked of
> deeds of valour to be done, for my part as Falstaff says, a Tax upon such an
> honour, I would much rather that they would not pay us a visit at all, and
> I should be sorry to singe even a hair of their heads. We had a little drilling
> of the Platoon exercise and when we were ordered to stand at ease, it was
> anything but that, for we could hardly stand at all at all, as they say in our
> sister Isle.[17]

The male passengers seized on the idea of drilling as a good expedient
for passing the time. There were several military gentlemen on board
to train them. The four Bussells had to take part:

> We were enlisted in the corps and were accordingly summoned by the blast
> of the bugle to parade, and considering it was the first time of its being called
> out the whole corps under the command of one Captain Graeme [Graham]
> went through its various evolutions in very tolerable style. . . . The thing
> is, however, a mere hobby and is not likely to be continued after the amuse-
> ment of novelty has worn off. . . .

Boredom was indeed the worst of their troubles. The ship was so crowded, there was so little deck space that practically no exercise could be taken, with the resultant effect on livers sluggish with wine and lack of fresh food. Quarrels began to spring up, factions and sides to be taken.

> Last night there was a general quarrel in the cabin between the Scotch and Irish passengers. It commenced by finding fault with the general conduct of Sempill, and one of the passengers who in general drinks too freely told Sempill to expect to be overboard some evening and went so far afterwards as to say that he would hoist him over, and I expected that there would have been a general fight; but the Captain interfered and all ended in high-sounding words without bloodshed.[18]

There were on board the usual motley assortment of shipboard characters, one of whom was a focal point of trouble. Matters came to a head when some of the hotheads refused to obey Captain's orders and there was a scrimmage between them and the ship's officers. The *Warrior* was nearing the Cape Verde Islands, and when anchor was dropped at Porto Prazo, the Captain had the wrong-doers taken before the Consul there. 'We understand from those present,' wrote Charles Bussell, 'that the evidence of Captain Molloy was given against De Burgh and his fellow mutineers and that of Captain Byrne on their behalf. The result is that this Mr De Burgh is to be left behind on receiving a part of his passage money and having the whole of his goods sent on shore.'

For a week before they reached the Cape Verde Islands the weather had become calm and mild. The ladies began to make their appearance on deck, among them Georgiana, whom Charles Bussell now described in his journal.

> Mrs Molloy has all the air of a lady well born and well bred without having mixed much in the world, and there is consequently a great deal of interest about her. She is rather inclined to the romantic and is delighted to have anyone with whom she can contemplate the sublimity of a night scene or expatiate upon the beauties of this or that piece of poetry. We find her quite an acquisition to our society for we cannot until now have been said to have been acquainted, her visits upon deck having been hitherto too short and too seldom to allow of anything further than the mere compliments of etiquette to pass between us. Her husband is a gentlemanly, good-natured kind of man and that is all I believe I can say for him except that he is rather too *nestorious* for so young a wife.[19]

This allusion to Nestor, a character in Homer renowned for his

age and wisdom, coming from a twenty-year-old youth, draws attention to Captain Molloy's seniority in the society in which he found himself. The Bussells were young, the Byrnes were young—he thirty-one, she twenty-two—the other military families, Grahams and Kollers, were young. Mr Turner, it is true, was the same age as Molloy, but Mrs Turner was ten years younger, and his pretty daughter Ann was just eighteen, and engaged in a flirtation with Alfred Green, assistant to Mr Koller the surgeon. The days when Molloy was 'Handsome Jack' were passing, as the outlines of the still good-looking face thickened and the stiffness of the military carriage became the stiffness of muscles and joints. Unsuspecting that his youth had gone— for the spirit of such a man does not grow dull and stiff with his body— the Captain looked ahead to the estate and family he would found. The horses, cattle and livestock were essential to its beginnings, and required his supervision over what his labourers could do for them. That this was his young wife's honeymoon may not have occurred to him with any particular force. She was obliged to still her romantic fancies as the ship sailed on through tropic sunsets and velvety nights in conversation with the Bussells, whom she found much to her taste. In Charles she had a willing listener, and with John she could indulge in theological argument. Charles Bussell wrote:

> We had known for many days we were in the neighbourhood of the Cap de Verde Islands. 'Why do you not go up and see the islands,' said Pearce, on seeing that I was the only one of us who still remained below. 'What do they look like, Pearce?' said I. 'Dreadful desolate, indeed, sir.' They did indeed look desolate and I could not help thinking as I contemplated the huge black mass of lava without a vestige of vegetation upon it with the clouds resting on its top how applicable was the word. . . . About sunset a sudden breeze sprung up and carried us at a tolerable brisk pace between this and another island, where we were again becalmed. Here Mrs Molloy who had during the whole day been as constant a spectator as any one else on board remained on deck in company with us till the late hour of 2 o'clock with the idea of seeing the islands by moonlight. The moon however had been long on the wane and did not rise till an hour much later so that she was at length constrained to retire ungratified.[20]

They stayed at the Isle of St. Jago for three days, during which time parties went ashore and walked round the little town in the dust and heat. Mrs Byrne went to stay with the Consul and did not return to the ship till the last moment. The Bussells went bathing. Everyone laid in large stocks of fruit—oranges, lemons, pineapples and bananas.

'This last is a fruit of which you inhabitants of a northern clime are entirely ignorant,' Charles Bussell informed his sisters. 'The fruit are about as large as a middling sized pear and have a flavour at once delicate and rich.' Much of the fruit rotted before it could be eaten, but while it lasted, fruit drinks were much appreciated in the growing heat.

It was now near the end of November. They were approaching the Equator. 'Very warm,' said Turner. 'Our berths are so close we can't bear any clothes on our beds and our nightshirts are wringing with perspiration. We sprinkle them with warm vinegar and I occasionally sprinkle our cabins and the passage way and water closet with chloride of lime and water.'

Everyone was feeling the heat. The younger children, owing to the unaccustomed food, (salt meat, no vegetables and little drinking water) were liable to convulsions. A child in the steerage died and its sad little funeral took place. There were few ways to relieve the heat. Mr Turner suddenly found himself very popular. 'The tin bath which I took out for the children to bath in is now in requisition every morning and several of the gentlemen bath in it. It is about five feet long and the Ladies propose to do the same if they can have a sail cloth fixed so as to form a screen room on deck.'

In the early morning the men and children walked about almost naked until the hour when the ladies began to make their appearance on deck, garbed in summer muslins and gauzes. 'We have the awnings up every day . . . [and have been] casting off all the clothes that decency will permit. I have left off all this fortnight all my undershirts, drawers, stockings and waistcoat.'[21]

Since the fuss before St. Jago which had resulted in De Burgh being put off the ship, steerage passengers were no longer allowed on the poop deck. Charles Bussell noted:

> Until lately it has been our custom to go up on the poop every day immediately after breakfast, with our books and to remain there three or four hours playing chess or engaged in conversation with the ladies. This comfort we have been compelled to forego on account of a disturbance in which steerage passengers were somewhat implicated.

Their dark, stuffy cabin was impossible, so they proceeded to climb the rigging, and there they sat, hooked in among the harsh ropes, with the sails creaking and straining above them, reading either aloud or in silence, Shakespeare and Byron, 'anything more serious not

going with the heaving of the ship'. On 10 December, they reached the Equator.

> Just before the amusement of crossing the line began, they had been around to the passengers making a collection before dinner, and I expected we were free from any rough ceremony. It was announced that Neptune was to come aboard at the time the tar barrel was lighted up and sent adrift from the forecastle with a flourish of music from a bugle; and Neptune with a speaking trumpet hailed the Captain requiring his name and also that of his vessel, and welcoming him and his company. On our arrival at the court of his dominion immediately several buckets of water were thrown upon the gaping auditors . . . ducking was the general order of His Watery Majesty, and Captain, Ladies and everyone upon the deck partook of the watery brine. . . . Several ladies as well as gentlemen had not a dry thread about them and several got their faces smeared with tar and soot. . . . The Captain put a stop to the amusement on the poop deck after it had continued about 10 minutes.[22]

Just before crosssing the line they had had another pirate alarm. Two ships appeared astern of the *Warrior*. The Captain thought they were American whalers but to be on the safe side, hoisted the British flag, while the passengers got out all their small arms again. A boat was lowered from one of the ships and came alongside. They were indeed American whalers, and it appeared they thought the *Warrior* was a convict ship. The American officer who came on board asked in his drawling accent were the ladies whom he could see fluttering at the sides, convicts too. This caused much slightly indignant merriment. The visitors were entertained on board for an hour and then went on their way, though the pessimists on the *Warrior* took wagers that they were pirates nevertheless and would attack in the dark small hours.

A tropical storm was the next excitement. Everyone rushed on deck 'with pails, basins, jugs and mugs, tin pannicans and wine bottles, braving the celestial inundation to collect a few pints of fresh water, and if the ladies had not been stirring (for it was just before we sat down to breakfast) most of us should have stripped to have the pleasure of a shower bath. . . . '[23]

As the warm tropic rain continued to fall, they took full advantage of it.

> Today has been a general wash. All the servants and steerage passengers threw dirty clothes upon the deck and washed them by stamping on them. . . . In the course of the day the fore and main shrouds and fixed ropes were decorated with some hundreds of shirts, shifts, napkins, gowns and trousers

etc. I think such a shower once a week would be one of the greatest blessings to us for health and comfort. It did not continue much above half an hour.[24]

Christmas Day was celebrated with a little extra cheer at table, but otherwise was not much of an event. Captain Molloy did not mention it at all in his diary, which was mainly concerned with the weather and the deaths of livestock. The Bussells merely remarked for the information of their loved ones at home: 'We regaled ourselves according to the custom of our countrymen with a plum pudding of no small dimensions, the manufacture of our friend Morgan, and with dear Emily's cherry brandy which we had all along reserved. . . .' The loquacious little Mr Turner, however, gave a fuller picture of the festive occasion, (which could not have been so very festive for the steerage, who had to provide their own fare, unless they had a friend among the crew to make them a pudding, as the sailor Morgan did for the Bussells).

> Very little appearance of a Christmas Day though we did not forget the usual greeting each other with the Compliment of the Season, and we often thought how you were perhaps sitting around the fireside enjoying every good luxury, while we were thrusting in our plates and bawling out to obtain only a belly-full of something inferior to the ordinary fare of a London tradesman's family. Not but what our boards had a good extra supply, and I believe everyone had their belly full which is very seldom the case. After dinner we had a good supply of claret and several did not leave the table till 10 o'clock, but the company in general kept very sober. Two only were disguised in liquor. It was also a holiday with the seamen. I gave a few bottles of wine and some biscuits to my people and good humour prevailed from stem to stern of the ship.[25]

As there were quite a number of Scots on board it was only to be expected that New Year's Eve would be equally well observed. The Turners had proposed to hold a musical party in their cabin, as they had a small piano. There was plenty of talent on board. Mr Green, the 'medical gentleman', played and sang very 'chastely', and was interested in Ann Turner. He was invited and so was the Captain of the ship. Just as the party assembled, the Captain said he had something to attend to, and disappeared. No more was seen of him, nor of several of the other gentlemen invited, Mr Green among them, it is to be feared, in view of his later history. It turned out that 'the Captain and the other passengers were regaling in the Cuddy, and that they had had two tongues for supper and then two bowls of good

Punch on the table. . . . They very soon got noisy and in liquor. . . .'
As a result on New Year's Day: 'We had a very poor muster at break-
fast and most felt the effects of the Punch. We have a dead calm and
made little progress in the last twenty-four hours. Dancing and
merrymaking among the crew and steerage passengers has been all
day and is likely to be kept up till daylight. . . .'[26]

Nearly a fortnight later they arrived at Cape Town. The heat
gave place to cold winds blowing up from the South Pole, and rough
weather. Everyone was glad to see land again, none more so than the
Molloys. Captain Molloy was about to greet several old friends,
Colonel John Bell, the Colonial Secretary, and Colonel Harry Smith,
the Quartermaster-General, both of whom had been in the Rifles.
The Governor of the Cape at that time was General Sir Lowry Cole
under whom Molloy had served in the Peninsula. The Molloys called
at once on him, and were very kindly received by the Governor
and his wife, Lady Frances Cole. Molloy was carried off on hunting
expeditions by Harry Smith, who promised him antelopes, partridges,
pheasants and bustards, but admitted that the coursing after hares
was not as good as in the old days in Spain. Georgiana meanwhile
spent a very pleasant time at the Smiths' 'dear little cottage at Ronde-
bosch' four miles from Cape Town. She found Colonel Smith's
Spanish wife, Juana, very amiable; she made an expedition to Wine-
burg in the Governor's 'waggon'; and she was absolutely delighted
with the many colourful shrubs and trees she saw. She prevailed on
Molloy to spend £7 17s. 6d. on seeds of Cape plants to take with
them to Swan River, and in the next few years she was often to
allude to 'the seeds from the Cape' which fulfilled all her expectations.
Among them were oleanders, Cape gooseberries, and a pink lily,
the Watsonia, which blooms today in profusion where she planted
it in her garden.

From the Cape Georgiana wrote to her friend Helen Story and her
husband on 25 January 1830:

My dear Brother and Sister,—I have scarcely a moment, but I must write
to convince you that I am as much attached as ever to you both, and never
pass a day without thinking of you one way or another. I have suffered very
much and am very weak in consequence, and if I had been able, would have
written many letters on the voyage, but for nearly two months I was in-
capable of exertion—first from violent sickness, then from heat and the
weakness sickness had caused me. Indeed, I often regretted my promise to
keep a journal as for some days I was unable to hold a pen. My letter to

Keppoch is more circumstantial than time will permit this to be, as we hourly expect to go on board.

The accounts of the new Colony are varied, but I shall be able to give you a more correct account when we arrive there. I hear the Stirlings are very nice people,—at which I am delighted. I like the Cape very much, and we have met with much hospitality and kindness. The Dalhousies were here, also the Bishop of Calcutta, and each party gave much pleasure.

Pray remember me most kindly to all my Rosneath friends. Often have I lain in bed on board and thought of you all with my eyes shut, and could for the moment fancy myself at Rosneath. Call me to the fleeting remembrance of John Anderson and his newly acquired spouse. If they are as happy as Jack and I they cannot wish for more conjugal affection. Molloy is a dear creature and I would not exchange him for £10,000 per annum and a mansion in a civilized country.

Oh how it sinks me to think of the Manse—the Clachan—the road to Portkill in Mary's cart. I do not despair of soon leaving Swan River, if we do not find Governor Stirling's report true, which seems to be suspected— not from design but ignorance of the soil. The Governor and Lady Frances have so frequently expressed their wish to have us there. Do not be uneasy if you do not hear soon from us, as much delay must be occasioned one way or other. Be assured I can never forget you. Distance only enhances your value. Pray for us and our people, and believe me, with the most cordial affection,

Jack and Georgiana Molloy.

Molloy added his own few words to the letter : 'You, my dear Mr Story, spliced us so securely we have not had the least difference of opinion yet.'[27]

After two weeks at the Cape the *Warrior* sailed on 26 January. From now on all the diarists' pens were laid down. This may have been because of the dullness of the next six weeks when they saw no sail nor sight of land. Some ships coming from the Cape touched at the desolate rocky French island of St. Paul, but no one on the *Warrior* mentioned having done so in letters written after landing at Swan River. Mr Turner, writing home four months after arrival, referred to his cattle 'having been put on short allowance soon after we left the Cape of Good Hope, and was obliged to feed them on Oatmeal, Peas and Biscuits. I found great difficulty in finding out a little grass and fresh water for them.'[28] According to his application for land made on arrival at Swan River, he had bought all his livestock at the Cape. All the owners of cattle on the ship must have had the same difficulty. To see their cattle, which represented not only their capital but also their livelihood for the next few years, daily growing weaker, was

very depressing. Their experience convinced them that it would have
been wiser to have imported their livestock from Van Diemen's
Land after they had arrived in the colony.

It may have been during this last period of the voyage that conver-
sations took place between Captain Molloy and John Bussell on the
subject of the land grants they could expect. Possibly Mr Turner
was included too. There is no doubt that Captain Molloy's upright
character and aptitude for leadership made him respected by the
younger man and the middle-aged builder. The link between these
three men is not obvious. It might have been expected that on arrival
at Swan River they would have gone different ways, but they did
not. They stuck together, and it is reasonable to suppose they had
decided upon this beforehand.

While Captain Molloy was growing impatient for the day when his
cattle could roam free in his own meadows, Georgiana Molloy would
be longing to set foot on solid ground again, and wondering under
what greenwood tree or shingled hut her child would be born. She
still had several months to go, but her discomfort would be growing
and her thoughts turning to a home of her own. The weather was
pleasanter, and the nights of a starry brilliance to entrance her romantic
eye. Did there come a night when the sailors said they could smell
land, and could she smell it too—the smell of Australia, scent of gum
leaves on the warm breeze, whiff of bushfire smoke, peculiar acrid
sweetness like to nothing else on earth, although a later diarist was to
refer to the warm breeze off the land as bearing a scent 'like a beanfield
in bloom'?

One morning she awoke to find the cabin full of a sparkling dancing
sunlight. There was the land, a line of long white beach stretching
as far as the eye could see into the blue distance, a plumy column of
smoke curling lazily upward from it here and there. The *Warrior* lay
off a rocky island of considerable size. Other ships were anchored
there also. All day Georgiana regarded the dazzling white shores set
in turquoise shallows. The sun was warm with a cool breeze blowing.
There was a quality in the air she had not felt before, dry, clear and
exciting. This was the land which she and Molloy were to make their
homeland, waiting for them empty and challenging, like a glove flung
on the blue floor of the ocean.

Chapter

5

Arrival at Swan River

THE *Warrior* anchored in Gage's Roads on 12 March 1830.[1] The next day the passengers landed at Fremantle, and had their first sight of the infant port of the colony. Descriptions vary according to the eye of the beholder. 'When we landed,' said the jolly little Londoner, Turner, 'the town was composed of a good number of miserable looking tents, most of which were grog shops; however, these grog shops were very good things, as I got some bread and cheese and porter in one of them, half an hour after I landed.'[2]

A taste of familiar things, after a long spell on shipboard, can induce a feeling of well-being that disposes anyone to overlook short-comings for a while. Charles Bussell saw it as a place of glistening white sand, like snowdrifts, 'a delusion, however, most forcibly contradicted by the intense heat of the sun and the glare it occasions'. Indeed, there was a great deal of white sand to be seen, giving rise to the witty saying about Fremantle: 'You might run it through an hour-glass in a day.' There were a few wooden houses brought out ready cut from England, and even fewer low white cottages made of lime-stone, of which there was plenty; but on the whole the population lived in tents. There again the appearance of the town depended on the frame of mind of the observer. If joyous, like Mary Ann Friend, a young lady who had landed a month or two earlier, it resembled 'a country fair and has a pretty appearance, the pretty white tents looking much like booths—at present there are not above five or six houses . . . ';[3] if not, it was 'a bare, barren-looking district of sandy coast; the shrubs cut down for firewood, the herbage trodden bare, a few wooden houses, many ragged-looking tents and contrivances

for habitations—one hotel, a poor public-house into which everyone crowded'.[4]

It is hard to understand how anyone could have expected it to look more, in those first six or nine months. Those who came out aware that for months or perhaps years they would be living under alfresco conditions were not disappointed, and could feel a distinct sense of achievement when they saw squat, rough buildings rise from the sand. Others, whose minds were set in petty urban and provincial ways, were put out and irritated that the Government did not proceed faster to create neat civic grace out of the vast, strange, savage landscape.

It did not take long to see the sights of Fremantle. The next thing to occupy the passengers' attention was the unloading of their goods and stock. The stock went first, and were generally in a very weak condition after their long voyage from the Cape. Not much care was taken in landing them. There were no yards to put them in when they did reach shore. Distracted animals often made a dash for freedom and got away into the bush; distracted owners, shouting to their servants to do this and do that, tried to prevent their capital from escaping. All was bedlam as horses kicked up their heels, dying sheep sank to the ground, dogs barked and strained at the leash, pining to run loose after their cramped conditions, crates of fowls overturned with great outcry, and the hot sand and the blinding glare frayed men's tempers as they tried to herd animals and get buckets of brackish fresh water to them.

Stores and personal effects were unloaded piecemeal and even more carelessly. Mr Turner's account of his experiences rings like a cry of woe, no doubt echoed by all his fellow passengers:

> I experienced great difficulty in disembarking my stores. They were landed on the beach, some in one place, some in another: several of my largest packages were pulled to pieces, the Goods taken out, sent on shore and thrown on the beach. I collected them together on a spot about a quarter of a mile up the river where the first boatload of my Goods had been landed, out of the reach of high tide; I was obliged to keep watch night and day. . . . Sometimes through carelessness the Goods were upset, one day I had three tierces of beef sunk, two I recovered, the other was a serious loss. Some of my packages got so wet that even at this time I do not know the extent of my loss in stores. . . .[5]

Aided by his sons and his servants, Mr Turner managed to get all his goods into one place. His servants quickly erected a pre-cut wooden

building and some tents, so that they were soon all reasonably comfortable. This place was called 'Lilburne'.[6]

On the afternoon of the day they had landed at Fremantle, Mr Turner and his brother-in-law had gone up the river to Perth in a boat. A passage boat service plied between the port and the town, and private boats could be hired at great expense: £5 for one boatload. The afternoon was the best time to go, for the sea breeze would be behind them. Mr Turner had waxed poetical about the trip. 'We were quite astonished at the splendid scenery on both sides of the river, although the soil is nothing but white sand. The foliage of the trees was exquisite and together with the many beautiful turnings in the river one might fancy themselves in fairyland.'[7]

The Bussells too established themselves at Fremantle. John decided to see about a grant of land as quickly as possible, so he, with Charles and Alfred, also made the boat trip up to Perth. Vernon had not been well, so he and Pearce the servant boy were left behind to look after their belongings, for Fremantle was full of light-fingered characters who took full advantage of the lack of lock and key. Vernon was young enough to glory in the adventurous colonial life he was leading. The family in England must appreciate it too—

> While I was alone, Captain Byrne used to pay me frequent visits in the evenings. Picture to yourself the tent where we used to sit, the pole was surrounded with guns, three double barrels, two single and three rifles. Over them were hung four brace of pistols and two cutlasses, the table a slab of wood supported by three desks and our seats consisting of a saucepan and a bucket turned upside down and the door crowded with dogs, who were not allowed to come in.[8]

Captain and Mrs Molloy had decided to stay in Perth instead of Fremantle, so boats were hired accordingly to transport them and their tents and belongings. Georgiana would not be sorry to leave Fremantle, where the sun struck the white sand with a blinding glare, and the sea winds blew it everywhere, stinging the face and eyes. It was the end of summer and the heat was intense.

It was fourteen miles up the river to Perth, and Georgiana would be glad of her wide plain bonnet as the sun beat down. It would be late afternoon by the time they reached the narrow neck that opened out into Melville Water, a beautiful wide bay. They would scarcely be able to see Perth, the buildings being hidden among the trees that crowned a woody ridge along which the main street lay; but they

would be able to descry the ring of low blue hills in the distance. Their boat would pull into a long narrow wooden jetty. They would have a short uphill walk over a sandy track, then the tents would be pitched, fires lit, and the bustle of getting a meal would begin.

❦

It was the custom for intending colonists on arriving at Perth, to put their names in the Register and receive permission to reside in the colony. It was also their duty to call on the Governor. The passengers of the *Warrior* were not lacking in their duty, but they found that the Governor was away on a survey to the south.[9] They found, too, in conversation with new acquaintances, that there was a great deal of dissatisfaction with the granting of land. As the acquirement of land was the reason for their hastening to the colony, it was a subject that occupied both the newly-arrived and the not-so-new emigrants. All the best land, so the new-comers were informed, had gone. By the best land it appeared they meant the land along the Swan and Canning Rivers. Being nearest to settlement and transport by water, it was most in demand. The officers of H.M.S. *Sulphur* and H.M.S *Challenger* who had arrived in 1829 had taken up much of the river frontage on the Swan and Canning, and one or two others in those early months had secured lots of 10,000 acres or more on the river. 'It was the opinion of not a few, that the Governor had acted very improvidently in giving . . . an extent of river frontage to one individual. It would perhaps have been better, to have made a square mile the maximum of any grant on a river. . . .'[10]

525,000 acres had been granted by the end of 1829, not all of it at the Swan. 250,000 acres had been conditionally granted to Mr Peel; Colonel Lautour had 10,000 acres at the Swan and the promise of 100,000 acres in the 'interior' (an expression used to cover any good land that was newly discovered); and Captain Stirling had been assured of 100,000 acres with priority of choice even before he left London.

Even at that time Stirling must have had his eye on a certain part of the country. A letter of 10 January 1829, from Mr John Stirling to R. W. Hay Esq. announcing that he was about to proceed with his brother, Captain James Stirling, to the new settlement, asked whether he could choose land proportionate to the capital he was laying out on a 'Steam Engine for sawing Timber and for grinding Corn',

although the engine would not be completed in time to accompany him. A fortnight later, on 24 January, he despatched a letter to Horace Twiss, specifically asking 'that he shall be allowed to proceed to the choice of 100,000 acres in the neighbourhood of Géographe Bay next immediately after Captain Stirling's selection in that quarter'.

This letter was marked: 'Inform Mr John Stirling that his request is acceded to.'[11] However, Mr John Stirling, for some reason, did not sail with his brother when Captain Stirling set out in the *Parmelia* on 4 February and his selection was never taken up, while Captain Stirling, having arrived at Swan River, changed his mind about Géographe Bay. This became a habit of Captain Stirling's which gave rise to a caustic comment by Lieutenant Bunbury who was on military duty in the colony in 1836-37. The Governor, said Bunbury, at first proposed to take up his land at Géographe Bay.

> But he has since been constantly changing his mind, and on the discovery of any new or fertile district he has immediately appropriated the best part of it to himself, thus severely checking enterprise and the spirit of exploration amongst the settlers, who cannot afford either the time or the money to explore land for the Governor, when they go out to look for what they require themselves.[12]

At one time the Governor had been attracted to King George's Sound and had given the name of 'Stirling' to one of the southern counties. Then his enthusiasm for Géographe Bay returned, and according to the Return of Lands of 1837, he selected 83,834½ acres there.[13]

As for the other two owners of large land grants for settlement purposes: Colonel Lautour never came to the colony, though he sent out an agent and eighty-five settlers; the later months of 1830 were to see the agent's establishment broken up through lack of funds,[14] Lautour's 100,000 acres, which had finally been located at Port Leschenault, remaining idle until it was purchased in 1840 by the Western Australian Company, to become the settlement of Australind;* while Thomas Peel, whose late arrival in the colony had made him forgo his prior claim to land at the Swan, had to take instead his 250,000 acres at Cockburn Sound and never managed to carry out

* The Australindians were a body of people who came out from England to settle an area near Port Leschenault (or Bunbury) named Australind. This area had been part of the large grant made to Colonel Lautour in 1829. A company called the Western Australian Company had been formed to establish a settlement there according to the principles of Edward Gibbon Wakefield. The first settlers arrived in March 1841.

his settlement scheme properly, partly through mismanagement, and partly—but this is arguable to the present day—to the poor quality of the soil of the area he was awarded.

In fact, the greed for land hindered the first settlers from looking before they leaped. The limitless acres in this new country were not capable of the sort of farming to which the settlers were accustomed. To own vast tracts of land gave a comfortable feeling of proprietorship but its very vastness demanded a labour force that just did not exist. That there was a certain amount of cause for dissatisfaction is true, for in many cases good land near settlement had been granted to individuals who did not remain in the place long enough to work their land. But the main cause of dissatisfaction lay deeper. Many claimed that they had been misled by the report of Mr Fraser, the botanist who had accompanied Captain Stirling on his initial exploration in 1827, as to the fertility of the land. What they did not perceive as an accompanying factor to be taken into account with the fertility of the land was a fundamental part of the very nature of this new country. It was not an easy land. It demanded hard work. Gentleman and servant both had to work as they had never worked before, and both found it hard to accept.

Many of the gentlemen emigrants had hoped in a vague way to make their fortunes without any practical experience of either working themselves or of directing their servants. In hiring servants, they had often taken on the most easily available, and many of these had their own reasons for wishing to leave England. 'The servants are, for the most part, hulking lazy fellows and exceedingly insolent; but what else could be expected, from their previous character, having been, I believe, mostly taken from the workhouse,' averred Dr Wilson, who visited the colony at the end of 1829. His observations led him to argue that the colony could not get on well without the aid of convict labour, but these ideas met with opposition—'if the soil were to be polluted with those sort of people, no gentleman of respectability would have anything to do with it'; but, Wilson commented sardonically, 'it appeared to me that many of those I saw, although belonging to the undetected part of the community, owed such advantage more to good luck than to their own undeviating adherence to the moral law.'[15]

It was, in short, a case of the little couplet composed to describe the inhabitants of early Sydney:

> *True patriots they, for be it understood*
> *They left their country for their country's good.*

The fact remained that in this new country, no 'gentleman of respectability' or of any rank of society was successful unless he could and would work.

❧

Apart from the weather, which continued hot, and the constant irritation of flies, fleas and mosquitoes, there was a certain rustic charm about life in Perth, in the little town growing out of the wilderness. The main street, of a fine width, named St. George's Terrace, was already cleared. The surface was still sandy but there was a footpath on one side shaded with lofty trees. Here could be seen, as a traveller put it,

> the *written* newspaper of the place, appended to a stately eucalyptus tree, where among other public notices, I observed the Governor's permission for one individual to practise as a notary, another as a surgeon, and a third as an auctioneer. There did not appear to be an opposition tree, and so much the better: as, although a free press may do good to a community arrived at a certain state of perfection, yet I think it may be doubted how far it can be serviceable in an incipient colony, where private affairs are narrowly noticed and animadverted on. . . .[16]

A few buildings had been erected for dwelling houses and offices, and three hotels had been licensed in January 1830. These were the 'Perth' Hotel, Lewis Mayo; the 'Swan' Hotel, James Kenton; and the 'Happy Emigrant' public house, Thomas Dent.[17] If the Molloys found tent life too uncomfortable, it was possible that they found accommodation at one of these. The hotels were chiefly patronized by the gentry. For others, there were several tents selling coffee and grog which did a thriving trade, 'the lower orders having plenty of money'. To meet other spiritual needs, in the previous December a large and spacious church with a vestry at one end had been built, with a timber frame walled in with rushes, and thatched with rushes. Beside it was the parade ground of the 63rd Regiment, ringed by their tents. Their commanding officer, Captain Irwin, dwelt near by in a very comfortable house, and further along was the Colonial Secretary's house, a wooden building with a shingled roof. On the other side of the street, where the ground sloped down to the river, was the temporary residence of the Governor, 'a commodious wooden building'.

Perth society was then largely composed of retired naval and military officers and their wives, all drawn from the same class in England—the landed gentry. Many of them, if not known to each other before arrival in the colony, at least proved to have mutual friends, or were recommended to the Lieutenant Governor by persons of note. This made for a very pleasant, select little group, which Mrs Molloy found very congenial upon her introduction to it.

Upon arrival, she and Captain Molloy had called upon Mrs Stirling in the Governor's absence and had found her exceedingly amiable. Without exception, everyone spoke well of Mrs Stirling. At a time when manners were formal and conventions were rigid, she was pleasingly natural. A young lady of fourteen, Miss Anne Leake, on arriving in Perth 'took tea two or three times with Mrs Stirling, the Governor's Lady, with whom I was very much pleased. She is very affable and unaffected.' A young gentleman referred to her 'freedom from pride and lady-like manners [which] formed a pleasant contrast to the bridling and haughtiness of some half-bred persons whom I remember at home'.[18] While a few years later (after Captain Stirling had been knighted), Miss Bussell, writing home to England, said:

> I am more delighted every day with Lady Stirling, never was anyone better fitted for her very peculiar situation as it is not the courteous style of a Governor's wife that is wanted here but the warmhearted interestedness of a friend, and you would not believe the fond affection with which she is greeted. . . .[19]

Ellen Stirling was young—at this time only twenty-three. She had been married at sixteen and had been then rather a tomboy. She evidently liked the freedom of the open-air life in which she found herself. The other women around her, the wives of civil servants and naval officers, were also young—the Colonial Secretary's wife, Mrs Brown, was twenty-three and so was the Surveyor General's wife Mrs Roe—and their amiability is vouched for by the Surveyor General in a shipboard letter. After remarking about his wife that 'dear Matilda has been rather queer in the head since we sailed, but is this evening infinitely better and in a few days will laugh with the best of us,' Mr Roe went on, 'Mrs Captain Currie and Mrs Secretary Brown and Mrs Commissary Morgan are very pleasant women, and so also may be Mrs Sutherland, the wife of my assistant; but she is very retiring in her manners and has not yet spoken a dozen words. . . . Mr Drummond's wife seems rather out of her element

and will, I hope, improve, as she seems disposed to be rather touchy. . . .'[20]

These ladies kept up the social order to which they were accustomed, cultivating 'the elegancies of life'. One such elegancy was a Literary Society. Mary Ann Friend wrote in March 1830:

> A Literary Society is established at Perth to which Ladies are admitted as members. I put my name down, was ballotted for and elected. I was the third Lady on the books, being preceded by Mrs Stirling, the Governor's Lady, and Mrs Roe, the Surveyor General's Lady. The subscription was two guineas. They have already funds in hand and intend immediately to commence building the rooms.[21]

Unfortunately this Society did not last long. In December 1832, G. F. Moore alluded to a letter which had arrived addressed to it, and commented that there was no such body.

There were also incipient agricultural and botanical institutions—the latter fathered by the Horticultural Society of London, which had given a collection of plants and seeds to Mr Drummond,* the Superintendent of Gardens, to take out to the Swan River colony in 1829, on condition that they were to be propagated and used by the Government for the colony. The collection included peaches, vines and fruit tree stocks, gooseberries, currants, rhubarb, potatoes, artichokes, dry roots of dahlias and chrysanthemums.[22] Mr Drummond began the first Government garden on Garden Island. This was abandoned when the seat of Government moved to Perth. The idea was not abandoned, however. In March 1831, Governor Stirling wrote to the President of the Royal Geographical Society: 'We are just about establishing a botanical garden at Perth in which it may be hoped that, besides collecting and arranging the plants of the country, experiments may be made as to acclimating foreign productions.' A few months later the garden was in existence: 'a botanical garden has been lately laid out here in which I walked with the Governor and his lady, accompanied by some of my kind friends,'[23] said G. F. Moore. This garden still exists where Governor Stirling had ordered it to be placed, on the corner of Barrack Street and St. George's Terrace.

The standards of fashion were also kept up by the Governor's lady

* James Drummond, 1787-1863, was born in Perthshire, Scotland. He was elected an associate of the Linnean Society, in 1810, and was later in charge of the Cork Botanic Garden. He emigrated in 1829.

and her friends. 'Dress is by no means neglected here and far more observed than in England,' remarked one writer, while another member of colonial society noted with pride that 'in company, or on state occasions we are a very well-dressed and *particular* people.' Words failed him, unfortunately, to describe what 'the fair ones of the upper grades' wore, but 'the Government officers and naval and military men wear blue cloth coats with gilt crown buttons, and blue frocks and trousers—on great occasions, white duck trousers,' while on ordinary occasions, 'substantial clothing seems to be the taste of our sensible people . . . blue striped shirts, shoes, boots, buskins and corduroy trousers . . . light black beaver hats. . . .'[24]

The Governor returned from his trip south on 18 March. He had embarked on the schooner *Eagle* and had been away fifteen days examining the coast of Géographe Bay and Port Leschenault. He had come back very pleased with what he had found. A Government Notice, issued from the Surveyor General's office on 22 March 1830, gave details of the exploration and noted that:

> the general result has afforded the Lieutenant Governor the greatest satisfaction by shewing that the industry, enterprise, and intelligence of the settlement need not remain unemployed, for want of the materials on which to act. The country inland from Port Leschenault, as far as it has been seen, offers fertile soil, and good stock stations. The climate is decidedly cooler than in this district; and judging from the quantity of grass, and the verdure of the foliage, it appears to sustain a dry season not so long in duration as that experienced in this quarter. For these reasons, the Lieutenant Governor recommends it to the notice of settlers . . . [who] will do wisely to make an early selection in the territory thus laid open, as it is not intended to open other districts during the current year, at the end of which the present mode of distribution will expire.*[25]

This notice was read with interest by the newly-arrived emigrants of the *Warrior*.

On the Governor's return, Captain Molloy had immediately waited on him. Their mutual friendship with Colonel Harry Smith was a point of interest between them and Captain Molloy was able to acquaint Captain Stirling with recent news of Colonel Smith at the Cape of Good Hope. There were also tidings from Home to be brought up to date. Whilst Captain Molloy gave his opinions on the political situation in England and the need for electoral reform, and

* i.e. At the rate of forty acres for every £3 brought into the colony.

Captain Stirling imparted information as to the character and future of the new colony, the two gentlemen were no doubt taking stock of each other.

Stirling was a Scot, black-avised, with a frowning, intent gaze. He was an intensely ambitious man. The years he had spent in enforced idleness after the war with France had determined him not to wait solely for preferment in the navy. The voyage into Australian waters in 1826 had decided him that here was the place to make his mark. His consequent exploration and glowing accounts of the Swan River were not without this end in view. Having once decided this, he fought to bring the colony into being and the same energy and determination that had impressed a reluctant Colonial Office were now brought to bear on dissatisfied settlers and civil servants. It was necessary to Stirling's career that this colony should succeed and succeed it would, no matter whose blood and sweat and tears should be expended in the doing of it. The energy that he put into the task he demanded that others should put into it. There were few that could stand the pace he set. There were consequent grumblings. He took no notice of them. His eye was on a goal ahead.

An autocrat to the fingertips, the Governor could on occasion assume an air extremely 'civil and condescending', to quote a contemporary description of him. He now found before him, in the person of Captain Molloy, an autocrat of equal condescension. Whether he knew anything of Molloy's background is uncertain; it was the sort of thing that was known and yet not known; but it is likely that Colonel Smith would have passed on anything he knew of the friend of his youth. It is also likely that in conversation with Stirling, Captain Molloy would have mentioned that he had been recommended as a settler to the Secretary of State for the Colonies by the General Commanding-in-Chief himself, Lieutenant General Lord Hill, who had known Molloy well in the Peninsular Campaign. A letter to this effect from the Horse Guards was in Molloy's possession.[26] This, together with the aristocratic bearing of the older man, may have impressed Captain Stirling. It may also have occurred to him that there was not room in such a small place for two autocrats.

In the days that followed, Captain Molloy made expeditions with the Governor to view the land on the Canning River, and on the Swan beyond Guildford. They were sometimes accompanied by Captain Byrne, who was also looking about for land. The Governor

had taken up a tract of land at Guildford between the Swan and Helena Rivers, and was very enthusiastic about it. He was, however, even more enthusiastic about the excellent country he had seen on his recent visit to the south. Captain Molloy had been attracted to the Canning, but as day succeeded day and the Governor's praises of the south continued, he wondered whether he would not do better to go there. The climate, said Stirling, was decidedly cooler than at the Swan. Mrs Molloy was feeling the extreme heat, and perhaps the English roses fading from her cheeks influenced the Captain. When he indicated to Stirling that he was interested in his account of Port Leschenault and Géographe Bay, Stirling, who had his eye on Géographe Bay for himself, but had not yet made up his mind, became even more enthusiastic about the country at Cape Leeuwin. Sealers who called at Fremantle had given reports of a large river or inlet there. The previous November, the Governor had requested Captain Barker and Dr Wilson to examine the coast to the east of Cape Leeuwin as they were on their way in the *Governor Phillip* to King George's Sound.[27] They had not found the river or inlet mentioned by the sealers, but after arriving at King George's Sound, Dr Wilson had conducted an expedition by land to the north-west and had reported 'that the area passed over contained as much, perhaps more, land fit for all rural purposes than any portion of equal extent . . . in New South Wales'. This was encouraging, but the Governor still felt that the reports of a large river or inlet must be based on fact. Sealers and whalers had been accustomed to landing on the southern coasts before there had been any idea of settlement. The Governor thought he might arrange an expedition himself, and invited Molloy to participate. Whereupon Molloy, recalling his conversations on the *Warrior*, sought out the Bussells and Mr Turner, to see if they would join the party. Turner wrote:

Captain Molloy spoke to me on the subject, and I agreed to go southward if a party could be formed and left arrangements entirely with him as he was mostly in the company of Govt. officers, and a party was forming by the Governor to go and examine the river and bay at Cape Leeuwin to see if it was advisable to form a Settlement there. I as an humble individual had no knowledge of the real views of the Govt. but was led to believe that it was to be the principal Residence of the Governor and was led to expect a deal of employment for my establishment and had I depended on those allurements I should very soon have wanted a mouthful of bread for my children. . . .[28]

No doubt the Governor misled the Molloys and Bussells as well as Turner; this was characteristic of him. Lieutenant Bunbury was to make a penetrating estimate of him in saying:

> I feel bound to state this regarding the character of the Governor, as a warning to anyone that may have dealings with him, it is but fair to remark that in my opinion it is more owing to his hasty unguarded disposition and enthusiastic temper than to any want of principle or wilful deceit or mis-representation. He is sincere in making the promise at the time, when he enters warmly into the business in hand and it engrosses his whole attention. Afterwards other matters occupy his thought, his attention and means are directed elsewhere, and he finds too late . . . that he has neither the power nor means of fulfilling what he rashly offered in the enthusiasm of the moment. . . .[29]

Six weeks of continuous heat, immediately after the voyage through the tropics, had been too much for Mrs Molloy. She had given her vote for the south. Years later she was to write to Helen Story: 'I cannot bear heat, or it would be more advantageous, as this place is not so propitious, for us to live at Headquarters, viz. Perth.' As March passed into April, the nights and early mornings were cool but the sun throughout the day was still strong. Although most people found the climate very healthy, the end of summer produced a type of dysentery due to the brackish water, and a good deal of purulent ophthalmia. Both were probably spread by the flies. Lack of fresh vegetables caused scurvy which was uncomfortable rather than severe, and for which the remedy was lime juice, issued by the Colonial Storekeeper on the order of Dr Milligan. It may have been dysentery that caused the deaths of pretty, frivolous Matilda Byrne's two little girls,* Frances Eliza, aged three, and Selina Jane, aged one.[30]

The sad deaths of these two children may have been a topic of conversation over the tea-tables at which Mrs Molloy was entertained. The taking of tea, that British institution, was a ceremony to be continued even in a wilderness. Though the tea-tables stood on bare rough-hewn plank floors, their appointments were of the finest china and beautiful family plate. There might be no ceiling overhead except the thatched gable roof, but in many a house splendid chandeliers hung from the rafters, and silver candelabra stood on the jarrah mantel-pieces. At these tea-parties, Georgiana heard what Mrs Stirling, Mrs

* These two children are listed as in Captain Byrne's household in his application for land, and so must have arrived in the colony. Captain Byrne, however, did not put in his application until four months after arrival, and the children are marked 'deceased'.

Roe, Mrs Brown, and the others had learnt of life in the new colony. They were all mothers of very young children. The health and safety of the children would certainly be a matter for conversation, from which they might pass to the recent loss of the Dutton child.

Less than two weeks before Mrs Molloy arrived, she would be apprised, a Mrs Dutton of Fremantle had lost her child, a fine little boy about four years old. It was supposed that natives had carried him off, and parties of gentlemen were formed to pursue them. Then a man named Eyre created a diversion by alleging that there were several seamen living in a hut near Preston Point after the manner of bushrangers, stealing from their neighbours. These men, Eyre thought, had concealed the Dutton child in their hut and were holding it for ransom. He said they threatened anyone who approached their hut with firearms. The Colonial Secretary had been, obliged to request the Justices of the Peace to look into this report about the seamen, and they had replied that there was no truth in it. They were inclined to blame the natives, and advised taking native hostages until the return of the child. The Colonial Secretary had dismissed this idea firmly. However, feeling ran high and some natives had been fired upon. Lest there should be a serious incident, a Government Notice was issued, offering a reward of £25 for recovery of the child, and cautioning 'those individuals who may go out in search of the child, from committing an outrage against the aboriginal race of inhabitants of this country on pain of being prosecuted and tried for the offence as if the same had been committed against any other of His Majesty's subjects'.[31]

Up to this time the child had not been found. This story would give grounds for the ladies to exclaim about what a 'den of thieves' Fremantle was becoming, and about the mischievousness of the natives. Though the natives were not dangerous like the Indians of North America, they were deceitful and sly and quite undependable. Their curiosity was insatiable and often led to trouble, while their chief, Midgegoroo, was becoming a menace. And how ugly they were! Nothing about them of the 'noble savage' that Rousseau lauded, the ladies would deplore, shaking their topknotted heads and glossy side ringlets.

❧

The *Warrior* remained at Fremantle for a month. If it had taken a long time to load at Gravesend and Spithead, it took a longer time to

unload at Fremantle. Captain Graham, writing from 'the Encampment opposite Fremantle' on 3 April, was obliged to apologize for not yet having paid his respects to His Excellency the Lieutenant Governor because he had had such great difficulty in obtaining his property from the *Warrior*. The Colonial Chaplain, the Reverend J. B. Wittenoom, who had arrived on the *Wanstead* at the end of January, had had a shipment of goods on the *Warrior*. He too had trouble in getting them off, and sent a blunt message about it to Mr Sempill, who replied so rudely that Mr Wittenoom complained about him to the Colonial Secretary.[32] There had been other complaints about the charterer of the *Warrior*. A week after the ship had anchored, one of its indignant passengers, fired by the resentment of foregoing months, had taken action. Mr William Proctor, 'a Controller of His Majesty's Customs' as he called himself, and a passenger to Van Diemen's Land, sent a 'humble Memorial' to the Lieutenant Governor complaining bitterly about the provisioning of the *Warrior* and asking for proceedings to be instituted by which he could 'procure Redress for past sufferings and secure himself against similar evils for the remainder of the voyage.'[33] He was advised by the Colonial Secretary to wait until he arrived at Van Diemen's Land before instituting proceedings, but that he should take depositions from all 'the respectable passengers . . . in this Settlement'.[34]

Word of Mr Proctor's movements reached Sempill and that brash gentleman wrote to the Governor on 14 April, asking for a copy of Proctor's memorial in order to reply to it, and remarking that he believed he might not stand well in the Governor's estimation. The Governor dictated a very cold reply to the letter,[35] and that was the last of Mr Sempill, for the *Warrior* sailed from Swan River the next day.

On 12 April a Government Notice was issued to the effect that His Excellency the Lieutenant Governor would hold a levee at Government House at noon on the King's Birthday, 23 April. The function duly took place, and is described in the diary of Mrs Currie.

> King's Birthday. The Governor held a levee, at which were present sixty, the Ladies eight in number joined the breakfast. Sixteen naval officers attended. The civil officers and magistrates gave a dinner to the Governor. Sixty attended. All went off to the satisfaction of those interested.[36]

On the same day, a Government Notice appeared stating that H. E. the Lieutenant Governor appointed as Justices of the Peace the

Reverend J. B. Wittenoom for Perth, Captain E. Pickering for Upper Swan, Captain F. H. Byrne for Lower Swan, Lieutenant Bull for Canning, and Captain John Molloy for Stirling.[37] By that date, then, Molloy must have decided to go south. The earliest map of the colony since its foundation, printed in 1833, shows the county of Stirling as comprising just that part of country between Cape Chatham and Wilson's Inlet explored by Dr Wilson in November 1829. East of it was the county of Plantagenet, which included King George's Sound, and west of it, from Cape Chatham to Cape Leeuwin, the country was still unexplored. This was the part to which Captain Stirling was inclined to think the sealers referred, and which he wished to explore for himself.

Captain Molloy, Mr John Bussell and Mr James Turner now began to look for a ship to take them to the south. They engaged with Captain McDermott of the brig *Emily Taylor* to transport them and all their goods for a sum of £200. It seemed an exorbitant amount, and they sought about for others to share the voyage and lighten the cost. Mr Turner gives the details of the final arrangement: '£50 was to be made up by other passengers and the £150 by our trio, my share of which was £95. The Governor at length made up a party for us for the £50 and also accompanied us. . . .'[38]

Mr Turner's account is clear enough, but the Governor charged the cost of his own passage to the Accounts of Public Expenditure, where it appears as: 'Freight of the Brig *Emily Taylor* to convey the Lieutenant Governor and Suite from Swan River to Augusta, and back, £150.'[39] It was an item questioned by the British Treasury before being passed for payment, and was still being quibbled over three years later. It may mean that the cost of the Governor's suite there and back was over and above the £200 arranged for by the colonists. A Government Notice of 11 May 1830, states that the Governor was accompanied by Captain Currie, the Harbour Master of Fremantle, when he embarked on the *Emily Taylor*. Mr Richard Dawson of H.M.S. *Sulphur*, and four sailors also accompanied them, and Mr John Kellam, Assistant Government Surveyor. These might legitimately expect to have their fares paid, but they would not have been return fares, as Kellam, Dawson and the sailors remained at Augusta. The party made up for £50 mentioned by Mr Turner may have been odd settlers who wished to go south and took advantage of the opportunity. A list of Land Assignments dated November-

December 1830 shows who they may have been, as the fact that the land is stated to be improved, cultivated and fenced shows that they had been in possession of it for some little time.*[40]

Before the *Emily Taylor* sailed, Captain Molloy took care to send in to the Colonial Secretary's office, on 24 April, his application for land, accompanied by a schedule of property which he had brought into the colony as capital, and a list of persons whose passages, paid for by him, were also to be included as capital.[41] Mr Turner had already sent in his application on 5 April. John Bussell was slow in putting his in—it bears the date 9 May.

Captain Molloy's household consisted of himself and his wife, five other adults and three children. The value of his property amounted to £960 10s. 5½d., and on this in due course he was allotted 12,813 acres of land at the rate of forty acres to every £3 of capital, (a rate which lasted only until the end of 1830). Mr Turner had a household of thirty people, an enormous quantity of property including 'a Square Piano Forte', a long list of livestock ending in '1 Rabbit'; and wood sawn into boards and planks, fittings of doors, windows etc. The capital value was £1,502 3s. 6½d., and he was allotted 20,026 acres of land, which was later increased by another 5,000 acres. Mr Bussell's household consisted of himself, his three brothers and one servant. The value of their property was £317 12s. 11d., and they were allotted 5,573 acres.

Soon after the Governor's levee, Mrs Molloy took leave of her new friends in Perth. It was necessary for the Molloys to return to Fremantle to supervise the loading of their possessions on to the *Emily Taylor*. On 29 April, they embarked and sailed from Gage's Roads. Once again Georgiana experienced the heaving decks and the clean sea wind, and once again she suffered the pangs of seasickness as their small ship plunged southwards to round the surging seas of Cape Leeuwin. It was of short duration however. On the evening of Sunday 2 May, the *Emily Taylor* dropped anchor in Flinders Bay, 'near the mouth of an inlet communicating with the sea'.[42]

* John Dawson, Daniel Syred, George Chapman, George Layman, George Earl, Henry Kellam, John Welburn, John Cook, Ludlow, John Herring. None of these belonged to the establishments of Molloy, Bussell or Turner, though John Herring sometimes worked for the Bussells and is alluded to in their earliest letters; while John Dawson's son, living in 1954, is certain that his father was among the first people landed at Augusta. Other land assignments for December 1830 all belonged to members of the three establishments.

Chapter
6

Home-making at Augusta

ONCE again Georgiana Molloy looked through her cabin window in the early morning at a strange landscape—a rocky, surf-battered coast rising and falling with the motion of the ship. When she was dressed and on deck, there was more to be seen. The rocky shore, with small humps of islands off it was that of Cape Leeuwin. Waves breaking white on a sandy bar indicated the opening of the inlet and beyond that was a wide sweep of bay stretching out of sight into the sea mists. The morning was fresh, with a tang in the wind that told of the Antarctic snows from which it came rushing up. Perhaps it recalled to Georgiana the winds from the Hebrides.

The Governor, Captain Currie, Captain Molloy and the other gentlemen were keen to go on shore and examine the country near the anchorage. The next four days they spent in this manner, and professed themselves very pleased with the situation and nature of both shores of the inlet. It was decided to form a settlement there. The next morning, Friday, the passengers of the *Emily Taylor* began to disembark, while the Governor and his suite took one of the ship's boats and set out to explore the course of the river, which they had already named the Blackwood.

It was a long process getting all the families ashore. The crew of the ship were Lascars and were no help at all. The remaining ship's boat had to ferry the passengers to the shallow water and then they had to be carried to shore. There were some ridiculous moments, as when the large figure of Corporal Elijah Dawson, clutched in the burly grasp of young John Dawson, was precariously conveyed to the sand, and when John Bussell could not trust his precious broody hen nesting in a bucket to the less careful hands of anyone else, so waded ashore

with the uneasily squawking bird himself. Meanwhile rafts had been made on which barrels, chests and heavy packages could be dragged across the shallows into the mouth of the inlet to the place where the settlers decided to erect their tents. It took three days to complete the disembarkation. By that time the Governor's party had returned. They reported that the river ran north for fifteen miles and then ten miles to the east. Its banks were covered with good timber of the stringy bark and red gum variety, but that the best soil was to be found on the hilly land along the estuary. There was plenty of good water to be had near the mouth of the inlet, and it was decided to place the town-site there, the town to be named Augusta. The settlers erected their tents on the white sands of the western shore of the inlet. Having seen them more or less established, and having presented Captain Molloy to them as their Resident Magistrate, the Governor returned to the *Emily Taylor* and the brig put off. The little band of settlers were on their own, a tiny outpost of King George IV's loyal subjects, ready to repel the French if they should come, or let the American whalers know that they now visited these waters only by courtesy. But their real enemies, as they would find—the giant karri—stood tall and straight on the hillsides behind, as they had stood for centuries. The bush was waiting for the invader.

It was the break of the season and winter was setting in. Obviously the first thing to do was to get their houses built. But before that could be done a preliminary survey had to be made. The Governor had left instructions with Mr Kellam about this.

INSTRUCTIONS TO MR KELLAM

Memo

It being expedient that the ground on which it is intended to establish the town of Augusta should be immediately surveyed and a plan of it made, you are hereby directed to remain in this District instead of proceeding to Port Leschenault and to take instructions which the Surveyor General furnished you with under the notion of your being to be employed at the taken place, for your guidance here in every respect as regards the differences of place [sic].

You will comprise in your ground plan the coast line from a mile to the southward of the rivulet's mouth to the entrance into the first branch of the inlet which tends to the westward.

When you shall have laid down the coast line indicated, you are then to ascertain and map the nature of the ground behind it to the extent of one quarter of a mile from the shore all along the line and having completed the survey up to that point you are then to proceed to the examination and

survey of the neighbouring country as pointed out in Mr Roe's intentions.

As it is to Captain Molloy the Resident Magistrate of this district that I especially look for the general regulation of affairs in this quarter you will receive and adopt any suggestion or intimations he may give you and it is to him you are to apply in the event of your requiring protection or assistance in the general execution of your duty still considering the chief of your department the person to whom you are to make your reports and to render accounts of your proceedings.

Until the place of the town shall be formed it is not intended to open it for general occupation, but as certain individuals are already on the spot they have received the following permission to occupy land which will be confirmed to them on the opening of the Town and neighbouring country: viz.—

1st Captain Molloy

To occupy 15 acres of ground near the entrance of the inlet commencing at a point to be indicated to you, and extending along the shore to the boundary of Messrs Bussell and Herring.

2nd Messrs Bussell and Herring 10 acres to commence as above with frontage intervening between Captn. Molloy and Mr Turner.

3rd Mr Turner 20 acres. Mr Turner's frontage will occupy the shore to a point which he will indicate to you about 800 yards from Captn. Molloy's S.E. limit.

The side line of all these allotments are to run S by W by compass.

4th Mr McDermott of the 'Emily Taylor' has my promise of a town lot to begin 100 yards to the north of the rivulet entering to the north 1½ chain.

5th Mr Kellam on the north of Mr McDermott two lots comprising 5 chains of frontage.

The side line and rear of these lots will not be decided until the Plan be completed.

6th Mr Turner has the promise of a mill site on the rivulet if it should be found available for that purpose.

7th Messrs Turner and Bussell and Captn. Molloy have been promised the first choice of land in which order as they may agree upon before other settlers as soon as the country shall be opened for general occupation in the immediate vicinity.

JAMES STIRLING
Lt. Governor

Augusta, May 11th, 1830.
To Mr John Kellam,
Assistant Surveyor.[1]

Captain Molloy was now very occupied with Mr Kellam and Mr Dawson in stepping out the boundaries of the block that he had chosen. It was at the mouth of the inlet facing across a shallow bay, on land that shelved down to a narrow beach and was sheltered from the sea winds by the high land behind it. The ground was covered with high

timber and thick undergrowth, which made the survey difficult. Bulky in their fearnought coats, they pushed and fought their way through the prickly clinging scrub, which smelt rotten-sweet with an odour that they had yet to recognize as kangaroo. Often their crashing through the undergrowth would start the grey creatures leaping through the bush ahead of them, so that they would pause to watch the strange swift passage till the springing bounds took the shy animals out of their sight.

Georgiana, to whom any motion would be difficult in these last days, spent her time in the tent on the shore. Sometimes the grey skies would open and hurl strong shafts of rain on the taut canvas, at other times only a light mist fell, like those on Scottish hills. The river was a metal mirror, reflecting the muted tones of the landscape, the dull green of the trees, and the darker hues of the sedgy banks. The sombre scene probably fitted her mood. On a day when the shafts of rain were needling the tent, she asked Molloy to stay with her. There is nothing to tell what arrangements they had made for a midwife—there may have been one among the servants of the various establishments—for doctor there was none. It may have been Anne Dawson who helped. She had lost her first child on the voyage out. On a day when it was so wet that an umbrella had to be held over her as she lay on the rough bed, Georgiana's daughter was born. Not many days later it died. It was nearly three years before she could trust herself to write to Helen Story, who had just lost a child herself:

I was indeed grieved, my dear Nelly, to hear of the poor infant's demise. . . . I could truly sympathize with you, for language refuses to utter what I experienced when mine died in my arms in this dreary land, with no one but Molloy near me. O, I have gone through much and more than I would ever suffer anyone to do again. I fear—I need not say fear—I know, I have not made the use of those afflictions that God designed. It was so hard I could not see it was in Love. I thought I might have had one little bright object left me to solace all the hardships and privations I endured and have still to go through. It was wicked and I am not now thoroughly at peace. . . . Your dear little one, did you call the dear infant after me? Mary told me of your affectionate kindness in thinking of it. The one I called after dear Mary was like 'a little angel'. Its grave, though sodded with British clover, looks so singular and solitary in this wilderness, of which I can scarcely give you an idea.[2]

May, the English month of spring but here the prelude to winter, was over. The rain poured down. The axes rang and the tall trees

crashed. Saws snarled into the hard red wood, palms blistered, and little houses rose out of the trodden and withered undergrowth. The Bussells made a frame house, thatched with rushes, with 'a large farmhouse chimney' made of clay and rubble. They were aided in this construction by Mr Herring, who had often seen such chimneys made in the part of England that he came from. He also took over the superintendence of their garden for them, leaving them free to get on with clearing the land and finishing their building, while Pearce their servant did the household work. Their house stood in a belt of trees on a long narrow block between the larger blocks of Turner and Molloy. The Turners were again happily settled, for they had brought much of the materials for their house with them. Their house, named 'Albion', was set well back on to the hillside, and Molloy's was placed near to the water's edge, with a fine view up the estuary. Thomas Turner's paintings show it as a two-storeyed, rectangular building, smaller than the Turner house, and with fewer outhouses; but Mrs Molloy's letters refer to it as having a verandah, and several exterior rooms about forty yards from the house, such as a kitchen and scullery, and living quarters for the Elijah Dawsons.

After the houses had been built, the land had to be cleared for pasture. The Bussells refer to the 'prodigious size' of the trees, their 'stupendous magnitude and great hardness'; and Mr Turner says that it took 'half a dozen men two or three days to cut them down and dig up the roots, and as much time to cut them up'. This hard work had to be done before the settlers' tiny ploughs could make an impression on the ground, before grain and vegetables could be planted. It was vital to get the crops in, for food might go short, and supplies from the Swan might be irregular at first.

At the end of August 1830, H.M.S. *Sulphur* arrived on a very brief visit, arriving one day and sailing the next. She brought a detachment of troops of the 63rd Regiment who had been stationed at Port Leschenault under the command of Lieutenant McLeod. Also with them to be stationed at Augusta was Dr Simmons, a young man of twenty-eight, who hailed from Yorkshire and spoke with a broad accent. With what feelings must Georgiana have observed his arrival, wondering whether her baby could have been saved if he had come earlier. Molloy would have no time for such musings. He was busy penning despatches to the Governor acknowledging receipt of the latter's communication formally appointing him Government Resident

at Augusta with a salary of £100 per annum, commencing from
1 July, and informing His Excellency of the progress made at Augusta.
He was able to state that 'in the aggregate' seven or eight acres had
been cleared and cropped, and he wrote a word of appreciation about
Lieutenant Dawson and the sailors of the *Sulphur* who had arrived
with them on the *Emily Taylor* and who were now to rejoin their
ship. 'We have on all occasions received so much attention and
assistance from Mr Dawson and his party that I should feel I had been
guilty of a great piece of ingratitude if I did not say how cordially I
regret him and his Man of War and how much we all feel obliged
to them,' he wrote.[3]

Lieutenant Dawson was a very pleasant young man of Irish
extraction, who had been liked by everyone. The Bussells particularly
found him congenial, being of their own age and interests. They
had discovered they had mutual friends in England. For his part, he
liked Augusta so much that he managed to return there the following
year as Deputy Harbour Master, during which time he also kept a
meteorological table. In the first few months he had built a house for
himself and two smaller buildings for his men. These were not far
from Captain Molloy's house.[*]

With the coming of the soldiers and their wives, barracks and more
cottages had to be built, also a temporary hospital and colonial store.[5]
The town-site began to develop between the inlet and Cape Leeuwin,
facing towards Flinders Bay. John Cook and George Layman con-
tracted to build the barracks, which were in use by the following
April, though they still lacked doors and windows in July, and were
not yet painted white according to specifications. There was no
church, to Mrs Molloy's distress, although land was allotted for one
on the plan of the town-site. Church services were held on the Molloys'
verandah, with the Captain or John Bussell conducting them, but
Mrs Molloy feared that they did not do much good; she wrote to
Helen Story:

* The first surveys of Augusta show these houses as erected on a long narrow block,
marked off from Molloy's larger block, and numbered 89. The map of 1834[4] surveyed by
A. Hillman specifically notes that J. Molloy had location *a*, 14.0.24 acres, and one acre,
building lot 89. The Instructions to J. Kellam allot Captain Molloy 15 acres, so it seems
that he allowed Lieutenant Dawson the use of one acre. Nathaniel Ogle's Land Assign-
ments of 1837 give Richard Dawson lots 89 to 130 at Augusta; but Richard Dawson
returned to England in 1833, and his land reverted to the Crown. Captain Molloy may
then have resumed his one acre. He certainly made use of the Dawson houses to accom-
modate visitors to Augusta.

I can give you no idea of the open state of regardless wickedness that . . . reigns here. Molloy ordered an observance of the Sabbath from the first of our arrival. Prayers are read and a sermon or Homily, but even that is thought tedious. This last two Sundays he had read one of Binder's Village Sermons, but all is heard as if not heard; and the soldiers' wives who are compelled to attend or to go without their rations, very often quit the service in the middle of it to hold their enebrious [*sic*] orgies.[6]

The arrival of the military had brought a new and rougher element into the little community, which already had a preponderance of lower classes. If these were better fitted to cope with the hard work required, they were less equipped to endure the isolation and loneliness of this cut-off corner of a continent than were the gentlefolk. After the hard toil of the day and the struggle with the stubborn bush, the educated mind could withdraw to its own solaces—John Bussell to sitting on a log composing Latin verses, his brothers penning literary effusions to their sisters; the Turners to musical evenings among their own large family group; the Molloys to reading. Captain Molloy read reminiscences of the Peninsular War by brother officers; Georgiana—in her own words—

> read only books relating to religion—Pollock's Course of Time, recommended by my sister Mary and a delightful book it is, pray read it if you have not. I am now reading for the third time Henry Martyn's Life. . . . I confine myself chiefly to these books for my conscience seems to say when reading any others, 'Is your peace made with God?' I cannot help looking at myself. I am not exalted enough from the world to look only to where I know my Peace lies. I ask myself if I possess the Fruits of the Spirit—Love, Joy, Peace. No, no, no. St. John says, 'Try the spirits whether they be of God.' But I would write volumes for I have no Physician here to apply to, and really long and pray for some faithful minister.[7]

For the lower orders, however, the only thing to brighten their lives was the daily ration of rum. It was not much—half a gill per day, according to the scale of rations proposed by the Magistrates of the colony in March 1830—but there were, no doubt, ways and means of getting more. Captain Molloy was not very worried by their excesses which as a soldier he understood; he had ordered stocks to be set up, in which serious offenders could sit out their hours of punishment.

With more mouths to feed, the lack of food that had threatened became real. When the *Sulphur* had arrived in August 1830, some provisions had been requisitioned from her. Mr Turner had sent a

note to Captain Molloy informing him that if he was getting stores from the *Sulphur*, the Turner household would require 5 cwt. meat, 1 cwt. sugar and 2 cwt. flour, peas or oatmeal, supplies which Turner estimated would last till they could expect the next ship some six weeks ahead. Captain Molloy therefore penned a polite note to Captain Dance of the *Sulphur*: 'The immediate necessities of the settlers of the place for provisions induce me to request you would, if possible, furnish me with the supplies named in the margin,' and asked for 4 barrels of meat (this would be salt meat), 3 cwt. sugar, 3 casks of flour, 20 gallons of rum. These were to be paid for by the persons who received supplies, but the account was not rendered till much later.

The estimated six weeks ran out, but the expected vessel did not arrive. Supplies of flour became low. As Government Resident, Captain Molloy ordered the settlement on to half rations of bread. The little community was not exactly starving, however. There were plenty of fish to be had, though Mr Turner suffered a disaster when his men lost a large seine net which had kept his large establishment well supplied. Ducks, herons and swans abounded on the river, but it took time to shoot and retrieve them. Swan pie was a delicacy, and so was cockatoo pie. It took a little longer to learn to appreciate the flesh of kangaroo, though the tail made very good broth, and a sizzling hot kangaroo steak could be very tasty. They did not go hungry; but they grudged the time spent in hunting, when there was so much clearing and building to be done.

Fortunately the period of rationing only lasted three weeks. The arrival of the *Eagle* schooner on 12 November relieved the situation, but it had caused a lot of grumbling among the soldiers' and servants' wives. In this new country they were far more vocal than they would have dared to be at Home. 5 cwt. flour was taken from the *Eagle*, at a cost that seemed excessive to Molloy. Writing his despatch to the Governor to go back with the *Eagle*, he remarked that 'the great disproportion in the price of flour and grain' made the small handmill belonging to Mr Turner 'a great resource to our small community'. Unfortunately, Mr Turner saw fit to make a charge for the use of the handmill. The cost of this and of the other provisions he felt forced to order worried the Captain. He was not sure if he was acting rightly as Resident. 'I have been placed in circumstances which my former life supplies no example to guide me,' he wrote to Stirling. It was a

very long despatch he sent by return of the *Eagle*. He reminded the Governor that he had promised to 'rake up an old edition of Burn's *Justice* to aid me in my legal capacity'. He also remarked: 'Mr Turner has a field of wheat and one of rye on light sandy soil. On the richer lands our crops do not look so well. From my garden I have received daily contributions for some time past.'[8]

With the advent of summer the making of homes and clearing of land went on satisfactorily. In April of the next year, 1831, an exploring party appeared, led by Lieutenant W. Preston, R.N.; at first they were taken for escaped prisoners from King George's Sound, so ragged and bearded they were. While Mrs Molloy from her verandah watched them being ferried across the inlet, Captain Molloy went to meet them.

Lieutenant Preston reported later:

> I cannot help mentioning the kind and hospitable manner he received us; indeed, all the people were ready to supply our wants. Sent Mr Skottow with the men to the barracks. [They] were quite well, but still fatigued; walked with Captn. Molloy to visit the different settlers' habitations, and was astonished to find so much had been done by the labouring classes in building their cottages and clearing their grants, and they all appeared perfectly happy and contented.[9]

The same note was struck by Molloy in his report to the Governor in July 1831. He spoke of 'a degree of activity, confidence and industry among this increasing community'. The famine of the previous year had not been repeated; ships had been in more often—the colonial schooner *Ellen*, the barque *Nimrod* and the cutter *Mary Anne*—and the settlers had replenished their supplies. A feeling of hope and satisfaction was general, except with the Bussells.

The Bussells had had their first experience of the bad luck that was to dog them at Augusta. The remittance of money from England which should have reached them in the later months of 1830, and on which they were counting, had gone astray. They were practically penniless in a place where supplies had to be ordered in quantity until the land was made to produce; and the land was proving difficult. John Bussell had made some exploring trips up the Blackwood River, and had come to the conclusion that he and his brothers would do better on a promontory of land, about twelve miles from Augusta, which they named 'The Adelphi'. John wrote:

I was induced to take this step, by several considerations. In the first place, I was able to avoid all society, and reduce our living to the smallest possible scale. Next I hoped to be able, with our guns, to procure more food than the neighbourhood of Augusta yielded; and lastly, I expected a larger return for our labour, inasmuch as abundance of rock and heavy timber rendered our first attempts at clearing very arduous; while the land up country was free in a great degree from these impediments, and moreover, offered from its peninsular form great facilities for fencing.[10]

The neck of the peninsula was only about four hundred yards across.

They were not so isolated as they might have been, had their friend Lieutenant McLeod not left them a parting present when he received sudden orders of transfer from Augusta.

He wrote from there on 2 September 1831:

Dear Bussell,

I am sorry to say that I shall not have the pleasure of wishing you goodbye by word of mouth; I am therefore obliged to take my leave of you and your brothers in writing, which though not satisfactory is not the less sincere.

Green will bring my boat up to you, which I beg you to take care of and use as your own till I return. I shall never think of the year that I spent at Augusta without thinking of you and your brothers as the best friends that I ever knew.

Preston desires me to say that he left some pigeons with Mrs Molloy to be given to you. Remember me to Charlie, Vernon and Alfred, and believe me that

I am, dear Bussell, your very sincere friend, D. H. McLeod.[11]

Captain Molloy was also very good to them. He took their servant Pearce into his own employ, so that they had not to provide for him. He lent them grain to plant. He wrote to the Governor suggesting that Charles Bussell might be made storekeeper: 'Having heard your Excellency express an interest in the Messrs Bussells' welfare, if an opportunity offered of placing Mr Charles Bussell it would be the most essential service to the whole. I think he would prove himself steady and attentive.'[12]

His Excellency approved; Mr Charles Bussell was appointed Storekeeper of the Colonial Store on 14 September 1831, at a salary of £60 per annum and rations. He then moved back to Augusta to the little house they had first built. This house was called 'Datchet'.* His

* Professor Shann in his book *Cattle Chosen* seems to consider this name an aboriginal degeneration of 'Thatched House'. But the Bussells were fond of allusions in naming things. 'The Adelphi' means 'The Brothers'. Datchet in England is near Windsor, the home of the Royal family. 'Datchet' at Augusta was near Captain Molloy's house.

salary meant that after a while the brothers were able to have the
services of Pearce again, though that was not altogether a blessing.
'We have found Pearce almost everything that is bad, a lazy, shuffling,
pilfering scoundrel. To be plain, a complete townbred blackguard.
He is indeed of such little service to us that I think it probable we
shall get rid of him,' and advice was given to the rest of the family
when about to emigrate, to

> enlist into your train a fellow of a different description; one who would
> do his utmost to serve you. He would be none the worse if he were to know
> a little of brick-laying, carpentering, or some other useful trade. As to the
> maidservant, if you could get one . . . whom you know to be honest and
> capable of forming an attachment to the interests of the concern, you would
> find her invaluable. A capability of forming an attachment is a very necessary
> qualification, for you are more at the mercy of your servants here than in
> England.[13]

At least Pearce managed to cook their meals for them while they
built their dwellings and began the work of clearing again. Two
years later he decided that a life on the ocean wave was preferable
and left them to join the crew of the colonial schooner *Ellen*.

In that first year, Georgiana Molloy had turned all her energies
into the business of home-making. It took her mind off her lost infant,
her distant friends and the Scottish country-side she loved. 'Oh my
dear and lovely Rosneath, my heart bleeds when I think of the truly
happy celestial days I spent there and all the violets and primroses
all fresh in my memory!' she sighed. She did her best with her colonial
garden. The servant-man Staples dug for her, and she sowed the
seeds from Home, also some she had got from the Smiths at the Cape
of Good Hope. They throve in the damp Augusta soil. It took away
the loneliness to go out each day and watch the green leaves springing,
the English buds appearing in the alien earth. If she only had someone
to talk to about the things that interested her—the serious disregard
for Faith and Belief in the lower orders, and what she herself should
do about it—the methods of conversion in a place where minister
there was none. These were things that she and Maggie and Mary
Dunlop and Helen Story could have discussed for hours on end.
Now there was no one. Molloy was too busy. The Bussells had a
different attitude to religion from hers; theirs was the conventional
Church of England approach, although John Bussell could sometimes
be drawn into a discussion, particularly as to the need for a church

in their little community. The Turners did not enter into her sphere of thought at all. What Georgiana missed was the strong appeal to the emotions that the Scottish revival had given her; the consuming interest as to the next world. It would have been, though she would not see it as such, an escape from the hardships of pioneering. She knew well enough that there was a lack of something in her life, and so she absorbed herself in her garden to make it a place of beauty, soothing to the soul.

It lay not a hundred yards from the water's edge. The waters of the inlet stretched away beyond bend after bend of dark headland. Sometimes a light misty rain hung over them so that they reminded her of Scottish lochs, but never of Loch Long, nor of that day when Loch Long was bright with little boats bringing from all points an eager congregation to hear the inspired words of Irving from the wooden outdoor pulpit set up outside the little church at Rosneath. He had proclaimed the coming King. But no King had ever come to this land. Her tear-filled eyes surveyed the scene as she set down her impressions to her sister Elizabeth.

> This is certainly a very beautiful place—but were it not for domestic charms the eye of the emmigrant would soon weary of the unbounded limits of thickly clothed dark green forests where nothing can be descried to feast the imagination and where you can only say there must be some tribes of Natives in those woods and they are the most degraded of humanity.[14]

Yet when spring came a second time, she found other beauties. Little delicate flowers appeared in the bush everywhere, in a wealth of colour and infinite variety. Sprays of purple creeper hung from the shrubs and trees, or clustered near trails of a starry white flower bridal in its purity; small flowers golden as buttercups and twice as vivid; tiny white bells exquisitely formed. If only she knew their names. Could she mix them with her own garden? No; the English flowers bloomed in a thick, close profusion. She was grateful for their familiar appearance and sweet fragrance. The bush flowers had a honeyed smell that was overpowering, and yet haunting.

On the second day of November, news was brought that a sail was in sight. Soon the ship that anchored in Flinders Bay was recognized as H.M.S. *Sulphur* by Lieutenant Richard Dawson, formerly one of its crew, but now Deputy Harbour Master at Augusta. Captain Molloy went down to the landing to meet the ship. On board were the Lieutenant Governor, Mrs Stirling, the Surveyor

General, Mr Roe, and a visitor from India, Quartermaster-General
Colonel Hanson. It brightened the humour of the little settlement
when visitors arrived, and visitors such as these were doubly welcome,
for the Governor could see for himself the problems that beset them,
the Surveyor General could be consulted as to the layout of the
town-site, and Colonel Hanson brought a breath of the outside world.
Mrs Stirling's presence, moreover, would be a boon to Georgiana
whose main complaint was that there was no one of her own class
she could converse with: 'How would you like to be three years in a
place without a female of your own rank to speak to or to be with
you whatever happened?' she was to ask Maggie Dunlop later.[15]

The dinner party that took place that evening in the Molloys'
small house can be clearly imagined. In the soft candle-light, His
Excellency Captain Stirling, Captain Molloy, Colonel Hanson, and
Mr Roe who had been in the Royal Navy, would exchange
reminiscences of the war with France and discuss points of strategy,
and their different commanders. After the port had gone round,
and they had joined Mrs Stirling and Mrs Molloy, Georgiana would
hear of the gay doings in Perth since Colonel Hanson had been there.
He had come from India to recuperate from an illness in the milder
climate. His recovery had been swift. The Governor and Mrs Stirling
had given a ball for him, which had impressed him so much that
he recounted it in a letter home:

> I could wish that you had seen an entertainment given by the Governor to
> the Ladies and Gentlemen of the Colony. I think you would have acknowl-
> edged that the whole affair would have done credit to any part of the world.
> We quadrilled and waltzed until midnight—sat down to a sumptuous supper
> laid out for a hundred and fifty people—returned to the dance enlivened by
> champagne and separated only when the rising Sun began to smile upon
> our Orgies.[16]

Colonel Hanson was now making a trip to King George's Sound
to see the outposts of the colony. Of Augusta he said: 'The Town
will be built upon the face of a rising ground, looking South upon
the Sea, and a few years will possibly shew a passing stranger one of
the most picturesque little sea ports in the world.' It is possible that
the gay colonel did not impress Mrs Molloy much, nor she him.
There is a slightly patronizing note in his account of her: 'Mrs Molloy,
a very interesting young woman, complains sadly of solitude; but
as she appears to be in the way "Ladies wish to be, who love their

Lords," she will not be long without occupation.' A few days after the *Sulphur* left, Georgiana's second daughter, Sabina, was born, so she could not be feeling her most fascinating, and though she had politely shown Colonel Hanson her garden, he had not proved a kindred spirit even about that: 'Mrs Molloy's garden abounds with the choicest flowers; but I am sorry to say I am unable to describe them more particularly, than that they are all of them very fragrant and very beautiful.'

The time went all too swiftly. The Governor heard that the bull and cow he had sent for the use of the settlement had landed safely a month or so before. He inspected the Barracks and the settlers' houses, while Mr Roe held consultations with the assistant surveyor stationed at Augusta, Mr Edwards, and gave him instructions. Then the ladies said their farewells, and the party re-embarked. The day after it had arrived, the *Sulphur* sailed.

On 7 November 1831, Mrs Molloy was brought to bed. This time the baby throve. The trouble now was lack of help. Although the Molloys had brought out five servants, they found, as did so many other employers, that their people now wanted to leave them and set up on their own. This occurred particularly with the married couples, the wives becoming discontented and nagging at their husbands to take up land for themselves. Soon after the settlement was established at Augusta Mr Turner was deserted by Thomas Willy and his wife, and by John and Mary Dewar and their eight children. These two families were assigned town allotments, 'having made amicable arrangements' with their former master.[17] The same thing happened with the Heppingstones who had come out with Captain and Mrs Molloy. Captain Molloy recorded that 'Robert Heppingstone, a very honest good man . . . I have also placed in a similar way and he has so far prospered since he left me that he has been enabled to lay in an ample stock of provisions for six months.' This left the Molloy household staffed only by Staples the gardener, and Elijah and Anne Dawson. With a baby to look after, and with only the increasingly unwilling Anne Dawson to help with the primitive arrangements for cooking, washing and cleaning, Georgiana found herself doing work that she had never imagined herself performing. 'I told you how it would be,' she wrote to Maggie Dunlop, 'I should have to take in washing and Jack carry home the clean clothes in a swill. The last of this has not yet happened,

but between ourselves, dear Maggie, the first is no uncommon occurrence.'

What had been a joking matter when she and the Dunlops first tried to imagine life in a new colony was now the reality. Yet she rose to the occasion. Charles Bussell was full of her praises.

> The only neighbours we possess at present, of our class, are a Captain and Mrs Molloy, who are co-colonists with us. Of the latter I cannot speak in too high terms. She is perfectly lady-like, and yet does not disdain the minutiae of domestic economy, an indispensable accomplishment in a settler's wife.

Georgiana probably regarded the defection of her servants as an annoying but temporary matter: actually it was an indication of two trends that would become more and more marked in the formation of an Australian way of life, one being that numbers of those who came out as servants underwent a change of status and class when they became landowners and as their children intermarried with the children of the gentry; the other, that no matter how they had been brought up, women must work with their own hands in the keeping of their homes.

Once the urgent matter of clearing land, erecting houses and sowing crops had been satisfactorily performed, Captain Molloy turned his attention to what was becoming an equally urgent matter, the assigning of allotments of land. On 16 December 1830, the following Government Notice had been issued by the Resident:

> Selections of Land are to be made without further delay and as accurate descriptions thereof as can be furnished, are to be sent in to me at this place or to the Surveyor General at Perth.
>
> The ground reserved for Town Grants extends for one mile from the entrance of the River on the Eastern Shore, and as far as the first inlet on the Western side, from thence to the second inlet terminating in a small stream is also observed. A line drawn from that point to Géographe Bay which is supposed to be due North, will include the remainder of the land reserved by Government, leaving the whole on the right side of that line open for selection. J. Molloy.[18]

This had resulted in some fifteen persons applying for allotments facing Flinders Bay. What appears to be the earliest list of land assignments at Augusta is written in Molloy's own hand for the year between November 1830 and December 1831, and shows reference number of blocks and remarks as to the state of the land—whether fenced, cultivated or otherwise improved.[19] It was probably made at some

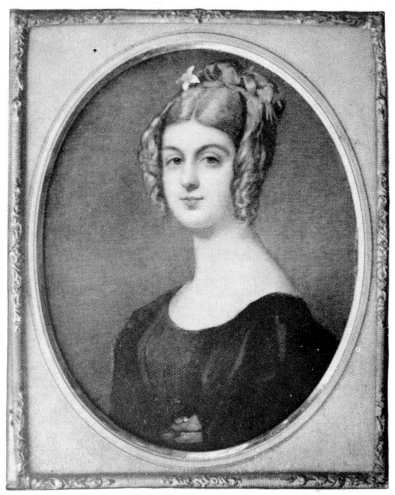

Reproduced by permission of Mrs V. M. R. Bunbury, 'Marybrook'

PLATE I Georgiana Molloy

PLATE 2

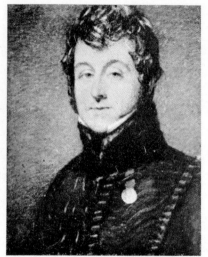

John Molloy

*Reproduced by permission of
Mrs A. M. R. Bunbury*

(*below*)

Captain Molloy about 1855

Reproduced by permission of Mrs Willmott

PLATE 3

The Bussell family: (*left to right*) Lenox, Mary, Fanny, Charles, William, Mrs Bussell, John, Bessie, Alfred, Vernon

PLATE 4 Augusta in 1838 (from a painting by Thomas Turner)

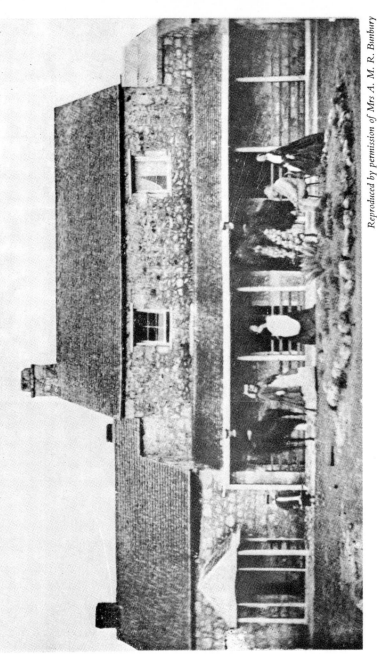

PLATE 5 'Fair Lawn', about 1865: (*left to right*) Mervyn Bunbury, Miss Guerin on horseback, Mrs Bunbury, a nurse with baby, Miss Georgiana Molloy on horseback, Captain Molloy, Miss Turner

'Cattle Chosen': the home of the Bussells

PLATE 6

The township of Busselton (the Vasse) about 1860

PLATE 7

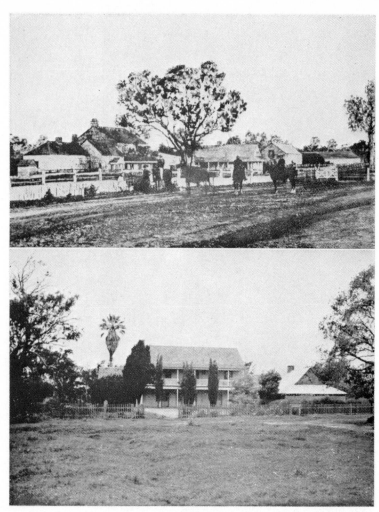

Photo by Mr F. Eggleston

PLATE 8

(*above*)　　'Fair Lawn' about 1870; Bishop Hale's cottage, with the shingle roof, is on the right of the main building. (Reproduced by permission of Mrs V. M. R Bunbury)

(*below*)　　'Fair Lawn' today

time after 1831 and before 1834, as the map of 1834 has an inset of allotment numbers identical with it. Those who had been assigned land in 1830 were Robert Heppingstone, Thomas Willy, John Herring, John Hurford, – Dawson, (a later letter of Molloy's shows that this was John Dawson), Daniel Syred, George Chapman, George Layman, George Earl, Alexander Dewar, Henry Kellam, John Welburn, John Cook, – Ludlow, John Kellam. Nine more persons had been assigned land in 1831, among them James and Henry Chapman, who had arrived at Augusta about March. In September they had notified the Resident that they had selected land on 'the Peninsula adjoining Mr Herring'. The map of 1834 shows the allotments taken up in 1830 shaded grey and of irregular shape, with the buildings erected on them marked in black. The buildings were apparently put up first, then a survey was made which resulted in irregularly shaped blocks, and a later survey correctly made re-formed the town-site into blocks regularly shaped and numbered. The reasons for this will appear.

Among those who had sailed south in the *Emily Taylor* in 1830 were two brothers, Henry and John Kellam. Henry Kellam had arrived in the colony by the *Protector* a week before the *Warrior*, bearing a letter of recommendation which stated that he was Lady Grey de Ruthyn's youngest brother. His brother John had arrived on 6 October 1829, presumably also with a recommendation, for in April 1830 he was appointed an assistant surveyor with a salary of £100 per annum, furnished with some equipment, and ordered to proceed to Port Leschenault by the *Emily Taylor*. The *Emily Taylor* proceeded instead to Augusta and Kellam was ordered to remain there as surveyor. His talents as such must have been indifferent if he was responsible for the first blocks shown on the map. He could not have been very energetic in his duties; a year later Lord Goderich writing to Captain Stirling informed him that Mr Kellam was to be superseded by Mr Edwards, although if surveyors were required, his services could be retained elsewhere.[20] Mr Edwards duly arrived at Augusta on 27 September 1831, and was given permission to occupy one of the Barrack rooms.[21] He and Captain Molloy then made a journey up the river to 'The Adelphi' where Kellam was staying with the Bussells. The surveying instruments were turned over to him by Kellam, who promptly left on a trip to Perth, which he made overland, walking the whole way—some 206 miles, having for company two labourers, Ludlow and Welburn.

Meanwhile on returning to Augusta Mr Edwards made the discovery that his instruments were out of order. He indited a rather terse letter to the Surveyor General on 16 October 1831.

Sir,

I beg leave to inform you that the Circumferentor which I have received from Mr Kellam is so much out of repair that it would expose my operations to much inaccuracy; that I wrote to the Government Resident to that effect, and to ask his advice as to the course most proper for me to pursue; and that Captain Molloy recommended me to begin a survey of the Town-site of Augusta with the assistance of a pocket compass, on which I am now engaged.

I will thank you to send me a measuring Tape; a paper of red ink powder and a copy of the regulations relative to Town Allotments.

You will receive herewith a Copy of the list of Instruments etc. which were delivered to me by Mr Kellam.

I am, sir, your obedient Humble sert., R. V. Edwards.

P.S. I have received the Copy of the Plan of the Town-site of Augusta by G. W. Earl.[22]

This letter indicates that there was a plan of the town-site made before Edwards's arrival, copied by G. W. Earl, a shadowy figure of clerkly attainments, who in November 1831 was appointed Captain Molloy's clerk with a salary of £3 a month and one free ration from the store. There was a considerable amount of paper work to be done by Molloy in the way of statements of accounts for building, public accounts, provisions accounts, bills for the payment of the detachment of soldiers, salary abstracts, etc., so he pressed to be allowed the services of Mr Earl. The plan of the town-site which Earl copied was probably made by Kellam, and the above letter indicates why the first blocks were irregular in shape. Kellam's circumferentor—a type of theodolite now obsolete—was out of order.

Edwards struggled on as best he could with his pocket compass. October found him surveying the shores of the inlet by Captain Molloy's block, and the sea coast of Flinders Bay, together with the rivulet and stream. He had the aid of several soldiers of the 63rd, (W. Car or Ker, J. Rahill, I. Riley, T. Hughes, Kenny and Mallory) for whose services he paid Corporal Madill the sum of one pound. At the beginning of November he made an expedition with John Bussell which took ten days, and two months later he accompanied Lieutenant Dawson to Turner's River, a wild and romantic spot on the western coast, where a small winding stream ran through a

high gorge of limestone rearing upwards some three hundred feet, rampart-like from the green and ferny valley. There is a note of discouragement about his diary, sometimes shown by the entry: 'No employment—men absent alias drunk'; sometimes by:

> Operations suspended; the excuses or causes are—the chief resources for subsistence during a great dearth of provisions rested on my own exertions, the consequent occupation of a portion of my time, the difficulty in these exigencies of hiring men, and for a while indisposition—the following reasons also contributed to determine a cessation of the performance of my duties, viz. having completed a Survey of the Town-site of Augusta and being wearied with the discouraging labor of attempting to mark off the Town allotments with any degree of accuracy of which a defective instrument would not admit.

Six months later he was still writing letters requesting to have the defective circumferentor repaired.[23]

Finally he could not stand it any longer. There is a distinctly relieved note in the letter he wrote to the Surveyor General, headed Perth, November 1832: 'Sir, by intelligence lately received from England I am informed of the urgent necessity there exists for my return thither which I trust will be deemed a sufficient apology for my sudden arrival from my station at Augusta which would not have been the case had an opportunity offered for advising you thereof . . .' and he finished by asking for his resignation to be submitted to the Lieutenant Governor. An afterthought prompted another letter to Mr Roe on the same day: 'Sir, I take the liberty to advance my claim for twenty pounds for appropriating an apartment in my house at Augusta for the use of a public office during one year.' He did not, however, manage to leave the colony till January 1833.[24]

The expedition which Edwards and John Bussell had made in November 1831 had taken them northward to Géographe Bay. There they found 'fine undulating grassy plains' which looked infinitely better than the heavily timbered country round Augusta. On returning to 'The Adelphi', Bussell wrote up his account of the expedition.[25] Although it had some allusions to classical mythology in the Bussell manner, it also contained some very practical observations of the type of country and vegetation that they passed. This journal Bussell sent to Captain Molloy, who handed it on to Mr Edwards. Edwards copied it and sent it on to the Surveyor General in Perth. Captain Molloy was very struck with the account of the

Vasse River and country, and no doubt asked John Bussell to come down the river and dine, so that they could discuss it. Although they had not been at 'The Adelphi' long, Bussell was doubtful of the prospects there and talked of transferring to the Vasse at Géographe Bay.

Edwards's diary began the New Year of 1832 on a Sunday. The next day's entry reads: 'Men absent.' It is not hard to guess why. So instead of working Edwards found himself 'perambulating the town with the Government Resident and indicating certain boundary lines'. Perhaps this was the day when Captain Molloy decided on the names for the streets of Augusta. They were extraordinary names for such a little place. The main streets of Perth at this time were being named after the English statesmen connected with the founding of the colony—Hay Street, for R. W. Hay, Under-Secretary for Colonies; Murray Street for Sir George Murray, Secretary of State for Colonies; Wellington Street, Goderich Street. The streets of Augusta were named Osnaburg Street, York Street, Albany Terrace; while the two heads of the opening to the inlet were called Duke's Head and Point Frederick. These were the names and titles of the Duke of York, brother of King George IV. The Duke of York had died in 1827, so that there was no topical reason for naming the streets of this little village after him. But Duke's Head and Osnaburg Street bounded Molloy's property, and York Street and Albany Terrace ran at right angles to it. This was the demesne where Molloy hoped to found his family. These street names were to remind them of the founder.[26]

Besides location *a*, the first block inside the inlet, Captain Molloy had several others further along, some in his wife's name. After the struggle in the first year to clear land on these thickly wooded slopes, Molloy, like the Bussells and Turners too, had had himself rowed up the inlet looking for better ground. A year's experience had shown that crops planted in sandy soil did better than those in rich loam. He had examined the shores of the inlet carefully, as the little boat bore him along in the dead water close to the banks.

The banks were reedy and overhung with twisted paperbark trees. The inlet grew wider in its upper reaches—two and a half miles at one point, where it was shallow. Black swans and black and white pelicans, solemn and ridiculous, floated peacefully here, and made their nests among the reeds. Six miles up was the entrance of the Blackwood. A smaller stream, the Scott River, flowing into the Black-

wood, cut off a point of land into an island of some size. Captain Molloy fancied this. It was about four hundred acres in extent. When Governor Stirling and his party together with the gentlemen settlers had first gone up the river in May 1830, Stirling had named the inlet Hardy Inlet and the river, the Blackwood, after naval commanders he had known. This island, which they would certainly have seen then, may have been named Molloy Island at that time, for when in 1832 Captain Molloy decided to apply for it and received a letter from Roe granting his request, he wrote at once to acknowledge it, with a postscript: 'If the name given to my Island should not be immutable, I would prefer its being changed to that of "Dalton Island".'[27] Dalton was the name of Mrs Molloy's brother, and in her letters she often referred to 'Dalton Island'; but the name on the map remained 'immutable', then and today, 'Molloy Island'.

As well as applying for Molloy Island, Captain Molloy applied to select his grant of 12,400 acres on the right bank of the Vasse River at Géographe Bay, which location he changed to the left bank early the next year, 1833. This seems to indicate that John Bussell's recommendation had had its effect and that as early as October 1832 Molloy had decided not to stay at Augusta, or at least to take up his main grant elsewhere. On the property or capital he had brought into the colony he had been awarded 12,813 acres, so that he owned 413 acres at Augusta.

❦

Early in the year 1832 an event of considerable interest occurred to cause some excitement in the little community at Augusta. This was the wedding of Mr Turner's eldest daughter, Ann. When the ship *Emily Taylor* had brought the little party of settlers to found the town of Augusta, her Captain, James McDermott, had been very taken with the sprightly Ann and determined to make her his bride. Now, nearly two years later, he returned to do so, and the Turner household was thrown into a flurry of preparations for the wedding. McDermott's ship, the *Emily Taylor*, had gone aground on some rocks near Fremantle in July the previous year. He had applied to Captain Dance of the *Sulphur* for assistance in getting her off, and, on being refused, to the Governor, for 'such assistance as the colony affords'. This took the form of a grant of prisoners from Fremantle for a strong pull in getting the brig off, but whether it was successful was not disclosed. It seems likely that he arrived at Augusta in the

colonial schooner *Ellen*, which came in about the middle of March. The wedding ceremony was performed in the drawing room at 'Albion', Mr Turner's house. Captain Molloy in his capacity as Resident officiated. That it was not quite the matter of high romance it seemed is shown by a passage in one of Mrs Molloy's letters. After the tragedy that later befell poor little Ann Turner, Georgiana in narrating it said:

> She was a Miss Turner, a neighbour of ours, the eldest of nine children and the link that bound together as far as in her solitary capacity could a contending family. Mr Turner unfortunately married his first wife's sister by whom he had one child, the subject of much jealousy from its mother's foolish affection. And I believe had her home been happy, Miss Turner would never have married one whom she had neither time nor opportunity to be attached to. Molloy, who acts here in every way as clergyman, united them.[28]

Ann Turner's reasons for marrying Captain McDermott may have been those suggested by Mrs Molloy or she may have preferred a merry, seafaring man to the surgeon Alfred Green, now stationed at Augusta. Green had pursued her with his attentions when they were on the ship *Warrior*, and ever since his arrival at Augusta in September 1831, when he had succeeded Dr Simmons. Although Captain McDermott was considerably older than Ann, she seems to have been very happy at the time of her marriage. After a wedding breakfast composed of whatever dainties and wine the Turner store-room could provide, the newly-wed couple went on board the *Ellen*, accompanied to the landing place in Flinders Bay by the pleasantly excited wedding guests. No doubt the working men whose cottages looked out to the bay stood outside their doors, puffing their clay pipes, and watching the waving, the singing and hallooing that went on. No doubt they were amused by the antics of Mr Green, exhilarated by too many toasts, as he shook his fist at the distant vessel and shouted that he 'would have her yet'. *In vino veritas*—twelve years later he did.

When the McDermotts reached Fremantle they were a little dismayed to learn that the Colonial Chaplain, the Reverend J. Wittenoom, thought that Captain Molloy had exceeded his duties in officiating at a wedding. A family story has it that though they were in the midst of disembarking their goods, they knelt down on a box of boots on the open beach while the reverend gentleman tied

the knot again to his own satisfaction. The records show that Mr Wittenoom signed an authorization of intended marriage on 2 April 1832.[29] But whether James McDermott procured this before he left to be married, or forgot to get it from the parson till after his return, thus annoying him, cannot be decided, for the date of the ceremony at Augusta is unknown. It can only be arrived at in the light of later events.

Mrs McDermott became the mistress of a little home at Fremantle which the Misses Bussell visited a year or so later. They reported her 'a very nice little woman' with a 'nice drawingroom with every English comfort, except a looking-glass, a tea-table with all appliances and means to boot, but the Hindoo servants in attendance partake more of the Oriental style'.

The wedding of Ann Turner was the only light-hearted moment the Augustans were to know for several months. Already, at the time it took place, the hand of famine was upon them again. At the end of February 1832, Captain Molloy notified the Colonial Secretary that only thirty pounds of flour remained in the store, that no vessel had called for a considerable time and that he was sending his despatch by a tiny vessel lent by one of the settlers and navigated by another. Unfortunately the famine was not peculiar to Augusta. In Perth the price of flour had risen from threepence to sevenpence per pound in December. In January there was no more than a few weeks' supply left. The *Sulphur*, the *David Owen*, and the *Swan River* were daily expected, but flour had risen to twenty-five shillings a bushel. Writing in March, G. F. Moore said:

prices have risen to a very serious height just now, and there is consequently a great outcry in the colony. Some of our friends appear to think that we are so well off that we cannot possibly want for anything; and others probably imagine we are so far gone that it is hopeless to send us anything; so we fall between the two stools. Can you picture to yourself a new colony? You cannot. It is impossible for one, in the midst of the luxurious refinements of the old country to conceive of the actual state of a new one. Not that there are intolerable hardships, nor even great privations; but people's fancy will play them the trick of supposing that from throwing seed into the ground we can ensure a crop without any other trouble; whereas our culture, and all our operations are most laborious.[30]

If Perth had no flour, then Augusta had no flour, or other foodstuffs save what the country could produce. The pioneers learnt to appreciate rock spinach and 'another plant which is found growing on the rich

stiff flats on the banks of the Blackwood; the flower much resembles groundsel, it has a strong taste of celery, and is often much used in my house for flavouring pea-soup; pigs eat it readily.' This time the famine was extreme. 'In consequence of the great scarcity of provisions in the settlement, I was obliged to go out in quest of Game and was absent three days in the bush,' said Edwards at the end of February. In March he reported: 'Operations suspended for want of provisions and men'. In April: 'Operations suspended; the excuses or causes are . . .' as before, that he had to go hunting. Fortunately the Bussells had sent home for a seine net which had arrived with the *Ellen*, replacing the one Mr Turner had lost the year before. This had proved of great benefit to the settlement, though the lack of starchy foods caused great discomfort. By May, John Bussell was writing home to England: 'We have for the last month been reduced to the greatest extremities. The fishing net sent us from England proved an instrument in the hands of Providence to save not only ourselves but many of our fellow colonists from absolute starvation. Our subsistence has been grass and fish.'[31]

Just when it seemed that they might all perish, the *Sulphur* arrived. Fortunately for the Augustans, it called on its way from Hobart to Fremantle. 'After living on half a gill of peas a day as the only farinaceous food, without garden vegetables, such a sight was more pleasing than those who have never known want can well conceive.' Wheat had been hard to procure even in Hobart, and when vessels did arrive in Fremantle, their cargoes were disposed of at very high prices. But the *Sulphur* had brought flour and that was all that mattered.

At least that was how it seemed at first. But on 30 May, James Turner was writing to Captain Molloy: 'I have weighed one of the bags of flour which I received from H.M.S. *Sulphur* and find it deficient in the weight. I will thank you to appoint some person to see the whole of them weighed.'[32] The testy tone of this letter cannot be attributed solely to the effects of famine on a well-fed little man. It is an indication of a change that was taking place in the character of Mr Turner.

In his diary written on his way out to Swan River, the pleasant little London builder revealed much good nature and a philosophic turn of mind. 'Today we passed the Tropic of Capricorn and are now in the Southern Temperate zone and which I think I will end my

days in. I think when I set my foot on shore in our future anticipated country I shall be a fixture to the soil and my little body may help to manure it.'[33]

Although the first days at Augusta were difficult he was still content with his new country. 'I never worked harder in my life and I do assure you that forming a new settlement is not an easy task. . . . I enjoy good health barring being rather stiff when I rise in the morning but like an old horse it goes off when I get warm at work. . . . I do not regret coming out, my spirits are good. My wife and children enjoy better health than they did in London and are quite pleased.'[34] But he was not quite so satisfied with the amount of his new country that he had been granted on capital brought out. He had been awarded 20,026 acres which he did not think was commensurate with the number of people—thirty—he had brought out and paid passage money for, nor with the amount of property he had brought with him. In August 1830, he wrote to Governor Stirling on the subject. This was the first of a series of letters, increasingly disputatious as his grievances mounted, which he addressed to the Colonial Secretary in Perth over a period of ten years.

While his demand for an extra grant was being considered in Perth, Turner went ahead with his selection at Augusta. He was pleased when a competent surveyor in the person of Mr Edwards arrived. In January 1832 Edwards recorded in his diary: 'Walking over ground with Mr Turner and pointing out to him his boundary lines.' A fortnight later he mentioned sending Mr Turner, J. Bussell and Messrs Chapman a 'Circular enclosing form for the Report of lands selected by them'. As he was having trouble with his circumferentor he did not get on with the survey. By the end of July a disgusted Turner wrote to him:

Sir, Nothing heard officially from you respecting the application I made to have the Boundary lines of my selected grant of land pointed out to me so that I might commence operation and improvements thereon. I have now to request that some means may be adopted to put me in possession so that I may be enabled to fence a portion nearest to the Township for the purpose of securing any stock of cattle I now have or may have and for the want of which I have and am suffering great losses and expense in looking after them and supplying them with food to prevent them committing depredations on Town allotments and to keep my people employed am expending a great portion of my Capital on my land in the Town which is not likely to make any return for some years.[35]

Edwards replied at once that the Resident and he would go at an early opportunity to his grant of land, but that they were awaiting instructions from the Surveyor General. After that there was silence for several months.

It is quite understandable that Turner was irritated at not being able to fence off his property. With the dearth of foodstuffs, any garden produce was more precious than gold, and if cattle (also hungry) strayed on to other property and munched the sprouting vegetables, they were promptly shot as trespassers with an abandon that is hard to understand when the cattle themselves were precious. The Government cow was found dead near Robert Heppingstone's grant, shot with slugs. 'As yet I have not been able to discover the perpetrator of this atrocious deed,' reported Molloy to the Colonial Secretary, while Georgiana sadly remarked that she must 'make tea and drink it without milk as they shot our cow for a trespass'. Turner's letter to Edwards about fencing his selection shows that he dreaded the same thing.

As the weeks went by, Turner's discontent increased. Not only was it a matter of wanting to know, what portion nearest the township he could fence; now he wanted to know whether land was available for selection right up to Géographe Bay. He too was attracted by the sound of the grasslands at the Vasse. At the beginning of November he went to see Edwards at his office over at the Barracks. Edwards showed him the map made after his expedition with John Bussell and drew a rough sketch, probably to indicate types of land. He also referred him to the Government Notice issued in 1830, which had set out the area for selection quite clearly.* Turner went home. After some thought, he wrote to Edwards repeating his request for information, and on the same day he wrote to the Government Resident:

> Sir, I have to request the favor of a perusal of a Copy of all instructions which may have been issued or furnished by the Government or local authorities for the information of the settler of this part of the Colony as respects the place open for location with the lines of boundaries and regulations of selections.[36]

On the face of it his request was simple enough, but he must have given Edwards to understand that he thought all was not quite above-board. Edwards evidently talked it over with the Resident, who met Turner face to face, perhaps riding through the bush, and had the matter out. Perhaps the gentleman was rather high-nosed, and

* See p. 84.

the builder aggressive. Whatever occurred between them, Turner went home and wrote at the bottom of the copy of his letter to Molloy:

> Memo. Never returned me an answer, but asked me what motives could I have and that it was well understood by the first notice of selection fixed up at this place that the whole country was open to the right of the Boundary line running up to Géographe Bay. The notice was only up a few hours and taken down before my son could copy it. I was informed it was not convenient and I never could get a copy of it or see it.[37]

The situation was not improved by a cool note from Edwards referring Turner to the Surveyor General.

Both the Surveyor General, Mr Roe, and the Colonial Secretary, Mr Brown, received communications from Mr Turner. By February 1833 he was allowed to select an extra five thousand acres of land, this time at King George's Sound; but the annoying proviso was added that he would have to make the selection in four months.

Turner had changed his mind about King George's Sound, which he had at one time fancied, so he objected that it would take too long to get there to examine the land and that he would prefer to go to the Vasse which was closer. He took the letter in person to the Governor who happened to be at Augusta at the time. The interview with that personage was not successful. That night a disgruntled Turner added a note to his copy of his letter:

> Memo. I delivered the above letter to the Lieutenant Governor at Captn. Molloy's house, and in conversation with him and Captn. Molloy I found the situation I had partly fixed upon in my mind at the Vasse was now granted to Captn. Molloy, he having obtained permission to exchange that from which he at first selected adjoining Messrs Bussell on the north side of the Vasse.
>
> I also made a proposition to Captn. Molloy to survey and mark out the boundary line as described running due north from Turner's Creek into Géographe Bay to see where selections of land might commence—but Captn. Molloy mentioned his objection to it—I then made up my mind not to take land at the Vasse. J. W. T.[38]

He finally took up his extra five thousand acres on the Scott River. Years later he was still complaining about the amount of his grant, the delay in assigning it, and the way that local government was administered at Augusta.

Whatever Turner may have thought of the Resident's administration, the Resident's duties were firmly laid down in the 'General

Instructions issued to Government Residents in Western Australia'
by Governor Stirling on 21 March 1831.[39] A perusal of them shows
that a Resident was considerably restricted by the order to refer
everything back to Perth. Perth in its turn often had to refer matters
back to the Colonial Office or the Treasury in London. With the
slowness of communications (and of Government departments) it
was sometimes years before accounts were passed for payment, or
other transactions confirmed. A few lines from the Resident's in-
structions will show that Molloy was only carrying out his duty in
the matter of Turner's selection:

> Should there be no Officer on the Spot in Charge of the Duties of the Sur-
> veyor General's Department the Resident is to afford all necessary infor-
> mation to Applicants on the Subject of Land and to receive and forward all
> Requests for Grants. But he is not to give even Temporary Permission to
> occupy any Land nor to hold out any Prospect of Land being assigned to
> any Applicant until the case shall have been submitted for the Lt. Governor's
> Sanction by the Surveyor General.*

Edwards was the officer in charge, and he was obliged to submit
everything to the Surveyor General for approval.

Annoying as the delay was for Turner, it is probable that the manner
of the Resident was an additionally aggravating factor. There is no
denying that Captain Molloy had the grand manner. He carried out
his duties as Resident with a paternalism that was not unmixed with
feudalism. It has been pointed out that the class attitudes of the day
were strong. As a gentleman born, and with the aura of even higher
birth about him, a rather high-handed manner would be natural to
Molloy, and he would expect Turner to keep his place; while Turner,
a member of the well-off middle class rapidly coming to the fore at
this time in England, was aware that in this new land money and
broad acres (and the ability to work them) made him as good a man as
anyone else, with the right to criticize those in authority. The difference
between them was fundamental. It did not improve as the years went
on as a later incident proves. At a time when the natives had been
troublesome, Turner demanded a military guard from the Resident
to accompany him on a trip up the river. His request was refused
without any reasons given. This called forth one of Turner's
denunciatory letters. The answer he received shows the tone that
Molloy could use when he chose.

* See Appendix D, p. 258.

Sir, Not being either aware of your intention to go up the river today or bound by any arrangement you may think convenient to make, I do not feel called upon to give any reason to you for the measures I may deem necessary to observe in the administration of the affairs of the district committed to my charge. I have only to remark that I have on all occasions treated you with courtesy but I wish you distinctly to understand that I am not bound to be guided in my public office by your private convenience or intimidated by your puerile and frothy threats.[40]

Next day both parties sent each other conciliatory notes, Captain Molloy explaining that Turner could not have a military guard until the escort came back from the Vasse because it would leave the settlement without protection.

~~≈~~

While Mr Turner and Mr Edwards were corresponding about boundaries of land in November 1832, Captain Molloy together with the Resident of King George's Sound, was summoned to Perth. Mr Edwards's private affairs made it necessary for him to go too. The *Ellen* had been expected about 7 November but did not arrive till a week or so later. This gave Mrs Molloy time to get several letters ready for despatch to England, including one for her sister Elizabeth. Relations between them had improved before Georgiana had left England, nevertheless her letter is rather stilted and lacks the intimacy one would expect between sisters. In describing her new surroundings Georgiana felt she was on safe ground. Her pen raced along, setting down her first observations on the flora of this new land, the study of which was to become the main interest of her life.

On 7 November 1832, she wrote:

My dearest Eliza,

By our last despatches you will receive a short note to intimate our distance and assurances of our increasing regard to you and yours. Last week brought Mama's and May's letters with Jonathan's book which I have not had time to peruse but Molloy has seized every leisure moment and seems much pleased with it. 'Comparisons are odious', and therefore to say it is superior to Johnny Kincaid's is neutral commendation. From the apparent language of the last mentioned I do not intend to read it.*

Today is my darling Baby's first birthday and as we are daily expecting the return of the *Ellen*, the Colonial schooner, I am obliged to scribble, work, nurse and put up sundry parcels, besides siding the rooms whenever I can.

* Jonathan Leach and John Kincaid were brother officers of Molloy's. Leach wrote *Rough Notes of the Life of an old Soldier*, published in 1831. Kincaid wrote *Adventures in the Rifle Brigade*, published in 1830. This is a spirited and well-written account of the Peninsular and Waterloo campaigns, with an occasional 'damn' in it.

You must consequently forgive a hurried epistle if you agree with me such a one is better than none at all.

Dear Molloy and I rejoiced to hear of Mr Besley's promotion and preferment, and I quite envy your northern situation as from what I remember of the banks of the Tyne the scenery was generally pretty, besides, the vicinity to dear Cumberland would greatly increase my charm in it. Pray write to me a long account of the Parsonage, your neighbourhood, and everything concerning yourselves. I am sorry to hear of Mrs Troutbeck's indisposition—when I left England I understood Miss Stevenson was the highly favoured woman. How came it then that Wilkin has the pre-eminence?

I am sorry to lose my dear Molloy. He and the Govt. Resident of King George's Sound are summoned to Perth to represent the Affairs of this place and Augusta at Head Quarters. Diddy and I therefore will be very desolate with not a creature to speak to, or even protect us, as the menservants are at an adjacent island called 'Dalton Island' on the River Blackwood, and no one but our personal domestics are left behind.

This is certainly a very beautiful place—but were it not for domestic charms the eye of the emmigrant would soon weary of the unbounded limits of thickly clothed dark green forests where nothing can be described to feast the imagination and when you can only say there must be some tribes of Natives in those woods and they are the most degraded of humanity.

Our clime is heavenly, and while you are burning the front breadth of your frock and the nebs of your shoes at an excellent fire of Newcastle coals, I am sitting in the Verandah surrounded by my little flower garden of British, Cape and Australian flowers pouring forth their odour (for the large white lily is now in bloom) and a variety of beautiful little birds most brilliant in plumage sporting around me. These little creatures seem quite delighted at the acquisition they have made in our emigration and are much tamer than any but the robin and sparrow in England. There is a small bird called the Australian robin with shining black back and head, and the breast of a very bright scarlet. Also a little bird of a complete blue colour all over resembling Smalt or Cobalt, with short green wings, and the Honeyeater are minutely beautiful. I cannot describe them—they have a long curved beak which they insert into the cup of the different flowers and the symmetry of their form is perfect, accords with the elegance of their food. You see them perch on the most slender flower stalk and apply the beak to the blossom, every moment expecting to see the flower drop off, but their light weight does not in the least effect this. The native flowers are all exceedingly small but beautiful in colour, although that flies when dried. I only know three kinds and those are two white and one blue of the herbaceous plants possessing an odour. Many of the shrubs are powerfully sweet, some like may, some like bergamote. Another remarkable feature in the Botany of this country, S.W. Australia, is the numerous kinds of leaves with the identical flowers—some of the leguminous now I know; one purple pea flower with three kinds of leaves, one of which is a creeper and called the blue vine; the other is an erect shrub with no smell and leaves like a holly,

the third is also erect with leaves like the Privet—and in shady places the blossom emits a scent about three in the afternoon like allspice or clover.[41] Another sort is yellow and straw colour of which there are five sorts of flowers with leaves utterly distinct. But I fear this last page may be somewhat tedious as you are not likely to behold all these aborigines.

I was very glad you sent us the *Patriot* announcing your marriage, and we have taken much care of the Paragraph. We have not heard from dear Dal since we arrived—and indeed have been very remiss in writing, but you can form no idea of every day's full occupation. Mama told me in some fussy letter you had become an Authoress, but the name and subject or extent of your work was omitted. Do send us a specimen or tell me something about it.

I fear we are thought inattentive to our friends, but it must always be remembered that we are a hundred and eighty miles from Fremantle, the Port on the Swan, and Vessels only occasionally touch here to supply the wants of a few settlers; but we have never yet omitted writing whenever there was an opportunity, although our letters must always appear egotistical as our lives afford no other subject. We continue to like Augusta very much indeed and so do all that have visited it.

The retrenchments that the Home Government are making have been inauspicious to our infant Colony but we are in hopes the Governor's presence may effect some brighter prospects.* At all events, we are freed from many unpleasant circumstances now existing in Britain—and I hope the Almighty will have mercy on our irreligious law—and not smite according to their ill-doings. I sincerely trust the Cholera Morbus had ceased before you moved to Northumberland.[42]

I think Irving's prediction to take place about this period must startle many.†

Tell me what you think of the present state of affairs in England. We know nothing but what we glean from newspapers and those so old that a Revolution might be begun and ended long before we should know.

Baby cries to go to bed, so I must say *goodnight until tomorrow*. I believe I described Sabina in my last to you. She reminds me of you in the formation of the cheeks. Her nose is Molloy—but otherwise more like my family. She can walk a little and amuses us very much when we sing Pantalon in Hart's 7a etc. She stamps away with her little feet and really keeps time wonderfully well. I wish you could send me your picture if you can have it again taken.

We often talk and think of you. Perhaps had we the time to spend together again we should be more harmonious than we used to be, dear Eliza. I know in my eventful life past circumstances appear very trivial to the forbearance every day's experience demands; and yet if a perfect absence of grief or pain constitutes happiness we certainly ought to possess it, for our lives are only now and then interrupted by the remissness of domestics, which is gradually decreasing.

* Governor Stirling left Western Australia in August 1832 to go to London to make representations on behalf of the infant colony.
† Irving had predicted the end of the world.

Molloy has had heavy and frequent losses in stock. One fine cow in calf he paid £40 for. Staples tethered her on a declivity, she was cast on her back and the rope being entangled round her leg and neck, she strangled herself. We have besides lost 25 pigs, goats, sheep without number, and Jack the Pony, who has been this last year kicking up his heels in the Bush. He is miserable as soon as the dry weather sets in. Animals are bad property to begin with. They require constant attention, if not, they stray away. Now this said Horse decamped with a neighbouring Mare about 10 months since and the other day they were discovered with a fine colt in addition.

Baby has just been brought in and so clamours to come to me that I have taken her on condition of her writing to you with my holding her little hand. The specimen you will see. Mrs Stirling tells me she hears she was the largest and finest child in the Colony. She certainly is remarkably healthy and never cries, and you may be sure has plenty of soap and water. I shall be very anxious to hear of young Besley, as Molloy has all along drunk your health with honourable mention of your son and heir, and I have for some time since selected a pattern for its cap—one I worked for Baby, which looks very well.

Mama sent me some beautiful baby's clothes and so did dear Mary contribute some pretty little things. I have just completed an elegant Pelerine for Lady C. Bell in shape like Elizabeth Sinhouse's, but worked all over with small sprigs in imitation of Honiton and sprigs like my veil in the three ends. I wish you could see it. I never saw anything more like real lace. I do not consider this as Vanity, as you have no other means of hearing it. I wish you would write us a fond long letter—we have expected one by every post. I know you are a prolific scribe, and on none could you better bestow your well-penned effusions than on Jack and myself. As to any literary news, the Muses avail us not in the least, but we shall at all times be glad to hear of what is going on in the reading way.

I have sent for a piano from the Cape and hope to send you some most beautiful and melodious airs from a Mrs Smith, a Spanish lady who plays divinely on the Guitar and is wife to Colonel Smith, late of the Rifles.

I must suspend these pleasing operations but will not finally close my despatch until the *Ellen* arrives.

Remember simply to address to Captain Molloy, Govt. Resident, Augusta, Blackwood, S.W. Australia. Commit to the Post Office. If requisite, pay the accustomed sum, but do not frank or endanger Mr Sullivan's sine-cure,* as we receive all letters sent direct but by an circuitous means they are delayed and perhaps never more heard of. I cannot afford Paper to enrich the Postmasters in England and Molloy cordially blesses 'your good Mama's' memory whenever I speak of her desire to hear by a frank. He says it is a

* Penny postage was not inaugurated until 1840. Until then the cost of postage varied according to distance, and a letter of more than one sheet was charged double. To save postage, the lines of a letter were often crossed with other lines of writing. The franking of letters (i.e., superscribing with a signature ensuring free conveyance) was a privilege of peers and Members of Parliament, who franked their own and their friends' letters. This ended in 1840.

fraud on the revenue, and 'those that little Eliza used to write till the ends of her fingers were blue, and fire off her letter at Mr Brown without remorse of conscience'.

13 November. I must now finish this as we are hourly expecting the vessel. With our united best love and sincere wishes for every special happiness, believe me, my dear sister,

Your sincerely attached sister,
Georgiana Molloy.

Chapter 7

Hardships of Pioneering

THE afternoon was hot, even for midsummer. No breeze rippled the closely-written sheets of paper on the table by the window. Yet the wind could be heard as always, sighing through the high branches of the trees on the hillside behind the house, blowing away the harsh screaming of the gulls as they swooped and squabbled over the shallows of the river. The continuous faint roar of the surf on the bar vied with the wind in the tree tops in producing a mood of nostalgia and despair in the writer at the table. Pushing back the heavy fair hair from her damp brow, Georgiana Molloy laid down her pen for a moment. She was very tired and very lonely. After a month spent at the Swan River, Molloy had reached home in time for Christmas, and had been home barely a fortnight when he decided to go off to the Vasse to examine his grant of land there. Little Sabina, aged fourteen months and just starting to walk, was her mother's only companion. Georgiana could not forbear thinking of the three dear friends she had once had, whom now she could address only on paper. When seas and time divide, the quality of friendship changes, though it does not become less dear.

Georgiana wrote from Augusta, 12 January 1833, to Miss Margaret Dunlop, 'Keppoch House', Dumbarton, Scotland:

My beloved Maggie,
 I received your and dear Mary Ker's letters of September 1831, in October 1832.* You do us an injustice to censure us for a moment for not writing and thinking of you. Never a day passes that we do not speak of you; and, as I have all along told you, so few vessels call at this port except to barely supply us with provisions, that we have not frequent opportunities of sending.

* Mary Dunlop married the Reverend Stewart Ker.

Besides, I always hesitate to send a single letter, knowing the expense thereof.

We have all been quite well since writing. In November Molloy went to the Swan on business, where he remained a month, and was brought back in H.M.S. *Imogene* by Captain Blackwood, perhaps a friend of Robert's, as he is a nephew of Sir H. Blackwood, from whose name this river is called. He is a very nice gentlemanly man and connected with the Grahams of Netherby.

Molloy again went last Monday to view his large grant of land on the Vasse—a most pleasing country and answering with truth to the description given of its park-like appearance, with long waving grass, and abounding also in kangaroos.

In the interim a vessel has been in, which has given me not only my own, but Jack's letters to write—which I am almost unable to do—as at the beginning of the week I was confined to bed from over-exertion. For in truth, Maggie, I have not time to say my prayers as I ought—I must unbosom myself to you, my dear girl, which I have never done—but this life is too much both for dear Molloy and myself. And what I lament is that, in his decline of life, he will have to lead a much more laborious life than he did in one and twenty years' service. He does not despair, but I never knew or heard of anyone having his losses to bear—but who would?

May God have mercy on us and poor little Sabina Dunlop who is remarkably well. As I lay in bed on Monday she all at once got up and began to walk. She came to my bedside and said 'Mam, Mam'. She keeps going backwards and forwards the whole day long with something for me. Never cries, though I dip her in a tub of water. She is a great blessing. I need not blush to tell you I am, of necessity, my own nursery-maid.

By this I write to Mary and Mrs Caldecott. I have had seven letters of Molloy's relating to business to answer, besides my own correspondence, to weigh out rations, attend to baby; and, although needlework of every kind both for her, Molloy, myself and servant is required, I have not touched a needle for this week. I am now exhausted and the day uncommonly hot. I told you how it would be: I should have to take in washing and Jack carry home the clean clothes in a swill. The last of this has not yet happened, but between ourselves, dear Maggie, the first is no uncommon occurrence, but time will show. What goes to my heart is that dear Molloy has so much exertion bodily and mentally, but I am repaid with interest when any part I can perform eases his burden. The Lord is good and has shown Himself to us in many wonderful instances, but we are sadly forgetful of His Love and bounty amid the hurried concerns of this life.

Oh, my loved 'sister'! I cannot contain myself when I think of the past. I never, never trust myself to think of all we have said to one another. What is all this about Irving and the super-natural gifts and strange tongues?* Please tell me. My head aches. I have all the clothes to put away from the

* *The Times* of 19 November 1831, reported: 'On Sunday the Rev. Edward Irving delivered two sermons on the extraordinary gifts of the Spirit, on each of which occasions the congregation was disturbed by individuals pretending to the miraculous gift of tongues.'

wash; baby to put to bed; make tea and drink it without milk as they shot our cow for a trespass; read prayers and go to bed besides sending off this tableful of letters. I wish I had you here to help me. What golden dreams we used to have about your coming to stay with me! How would you like to be three years in a place without a female of your own rank to speak to or to be with you whatever happened?

Sabina has just toddled in, hiding her little face in her hand in play. She is sometimes so lively she is neither 'to hand nor to bin', as James Angus would express it. My kind love to Robert and accept the same with unabated affection from your sincerely attached sister,

<div align="right">Georgiana Molloy.</div>

The light was fading. The child babbled at her feet, pulling at her skirt. She felt tired and old. Another line to fill the paper, so as not to waste precious space: 'P.S. Mr P. Salmon would not look at poor worn-out Mrs Molloy,' she wrote, trying to make a little joke about some mutual friend. 'The thistle seed never came up; please send me some more quite new. G.M.'[1]

As she had written to Maggie, she did miss female companionship. Molloy came and went—to his Island for a few days, to the Swan, to the Vasse—but that was a man's way. Augusta was not without visitors. Although it was isolated, nearly every ship brought someone of interest to call on the Resident. But these were usually men. She was very fond of the young Bussell men who provided the only congenial company among her neighbours, but they were more often at 'The Adelphi' than at Augusta now. Still, there was a consolation: their mother and sisters were preparing to leave England and join them. In fact, at this very time, the two younger sisters, Fanny and Bessie, together with another brother, Lenox, were approaching the shores of Swan River. They had left England first. Mrs Bussell and the eldest daughter, Mary, were to follow later.

Mrs Molloy was looking forward very much to the advent of Miss Fanny and Miss Bessie Bussell. They were gentlewomen, cultured and accomplished, and about her own age. She had heard a great deal about them from their brothers. When the news came that they had arrived at Fremantle on 26 January, John prepared to go to the Swan to escort them back to Augusta. Mrs Molloy insisted that instead of going straight to their brothers' rough bachelor quarters, they should stay at first with her, and so, when John left in the *Ellen*, she began her preparations. There was not room enough in her own house, but near by—hardly more than a stone's throw away—was the house

Mr Richard Dawson had built for himself. It was empty as Mr Dawson was now Sheriff at the Swan, and was used by the Molloys to put up guests. The Lieutenant Governor, Captain Irwin, and Mr G. F. Moore had occupied it in February. Mrs Molloy now did all she could to make it pretty and comfortable for her eagerly awaited guests.

John Bussell reached Fremantle at the beginning of March. Having been so long in the bush he was not aware of the surprising appearance he presented to his sisters—'rather barbarous, but quite poetical, in large canvas trousers made by his own hands, a broad leather belt, hair and beard both long, somewhat, and moustaches enough to give a bandit look'. They decided it was quite time they came to do his sewing for him. The six weeks they had spent at the Swan awaiting him had been extremely gay, for there was much company and Miss Fanny, an incurable chatterbox, liked company. She enjoyed meeting Mr Richard Dawson at an evening party and hearing all about his doings and those of her brothers in the time Mr Dawson had spent at Augusta. 'With the latter I had one of my tremendous *tête-à-têtes* despite Bessie's reproving looks.'

They did not leave Perth till the middle of April, reaching Augusta on the twentieth. Miss Fanny's pen, as indefatigable as her tongue, described the arrival to her mother.

> I have kept out my desk that I may scribble to the last minute. We are still in the *Cygnet* and Bessie and I have been very busy since 4 o'clock in the morning in the unshipping of our goods all in good preservation, and none of the cargo in the least damaged, indeed they look as fresh as when they were put on board. We have not yet landed so this cannot be an all-satisfactory letter. Dear Alfred was on board with us all yesterday. Oh my Mother, how would your maternal feelings exult in seeing this noble boy, and how did his sisters' hearts triumph in looking and listening. . . . [Next day] I continue my narrative. Yesterday all our goods were landed. Captain Rolles pressed us to dine on board the last day. . . . The boys and Mr Green resigned the honour of wafting us to shore to the Captain but we were met at the beach by the soldiers and our own darlings. Mr Green, how Lord Walsingham would laugh! escorted me to Mrs Molloy's house.[2]

The landing was about half a mile from the three major establishments of Augusta—Molloys', Bussells' and Turners'. A footpath led there following the line of the beach but separated from it by a wall of sand-hills grown over with scrub. It passed by some of the labourers' allotments and their little cottages. It was a romantic little

footpath, with leaning trees and strange scents of sea rosemary and pelagonium, and the noise of the surf sounding faintly, cut off by the high sand-hills. Miss Fanny must have appreciated it as she trod it in the gloaming on Mr Green's arm. Miss Fanny was a romantic of the romantics. She adored a moonlit scene, a languishing glance, and a gentleman's arm to lean on. 'Mr Green escorted me to Mrs Molloy's; it was nearly dark but I could perceive that the river was broad and beautiful and the country more richly wooded than the English imagination can conceive.'

An eminently satisfactory introduction to the wilds—a gleaming river, strange-shaped trees silhouetted dark against the turquoise and lemon sky of evening; the lights of a house, a figure in the warm candle-light showing through an open doorway.

> Mrs Molloy came out to receive us with her little Sabina in her arms, looking so youthful and interesting. Her home is very comfortable and she is so active. We are to stay here for a few days, but as she has not accommodation for us she has fitted up one of Mr Dawson's houses so nicely, a French bed, and all sorts of land comforts. A vase of sweet mignonette upon the table and your picture, my own Mother, were its ornaments, and a large wood fire blazing on the hearth cast a cheerful light around. We spent a very pleasant evening, dear Charley and Mr Green being of the party, though I must stop to say that all [word indecipherable] with respect to him are futile, so let there be no speculations.

Miss Fanny had heard of his hopeless passion for Ann Turner.

There is no inkling as to what Mrs Molloy thought of her new acquaintances. They were at least good company, and it was a merry party that evening in her sitting-room. She was so exhausted with the usual day's work, however, that she was relieved when they retired to their little house further up the hillside. There were many days yet to get to know each other.

But the Bussell ladies were not tired; they were far too excited to go to bed. Miss Fanny continued:

> We broke up early and as we had little inclination to sleep we proposed taking the boys by surprise and walked down to their almost deserted abode. There among casks and barrells of all descriptions we found them seated round something by courtesy called a table, a lamp fed with pork slush, a huge chimney in which a wood fire was blazing, eating rashes of salt pork and pancakes, without either the adjuncts of knives, plates or forks. Two hammocks suspended from the roof completed the picture which Bessie compared to a bandit's cave.

This was wonderful: it far exceeded their wildest imaginings of the colourful, exciting existence their boys had been leading. They laughed and exclaimed, poured out questions and hardly listened to the answers. They ran to the door and admired the enormous moon rising from the dark line of the further shore and casting a sparkling pathway across the river. It was too lovely a night to be indoors. 'We proposed a walk on the beach though it was getting very late; Bessie with John, myself with Charley and Alfred, how nice to lean on two of them again. . . . It is here that one sees the magnificence of emigration. At the Swan, European comforts and luxuries have already robbed this life of all its wildness and grandeur.'[3]

April faded into May. Miss Bessie went up the river to 'The Adelphi', with one female servant, Emma, while Miss Fanny elected to stay at Augusta most of the time and look after Charles, whose work as storekeeper kept him there. She had with her Phoebe, an old family servant. Mrs Molloy's house being close by, they saw a lot of each other. Over-worked and run-down, Mrs Molloy was not at all well. She had gone on feeding Sabina far too long, and now the child had to be weaned. Miss Fanny helped through the first difficult days and nights by taking the little girl to sleep at her house. Captain Molloy was not well either. Things would have gone badly only that Mrs Molloy, by what she regarded as a stroke of Providence, was able to get a serving woman named Kitty Ludlow, who although a cripple was skilled at sewing and could mind little Sabina. She wrote to Helen Story in October:

> I at one time and especially when Sabina was younger, had not one moment's leisure. Now you will learn from Maggie I have had one to aid me. This I know is from God, for the poor woman is herself a striking wonder of God's mercy as all the medical men have given up her case as hopeless. Her husband, not by any means a good character, in a state of intoxication set fire to the house and Kitty was nearly in flames, but seizing her crutches escaped. She then came to me for an Asylum and said it had been her dearest desire for some months to be in my service.[4]

Kitty was to be a great help in the months to come.

A few torn pages of a diary in Mrs Molloy's own handwriting serve to show her daily life from May to October 1833.[5] It is a homely document, preoccupied with pig-killing, amounts of milk taken, seed-sowing and weather. The entries are short and factual, yet how

much they tell. Fresh meat was scarce: if one day announces: 'The little Black Pig's leg was broke so we had it killed,' the matter was important enough to be entered next day as: 'Had roast pig for dinner.' A white pig met the same fate the next month. Every week Mrs Molloy issued rations to the servants. She does not say what they were, but a scale of rations had been officially proclaimed by Governor Stirling, so that no disputes might arise between masters and servants. It included flour, pease, tea, sugar, salt pork or beef, vinegar and spirits. Every now and then Mrs Molloy was obliged to stop the spirits of servants who became troublesome. At the Quarter Sessions, held on 11 June, two men and one woman were fined ten shillings each for insolence.

In June the weather was stormy, with wind and rain that brought on rheumatism in Mrs Molloy's arm. Kitty was proving invaluable in fashioning new frocks for Sabina—often referred to by the pet name of 'Diddy'—and for Mrs Molloy. Diddy had a brown frock, a striped frock, and a new stuff frock. In two weeks Kitty began and finished a scarlet gown for Mrs Molloy. Later a blue gown was set in hand. Every few days Molloy and Ludlow or Dawson or Staples went up to the Island, although Staples was in great demand with Mrs Molloy. He was a very good gardener and while he dug and sowed vegetable seeds, Mrs Molloy sowed 'Cape peas and many other of Harry Smith's seeds'. In May, wheat had been cleaned and sown on the hillside behind the house, and in July Sabina and Mrs Molloy walked up to see it. It was to prove a triumph for her. She had ordered Dawson to wash the seed wheat in brine for want of lime. The harvest which ensued was the best in the settlement, the other settlers' wheat being 'much smutted and full of darnel'.

There was a certain amount of petty thieving. Pearce, the Bussells' servant, was up before Captain Molloy for theft. Phoebe, the Bussells' maid, had some clothes stolen and the thief was found to be one of Mr Turner's men, working for Thomas Turner at his farm up the river. 'Molloy . . . went up with Mr Turner, the Constable etc. to Turnwood . . . when Andrew Smith was very insolent and threatened to strike Captain Molloy.' The Bussells came down the river many times, and often dined. One night John Bussell and Molloy dined together and 'Molloy punished "little Mary".' If he dined not wisely but too well, he worked it off the next day digging out zamia palms whose enormous boles would make it no easy task. In August, 'dearest

Molloy' and party set out for the Vasse, and returned a fortnight later.

In September an event occurred which might have been a tragedy. The diary simply noted on the thirteenth: 'At night we had a most wonderful escape from the Mud Wall falling in', but a letter to Helen Story told the whole tale. Although this letter was written two weeks after the event it was almost incoherent with the emotion Georgiana still felt.

Another incident which I know you will see the propriety of making a subject of thanksgiving occurred on Friday 13 September 1833. Molloy has lately had a mud wall and fireplace built adjoining the house. On the coming of that day Kitty, her husband, Tom (a most interesting servant Boy) on going out for the Kettle said, 'The wall is coming down.' They said, 'Oh no, it's the noise of the rain on it.' Kitty caught up her crutches. Tom replied, 'I tell you it is.' Ludlow, who was sitting behind his wife on the hencoop had only time to thrust his wife into an adjoining tent down a step, when down came all the chimney and wall and broke into the side of this tent which was comprised of Bulrushes and grass (you must remember our primitive state). Kitty now seized her crutches most providentially when Tom spoke the second time, and she was first down the step (owing to Ludlow's push and expression, 'Like enough it is. Get out of the way, old woman') when the clay fell just at her heels and with its force,—although it did not touch her—she fell against a box from the concussion. But for this miraculous interposition the poor lame creature must have been crushed to death. Tom exclaimed, 'Thank God I have saved your life, Kitty,' but judge of my situation and inexpressible gratitude to the Almighty when just as we heard the noise of it falling, I was dressing Sabina to go into Kitty at the new fireplace and she said, 'No, tay (stay) with Mama.' I was on the point of telling Tom to take her out on his going for the Kettle, but was withheld by mercy from the Lord, who had compassion to recall the threatenings sent out against us. She every evening sits on Kitty's knee about that time.

I cannot express my feelings to you . . . for had the child been on Kitty's knee, and she not able to walk without her crutches, they must inevitably have perished. I forgot to name that Ludlow had leapt into a corner whilst the ponderous mass was falling. It was the work of two days to recover the clay matted together as it was with stones and rushes for want of straw, and had not the Almighty spared them—judge of the care and time required to extract their bodies. Every time I embrace Sabina I feel how different it might have been, that instead of a dear little child blooming with health, she might have been a mutilated, pallid corpse. Oh dearest Helen and Mr Story, I tremble now and wonder. Do return thanks and praises, although inadequate I feel they are. Was it not wonderful! Only think of the child's reluctance to join Kitty. . . . Tell me all you say about our merciful deliverance. I did not name the particulars to Maggie, but doubtless you will to Mary. I shall give them and beg of her also to make it a subject of thanksgiving, yea if

they could be sounded in every part of the earth. And although dearest Molloy returned thanks in the service on the following Sunday, yet I think to myself, the very place where the accident happened will be the most mute in the song of gratitude and thanksgiving. A remark of Kitty's a day or two after will suffice to declare the state of her mind. She said, 'I was thinking if it had not been for Tom's speaking a second time we must both of us have been killed. It would have been better for me than for Ludlow— for I think he is very unfit to die—and I know that I am better prepared than he is.' I did not reply though I could have said much.

But the terrible evening was not yet over. Anticlimax was to follow. Spent with emotion and clasping the infant Sabina to her, Mrs Molloy went to her room.

We had not long retired to bed the same night when a person in a very disturbed state of mind burst into the house (for we lock no doors or windows), calling on Captn. Molloy to save him from two men who had attempted to shoot him. He rushed into my room, adjoining the room he entered. Sabina did not cry, and I was not much alarmed at anything but the cause of such abomination, as I regret to state it arises from great intemperance.

Molloy had to go for a light to the kitchen about forty yards away. Whilst Molloy was about, the person was trembling and begging protection,—he had jumped from a window 12 feet high. On Molloy's bringing a candle, the gentleman perceived some blood on his trousers and fell into a dreadful convulsion fit, foaming at the mouth and kicking violently as he lay on the floor. This was too much for Sabina. She and I were up by this time, and she clung alarmed to me. I was obliged to walk out with nothing but my nightdress on, and no shoes, up to Mrs Dawson's rooms, about the same distance as the kitchen. I sent down the menservants with some cold water, and remained absent on dear Baby's account until the person was taken back to Charles Bussell's house over the gardens. He again returned and kept us in a sad confused state until 10 in the morning. Nothing would convince him it was an illusion. I spoke to him seriously when he recovered, which was the following day. But I fear without hope of amendment, as this is the third fit and from the same cause. He spoke the most ridiculous things, and took leave of us for the last time; said he was going to enter on a world of spirits when Molloy was reproving him for his habitual excesses.

These incidents will interest you and give you some idea of the singular events to which we are exposed in this precarious life.[6]

The diary stated baldly: 'In the middle of the night we were disturbed by Mr Green.' The excitement of the night took its toll of Mrs Molloy. Three days later she was writing with emphasis: 'Not very well. Ditto, ditto. I—did—not—feel—very—well', and later still, 'Dear Molloy very kind to me.'

The next people to suffer catastrophe were the Bussells. They had been getting on well at 'The Adelphi'. The peninsula had been fenced off and six separate rooms or dwellings had been erected. The main one, some fourteen feet square, thatched with rushes and floored with stamped clay, had glass windows (glass was a luxury extremely rare), and a fine fireplace with a polished jarrah mantelpiece and a mirror. It was quite well furnished with tables, chairs and book-filled shelves. It had been built and made so comfortable by John Bussell, to house the bride he hoped to bring out from England. The other detached rooms were small. One was John's, two others Vernon's and Alfred's; there was one for the servants, and a store-house. These were set in neat gardens with stone-edged paths. Further away were the cattleyard and wheat-field. It was a considerable achievement after two years of hard work. The blow was therefore great when on the night of 5 November 1833, the whole of the central room went up in flames.

The fire apparently started in the kitchen next door, the chimney having begun to blaze. The servant Emma went into the main room in no particular haste, to tell the family. John had left that evening, and only Miss Bessie, Alfred and Lenox were there. The rush roof soon caught and they all strove with might and main to save the contents of the room. Much was saved, but much lost. The books, the piano, chests of drawers, boxes, were pulled out with suddenly endowed strength. Bedding and clothes were tossed out as the fire spread to the other rush roofs. The silver, the mirrors and the glass windows were saved, but Miss Bessie lost all her shoes and stays, save one pair. Frocks, bonnets, ribbons and small things all were gone. It was impossible to estimate straightaway the toll the fire had taken, but when the flames had died down, Miss Bessie, with a heart full to bursting, sat down among the wreckage to write a letter describing it to Miss Fanny, who was staying with Mrs Molloy at Augusta. No doubt she was too excited to sleep; but a formidable pair Miss Bessie and Miss Fanny would have been had the telephone existed to take the place of their pens. A wealth of interesting material would have vanished, if such had been the case.

The sequel was given by Miss Bessie to a friend in England in a letter of December that year. 'I left the dear Adelphi about three weeks since, at about eight in the evening, accompanied by Phoebe and Emma, our pigs, poultry, cats, dogs, cockatoo and pigeons, Mr Green,

John, Alfred, Lenox and Vernon for our crew and the two boats in tow, very deeply laden, so you can imagine we did not expect to make a very quick passage.'⁷ They had decided to remove lock, stock and barrel temporarily to the cottage at Augusta. John had decided that it was time to cut their losses at Augusta and take up their land at the Vasse. He had not been very hopeful of prospects at 'The Adelphi' after the first year there, and the fire had clinched the matter for him. However, a house would have to be put up at the Vasse before he could move the family there, and a suitable spot for it would have to be chosen. Until then they would remain at Augusta.

〜〜〜

Meanwhile, Georgiana was writing again to her sister Elizabeth— writing to a dead woman, did she but know it, for Elizabeth had died in March of this year, but the news did not reach Augusta till September 1834.

> Augusta, Blackwood River, S.W. Australia.
> 13 November 1833

My dearest Eliza,

I cannot express my anxiety to hear from you. I much valued your kind note in Mama's box, but quarrelled with its brevity. Pray write us a very long account of yourselves. If you but knew what I have to do and attend to, you would never offer the hackneyed term, 'I really have not time.'

Accept my grateful thanks for your kind useful and handsome presents. You may be sure Diddy takes great care of them and being made up, they were doubly valuable. I stitch my fingers to the bone to keep Molloy, Sabina and myself in constant repair. I think you would like little Miss Molloy— she is a remarkably good child. Never cries, not even when she falls, and seems more discomposed at the dirt her hands and clothes have contracted than any personal injury. She speaks so plain that we can hold conversations with her. She was two years old last Thursday, and did ample justice to the plum puddings. Molloy thinks she partakes a good deal in this particular of the nature of her good uncle George. Never shall I forget the finale to the evening he had the run of Mr Benn's garden. The Etruscan was fully exhibited without the slightest scruple on Mama's part.

Mama kindly sent me some of your chitchat letters when dearest May was ill. In one I see you mention having sent me 'Keble's Christian Year' and some threads and silks etc. I thank you most cordially for your kind remembrance, and much grieve to state that no such parcel had ever arrived. Nothing could have been more useful, and should your generosity ever fall upon its desired object, I shall take the earliest opportunity of informing you.

If ships went from Newcastle, you could be of great service to your forlorn brother and sister in executing our commissions, and so forwarding them either to London or to this place. Before I close, however, I will give you

an opportunity of serving materially and if I do not mistake, I can apply to no one who will more readily acquiesce. Cheltenham is not only dear, but so very remote a quarter that I refrain from troubling Mama and May. Besides, my dear Liz, you know our dear Mama's propensity to relieve the shopkeepers of all their slight wares. These are not worth the expense of freight. Therefore whatever you buy for us, let it be as reasonable as will suit the nearly exhausted pocket of the 'Poor Swan River Settlers', but endowed with that enviable quality, Durability.

Mr Butlin is having some money of Molloy's to expend on two hogsheads of Porter. One for his poor wife, who is now skin and bone; some cheese and other etc. I hope Mr Butlin will prevail on Mrs Caldecott to get him a box of common English preserves such as jams and bottled gooseberries, for Sabina rarely ever tastes anything but hard salt meat, and fruit we have not seen since we left the Cape in 1830.

One very good way of packing trees or plants is by putting them in tanner's bark enclosed in an iron pot or pan well closed down. Some fig or vine cuttings arrived here the other day for the Bussells, packed in this manner, and the figs had shoots on them of 3 or 4 inches.

You could not send old Georgy a greater treat than some seeds, both floral and culinary,—but they must all be seeds of that year's growth. In return I will send you some Australian seeds. I should have last time, but Molloy forgot where he put them. I hope ere this you will have received some little memento per *Cygnet*. I send you a bunch of emu feathers given me by Mobin, a native chief. You will perceive that they are covered with a sort of red earth. This they paint themselves with, and, mixed with fat they extract from their food, they besmear the hair, which is turned up *à la Grecque*, and confined by many strings of the oppossum hair which the women spin.

The natives are very fond of all the settlers at Augusta, and we live on the most peaceful terms. But at the Swan, from the indiscretion of several persons and particularly their servants, they are hostile. The natives call Molloy 'King Kandarung', and me, 'King-bin'. They are delighted with Sabina and she is not the least alarmed at their black figures and rude voices. She will dance opposite the native children with great glee; and an old native woman seized her by the leg the other day and embraced it, without producing the slightest emotion of fear.

At this point the letter was put aside for more than a week, perhaps for reasons of health, as her next daughter was on its way, or perhaps because Kitty Ludlow had been taken ill and could no longer help her. It was 25 November when Georgiana resumed from where she had left off:

You are, I presume, acquainted with the existence of the Bussell family. They have lately been so unfortunate as to have their dwelling house, composed of mud and wickerwork, burnt to the ground and the property much injured by the flames. Fanny, the eldest girl, happened to be staying at the

time with me. No lives were lost, but all their shoes, needles and thread destroyed, which in this far distant clime is really irreparable. They have a cottage at Augusta and thither they have all repaired, bringing with them their goods and chattels, amongst which Bessie's piano is placed in my sitting-room.

You may well conceive my gladness at this acquisition, as I have not heard the sound of music for four years. Sabina at first was a little afraid, but in an hour soon overcame it. She seemed to think it was an animal, and insisted on tying a piece of cord round one of its legs, hearing us speak of the legs of the piano. She put her fingers to the opening in the front board where the silk is visible, and exclaimed, 'Oh, Mama, it's coming out! It's coming out!' Hearing the vibrations at night when eating her supper, she said, 'If the piano had a mouth, Mama, I would give it some sop.' In time she has become fond of it, and her great delight is to sit upon the music stool. She asks me to sit by her. She strikes the keys and attempts to sing. It is most ridiculous to see her. She sings, 'Come a Rose, my bave Tossy Boy' (Come arouse thee, My Brave Swiss Boy), 'Little BoPeeps from Ingle (England) I come', 'Buy a Broom', and 'There was a Bonnie Briar Bush in One Kail Yard'. Yesterday morning on entering the room she asked Mrs Dawson the servant, 'If the piano was awake yet?' I should perhaps suppress all these juvenile details; but, my dear Eliza, to Molloy and me they are not only amusing but instructive, more especially when we rarely hear the sound of any loved voices but our own two.

The Bussells always intended leaving 'The Adelphi', their residence up the river, but this accident has obliged them to halt at Augusta instead of going to the Vasse, where Molloy and they have taken their large grants. They are genteel nice people and that sort of thing—but terribly *close-fisted*, which gives us the idea they belong to the *Take All* family, as we have on several occasions been most liberal to them. Yet they are not ashamed of receiving everything and you will hardly believe they have made no return; nor have Molloy or myself ever broken their bread. This must be secret. I told Mama but charged her not to mention it.

I quite envy you your delightful northern residence and especially seeing my dear and valued friend, Mrs Birkett. I am now, whilst writing, leaving loads of needlework neglected, but I cannot bear to think of giving up one's 'objets chéries' for these necessary employments. I had a person of the name of Kitty Ludlow in my service who greatly assisted me in this department, but she has lately joined her husband, as she became too ill to work. She has of late been seized with the most awful and alarming fits, and so she followed her own choice of joining her husband on an island of ours eight miles up the river and bearing the name of Dalton Island.

I am overpowered with work and expect an addition to my family in the spring, and have not a cap to put on the child's head.

The letter had again to be broken off, probably for lack of time to make the list of things Georgiana wished Elizabeth to send her.

Captain Molloy had to go to the Swan, as he had the year before. Charles Bussell went with him, and they arrived on 7 December, a notice of their arrival appearing in the *Perth Gazette*, a newspaper which had begun its existence in January of 1833.

Captain Molloy had hoped to remain only three weeks at the Swan, but the Governor was away at Albany and was detained there, so Molloy had to wait for him. Georgiana spent a lonely Christmas, she and Sabina eating their Christmas dinner alone, if what she says of the Bussells remained true. Perhaps the generous hospitality of the Australian bush had not yet come into being: perhaps Georgiana's sentiments must be attributed to her condition. The child which she expected ' in the spring' was to be born in June. It is, of course, possible that she had been disappointed in her hopes of friendship with the Bussell ladies. The Bussells as a family were an extremely self-contained unit. The lady whom John Bussell had hoped to bring to 'The Adelphi' as a bride had found this. She was a Miss Sophie Hayward, a woman of considerable property. John and she had been childhood sweethearts, and had corresponded ever since he had come to Australia. John had assumed too easily that she would accept the subordinate place in the family which he assigned to her when they would all be together in the new country. 'In domestic affairs, in her own circle my mother must be paramount; in general external affairs such as are not the province of women, as experience demanded I might assume control . . .' he wrote to her in 1832. This was no good to an heiress. She might be willing to let her husband control her money, but she would expect to control her own household. But the Bussell family felt quite firmly that their little Mama was their head, and the focal point of their family life. Their whole interest was turned in upon themselves; there was no room for outsiders.

Miss Hayward continued to correspond with John till 1837 when he made a visit to England. Then matters came to a head, and he wrote back to his mother in March 1838: 'My affair with Sophie is at an end. We have had nothing but differences since my arrival. I was estranged at first by foolish jealousy of my affections for you. . . . I have encountered distracting and humiliating scenes and bear with her silly friends the character of a fortune hunter.'[8] The engagement was shortly after terminated by John's asking for his freedom.

Georgiana continued:

21 February 1834. My beloved Girl,—Nearly four months are fled since this was commenced. On December 5, dearest Molloy left this for the Swan, expecting to be absent for three weeks. He has been prevented from returning but I have had one opportunity of hearing from him. His absence is agonizing, and from his valued letter he is as uncomfortable at his separation as I am.

Many events have occurred since he went—which have loudly called on me to act a more conspicuous part than I could have desired, knowing my insufficiency. Kitty died on the Island in a most lamentable state, totally deranged and unapproachable, saving by her husband, from disease which the climate made more offensive. Her funeral duties I was necessitated to conduct. She had to be buried by torchlight. Her poor frame was so highly discomposed, it made two of the bearers ill for some days.

The harvest then ensued, which was favourably stacked and proved the best in the settlement, owing to the seed wheat being washed in brine, and for want of lime. This operation I performed in June previous to the sowing time. All the other settlers' wheat was much smutted and full of darnel.

The Island being troubled with Natives who, though amicable, required watching in case of theft, I ordered a guard of the 21st Fusiliers* to repair thither to preserve stock and dwellings. I then set Dawson and the oxen to plough. The *Ellen*, the Colonial schooner, arrived one day when I was almost dead with expectation. I set off in the cart, left Sabina asleep in her cot, and when I got to the landing place, was told Captain Molloy had been prevented leaving Perth owing to the delay H.M.S. *Alligator* had caused to the Government. I returned very much disappointed. No letters, *as usual*, from England, but two most kind and voluminous epistles from Mary Ker, Rio Janeiro. From that period, nearly a month, I have hourly expected my honoured husband.

A barque was seen off here last Friday wishing to come in, but a strong breeze from the S.E. prevented her. This we surmised was the Governor and suite on their way to Swan River. Therefore my much loved one will again meet with detention. When he returns, he says he will never leave me again unless it is to enrich ourselves and procure more comforts than we have hitherto enjoyed. True, we have drunk many dregs since we embarked on this fatal Swan River expedition, fraught with continued care and deprivations.

I wish you would send Jack two pairs of List slippers to put on while dressing, and some Honey in jars. If not expensive, also twenty yards of *good black cotton velvet*, as much as would make me a *very full dress* and some over for children's frocks—I name the uses I shall apply it to as I am ignorant of the width—perhaps by taking a whole piece you might obtain an abatement, and I should not object to that quantity, but let it be a *very* good black. As you will be making up a box, dear Eliza, I will trouble you to get me some

* On 28 September 1833, a detachment of the 21st Royal North British Fusiliers was stationed in Western Australia, of which a sergeant and twelve privates were at Garden Island waiting to be embarked for Augusta. The sergeant was probably Sergeant Guerin, as Mrs Molloy mentions him by name later in this letter. The Fusiliers replaced the 63rd Regiment which was transferred to India.

other things; the only impediment the reimbursement, which Molloy will pay in time.

A little watering pot for Sabina and any letter book with pictures, or other little bagatelle.

I am very ill off for net to use for children's caps, and that, if you can meet with any proper width at a cheap rate and good in kind, send some also.

I wrote to Mama for Hair Oil, Pomatum and very fine small tooth combs. If she has not got them, enclose three combs, three short large size, two hair and six nail brushes, very hard. I had better draw out a list.

You never can do wrong in sending us out soap for which we sometimes pay 3/6 per lb. Let it be yellow or brown. Candles also, and glass would materially serve us, as what we do not want I could sell to great advantage.

Do make me a present of a nice new tea pot for Molloy and myself. I like either a biscuit ware or stone ware, such as mustard pots are made of, with silver rims. The one I use is a black one sine handle and half a spout. The consequence is loss of time and burnt fingers. Ask the price of a tea set of this kind, if such are ever made. Its strength is its great recommendation; I mean brown looking, with raised figures.

18 May. Dear Eliza, I send this with erasures and what I have scratched out, do not get. Apply to Mr Butlin for the money as reimbursement, and accept many thanks for your trouble. God bless and protect my darling Liz.

> Your devotedly attached,
> Georgiana.

Please send me *The Butterfly Ball and the Grasshopper Feast* for Diddy.*⁹

With Captain Molloy's protracted absence, the whole brunt of the pioneering life had fallen on the frail shoulders of his wife—'his poor wife, who is now skin and bone'—as she had said of herself. For a refined and delicate woman to supervise the ordering of harvesting and ploughing, to set a detachment of soldiers on guard against natives, and to undertake the emotional ordeal of reading the funeral service by torchlight on a remote island over poor Kitty's grave, as well as to perform the manifold tasks of keeping house under primitive conditions, was to undergo a strain well calculated to make her regard 'this fatal Swan River expedition, fraught with continued care and deprivations' as less than romantic.

What were her thoughts after driving the rough farm cart down to the landing to meet Molloy, only to find he had been kept in Perth? 'I returned very much disappointed' must have been a considerable understatement. The rough bush track under the towering

* This was a children's book which Georgiana would have known and loved from her own childhood. It appeared first in the *Gentleman's Magazine* in 1806. It was a fantasy in verse by William Roscoe, the historian. King George III was so pleased with it that he had it set to music for his daughter, the Princess Mary.

E

karri trees must have seen her bitter tears; the lonely house and the sleeping child must have seemed a contrast to the Bussell cottage next door crowded with babbling, laughing occupants.

One sort of courage was needed to deal with loneliness; another to deal with the visits of natives. Relations with the black inhabitants of Augusta were on the whole friendly. Such had been the case at the Swan in the first year or so of settlement. The accounts of various diarists prove this. The natives were not an aggressive race; they were a curious and a hungry one. In order to keep relations friendly the colonists made them presents of food and clothing. This the natives liked; but they could not understand why they could not take what they liked. They were persistent thieves; and while the better type of colonist could control anger at depredations, the lower classes were quick to retaliate, and start trouble.

That relations with the natives were friendly everywhere as late as 1833 is evident in the tone and matter of a despatch to Lord Goderich from the acting Lieutenant Governor, Captain Irwin, who had taken the place of Governor Stirling while the latter was in England. Captain Irwin said:

I proceeded in the *Ellen*, in the month of February last [1833] on a tour of inspection to King George's Sound and Augusta. I am happy in being able to inform your Lordship that the persons located at each of these settlements are perseveringly engaged in prosecuting the various and appropriate pursuits of a Settler's life,—are apparently contented with their prospects in the Colony,—have continued without intermission to preserve the most amicable intercourse with the neighbouring Aborigines and have found their respective climates remarkably healthy. . . . While at King George's Sound I directed the issue of trifling presents of knives and provisions to the Natives there which were promised them by Governor Stirling on a former visit.

In my despatch of 26 January, I reported to your Lordship the arrival of two natives from King George's Sound. After a residence here of several weeks they returned with me in the *Ellen*, when their arrival was hailed by their tribe with great satisfaction and increased confidence in our good faith and friendship. On my departure from the Settlement the same two natives with four others eagerly availed themselves of permission to accompany me here, on the clear understanding that they were not to return before the lapse of twelve months. When at Augusta, which I visited on my return, one of them chose to remain with the tribe there, the remainder since their arrival have been stationed at Perth, where they have had almost daily intercourse with the Swan and Canning River tribes, with the most perceptibly beneficial results; so much so, that I have directed three of them to be clothed and rationed at the public expense, and attached to the Superintendent of

the Native Tribes; and I attribute to their intervention an inconsiderable share of the success which I am happy to say has attended his daily intercourse with the Tribes of these districts. The two remaining natives not appearing calculated to be equally useful, I took an opportunity of sending back to their tribe at their own request. The conduct of all of them has been highly satisfactory and encouraging, though they have a difficulty in conveying their meaning to the tribes here, the dialects differing considerably, yet both parties are becoming more and more intelligible to each other by repeated intercourse, and I feel warranted in saying that we can obtain by means of the King George's Sound natives earlier and clearer information of the existing feelings and intended movements of the local tribes, than from the most friendly and familiar of the latter.

In my despatch of 26 January I had the honor to inform your Lordship of the Appointment and duties of the Superintendent and Assistant Superintendent of Native Tribes. Since that period these Officers have been posted at Perth. . . . In order to give the Superintendent an influence with the Tribes and to encourage a continued intercourse with them, I sanctioned the occasional issue to them of small quantities of bread at the discretion of the Superintendent, which has been diminished to a trifling amount on the object being attained. To prevent any disappointment from the discontinuance of the issues the Superintendent was instructed to encourage the natives to bring in fish, of which they can obtain a plentiful supply with facility, and by barter to obtain from the inhabitants of the town the bread before issued from the Government store. The plan has so far succeeded.[10]

Captain Irwin went on at some length to state that abuses of natives by the poorer whites on the edges of the town had caused what appeared to be inconsistent acts of hostility by the natives. He was, however, of the opinion that in time they would adjust themselves to the great changes they would have to undergo; and he held that it was the moral duty of the whites, having entered their country, to help them to become adjusted. In theory this was sound; but in the month after the above despatch was written, numerous small acts of theft or violence on the part of the natives culminated in the spearing of two white men. The murderers escaped, but Captain Irwin was obliged to issue a proclamation outlawing the native leaders, Midgegoroo, Yagan and Munday. Feeling ran high. Midgegoroo was caught, given a fair trial, condemned and shot. This occurred in May, and two months later, Yagan was taken by surprise and unfairly shot. After this, the situation simmered down a little, but increasingly the settlers and those in authority felt their hopes of educating the natives to adjust to the ways of the white man wither and fade.

In October 1833, Captain Molloy had written to the Colonial Secretary: 'In cultivating a friendly intercourse with the native tribes at this residency it becomes necessary to supply them occasionally with small presents of provisions', and asked what was the policy at Swan River on such a matter. Such a policy may have promoted friendly intercourse, but it often had unfortunate effects. Early in the next year, 1834, while Molloy was on his protracted visit to Perth, Mrs Molloy, like many other settlers' wives in lonely places, had an experience with the natives that was unlikely to make her regard them as black brothers.

In February, while Molloy was away, one morning when Dawson was the only man about the premises, about twenty natives came about and, seeing potatoes in the garden and being instructed in the use of them by one who had been domesticated with some of the settlers, they were anxious to attack them. The women, more notorious thieves than the men, came to my dwelling at some distance from the kitchen. (I had Sabina in my arms—no servant or any one near me.) One of them endeavoured to snatch a worked urn rug from the table. I perceived this and made a sign for them to retreat from the verandah. They seemed unwilling to obey. The women went out, and two men began to play with Sabina, then little more than two years old. I did not like their manner and said, 'Ben-o-wai (begone).' I called Dawson and met five others between this and the kitchen. On Dawson's coming up, one of them, a very tall strong man, flourished his club or hammer over Dawson's head, and pretended to hit him with his wallabee stick (a short thick stick). Dawson parried this and shook him off. Dawson grew very pale and turning his back, went towards the kitchen.

As soon as Dawson's back was turned, this same man and another a little lame, came up to me and took hold of Sabina's legs and shook their spears at me. I was afraid to show fear and smiled. The tall man, perceiving that I was not intimidated, cut the air close to my head with his wallabee stick. I stood it all, taking it as play, but I heard the whizzing and expected either Dawson, the child or I should be struck. Dawson and Mrs Dawson were keeping them out of the kitchen but could not see this transaction. I called to Dawson not to go but not to interfere, as I knew their numbers much exceeded ours and I was unwilling for a breach. He (the native) then, seeing that I cared not for his manner, drew a piece of broken glass bottle close to my cheek. I smiled and trembled, and said 'Dirila' or glass, meaning that I knew they used it for sharpening their spears. He rubbed his fore-finger in his hair until it was covered with the fat or red earth with which they rub themselves and poked it right into my face. This I could not stand and, but for Sabina, I should have knocked his insulting hand away. I then left my ground, and for some time he dogged me—not letting me go one way or the other. I told Dawson to disperse them and call in the dogs. Not one of them would even bark (the servants are in the habit of correcting them when

a forbidden stranger appears). About this time there were thirty altogether, and Yarner, a great thief, pointed to the potatoes, and wanted Dawson to give him some. Of course he did not. I never once thought in my alarm of the firearms, but when Dawson was drawing water for the natives, brought out a pistol and Molloy's rifle, and laid it where they could see it as soon, as they returned. On finding these weapons, they one by one dropped off and went over to the Miss Bussells, where they hung about for some time.

After their departure Miss Bussell missed four cut glass salt cellars. They came to me and said the salt was emptied out and the cellars gone. I instantly despatched Dawson (an old soldier in the Rifle Brigade) armed, to the barracks, and desired Sergeant Guerin would pursue the natives with the detachment and endeavour to procure the stolen property, only to use no violence. They seized the women and found the cellars in the kangaroo skin pouch that they carry their children in on their backs, and their only punishment was to make the women kneel down, and threaten to bayonet them. The woman on whom they were found was the identical one that had attempted to steal the urn rug. The man who behaved so ill to Dawson and me we have never seen again.

That was on Friday, and on the following Sunday, many came down with wallabies (a kind of hare) and gave one each to the settlers, which we accepted as a peace offering. I am sure if Dawson had not been present, Mrs Dawson and I and the poor children would have been murdered or otherwise injured, for it seemed that man's full intention to prevent me leaving my own premises. It gave me a great fright.[11]

Georgiana, however, was not too frightened by the presence of natives in the offing to take little Sabina for a walk along the beach to Duke's Head in the cool of the evenings. There she would sit on the white sands strewn with dry seaweed, and look out over the heaving seas hoping to see the sails of the ship that would bring Molloy back to her; the child meanwhile happy and busy picking up shells and bits of cuttlefish, and dabbling fingers and toes in the rock pools.

Just when it seemed that he would never come, 'one morning about 6.30 we heard a ship's gun in the Bay, and shortly after dear Molloy appeared in his rifle jacket looking quite fat from the gentlemanly life he had been leading in Perth.' Then there was much to hear of all he had done in Perth, of all the people he had visited, and of the new buildings and general progress of the town. A water mill built by the Civil Engineer, Mr Reveley, just below St. George's Terrace, had commenced operations. There was a good hotel—the 'Perth'—which in announcing new additions to its premises, also mentioned, 'Dinners, Lunches etc., on the shortest notice; a Bagatelle board within, and an excellent Skittle Ground immediately adjacent; Stabling provided.'

Another inn—the 'Cleikum' at Guildford—catered for the Hunt Club, whose members sometimes gathered there to dine at 2 o'clock on a Saturday afternoon, or assembled preparatory to a kangaroo hunt. Kangaroo meat was on sale in the stores at 1/4 per pound, but fresh meat was scarce.[12]

Mrs Molloy would have been very interested in accounts of what the stores could provide, and in prices generally. If Captain Molloy brought with him some copies of the *Perth Gazette*, her curiosity would have been satisfied. The issue of 15 June 1833, announced:

To be sold
at very low prices,
at
Mr Wm. Dixon's, Fremantle.

A quantity of Ladies' Leghorn Hats. do. Printed Muslin dresses, and Striped ginghams. do. dark prints, fashionable Patterns. do. assorted Calicos.

An assortment of jackonet, book, haircord, cambric and other Muslins. do. of figured stuffs.

An assortment of fashionable bonnet, cap and waist Ribbons.

Ladies' and Gentlemen's Black silk Stockings. Pieces of Net of different qualities.

The prices of articles of food advertised on 6 July 1833, were:

Butter (salt) 1/6. 2/- ditto. (fresh) 3/-. Bread, 4lb. loaf, 1/4. Beef (salt) 6d. lb. (fresh) 1/6. Mutton, 1/8 lb. Kangaroo, 1/2. Pork, 1/6 (fresh) 8d. (salt). Cheese (Sydney) 2/- lb. English, 2/-. Coffee, 1/6 lb. Eggs, 4/- doz. Milk, 8d. quart. Wine, Cape, per gall. 5/- & 6/-. Rum, Cape, 16/-. Brandy, 14/-. Sugar 8d. lb. Tea, 5/- & 7/- lb.

The *Gazette* contained items of news from abroad, such as the illness and approaching death of Sir Walter Scott. It reported the Fremantle Races on 5 October, run with imported Timor ponies, and watched by 'groups of fashionably dressed ladies and gentlemen promenading to and fro'. It was apprehensive: 'It is intimated to us that the hooping cough has been introduced into the colony; we are requested therefore to caution the Public that it prevails among the children newly arrived,' and rightly so, for three weeks later: 'Hooping cough very prevalent.' It also contained articles of a general nature, one of which probably provided much controversial discussion, or even derisive laughter, although it was to prove of the greatest importance to the State and to mothers of young children, as settlement spread. This article was headed:

PRESERVING OF MILK

M. Kirchoff, the Russian chemist, who some time since discovered the process of converting starch into sugar, has just made several experiments upon milk. The result which he has arrived at is curious. He is said to have found out a mode for keeping milk for use for any indefinite space of time. The process of preserving is this: He causes new milk to be evaporated over a very slow fire and until it is reduced to a dry powder. This powder is then put into a bottle hermetically sealed. When the milk is wanted for use, it is only to dissolve some of the powder in a reasonable quantity of water, and the mixture so dissolved will have all the qualities as well as the taste of milk. This powder will prove to the many a desideratum long looked for.[13]

To Mrs Molloy it would be like a breath of the outside world to read a newspaper again, and to listen to her husband's reports of people and their doings. It would be an immense relief to be free from the duties of the Resident, and to become merely the Resident's wife again.

On 13 April, 1834, the *Ellen* came in to anchor in Flinders Bay, bringing with her Mr Alfred Hillman, lately in charge of the Survey Office at Albany, and now to be stationed at Augusta. He disembarked amid a scene of great activity, for while he was getting his instruments and baggage off the *Ellen*, John Bussell and his four brothers were transferring on board all the equipment they would need to start their new home at the Vasse. The *Ellen* was to sail them round to Géographe Bay. After four years of struggle at Augusta they were detaching themselves and most of their possessions to begin anew. Instead of the boy Pearce, they had their old maidservant, Phoebe Bower, with them to cook for them, and they also had with them 'Dawson, a man we have engaged for six months'. From later allusions, this was Elijah Dawson. His indentures with Captain Molloy would be up in the next year, and there is no doubt that he too was keen to take up land of his own at the Vasse. The Bussells had evidently come to an arrangement with Captain Molloy for Dawson to join them. He was a tall, strong man, and a good worker. Captain Molloy had a high regard for him and would want him to take the opportunity to find good land to settle on. With the Bussells went another Augustan settler, George Layman. He had been among the first comers at Augusta, had taken up land there and had brought a young wife there from Perth in 1832. Now he was going to examine the land at the Vasse.

While this party went round to the Vasse by sea, another party,

consisting of two of the three Chapman brothers and two soldiers, walked overland from Augusta to meet the others at the landing place. John Bussell had a fairly good idea from previous visits of where he intended to settle, but 'the Chapmans have not yet decided what part of the country they intend going to. They made several expeditions to the Inlet, but thought they had better come and settle near us, the natives being so very numerous on the Sabina.' This of course referred to the Sabina River, where the Chapmans eventually took up their grant.

Working hard to get their buildings up before the winter set in, and adopting the plan as at 'The Adelphi' of four or five separate rooms, the Bussell brothers reported progress to the sisters left at Augusta. 'As the Vasse is only sixty miles from Augusta,' Fanny told those at home in England, 'we have frequent visits from the different members of our infant colony. A walk of two days and a night in the bush is compensated by a short spell of home society.'

The drift from Augusta had began and was to grow, as settler after settler followed the Bussells' example. Nevertheless, the surveyor, Mr Hillman, busied himself with correcting the surveys of his predecessor Edwards, and mapped the town-site and surroundings. His maps of 1834 show the earlier lines of allotments, and faintly written in pencil, Mr Edwards's stations for bearings. Scarcely a month after his arrival, he was able to write to the Surveyor General:

> Sir, I have the honor to forward you the accompanying plan of Augusta shewing the proposed alterations in the allotments as arranged by the Government Resident and myself. The only difficulty in carrying the same into effect will be the removal of the front fences, but should it meet with the approbation of His Honor, I would propose that the soldiers stationed here be employed on fatigue duty in their removal to the proper situation. I have endeavoured to divide the plot land given to Messrs Molloy, Bussell and Turner, but cannot bring the last mentioned gentleman to any arrangement unless the whole frontage North of his cultivated field is given to him. This being the case I have left it to be divided by yourself. As the other part of the town is being readjusted, I think this should be also.[14]

Mr Hillman, like Mr Edwards, was having trouble with Mr Turner.

Alfred Hillman's stay in Augusta was not long. He drew his maps efficiently and neatly, and put in his reports. In September he was withdrawn. The surgeon, Alfred Green, also received his *lettre de congé*. He was no loss to the Molloys, who did not think very highly of him, but his mooted departure was lamented by the Misses Bussell.

They had enjoyed his musical talents. 'Bessie is singing and Vernon and Mr Green are accompanying her in such a ridiculous style,' Fanny would write to John. However, they had by no means seen the last of Mr Green. He was in no hurry to leave and was still there the following April.

In June 1834, another little Miss Molloy made her appearance at Augusta. This was Mary Dorothea. Her mother, writing one of her voluminous epistles to Helen Story—the first for over twelve months—said:

> When I last wrote to you, my dear Helen, I believe I complained of multiplicity of business, but on 16 June this year, my third daughter was born, and I have not only to nurse and carry her about, but all my former occupations to attend to, having only Mrs Dawson as a female servant. I do not hesitate to say that I am overwhelmed with too much labour, and indeed my frame bears testimony to it, as I have every day expected to see some bone poking through its epidermis.
>
> My beloved husband much assists me and more than many would do, except such treasures as yours and mine, dear Nelly. You will fully believe me when I say I must either leave writing alone or some useful requisite needlework undone. The latter I would not attempt for Molloy's, myself and the children's sake, but there is not a person to be had here to do any. I never open a book, and if I can read a chapter on Sundays, it is quite a treat to have so much leisure.
>
> Baby will be six months old on the 16th of this month. She is a very large fat child and remarkably healthy. With great thankfulness I avow she has never had even infantine illness. . . . Everyone says she is a beautiful child and though it may appear very vain, I coincide with them. She is very fair—I call her *French white*—and her flesh is so hard and plump that her arms and legs are like polished marble. Her face is more like mine than dear Sabina is. Her eyes are rather dark blue.[15]

It may occur to latter-day Australian women, most of whom have to nurse the baby and carry it about, mind their other children, and perform household tasks without the aid of even a Mrs Dawson, that Mrs Molloy complains rather much about lack of servants. To generations now growing up, servants are almost legendary creatures: to Mrs Molloy they were simply one of the appurtenances of living. It must be remembered too, that domestic work was done with no other appliances than the scrubbing brush, broom and duster, and numerous hands. In the wilderness, if the broom wore out before replacements were ordered from Perth, bunches of twigs or feathers tied together on the end of a stick had to deal with the sand that was

constantly tramped into the house. One slight attempt at a labour-saving device that several of the colonists mention—notably the Bussells and the Reverend J. Wollaston—was a washing mill.* This was listed among the things that the Bussells brought out from England. Writing home before their sisters had come out, the Bussells gave an account of it.

> The price for washing is at present more exorbitant than for any other thing whatsoever. See therefore that your servant has been used to and will readily undertake this important affair. We have avoided the payment of 6/- per dozen by means of our washing machine which we have found of great service, though it certainly does not turn out its contents in the same style in which Mrs Edwards was wont to do.[16]

The Reverend J. Wollaston gives the information that the heavy things were done in the washing machine and the rest by hand. The theme of washing day occurs like a refrain in his journal: 'Heigh ho! washing day again—5 dozen and two pieces!' as indeed it does in Bussell and Turner diaries. It was one of the hardest things for gently born colonists to accustom themselves to doing.

Spring approached again and garlanded the undergrowth with starry trails of clematis. On the last day of September the *Ellen* arrived, bringing Mrs Bussell and her daughter Mary, to be welcomed only by Fanny and Bessie, as all her sons were at the Vasse. However, the ship had anchored there for a while on the way south, and Mrs Bussell had had the pleasure of seeing again her bronzed and hirsute brood. She had much to tell her daughters of all she had seen there, and in Perth, and of the voyage out on the *James Pattison*, on which were Sir James and Lady Stirling returning to the colony.

The ship which brought Mrs Bussell also brought a packet of letters for Georgiana which filled her with sorrow. Reviewing the events of 1834 in the long letter to Helen Story, she said:

> In September I received letters from Mama and George and one from dear Mary Kennedy, the import of which I can scarcely believe, remote as we are from the land in which it occurred. You are, by this time, I doubt not, in possession of the circumstances to which I allude, and know my poor dear sister Eliza has passed the awful limits of time and began last March never-ending Eternity. Oh! Helen, would that I could see and speak to you on this, or rather, that the dead might be recalled to retrace those heedless

* The washing mill was a wooden cask mounted sideways on supports, and had paddles turned by a handle. It was described to the writer by a daughter of Alfred Bussell, Mrs de Castilla, who added that it was not a great success and was later used as a butter churn.

steps which were so prematurely and suddenly arrested. I feel great consolation that we were good friends on leaving England and even better since I was out here. I received a very kind letter and present from her, and wrote in return and sent her some seeds which she expressed a wish for, but this letter and those May had in her box to convey to Liz, poor girl, when the mournful intelligence arrived.

May writes that Mr Besley consoled himself with the thought of Eliza's being more serious than she formerly was—that she never passed a day without reading some portion of the Scriptures and that he saw her recent pencil mark in the 'Whole Duty of Man', and some other religious works; but that her death was unexpected even a few previous hours even to herself was fully obvious. From the accounts though not from herself I fear she had not as good a mate as myself, or indeed few have; but Mr Besley's temper was not good, though she, poor girl, would never hint this to anyone. But Mama and May from staying there could easily perceive this. Now Helen, I tell you and my dear Mr Story this, but do not hint it to anyone as I know it would have hurt her. She was a most affectionate little wife and though there were many prospects of her having a family, it was the Lord's wisdom that only one should come into the world, and that one still-born. Write to me what you think her case will be. I am not happy neither about her or one of the family. Oh! pray write to Mary and urge the folly of remaining so long buried in this world's wiles. Mary is much to be pitied—she and Mama are not unanimous, and poor Mama's sand is quickly running—nay, when writing this I know not if she is yet among the living.

Doubts and fears as to whether her sister's belief and good works had been sufficient to assure her of salvation assailed Georgiana; yet even while she besought Helen Story's opinion on this, the exigencies of her own life pushed the other world away. The letter went straight on:

We are so unfortunately remote a distance—you remember my reluctance to come out to Australia and I wish I never had. We enjoy health and our children will perhaps have more than a competency, but Molloy and I have to work as hard and harder than servants will. In March our servants' indentures are up, and we are literally expecting to be without, and we shall be, unless some vessel most unexpectedly brings people here. I know I cannot do without a woman servant, however bad she may be, especially when there is no one to be got to wash even, and I have to carry baby. So fat she is, she makes my back quite ache. As to Molloy, he is a perfect slave; up at daybreak and doing the most menial work sometimes, so that all the former part of our lives was all lost time, and even reading and writing there is not time for here.[17]

'All lost time'—that part of her life which had not prepared her for living in a wilderness; which had been calm, contemplative and sedentary. The first years at Augusta demanded that she lead a life

of constant energy, and kept her at war with her surroundings. It was not till later, when they were more settled, that Georgiana grew to know the bush and to learn that she could turn to it as a consolation when life was hard. At the time of writing to Helen Story her household and her young family consumed her thoughts.

In November, poor darling Sabina was seized with a remittent fever, which came on suddenly. At last, at 2 o'clock in the day, I perceived her very drowsy, and she would hardly leave my side, though at another time I cannot get her to remain with baby and me, we are too quiet. Well, before ten she was in a warm bath, her head shaved and blistered. She was quite incoherent, and at one time convulsed; and before this she had never been half an hour ill from her birth. We were greatly distressed. Molloy and I prayed the Almighty to spare her, our dearest hope. She was only three on the seventh of the month, and on the thirtieth, Death rose—certainly hovering near her. As she sat on my knee to have her head shaved, she said, 'Mama, you will bring baby in,' and kept continually talking about baby, of whom she was very fond.

Molloy commanded me to go to bed, as baby, who lies all night on my arm, would be restless. I went, but not to close my watchful eyes. Molloy, dearest creature, sat up with Diddy, who remained in the same state till about three when, God be praised and glorified, the medicine took effect and the instant this occurred, she was better. Her pulse, which beat at 130 and had never been lower than 120, fell. She began babbling in her usual gay manner. She had a relapse a few days after, but, thank God, that was the last, and though still very weak and ill looking, I trust she will shortly regain her strength, though she is not the same looking child she was. I felt peculiarly grieved, for though the medicine man thought that it was a stroke of the sun, Molloy and I were persuaded that the symptoms were more those of remittent fever and I had for some time been lamenting my total inability to look after her—she who had always been my sole object of care. I know she ran about too much for her tender years; she was often so tired. Then, when the poor child sat down to dinner, she would almost fall from her chair with fatigue and be quite asleep. Her spirits, which are very great, are too much for her strength, and in the winter she would be running about without cap or bonnet from six o'clock to five; then, having baby to nurse and attend to, the darling child was neglected. I wish now I had a proper person to take care of her, and when I know there are so many that would be glad of such an asylum as my house would be to them, I bewail my smallness of means that I could not offer to pay their passage money. I would of course prefer an educated person, but would be grateful for one of good Christian principles and if you hear of anyone of sickly health wishing for such a situation I hope you will remember me. I would treat her with every kindness and she would only have to do a little needlework and be a companion to Sabina more to keep her from bad examples if she was not able to teach her.

Sabina can say the Morning Hymn which Papa regularly hears at Prayers. He has taught her to say the Lord's Prayer and the Grace of our Lord. I never knew her to tell a direct untruth till last Saturday when she was whipt for the first time, but still insensible to her fault. Tell me how you act when they are given to untruth. I have only one spelling book that your kind Father gave me and it is without pictures—for some object to engage her ever active mind I have already begun her letters, but she manifests no predilection for them. I wish we were nearer good instruction for I am persuaded many dear and precious minds will be lost for want of it. I am delighted you sent me your two year old letter. If you had not, I should have been quite ignorant of the highly instructive circumstances it contained, and which I had often much wished to be acquainted with.★ 18

Her preoccupation with the death of her sister and the illness of her child probably prevented Georgiana from seeing much of the newcomers to the Bussell household. When she did, she was evidently not greatly drawn to Mrs Bussell. Indeed, there are signs that they were definitely antipathetic. Mrs Bussell, in her haste to rejoin her family, had entrusted all her goods and provisions to a small and unsuitable vessel, the *Cumberland*, and would have sailed in it with her daughter, except that Sir James Stirling himself strongly dissuaded her. The *Cumberland* had been lost—as events proved, soon after leaving Fremantle—with all hands, and with the Bussell goods. To take the beginning at the end, Georgiana's letter to Helen Story of 8 December, started:

My dear and much beloved Helen, Last Friday the box containing your much valued letters was given to me through the medium of Mrs Bussell, to whose care Mrs Taylor entrusted it. A strange fate awaited it. The vessel on which all Mrs Bussell's goods were placed has never been heard of, and it is presumed is lost, as it was only a small craft and a gale came on three hours after she left Fremantle. However, this parcel has been put up with their books,—the only property they have saved from all they have brought out, amounting to upwards of £1,000.

None but herself would have ventured property of value in such a vessel, as it was only a boat built on. This is not the worst. The poor man, Captn. McDermott and three hands or sailors, were on board. Captn. McDermott has left a young widow and child of about two years and is daily expecting to be confined, without a *penny* to support themselves even now owing to his inadvertent speculations.[19]

★ This may refer to the trial of Edward Irving in 1832 by the London Presbytery of the Church of Scotland on the charge that he had suffered and permitted persons to interrupt and disturb the public worship of God in the church on Sabbath and other days. The Gift of Tongues had become suspect, and Irving with it. The verdict went against him, and he was removed from his church. After this he formed a church of his own—the Catholic Apostolic Church. This caused great pain to those who had known and loved him.

This does not indicate a high opinion of Mrs Bussell, but it may have been due to that bone of contention, religion. Mrs Bussell was the widow of a priest of the Church of England. Soon after reaching Perth she expressed indignation that with 'the church exactly what Fanny described, and Mr and Miss Wittenoom excellent worthy creatures, they have opened a conventicle here'. 'They' were a number of Methodists who in 1830, had come out on the emigrant ship *Tranby* which had been chartered by two Wesleyan families, the Hardeys and the Clarksons. The Hardeys used to hold services at their house, and also in the open air under a jarrah tree in Murray Street, Perth. Another company of Methodists had arrived in 1833. The term 'conventicle' for Mrs Bussell no doubt embraced any form of Dissenters, and if Mrs Molloy admitted, or more likely positively gloried in, her association with the Free Church of Scotland, Mrs Bussell might have disapproved. This may have been the cause of their disaffection. It would be interesting to know just what form of service was followed on the verandah of the Molloys' house, when the Captain or John Bussell performed the offices, but there is no indication beyond a remark of Miss Mary Bussell's that the Captain usually preached too long. A statement of Georgiana's: 'If you tell them here of the merits of their Saviour's atonement they will say, "I suppose you are what they call a Wesley or Methody . . . "' shows that she dissociated herself from that sect, albeit despairingly. There were obviously, however, deep-lying differences between her and the Bussells.

The loss of the *Cumberland*, as well as being another stroke of ill fortune for the Bussells, had been a grievous blow to James Turner. His eldest daughter, after only two years of marriage, had been made a widow. She had a young child, a daughter, and was daily expecting another. She had been left penniless and would not at first believe in her husband's death, nor would she return home to her father but remained in Fremantle to be confined. 'I am in hopes she will come down here after her confinement,' wrote Mrs Molloy, 'and if she does not feel comfortable at her father's, we intend offering her an Asylum at our house.'[20]

Ann McDermott did in due course return to Augusta. She found that her brother Thomas had left the paternal roof and had taken up land four miles up the Blackwood. He had begun this venture in January 1833, and by hard work and with the aid of one of his

brothers, he had cleared a good deal of land, fenced it with split rails, and had a small cottage with several outhouses and an open shed that served as a barn. He had named his property 'Turnwood'.

Whatever Mr Turner may have felt about having his daughter back on his hands with two children, he was preoccupied with a new grievance against the Government. He had wished to import wine and spirits for sale, and had found difficulty in getting commodities forwarded, while the cost of the licence was too high for the amount of trade. As usual, he sat down to let the Colonial Secretary know how he felt.

I have now biscuits and other goods which I imported by the *Isabella*, lying at Fremantle and I left orders (and Assets for them) for Rice, Sugar, Tea, Wine, Spirits etc. etc. to be forwarded by the first opportunity, but no one vessel excepting the Government One has been here yet from the Swan River. Had I received those articles they would have been of great benefit to myself and caused me to employ some of the population here, and might have been of some little assistance to the Govt. by payment of duties and perhaps a license for the sale of them, instead of which there has not been I believe any duty paid or license taken out this year, but has had the immoral evil attending it of landing spirits privately every opportunity.

There is not any public works doing here nor the least encouragement given to works of any kind by the Govt. and yet it is required of us to pay the same duties, and for a License of £20 a year, a charge in proportion in my humble opinion much beyond what is paid at Fremantle and Perth, where all the expenditure seems to be concentrated. We have only a population of about fifty souls, men, women and children, and most of them in establishments that seldom spend a shilling, and but few that can get employment to earn one, having only a few soldiers as customers, and they at times work without receiving their pay. I trust His Excellency Sir James Stirling has arrived, and that some little relief will now be extended to this part of the Colony. I am, Sir, Your Obedt. Servt. Jas. W. Turner.

Augusta, 2 September 1834.[21]

Chapter
8

Exodus from Augusta

It was the custom of the times to write very long letters. Mrs Molloy was adept in the art of letter-writing. The letter which she wrote to Helen Story in December recapitulating for her the events of the year 1834 continued into January 1835.

I have entered on another year which I trust may be productive of good to yours and mine. I shall never be happy till I have less to do and think of than at present.

On speaking to Molloy about someone to look after Sabina, he desires me to say he would be very glad to pay the passage money of such a person, and if agreeable, would settle land on her but that as soon as a vessel arrived, with an unmarried woman in it, the beach was crowded with candidates handing in written proposals to her—let her be the plainest woman ever seen. This I must expect in any single person I have about me; but the welfare of my uninstructed child goes near my heart, and instead of being able to direct and look after her I am obliged to perform the most menial offices. Now we are expecting two old servants of Papa's out,—Captn. Simmons and his sisters, which will make it worth while chartering a vessel from Augusta and by your writing to Mr George Turner, Biscuit maker, Bishopsgate street, London, he will put you in to the readiest method of communication and give direction as to means of passage. He is brother to our neighbour, Mrs McDermott's father. We do not personally know him but hear he is a very nice plain little citizen and has the welfare of this little Settlement much at heart. Indeed, we suffer materially from this place being as little known, as it makes our numbers so small we have no opportunity of progressing. Molloy says he would not like to be called upon for a year or so to discharge the passage money of anyone accepting the situation I name—but eventually he would do it. She cannot be dressed too plain. I never wear anything but dark cotton and a muslin kerchief, and a lighter print for Sundays; plenty of shoes and boots, for they are expensive articles here. Plaid or stuff are best for winter, but indeed it is so cool at Augusta that I make no change from England and have a fire always in the evening.

I shall be most thankful for a sensible and pious young woman, or even a widow, that would teach the children good habits and assist me in any way, either as a servant or companion. Her salary, though not large, would be sure, and you know us too well to think we should not be very kind to her.

The caps come in most opportunely for Sabina but you will think me altered when I thought them so gay that I divided the number of bows and keep them for their best caps. . . . I am sure you would be delighted with my two poor Australian weans. Baby is thought a beautiful child; but I cannot say she is so good as your Sandy—witness the last lines on the other side of this page. I am soon thinking of weaning her—before the servants go, as I am sure I shall not be equal to nursing her and all the other work. But I nursed Sabina until she was eighteen months.

I hope if you hear of emigration you will recommend its votaries to Augusta, and let them be supplied with woollen goods of dark colour. Shoes and even clogs would be good here in the winter, which lasts from May to September. . . . I wish Mr Story and you would think of coming over to us. You would do as much good here as there, and more, for the field is less occupied. . . . Besides, with what delight should we hail each other. As Mary finds Rio so very hot I intend strenuously urging her to think of Australia. I cannot bear heat, or it would be more advantageous—as this place is not so propitious—for us to live at Headquarters, viz. Perth. This is the height of summer. I am writing in the nursery with a fire in the hearth, and the thermometer about 71. We are now reaping the Killites, the hill behind the house.

If ever we leave Australia, I think it will be to settle in bonnie Scotland. I often dream of the garden of the manse. I used to take so much interest in it and that of our ever happy Keppoch.

I fear Dalton has acted unwisely in leaving the Army, indeed I do not know what his intentions are. We hope soon to hear from the dear boy.*

It is a month today since I began this. I have written it at the expense of needlework, and in great haste, so pray excuse its many errors and imperfections; but if it bears testimony to the unabated affection and regard for you both and all connected with your dear selves, it will fully serve.

> Your ever faithful and attached brother and sister,
> John and Georgiana Molloy.

P.S. 5 January 1835. I am often tempted to write on Sundays, but as yet, I have and intend abstaining from it. G. M.[1]

Mrs Molloy's observations on clothes are interesting. All the settlers had found that a different type of clothing from that which they had worn in England was necessary. Cotton clothes were more worn because of the heat, and because they washed well, while the bugbear washing day could be staved off a little if the cottons were

* David Dalton Kennedy, Ensign, 12th Foot, 12 February 1827. Retired as Ensign by sale of his commission, 21 June 1833.

coloured and small-patterned so that they did not show marks. 'Although things are coarse, let them be good, genteel and small patterns,' said Bessie Bussell, asking for things to be sent from England. 'For my own part, I like a dress that will wash and be new again better than constantly wearing a stuff with all its accumulations,' said Miss Fanny.

The need to bring plenty of shoes was stressed by Mrs Molloy and several other letter-writers. Shoes wore out quickly with the rough walking, and were hard to replace in the colony. A few were apparently made in Perth, for an advertisement in the *Perth Gazette* of 26 January 1833, stated:

> The undersigned having succeeded in tanning the native Kangaroo skin, has been recommended by some gentlemen, to agree with a shoemaker for making a few Boots and Shoes for sale—for his benefit.
> Gentlemen's Shoes made to measure, 15/-. Wellington Boots, £1. Ladies' Shoes, 10/6. GEORGE WATTS

Miss Fanny Bussell reiterated the same need:

> Shoes can never be too regularly despatched, stout and neat. I still wear my highlows. Had it not been for them I must have long ere this been barefoot. Merino dresses and coloured, neat and genteel, as dress is by no means neglected here and far more observed than in England. At the present moment we are wearing large Javanese hats, as our bonnets were burnt.

Highlows—laced boots reaching just above the ankle—were evidently the most useful form of footwear. Miss Fanny went on to give a list of the small things so necessary to a woman and whose lack was felt very much at such a distance from shops: 'Belts are very useful, jean stay-binding, needles of the best description, buttons of every sort, steels and chamois leathers are all of the greatest value. Thimbles,—as we wear them out very quickly where we have so much hard work; patent pins and very strong thread, black and white. In fact, nothing can be useless.'[2]

At the beginning of February the Governor paid a visit to Augusta. He and Mr Mackie the Advocate-General were on their way to King George's Sound. Sir James Stirling had recently returned from England and was able to reassure the settlers as to the Government's feelings toward them, though he may not have added that he had had to fight hard for recognition of the claims of the colony. He and Mr Mackie also brought news of the finding of the wreck of the *Cumberland*. Some, though not much, of the Bussells' property had been recovered

—notably several feather beds and some blankets. The more valuable part of it, family plate and trinkets, had been plundered.

Writing to Helen Story on 10 February 1835, Georgiana said:

> My dearest Helen, I much regret the accident the enclosed has met with. I believe it has been perpetrated by the kittens, but time will not admit of my writing it over again.
>
> Last week the Governor and party paid us a visit and Captn. Molloy accompanied His Excellency to King George's Sound where he will see Mr Taylor, I hope bring him back as we have not yet met.
>
> The wreck of the *Cumberland* has been found 20 miles from Fremantle and much of the cargo plundered. Indeed the sale of trinkets and other property belonging to Mrs Bussell led to the discovery of this wicked and revolting robbery, even when the body of Captn. McDermott lay unburied on the beach. Five of the thieves are transported. Captn. McDermott's wife was last week confined of a son and will not believe her husband is lost.
>
> I fully expect Molloy will go shortly to England and should not be surprised if Mama and Mary return here with him. Shall I send Sabina with Papa? Would any of you like to see her? Poor Mama seems very much distressed at the loss of my poor sister (Eliza Besley) and only wrote me a few hurried lines. I shall write next to dear Maggie but am overwhelmed with business. I hope this will not be heavy postage. My best love to you and yours, especially dear Mrs Dunlop.
>
> <div align="right">Your attached, affectionate Georgiana Molloy.[3]</div>

The Governor arrived on 1 February 1835. He had brought quite a suite with him and they all dined that day with the Bussells. Mrs Bussell and Miss Mary had been on the same vessel coming out from England as the Stirlings, so it was a reunion. There was a church service first, performed by Mr Wittenoom, the Colonial Chaplain, at which the three young Bussell ladies appeared in white dresses, pink kerchiefs about their shoulders, and little green bonnets given them by their cousin, Miss Capel Carter, a lady of considerable wealth. Miss Mary so described their church-going attire to her cousin. Miss Fanny enthused about the service.

> We have lately been visited by the Governor, Mr Wittenoom, Mr Mackie the Judge Advocate, Mr Lewis and Mr Roe. . . . It was delightful to hear the church service performed by a clergyman again. I could have fancied myself in England had it not been that instead of a church we were all assembled in Captain Molloy's verandah which commands an extensive view of our truly noble estuary. After the service several of the children were baptized, the parents being very glad to avail themselves of the first visit yet received from our [page torn]. The major part of the guests dined with us and sailed the same day for King George's Sound.[4]

This dinner party threw the four Bussell ladies into a flutter of excitement, for they had no servant. Phoebe was at the Vasse. As for Emma—there were no words for Emma! 'Emma has taken her departure from my service. She is the most abandoned creature. . . . She has violated every commandment!' declared Mrs Bussell in a letter of 1 February. . . . Emma had, in fact, broken the Seventh Commandment. On 17 February the Resident entered the birth of Emma's child, with particulars, in his Return of Births and Deaths for 1835. A month later, he entered the death of Mary, wife of Andrew Smith, at the age of 32. An inquest, presided over by the Resident and twelve jurors, decided that Mary Smith had died after drinking a bottle of brandy with the Kellam brothers, and that blows from her husband had contributed to her death. These revelations of immorality and violence in the little community must have distressed Mrs Molloy, while in the months to come a deterioration of neighbourly relations between the Molloys and Bussells must have worried her still more. This occurred over the affair of the horse 'Logic'.

After accompanying the Governor to King George's Sound, Captain Molloy must have decided on the way back to take the advantage of sailing on round to the Vasse, or perhaps the wind was unfavourable for putting in to Augusta and he was carried on. At all events, he would have been curious to see how the Bussell party was getting on, and how they were finding the country after ten months' dwelling there.

He found them very satisfied, and well established on a pretty bend of the Vasse River. In order to return to Augusta, since he had no transport, he borrowed a draught horse from John Bussell. Mounted on this sturdy beast—how different from those he had had his legs across in the wars—he plodded the long way home across the ironstone hills. Perhaps his thoughts were occupied with the fertile country round the Vasse, good grazing land, much easier to work than that at Augusta: perhaps he was weighing the chances of it being better for the whole settlement at Augusta to move to the Vasse, and whether Mr Turner could be so persuaded: he was evidently preoccupied in some way when he stopped to camp for the night, for he did not tether the horse firmly, and while he slept it got away.

'We lent our horse to Captain Molloy to return home after we landed him at the Vasse. The stupid creature tied a slip knot and lo, it left him in the night as he slept. Of course he is responsible for it, but out here, it is an almost irreparable loss . . .' announced Miss

Mary Bussell in some dudgeon and with little respect for the Resident.[5] The Resident had to walk the rest of the way home—a long walk for a man of fifty-five, with an old war wound that reminded him of itself from time to time. Whether he was alone or accompanied by a native is not evident, but somehow news was got to the Bussells of the loss. Lenox and Vernon were at once despatched to the Rapids— probably the rapids on the Margaret River—where Molloy had camped. They searched, expecting to be joined by Molloy and a party from Augusta, but found no horse and met no one. They were away five days, and then returned to report to John, who sent off a letter to Charles, back at Augusta in charge of the Government Store.

My dear Charles, Our party of searchers are just returned unsuccessful in their enterprise and a good deal disconcerted at the break of faith evinced by the Augusta party. What strange coolness that not an effort has been made for the recovery of an animal!

Five days Len and Vernon have been absent in which time they have traced the Rapids without so much as seeing a footstep. Had the other party as I had anticipated, gone upwards, there possibly might have been a chance. I really under existing circumstances do not know how to act, our loss will be very great, supposing we are remunerated with the sum for which [word indecipherable] offered the horse when he first brought them to the Swan R.—£60. Ploughing for ourselves is at an end and the profit arising from the employment by others. No event could more decidedly have baffled all our intentions. As it is, two hands and two horses have been employed five days in a useless search at a time when their services were wanted beyond everything. These things must be considered.

Len has just given into my hands a note I sent by him to be given by him to the Augusta party at the Rapids. I send it again, though it is couched in much the same language as this. And now to return to the horse. I really do not expect him back this winter, and if not then, when will be the time? Horses are cautious in their steps, in another month the plains will be impassable; in the ensuing summer when the country is dry, he will linger about some well-known drinking place.

I conclude you have had communication with Molloy. Let me know what transpires. J. G. Bussell.[6]

Communications on this important matter between Captain Molloy and Charles would have to have taken place by letter, because of Charles's stammering. A later and somewhat apocryphal story concerning Charles relates how he once had to tell Molloy about the death of a cow. He stuttered so much in the telling that Molloy impatiently said, 'Sing it, man, sing it!' Whereupon Charles burst into song:

Captain Molloy, your cow is dead.
The natives have speared it through the head.

'Dammit, man,' snapped the Captain. 'That's not a thing to sing about.'

In this case the saga of the horse was more than Charles could sing about. Letters passed to and fro. The Captain may have mentioned how he had once lost a horse and it returned next season sleek and fat, with a mare that had also been lost and a fine colt in addition. If he did, this by no means assuaged the Bussell sense of grievance. Lenox talked largely of charging Molloy £70.* The affair dragged on through the winter. The loss of such a horse was no mean matter, but it is to be feared that their fussing was the wrong way to handle Molloy. He does not allude to the matter at all in his correspondence, and there are no letters from Georgiana that deal with this period. It is evident that strong feelings were aroused, and that Captain Molloy was obliged to remind the Bussells that if loss of profit arising from the horse as well as the capital cost were to be considered, he had been generous to them in the past. In June 1833 he had sent them his oxen to 'The Adelphi' to plough. Miss Fanny said they were hired, and wrote home to England for extracts from 'The Adelphi' journals to know 'how many days were employed and what Sundays intervened', to see if Molloy had profited from them.†

Meanwhile the Bussell sense of outrage grew and their language became more exaggerated. Miss Fanny wrote in August 1835:

My dearest Johnny,

I have just concluded copies of the letters passing between Charles and Captn. Molloy. You will see that the latter was not unwilling to revive the wordy war. Charley will write you an account of all the business part of the transaction. I will confine myself to the more feminine details of a 'cut complete'.

* Lieutenant Bunbury in 1837 gives the prices of stock at Swan River as, 'A pair of mares to plough, if of good shape, strong and bony, will not cost less than £100, if they can be got so cheap—£70 and even £80 has been given for a cart mare of good shape to breed from. Horses are a little cheaper, but not much.'

† In justice to Molloy it is unlikely that he charged much for the hire. Mr E. Pettit of Busselton, aged 97 in 1953, and of a remarkable memory, who knew Captain Molloy in later life, describes him as 'a gentleman of great wit, who always wore an eye-shade. He had brought much equipment which he kindly loaned to others less fortunate. One man when requiring a ladder was charged at the rate of one penny per day, so that, as the Captain said, he could sue him for the return of the ladder. This was the basis of his loaning of articles.' It is therefore unlikely that he overcharged the Bussells for the use of his oxen: he would probably never have mentioned them unless he had been goaded.

Of course no intercourse can possibly exist between us now. Our road through the garden is not interdicted, although the fence is built with such skill that space is scarcely left for a 'wallabee', still less for either of your sisters in full evening costume; nevertheless we contrive either to creep or climb and thus afford constant exercise for Dick's ingenuity, which I assure you he does not spare.

Poor little Diddy no longer runs backwards and forwards, but looks blank and miserable when we meet as if she were prohibited all conversation with us. We have attended church as usual but last Sunday the usual compliment of chairs for our party was withheld. All this is very petty, is it not? But we have ceased to talk of them amongst ourselves and have fallen into our ordinary routine of employments as if there were no Molloys in the world. But we are all vexed, my darling Johnny, that your last visit should have been so disturbed by disputes and quarrels. I look upon Captn. Molloy as a dangerous and merciless enemy, but I trust we have nothing to apprehend from him and that we shall rise superior to his false representations and clandestine attacks.[7]

This 'dangerous and merciless enemy', evidently quite sick of the whole affair and the hyperbole attached to it, by November had come to some form of agreement with John Bussell. 'Captain Molloy and John have agreed to arbitrate,' Miss Fanny recorded, though we do not know in what way. By January 1836 she was writing *finis* to the matter: 'Our horse Logic has returned to us safely.' Experience might have led them to expect this, for in 1834 their cow Yulika which had been lost in the bush for over a year had walked into their midst at the Vasse. The cow had a young calf with it, and the spot where it had met them was on a pretty bend of the river. They decided to build their new house there, and gave it the unusual name of 'Cattle Chosen'.

❧

At the end of 1835 an exodus from Augusta began. Miss Bessie Bussell had set out on horseback with three of her brothers, John, Vernon and Alfred, together with Elijah Dawson, to ride from Augusta to the Vasse. Charles had accompanied them part of the way. It was a marathon ride for a young woman, but Miss Bessie with natural pride related that it only took them two nights and part of a day, although Dawson assured her that people at Augusta had thought it would take them nearly a week. Lenox and the servant-maid Phoebe welcomed them to 'Cattle Chosen', and Miss Bessie settled down to helping her brothers prepare for the coming of their mother and remaining two sisters. As well as the comfortable room with

bookshelves and wide fireplace that John had built for himself, like
the one at 'The Adelphi', and small separate cottages for the other
brothers, a two-storeyed wattle and daub building with stone chimney
was being erected. It had a good-sized room downstairs with a clay
floor and another room upstairs which formed 'a dormitory for all
the females of the family'. ('Cattle Chosen', as it is today, is shown
on Plate 6.) In January 1836, Mrs Bussell, Mary and Fanny arrived
to take up their residence there. Charles came and went from Augusta.
He remained storekeeper there until 1838.

Other families besides the Bussells had deserted Augusta. Elijah
Dawson, who had followed the Bussells, built a little cottage on a
bend of the Vasse River named Soldier Point, as the temporary
barracks were at this spot. Early in 1836 Dawson brought his wife
and two children there. Captain Molloy had given him two cows
to start off with, and he was made constable of the district with a
salary of £20 per annum. In October 1836 he paid £3 for the 3 acre
block of land he had built his cottage on, suburban lot 7.[8] It was on
the same side of the river as 'Cattle Chosen', and not far from it.
On this side of the river, past the temporary barracks, the three
brothers Chapman, who had followed from Augusta, built a cottage,
and just across the river from them lived George Layman with his
wife and two daughters.[9] It seemed safer thus to cluster their cottages
together while they looked about for suitable land.

Meanwhile, John Bussell, writing home to England about this
time, said,

> The present population of Augusta consists of the following establishments—
> Captain Molloy, Mrs Molloy, two children. Mr Turner, Mrs Turner, seven
> children (three of whom are grown up); Salkild, labourer; Hurford,
> labourer; Kellam, John, often working for me. Kellam, Henry a cripple
> since left. Mrs Heppingstone, widow of a labourer drowned. . . . The number
> of souls are now scarce half that were landed in the *Emily Taylor* on its first
> foundation.[10]

He did not mention John Herring who had been a good friend
to them in the early days of settlement and who had remained at
Augusta.

John Herring is a rather shadowy figure, an old man whom the
Bussells had met on the coach going down to Portsmouth before
they boarded the *Warrior*. (He is always alluded to as 'old' and probably
was so in appearance, but his actual age, as evidenced by his death

registration at Busselton, was only a year older than that of Molloy: fifty at the date of emigration.). His appearance could not have been prepossessing, for a Bussell letter from Augusta in 1830 alludes to 'the forlorn Mr Herring, whom contrary to dear Mary's suspicions, we have found a truly honourable servant to our establishment'. He had helped them with their garden and with their building and in numerous other ways. He seemed very lonely and glad to be of service. His domestic history was rather pathetic, and illustrated the suffering that distance and poor communications could cause.

In 1833, the Resident had received a letter from Peter Brown, Colonial Secretary, containing an enclosure. It was a copy of a letter to Lord Goderich from one Elizabeth Herring, and in tone and information it speaks for itself.

> *11 August 1831*. My Lord, Pleas to allow me to lay down my case before your Honor. My husband John Herring late of the Crown and Dolphin, Stepney, which House he occupied 18 years left me with six children and two aged parents on 5 October 1829 by the ship *Warrior* to Swan River with property which impoverished the business so that I was not able to carry it on. I was turned out by the Landlord with a mean trifle and that trifle is now exhausted and no account of him. I am worn down with grief and nothing but poverty before me. I was persuaded to apply to Yr. Lordship by yr. great influence I should get some tidings of my husband and be relieved in my unhappy situation. I hope Yr. Lordship will excuse me etc. Elizabeth Herring.[11]

This communication had been replied to, and was followed by a letter thanking his Lordship and saying that Mrs Herring would have no objection to being transported to her husband if she had the means. Both her letters were then forwarded to the Colonial Secretary in Perth, and by him to Augusta. (The fatherly manner in which the Colonial Office often conducted itself must be noted.) Captain Molloy then took up the matter. But for his evidence of the character of John Herring it would appear as if that worthy had simply deserted his wife and his responsibilities. Molloy's letter to the Colonial Secretary puts a different complexion on the case.

He wrote on 2 March 1833, fifteen months having elapsed between Elizabeth Herring's first complaint, that being a normal amount of time for Government departments to move and ships to sail:

> Sir,
> I have the honor to acknowledge the receipt of your letter of the 12th ult. with the copy of a letter addressed to Lord Viscount Goderich from

Elizabeth Herring, enquiring after her Husband, John Herring. Having communicated to him his Wife's letter he informs me, that on his arrival at the Cape, hearing accounts so very unfavorable of the Colony at Swan River, he wrote home to his wife saying that if he found things as represented he would return to England, that since then he has, as opportunities offered, through the Medium of a Gentleman here, announced his enjoyment of good health, begged a communication from home to know how they were succeeding in the business, and as he conceived he had left them a competency to support them, if not more, he felt no uneasiness on their account until he received a letter, which had been lying in the Post Office at Perth nearly two years, announcing the disaster of his Wife's having been robbed, and in the Prosecution of the Thief to conviction suffering a still greater loss. His means to my knowledge are very limited but what little they are, could he make them available, he would most willingly offer them, to assist in bringing out his family to the Colony. If it entered into the contemplation of the Government or as a matter of Humanity could it be effected, he would enter into an Engagement to defray the Expenses of removing his family to this Colony, after their arrival, by instalments.

Personally, I can speak of him as a most persevering industrious man, proverbially honest, and I am assured, one who whatever engagement he entered into, would endeavour most strenuously to fulfil it. I am pressed by time as the vessel is about to weigh and can only wish most cordially that he may have the satisfaction of finding his wife and children will be enabled to join him. I have the Honor to be,

John Molloy, Government Resident.[12]

However paternal the Government might be with regard to inquiries for missing husbands, it drew the line at paying for families of six or seven to rejoin them. It was twenty years before Elizabeth Herring rejoined her husband, and then she died four years later.[13] It must have taken John Herring a good time to save up the passage money. From October 1835 he held the position of Postmaster at Augusta, but it was an unpaid position. He also had a good deal of land there—eight acres on the inlet, lot 16 of the town-site on Flinders Bay, on which block he appears to have lived, and 900 acres on the eastern shore near the Swan Lakes. Like Mr Turner, he felt he had a large stake in the future of Augusta, and was reluctant to leave it. In 1839 the Resident noted in his official correspondence that Augusta was abandoned by every family but Mr Turner and Mr Herring (whom he refers to as 'a single individual') but in 1840 he was of the opinion that if a small salary were attached to the position of Postmaster, Mr Herring would move from Augusta to the Vasse. Herring did remove to the Vasse, where his wife at last joined him. Two of

his daughters came out and settled there,* and he and his wife, united in death, lie buried there. His is but one of the sad little stories of broken family life that make up the beginnings of Australia. (His house is still standing today.)

Although Captain Molloy may have been concerned about the number of families that were leaving Augusta in 1836, Georgiana would have had little time to think about it. In April she was brought to bed of a son, who was christened John. This would be good news to transmit to Helen Story, who had had a son in the previous year. Helen Story's son, Robert (later to become Principal of Glasgow University and a well-known divine and writer) was her first surviving child. She had lost two earlier babies; she and Georgiana had that grief, as well as their girlish joys, in common.

The event of his son's birth would have pleased Captain Molloy very much, for he was now assured of a successor to his name and to the domain he had acquired. His name was what he himself had had to make it, and his son should add to it. As for his domain, a year or so earlier he had jokingly referred to his estate in a letter to his sister-in-law, Elizabeth Besley:

> We are all in very good health, not much richer than we were on leaving England, beyond the possession of some miles of wild country to which I have not as yet been able to establish a good title, as in the periodical con-flagrations that take place in this country the original patent from the Emperor Kangarung is supposed to have been consumed. We lead a very original kind of life of the pastoral order and very much after the [word indecipherable] system. My little daughter thrives on it—is very lively and entertaining. . . .[14]

He was all the more eager now, with his young family increasing, to begin improvements on his large grant at the Vasse. It was obvious that the good grazing land there would provide better living than the difficult forest country at Augusta. There was a keen market at Swan River for dairy products, and with the good anchorage at Géographe Bay, ships could come and go more easily than at Augusta. He resolved to begin building a house on his grant, but kept his intentions to himself for the time being.

Mrs Molloy was so busy with her family responsibilities that she would have little time to notice how the settlement was dwindling. The Dawsons had gone to the Vasse and whether the old family

* Eliza Herring married George Holland Knapton. Mary Ann Herring married George Guerrier.

servants, the Simmonses, who were expected, ever came out is un-
known. If not, she would have had to rely on casual help from the
few labourers' wives that were left. A young girl of about thirteen,
Charlotte Heppingstone, whose father had been drowned in April
of the previous year and whose mother had been left with a large
family, was happy to come and help Mrs Molloy with the children.
She was an agreeable child and very intelligent, as Mrs Molloy was
to find later.

In spite of the hard work she had to do, it may be assumed that this
was the happiest period of Georgiana's life. She had her little girls
and her fat, bouncing baby son. Her home was comfortable and her
garden a joy. Seeing the shining river beyond the garden she could
almost imagine herself at Rosneath on the shores of the loch. The
children, however, were little Australians. They loved the sandy
shore and the grey shallows, warm and dappled and alive with darting
fish. Augusta was a lovely place for children. They had to be well
watched, though, lest they should wander and be lost in the bush,
or lest the natives should go off with them. The natives were giving
a good deal of trouble at this time by breaking into the Public Store
and stealing flour, and by 'depredations in the potatoe grounds',
as the Resident noted.

The Governor paid them one of his passing visits in December
1836, and once again Captain Molloy sailed with him round to the
Vasse. (This time, we may be sure, he borrowed no horse!) They
visited the Bussells and found there Lieutenant Bunbury who, with a
small party of two soldiers and a native named Monang, had just
arrived after an exploring trip down the coast from Pinjarrup. He
was camped on the Bussell property.

Bunbury noted in his journal:

Sir James was much pleased at the report I gave him of my journey,
and the result of his visit was the formation of a military post about five
miles E.N.E. from Yonderup station, between the two estuaries of the Vasse,
about two months afterwards. Like all his plans, it was changed several times
before being carried into effect and various were the places fixed upon for
the station, and at last, instead of a useful and important post of communi-
cation near Port Leschenault being formed, I was sent to build barracks and
form a township on a *presqu'isle* more fit for Dutchmen or frogs than British
soldiers; where there were no settlers and no land to be taken up, and where
in fact we were as utterly useless as it was in the Governor's power to
render us.[15]

The Governor had his reasons for fixing Bunbury's station where he did. He had probably had representations made to him during this visit to the Bussells, on behalf of the Chapmans and George Layman who were desirous of settling near Wonnerup, as the place described by Bunbury was called.

Lieutenant Bunbury, however, was often critical of Sir James Stirling's actions. He was a young man who did not suffer in the least degree from awe of authority. A grand-nephew of Charles James Fox, he had come out to the colonies in 1834. He arrived at Perth in May 1836 from Van Diemen's Land, and thought the little town 'a most dismal place, duller than anything you can imagine'. He evidently had a 'way with the ladies' for Miss Fanny Bussell gives an account of him when he visited them in the following year:

> Mr Bunbury is here now and returns with us in the *Champion*. I like him still very much. I think him gentlemanly, elegant in his manners, and his attraction to our party never relaxes for a moment, but I am inclined to doubt his reputation of extreme talent. That of drawing he possesses almost to perfection, but in other respects I do not think him above mediocrity, though a dash of satire rather gives the impression of superiority.[16]

Lieutenant Bunbury's observations on the Government, the country he explored, and the ways of the natives are extremely valuable, and it is a pity he did not settle,' as he intended, at 'the entrance of Port Leschenault Inlet, which the Governor named "Bunbury" in compliment to me', and in which place as a port he had great faith.

During this visit of the Governor and Captain Molloy to the Vasse, the latter may have broached the subject of his transferring there from Augusta. Some inkling of it reached the Bussell ears, for on Christmas Day 1836, John Bussell was writing:

> Augusta I think on the eve of dissolution. It will be deserted by everyone except Mr Turner who feels himself bound to the spot by the costly nature of his improvements, consisting of fences, buildings etc. For him, as he went there encouraged by Government, a small number of soldiers will be stationed there. Captain Molloy is dark and mysterious in his actions. He upholds the prospects of a devoted settlement in the presence of one or two labourers who cling with hopeless perseverance to the small improvements they have effected with great labour; but like a skilful general he has provided for his own retreat. Augusta has been added to our district in order that the Government Resident may move to his grant on the Vasse, without incurring the odium of absenteeism.[17]

This was less than generous of John Bussell. Molloy had taken up

his grant at the Vasse in 1832, at the same time as Bussell himself. Because he had been made Resident at Augusta, he remained there to continue the struggle while others left it. Nevertheless, there were the claims of his family to be thought of; he was not a young man, and development of land in this country was a slow matter. This was sufficient justification, if any were needed, for his determining to move to the Vasse. At the same time, he would have had strong doubts of Mr Turner's willingness to move, and whether he himself should move if Turner were left.

His doubts would have been well-founded. James Turner's property was the best developed at Augusta. He had thirty-three acres of land all improved (i.e. fenced and partly cleared), most of which was under cultivation, also the balance of his first grant of 20,026 acres in the environs. His house and outbuildings were comfortable and solid. (The strongly-built stone foundations of the latter, covered with undergrowth and in places rent by roots, could be seen in 1953, but were in the path of a bulldozer levelling a new street.) Even if his indentured servants left him, he had four sons to help him work the property. The eldest, Thomas, had quitted home to work his own property, 'Turnwood', four miles away, but in April of this year, 1836, he had suffered one of those blows that fell, one after the other, on the Augustans. 'On 28 April the whole of Mr Turner's buildings were wilfully set fire to and destroyed by the natives at Turnwood,' reported the Resident. They were wooden buildings and were razed to the ground. Thomas Turner stuck at 'Turnwood' for the rest of the year, and then lost heart and returned to his father's home; so Mr Turner had another pair of hands to count on. His other sons were then aged twenty, fifteen, and nine. He could soon expect to see his property pay its way, and more. In addition, he had in January 1835, in spite of the cost thereof, applied for and taken out a licence as a retail dealer in spirits. It had apparently been profitable, for he renewed it in 1836.[18] He was not pleased to see his customers leaving the district.

Chapter

9

Letters to a Stranger

In December of 1836, Mrs Molloy was surprised to receive a letter from a total stranger, and delighted to receive with it a box of seeds, an always welcome present. The letter was from one Captain James Mangles, R.N., who may have introduced himself with the information that he was a cousin of Lady Stirling's, or this information may have been tendered by Sir James Stirling himself, when he paid the Molloys a visit in this month. The contents of the letter may be deduced from Mrs Molloy's reply to it, when she had time to sit down and write, several months later.

<div align="right">Augusta, 21 March 1837.</div>

My Dear Sir,

Much to my surprise in December last, I received a particularly choice box of seeds, and your polite note requesting a return of the native seeds of Augusta. In truth, my dear Sir, I much fear you have bestowed your liberality on one whose chief pleasure is her Garden, but who does not enter the lists as a Florist, much less a Botanist. If we were nearer, I should much hesitate to accept so magnificent a present of so many long-wished-for Seeds, and as all my former pursuits have necessarily been thrown aside (by the peremptory demand of my personal attention to my children and domestic drudgery), I feel that it will be long ere I can make any adequate return in Australian productions.

We have already collected some seeds, as your box just arrived at the proper season. I am not even acquainted with the names of the native plants. I will, however, enclose a leaf and description of the flower in each paper. I had some dried plants by me from the Vasse,—a country apparently possessing some exquisite floral beauties, which I feel most happy in being able to send you, and when I obtain a sufficiency to make up a small box, I will despatch it and retain the large one until I am blessed with more leisure than at present. Another impediment to our being able to procure seeds is our approaching

removal to the Vasse, where Captain Molloy's larger grant is situated, but if you do not hear from me shortly, I trust that you will not consider me negligent or unmindful of your humble request. I have put some of my old acquaintances (of whom there are but few in this busy Colony) in requisition, and shall feel myself in duty bound to transmit to you their labours. Although my brother George was anxious to employ me as a collector also my time is so much infringed on I have not as yet sent him any specimens.

It is with much regret that I leave dear Augusta. Our climate is so heavenly and the scenery so superior to other settlements, the flowers scentless but minutely beautiful. I am told we possess many unknown in other parts of this Colony. Permit me to subscribe myself,

<div style="text-align: right">

Yours much obliged,
Georgiana Molloy.[1]

</div>

This letter marks a turning point in Georgiana's life. No more letters to the Dunlops or Helen Story are extant, though doubtless she continued to write them. She enters now upon a new series of letters in which the religious motif is entirely absent and in which the delightful, sensitive nature of the woman is revealed, delicately veiled by the polished and graceful phrases that the courtesy of the times imposed upon a gentlewoman's pen. Something in the nature of the first letter she received from this unknown gentleman must have impressed itself on her—a kinship of interests, an honesty of purpose and kindness of intention, for had he not begun by a gift of 'particularly choice' seeds?—something must have induced her to continue the correspondence as she did.

It was not really surprising that Captain Mangles should have written to Mrs Molloy: he already corresponded with several people in the colony. A retired officer of the Royal Navy, in which he had served from 1800 to 1815, he had come out to Swan River in April 1831, arriving in the *Atwick*. He had made the voyage simply as a visitor, not as an emigrant, and stayed for several months with the Stirlings. He liked to travel. In 1823, in conjunction with a friend, Captain the Hon. Charles Irby, R.N., he had published a work entitled *Travels in Egypt, Nubia, Syria and Asia Minor in 1817-18*. He was one of the first Fellows of the Royal Geographical Society; a Fellow of the Royal Society; a member of the Ornithological Society, and a keen horticulturist.

At Perth, in 1831, he made the acquaintance of George Fletcher Moore. The two evidently took to each other, for Moore recorded in his diary, with considerable acumen:

On 4 May 1831 had the pleasure of meeting in Perth one of a most agreeable party, Captain Mangles, who published his Travels in Egypt. Any man of sense, who has travelled far and observed much is invaluable as a companion, or as an author, particularly if he don't let the latter character absorb the agreeable qualities of the former. The author is often too retentive of materials which he is collecting for his work, to communicate them freely, whilst the *companion*, as such, overflows with interesting and useful conversation.[2]

Moore was to be one of Mangles's correspondents until he himself left the colony. As a horticulturist, Mangles must have been delighted with the strange and almost totally unknown plants that he saw around him as he made excursions around Perth. 'I gave Captain Mangles some specimens of flowering shrubs, besides a bottle full of snakes, lizards and scorpions,' said Moore. No doubt Mangles took them back to England when he returned after three months' stay in the colony.

In London (as we see from a two-volume collection of letters received by him which he had had copied and bound)[3] Captain Mangles led the life of a cultured gentleman of wealth and leisure. Perhaps his keenest interest was in gardens and their care. He sometimes wrote letters to the newspapers. The *Morning Herald* of 14 August 1834, held one on the subject of beautifying the parks of London (the Regent's Park and Hyde Park specifically) by planting them with clumps of trees, an assortment of suitable ones being named. He followed this by several others referring to landscape gardening, and was pleased to receive a communication from the Inspector of Hyde and St. James's Parks saying that that worthy would be glad to see the suggested improvements carried into effect. Mangles not only offered advice, however; he made considerable gifts to the projects he was interested in. In 1836 he wrote to Lord Duncannon 'relative to the Acquatic Birds in St. James's Park prior to the foundation of the Ornithological Society of London'.

My Lord,—I beg pardon for trespassing on your Lordship's valuable time, but having, and frequently at a considerable expense, put many valuable and scarce Waterfowl into the Ornamental Piece of water in St. James's Park, almost all of which have been devoured by the merciless cats who assemble nightly in prodigious numbers on the Peninsula at the Eastern End of the Lake, and whose depredations bid defiance to every attempt to keep up a stock of these interesting birds, unless a cut of 10 or 15 feet were made so as to form an island of the Peninsula. If I am not taking too great a liberty I therefore venture humbly to solicit Yr. Lordship, either to have a cut made or else to cause a fence with spikes to be put up as a protection for those

harmless objects of very great interest, to almost every description of persons who frequent the park. If this were done I will again recruit the great losses we have sustained and restock the Park with the very choicest Birds which can be procured. Again intreating Yr. Lordship's forgiveness for the liberty I have taken in addressing you, I remain, with much respect,

Your very obedt. humble sert.
James Mangles.

P.S. Gold and silver fish I put in upwards of two years ago.[4]

Three days later he received a reply from Lord Duncannon's secretary. His Lordship had drawn the attention of the Board to the state of the waterfowl, and Captain Mangles's suggestion that a fence be made was to be put into effect, after which his offer of more birds would be very acceptable.

Besides these activities, he carried on a large correspondence with most of the botanical gardens of England and Scotland, with leading nurserymen, and with several noblemen such as the Earls of Derby and Orkney, who were members of the Horticultural Society. The Duke of Devonshire, at that time President of the Horticultural Society, sometimes wrote to him, but Mangles more often received letters from Joseph Paxton, who was in charge of the Duke's famous garden at Chatsworth.

At first Mangles was concerned with the growing and cataloguing of rare plants of the British Isles, but his voyage to Swan River evidently increased his interests. A year or so after returning to England he wrote to G. F. Moore[5] complimenting him on the printing of his *Journal*, sending him some seeds, and asking in return for some seeds of indigenous plants. Shortly afterwards he wrote in the same strain to his cousin Lady Stirling,* who replied, 'I see you are as anxious as ever to collect seeds and plants from this colony, and I assure you I will with pleasure endeavour to promote your wishes.'[6] Moore also replied cordially to the effect that he had commissioned one of the sons of Mr James Drummond, under the superintendence of his father, to make a collection for Captain Mangles. This mode of procedure appeared the best to him as his own botanical knowledge was slight.[7]

James Drummond, who was to correspond with Mangles for several years, had been in charge of the Cork Botanical Garden before

* Née Ellen Mangles, daughter of James Mangles of Woodbridge, Surrey, who was M.P. for Guildford from 1831–37; also High Sheriff in 1808; a J.P. and a director of the East India Company. The Mangles family owned large shipping interests.

emigrating to Swan River in 1829. In the first year of the colony he held the position of Superintendent of Gardens. In 1830 Governor Stirling wrote to him that it had been decided to abolish the position of Superintendent of Gardens and in future Drummond would be known as Government Naturalist. Stirling also allotted him £100 per annum. This was questioned by the parsimonious British Treasury, and suspended in 1832. As Drummond had a large family this was a blow and probably soured his nature. Moore, writing to Mangles in 1835, said of Drummond: 'The poor fellow's mind was a little disturbed about the time he was removed from the Government Garden here; his mind soon regained its tone and he now lives in the country happily with his family.'[8] Nevertheless, in his correspondence with Mangles, Drummond was to show a grasping nature that finally made Mangles finish with him. His first letter in Mangles's collected volumes is in 1835, but there is nothing in it to show when they began to correspond. Drummond's style of writing is bald and concerned only with what he wants to know or to impart botanically. Given Mangles's interest in botany, it would seem inevitable that they met when Mangles was in Perth in 1831, but as he was there for a short time only, and as Drummond was continually making botanical expeditions, it is possible that he was away when Mangles was there. Evidently there was no sympathy between them. Drummond's first letter of 1835 asks for an analysis of three different types of soil to be found on his 3,000 acre grant in the valley of the Helena River, and continues by asking for orders for seeds and specimens of native plants: 'If you or any of your friends want anything in that way, I beg you will not forget me. If I could get orders for as many seeds and specimens of our native plants as would pay for the additional expense I must be at in living and travelling through the country, I would devote my whole time to making collections.'[9] A footnote to the letter in Mangles's handwriting refers to the types of soil sent by Drummond: 'All these were analized [*sic*] in Germany by a friend through Dr Lindley's kindness and the results sent to Mr Drummond by Captn. M.' Captain Mangles also inquired of Dr John Lindley, who was Secretary of the Horticultural Society, what chance there was of Drummond's getting orders for seeds, and received the reply:

I think good Swan River specimens would sell for £2 - 100 papers, that is the market price of such things. Probably a dozen purchasers at least would be found. But as it is not known how Drummond would prepare the

specimens I recommend him to send 2 or 3 sets of 100 or 150 each upon trial. I will take one set. We horticultural people wish for £10 worth of seeds and Bulbs as a venture. Nothing but very handsome things will do, we would rather have a good deal of seed of a very few sorts than a little seed of a good many sorts. If the seed suit us, we may be very good customers.[10]

This was apparently passed on to Drummond, who became even keener about orders, but his commercial attitude towards botany was not what Captain Mangles had in mind in sending seeds and plants to colonists in return for their collections. However, Lady Stirling was able to 'promote his wishes' by putting him in touch with several colonists who would do the work for sheer interest. One of these was a Captain Meares; another was a Mrs Bull, and it seems likely that it was Lady Stirling who gave Mrs Molloy's name to Captain Mangles as one who would be interested in botany for its own sake, and who lived in a little-known part of the colony. No doubt it was this that prompted his letter to her.

At this time there was a great interest in horticulture and botany in England. The scientific study of botany had been first encouraged by Augusta, Princess of Wales, in the gardens of her home, Kew House. On her death, her son, George III, continued the interest she had shown by appointing Joseph Banks, just returned from his voyage to the South Seas, as his adviser, thus giving Banks the opportunity to organize the study of the many plants he had brought back from various dependencies of the Crown. As Banks planned it, Kew Gardens was to be more than a herbarium; it was to be a place where plants from different parts of the Empire might be tested and transferred to other regions where their growth would be beneficial. When Banks died in 1820, Kew Gardens began to decline, for the new King, George IV, was not interested in horticulture. In 1828 the Government even contemplated turning it into a Royal fruit and vegetable garden. There were protests about this and a report was drawn up by Dr Lindley, Secretary of the Horticultural Society, recommending that Kew should be made a national garden. Little was done, however, beyond the Treasury issuing the report. It remained for men like James Mangles, who had the wealth, the leisure and the public spirit, to promote the fostering of specimens from foreign parts in other gardens throughout Britain, until at last in 1841, when the noted botanist Sir William Hooker became its director, Kew Gardens regained its rightful position once more.

While Kew Gardens was in its decline, the progress of horticulture was fostered by the Horticultural Society, which had been founded in 1804 by John Wedgewood. Its first President was the Earl of Dartmouth, who was succeeded in 1811 by Thomas Knight. The Society established Gardens at Kensington and Chiswick for raising seeds and plants sent from abroad.[11] The first chrysanthemums, camellias, peonies and wistaria were sent to it from China. It experimented with the crossing of plants to produce new varieties. It had donated a collection of fruit cuttings and roots to the Swan River colony at its inception. Now that the colony was established, the Society began to receive back seeds and plants of Western Australian flora, partly from James Drummond and partly through the offices of Captain Mangles, who was to correspond a good deal with the Secretary, Dr Lindley, and to pass on the seeds sent him by various collectors.

James Mangles's correspondence from 1835 to 1843 gives a pleasing picture of the London of those days, in which gentlemen had the leisure to indulge their interests and hobbies; when time was of little moment, so that it did not matter if a letter and its reply took eighteen months or so to pass between Mangles and his correspondents at Swan River. Interest did not fail in that time, and when the letters arrived, no impatience was caused by the long, flowery phrases which said so little. There was plenty of time—for gentlemen and for ladies in London who were interested in botany. A Mrs Loudon, who wrote a number of botanical works of a popular character and who assisted her husband with his publications on horticulture and natural history, was one of Mangles's correspondents. She often wrote to him about projects for books and for a magazine to be called 'A Ladies' Magazine of Gardening and Botany', which she proposed to bring out. Mr Loudon edited the *Gardeners' Magazine* and brought out Encyclopaedias of Plants and Gardening. The Loudons and others like them worked hard, but at their own interests. Only in Mrs Molloy's letters from the New World does one catch the echo of Time's chariots hurrying nearer. Time snatched for the dearly-loved pursuit of botany or other interests of the mind was time that should have been used for the daily activities that tied down the women who lived without servants.

Mrs Molloy's letter of March 1837 was fated not to reach Captain Mangles in a reasonable time, but she was not to know that. She began

at once her collection for him. Life could have been lonelier than ever
with so few people now left at Augusta, but as she was absorbed in
her family and in this new interest, the deserted cottages were hardly
noticed. The year went on. When spring came, she made many
expeditions with the two little girls and the toddling boy to collect
flowers to press for Captain Mangles.

The children loved the outings and were promised more when
it would be time to collect the seeds of the plants whose flowers they
helped to gather. The laughing bush spilled its gold and purple and
scarlet before their eager hands. But before the seeds had ripened in
the hardening pods, Disaster which always walked close to the
Augustans, matched its steps with the toddling boy.

No words can tell so poignantly as those of his mother what befell,
and it is strange that she should have chosen to narrate the way of
his death to a stranger; yet not so strange, for sometimes the over-
burdened heart can speak more easily to one for whom it need not
choose its words. To this man, from whom Georgiana had heard
but once—for there had been no reply to her letter of March—she
wrote, stiffly and impersonally at first, and then with a graphic
simplicity:

My dear Sir, Having at length complied with your desire to obtain flowers
and seeds from Augusta, I send you the result of my labours, which at one
time I had not the least hope of being able to do in a satisfactory manner.

Under the afflicting but unscrutable decree of an all-wise Providence, we
have recently been overwhelmed with the most bitter loss of our darling
infant and only son of 19 months by the aggravated death of drowning.
Painful as it is to record—distance of time and place compels me.

Captain Molloy, myself and his little sisters had been playing with him
watching his vigorous and frolicsome mood just after breakfast on 11
November 1837. We separated each to our necessary duties, (that morning
I was preparing to bake and churn). I left dear little Johnnie in my only
servant girl's charge. She imagined from having seen him with Mary and
near his Papa that he was still there. Mary appeared without him, which
instantly struck us, as they were inseparable. Charlotte had put the dear
child in his cradle, and not finding him where she last saw him, she asked
Molloy, then me. I had not seen him, but answered: 'He had his bell on,'—
(a little bell he wore round his waist, in case of his straying into the bush). I
instantly ran out, and on her running up and down and not finding him, I
exclaimed: 'Have you been to the well?' and became quite alarmed. Captain
Molloy said, 'Do not frighten yourself, he never goes there!' The fatal truth
stole over me, and on Charlotte going to the well, she said: 'Here's the Boy,'
and pulled out that darling precious child, lifeless, his flaxen curls all dripping,

his little countenance so placid, he looked fast asleep, but not dead; and we do not believe he really was so until some minutes after. But the medical man was at the Vasse, and we did not know what to do. We tried every means of restoration, but to no effect. And that lovely, healthy child, who had never known pain or sickness and who had been all mirth and joyousness the last time we beheld him together, was now a stiff corpse, but beautiful and lovely even in death.

The well is in full view of the windows, about a stone's cast away, concealed certainly by the Virgillia and Mimosa trees. He had not been absent ten minutes, but from being a very fat heavy child, and after eating an enormous breakfast I am told, this increased his rapid step from life to Death; but had any Medical Man been near, I am fully persuaded my little Johnny might have been saved.

Forgive me, my dear Sir, for thus using towards a Stranger the freedom and minute detail that Friendship warrants and desires. Our children and our necessary occupations fraught as they are with uncontemplated interest, engross the sole attention and exertions of myself and my excellent husband. Acute indeed was the blow, and when you reflect how dead we are to the World, and completely weaned from that sphere of pursuits, actions and modes of life in which we used to move, I trust you will pardon and excuse my entering thus egotistically and minutely on our present affliction.

The shock of the tragedy had made Georgiana very ill, and for a month or more she did not care what happened. Gradually the needs of the family drew her back to them, and for solace, to take her mind off her lost son, and to take her eyes away from the fatal well ever before them in the midst of her garden, she rambled through the bush, gathering the fresh brown seeds to be put up in a box for Captain Mangles. Her evenings were spent in packaging and labelling them to the best of her ability. Each package was numbered against the dried flower and leaf pressed and mounted in the *hortus siccus*, the book that Mangles had sent for the purpose. It was too small for the amount she had gathered, but she had brought out a *hortus siccus* of her own when she came from England, and now was the time to use it. It was January when she began her letter to Mangles telling him of the tragedy, and as was her wont, she continued it over a period of months, giving him much information about both bush and garden flowers, and describing the life she lived.

Since my dear Boy's death, my leisure has been much extended and I have, up to the present time, daily employed it in your service. We have but very few flowers until Spring. September and October are our most delightful months. The purple creeper begins to bloom in July, the red in August, but in those two months the Wilderness indeed 'begins to blossom as a Rose'.

The stiff and inelegant grass plant even is decked in borrowed colours from the purple and red creepers, and white Clematis (or Kennedia, I believe) the former appellative I gave it in ignorance of the proper one. Where the bush has receded and left an even surface of grass and weeds appears the 'enamelled carpet' of which we so often read. I am of opinion that these flowers are not so interesting as our own, and after the novelty is past, soon cease to please; they possess no association, nor does anything about them attract but the lustrous colour. Very few have any scent and I quarrel much with their excessively minute corollae. In this they constantly remind me of the Laurestinus. I do not know the name of any one of them, for dear Augusta is quite out of the world even the limited society of S.W. Australia, and very few bestow a thought on Flowers. The only person I ever met with here that I durst speak to on this subject was our lamented Mr Collie, and his visits were so transient I had little opportunity. Grubbing hoes, Beef, Pork etc., Anchors and Anchorage, Whaling, Harpooning, Potatoes and Onions are the chief topics of conversation; therefore I am well persuaded any observations respecting a flower garden would be ill-timed, and not agreeable to the generality of my guests.

I have sent you every flower we have worth sending and many I fear you will esteem unworthy, but having obeyed the 'Golden Rule', I have ventured to introduce some literal Weeds; often in hearing of foreign countries, I have wished to be acquainted with the most common plants, having more curiosity to see its weeds than the finer productions. The latter were too important to pass observation, the former too humble to be worth removing.

Georgiana was soon to change her opinion that the bush flowers were not as interesting as English flowers. Though she continued to lament their minute size, she came to appreciate their delicacy and beauty, their hardiness in continuing to blossom forth bravely each year from the hard inhospitable soil that fostered them as though grudgingly. There were so many kinds that it challenged her to collect ever more and more to have them classified. That task was for Captain Mangles to arrange.

Her letter continued:

What could have led you, my dear Sir, to have selected me as a collector, much more to imagine I had botanical knowledge, I cannot divine. The latter accusation I am fully absolved from; the former in a desire to comply with your laudable desire and curiosity to possess a knowledge of our floral productions, I have discharged faithfully and jealously, especially in the selection of matured and perfect seeds. Allow me to state that, fond as I ever have been of Gardening, I have always avoided the tedious operation of gathering seeds, therefore inexperience must apologize for their not being as cleanly and neatly executed as I could desire. Another reason was my not knowing the time they ripened, and on searching I found some shed,

others green, and perhaps before I returned for them a native fire or a hot day had accelerated their ripening and I found the seed scattered. This is my first attempt; a second one which it will not be in my power from the manifold duties of domestic drudgery to undertake, not indeed from want of inclination, for this pursuit is most congenial, I should from experience be enabled to discharge more satisfactorily to us both, and a third, and very important cause, is the universal badness of seed. In this uncultivated land and temperate climate, insects and reptiles have unrestrained license, and the seeds of each plant afford sustenance to some of the animal creation. Consequently, the seed vessels of each are generally inhabited by some worm or grub. This is particularly the case with those contained in a silique. I had several large quantities of numbers 67, 68, 71, 73, 85, to gather and open before I could meet with the small packages sent you. I have minutely examined every seed and know they are sound and fresh, as they have all been gathered from 15 December 1837, to the present day, 25 January 1838.

I have no hesitation in declaring that, were I to accompany the box of seeds to England, knowing as I do their situation, time of flowering, soil and degree of moisture required with the fresh powers of fructification they each possess, I should have a very extensive conservatory, or conservatories, of no plants but from Augusta. I do not say this vauntingly, but to inspire you with that ardour and interest with which the collection leaves me; and cordially thank you for being the cause of my more immediate acquaintance with the nature and variety of those plants that we have exchanged for the productions of our own country; and which also benefits my children, as from necessary avocations, but for your request, I should never have bestowed on the flowers of this Wilderness any other idea than that of admiration.

My two remaining children have been much gratified in the undertaking and have really been of great utility, as their eyes being so much nearer the ground, they have been able to detect many minute specimens and seeds I could not observe, for in our impervious Bush it is really difficult to find out what you are in quest of; the numberless specimens of flowers of the same colour with different leaves as you will perceive in the *Hortus Siccus*, and again, some as trees, others herbaceous plants, with a similar blossom. Indeed, Sabina I shortly found to be infinitely more *au fait* at discovering and remembering the abode of differently described plants than I was myself. I have known her unexhausted patience go three and five times a week to watch no. 83 & 74, lest the seeds should be opened and shed. She is six years old! and such a pursuit is highly delightful to her young Mind, besides the pleasing accompaniment of a distant Walk. Here the children are bereft of the amusements of a highly civilized country. Sabina has already imitated me in forming a collection of dried flowers fastened by ligatures, and Mary, who was also very serviceable in discovering and collecting, to say nothing of pulling flowers for Captn. Mangles, had made up several of the most strange parcels for your acceptancy. Ever since your Box arrived in 1837 you do not know the ridiculous articles presented to me for you. Every time her hair was cut a portion would be enclosed for the Box.

Although Mrs Molloy did not enclose the 'ridiculous articles' collected by the young Mary for Captain Mangles who had evidently become a figure of moment in her imagination, Mangles, a sentimental bachelor, must have been amused by the account. It is thanks to little Mary Molloy's early endeavours that we have the two volumes of Captain Mangles's correspondence. The fly leaf of the first volume reads: 'Mrs DuCane, Novr. 4, 1856, from J. M., Fairfield, Exeter', and that of the second: 'Mrs DuCane, formerly Miss Mary Molloy, with many thanks for her early and zealous services in his behalf'. The inscriptions are in Captain Mangles's handwriting.

Mrs Molloy went on:

I found your *Hortus Siccus* too small for the number and size of the specimens I wished you to possess. Having brought out a book of my own for that purpose, imagining that I should have a superfluity of time, I have much pleasure in appropriating it to your service. Many flowers from the Vasse were gathered for me by Captn. Molloy. Of these I have not been able to furnish an account, but on our removal thither, if you express a wish for their seeds, I shall be happy to send them as well as any other seeds my time will permit me to collect; but I much fear I shall be so much employed in the odious drudgery of cheese and butter making that I shall not even be able to attend to the formation and culture of my flower garden, for I am my children's sole instructress & semptress, and that in conjunction with in-numerable other peremptory duties.

Any particular seeds you desire and those I have imperfectly been able to transmit I shall feel happy against another season to repair; of the beautiful specimens you will perceive I have sent duplicates as far as I was able.

I must apologize for not pursuing your suggestions by tying in the speci-mens, but have fastened them so that they can be drawn out at pleasure and botanically arranged. Some of the fragile flowers such as nos. 118, 98, 97 and the aster species, I was constrained to adhere to the paper. They began to furl up the instant I took off the pressure. The colour is much more evanescent of the flowers here than in England, but this a Botanist excuses as long as the characters are exemplified.

I have British plants now by me with a more vivid colour (dried since 1825 and even 1823) than many of the flowers of your *Hortus Siccus*. The best idea I could give of the brilliancy of colour and richness of petal, would be to paint the flowers on Rice paper, choose different hues agreeing with the colour of the flower and so shade them off, and even then it would give but an inadequate idea of their minute beauty. I long to see again a large flower. We do not possess one. No. 121 is the largest size we have.

I need not add, before proceeding to another subject, that I hope the seeds will be immediately sewn, as the voyage has an injurious effect upon them. I almost wish the Box had been lined with Tin. It had the crack at the bottom when it arrived, but all the papers came particularly dry, and no

smell of damp or fustiness. I have begged your cousin Lady Stirling to despatch it by the very first opportunity and have commissioned Captn. Molloy now absent at the Swan to procure me a Tin case for the large *Hortus Siccus*.

We hourly expect a vessel, the *Champion* or Colonial schooner, and this will be her last visit for some time. I am therefore anxious to send the Box off. It arrived at an untoward season of the year in Decr. 1836, and under all circumstances must have remained a twelvemonth for the flowers to blow and the seeds to ripen. We have scarcely any flowers but the specimens sent, from Novr. to June and July. At the Vasse perhaps we may have more vessels in, but this year and in general we are not visited more than three or four times in the year.

It was Captain Mangles's custom to send seeds and plants to Swan River in boxes properly made for the purpose, intending them to be filled again with indigenous seeds and plants and sent back. His various correspondents refer to these containers as 'glazed boxes'; Lady Stirling mentions having a pane of glass replaced in the lead, and G. F. Moore describes them more definitely:

Captain Mangles has sent me two cases containing rare and useful plants and flowers such as tea, pomegranate, cork, oak etc. and wishes me to return the cases filled in the same way. The plants are put into earth in boxes having a glazed sloping roof, quite air tight. The earth is watered when first put in, but not afterwards, nor are they either opened or disturbed till they reach their destination.[12]

The glass often suffered damage, both from careless treatment in unloading, and from the fact that if the plants within were visibly worth stealing, they frequently were. Captain Meares notified Mangles in August 1838 that:

The glazed case of plants you have so kindly sent me and so politely presented under the protection of Lady Stirling, for which consideration I am much indebted for their safety, arrived in the most perfect order, the olives quite as fresh as when they were taken out of the Greenhouse. The figs also very vigorous, but the vines, notwithstanding the sacred seal, were, as the native word here terms it, 'quippled',* one only having arrived.[13]

while the same gentleman in a later letter remarked, 'A box which came out lately (I believe on board with the new Governor) has arrived. I met two men carrying it by chance in the most perfect safety, not a glass broken. So much for the master's eye!'[14]

* 'Quippal' according to G. F. Moore (in his *Descriptive Vocabulary of the Language in Common Use amongst the Aborigines of Western Australia*, London, 1842) was the aboriginal word meaning 'to steal'.

Meares suggested that the glass top should be made to fit into the case as 'a ground glass stopper drops into a decantur' [*sic*], then he could have a case made which it would fit. He could get seedlings well on their way and have the box ready to send when the ship came in, only having to drop the glass top from the new box into position. His advice does not appear to have been taken. Seeds were sent in 'small cannisters' [*sic*], and Mrs Molloy evidently preferred boxes lined with tin. Damp and sea air were the great enemies. Mangles and the nurserymen in England were to come to the conclusion that the only way to procure the Swan River plants was to raise them themselves from seed, but even then they had to contend with the fact that seed was often destroyed by insects packed with it, or had been held so long that it was not viable. Mrs Molloy was well aware of the need for sending the seeds while they were fresh. Though her first box to Mangles was long delayed, thereafter she took the greatest pains to catch each ship that came in, even if the collection were not complete. She knew the chagrin of sowing seeds in high hope and finding that not one came up.

Georgiana continued her long letter begun in January 1838:

And now, my dear Sir, having mentioned all necessary circumstances relative to your concern, I shall commence with my own and beg you to give me a patient hearing, with a thousand apologies for my prolixity.

You, I doubt not, have often heard of the inexhaustible properties of a Lady's pen; and as you have brought this infliction from an unknown person on yourself, I shall have less compunction in visiting you, although etiquette would demand the reverse.

My first request to you is, that you will oblige me by sending me the names of the different flowers according to their numbers. I have kept the number of each, and the duplicates of most of the specimens, that I might have the satisfaction of hearing some name attached to them and as through your medium I believe I shall be enlightened from the highest source, I shall esteem your compliance a great favor.

My brother George has long wished for some natural productions from the New World. As my leisure was always so limited I could not attempt to gratify his early demonstrated taste for Natural History by sending him any. Perhaps you will allow him to inspect the little collection I have made for you, too tedious to undertake for anyone but those who can justly appreciate its value; and I do not fear that to be the case when presented to a person of science. Now I am not aware of the progress that George has made,—he was a boy at Rugby School when I left. Since then he has become literally a Married Man and from ill-health we are very anxious he should join us at Augusta. What I have said seems rather derogatory to him, but

I am not really aware of his attainments, but confidently hope we shall yet number him and his little wife among our family party. I gave him your address wishing you both to be acquainted and now I will give you his, as he frequently visits London and would be pleased to see my handy work and perhaps it might induce him to join us quickly,—George Kennedy Esqr., Laurel Cottage, Blackboy Road, Exeter.

I regret to say very few (only fourteen) of the seeds you so liberally bestowed upon me came up. I sowed them at different times and in various modes, but fear the seed had not been that year's growth, in that case they do not answer. Many, such as the Poppy, Larkspur, Wallflower, Stock, and several common seeds will for a year or two retain their germinating properties, but none of these even appeared. George sent me a few of the same kinds you did. His answered very well, and were not nearly so carefully packed as the contents of your Box. This may be a salutary hint to your 'Nursery and Seedsman', whoever he was, for I was very irate against him. It took me a whole week at different times to consign the treasures of your bounty to the soil, and when they did not spring, I sowed again and again, and declared to Molloy, I would punish the man by informing you of him. Not any of the rare seeds sprang up. Many of the names were quite new to me, such as the recently imported annuals from America; and only one of each of the *Sutherlandia fruitesiens* and *Maurandia Barclayani* from the Cape. None of our highly prized acquaintances of old,—the Columbine, Pink, Foxglove, and numerous others ever appeared. I shall therefore beg you to send me the following list of seeds, and seeds of shrubs, and I annex a cheque on Greenwood & Cox for the attendant expenses.*

All Chinese and Cape plants thrive luxuriantly here; many annuals of England are biennial, and sweet peas and *Hibiscus Africanus* survive the Winter. The latter bears very large blossoms, and grows to the height of three to four and a half feet. I am endeavouring to procure a double flowering plant, which I think would be very magnificent. All English flowers possess more brilliancy of colour in this delightful climate. Were Captain Molloy a rich man, I should incur great expense in ordering numberless flowering plants and shrubs. As it is, I must be guided by prudence, but I am convinced no situation can be preferable or more congenial to the vegetation of all countries than our present locality.

The peaches and melons at Augusta are said to possess a stronger and more exquisite flavor than those at the Swan and Vasse. The weather is not so hot, and the soil very different, black mould in general, with only occasionally a mixture of sand.

I have some inferior single pinks and wish much for better seed. That you sent did not come up. The anemoni from being a Native of the East Indies would answer very well. I am anxious for blue flowers and those possessing an odour. I have frequently endeavoured to introduce the Native plants among the exotics. They do not succeed, from want of their native shelter. The Purple creeper alone has consented to be domesticated, and has associated

* Captain Mangles noted in his copy of this letter that he destroyed the cheque.

its beautiful Purple flowers with a very elegant Pink climbing Plant from Mauritius. I never saw it in England therefore have sent you some seeds to entwine round the pillars of a conservatory. It is ever flowering with us. I wish you could send me its proper name. These two creepers cover one side of our Verandah and the Purple has so peremptorily usurped the external framework of my window as to darken the room, but encreases the beauty of the prospect. This said window looks immediately up the Blackwood, the receding points give it almost the appearance of a Lake. In the background is the boundless and ever green Forest. On the other side of the Verandah, which is Molloy's work of rustic branches, grows the Nasturtium, which is of deeper orange than it ever attains in Britain. It is not at all afflicted by the winter months, and as it has not been sown since 1833, has formed a most impervious and cool shade of almost incredible beauty from its profusion of brilliant blossoms and gay light green foliage.

I must here thank you for the beautiful Crimson species you sent me, which formed a very handsome variety in the union.

None of the Myrtle berries appeared. Anxious to enumerate them among my floral beauties, I sowed them the day the Box was opened in pots and watered them, placed them under the verandah as it was the height of summer. Some again I sowed in May, and again in pots, boxes and the open border in August and September. The seed I found quite decayed and easy to crumble, so this will exonerate me from want of exertion to procure and retain them. Indeed, your collection as an introduction of select and desirable seeds into this infant Colony, was too valuable not to demand care and attention, and such I rendered it, to the cessation of other concerns. Often has Molloy looked at a buttonless shirt, and exclaimed with a Woebegone Visage, 'When will Captn. Mangles's seeds be sown?' And recently he has laid aside all his own operations and accompanied the children and me by Land and Water, for a day's search in quest of seeds and Flowers. We have had three or four Gypsy parties on your account, in which Sabina and Mary were much delighted. Indeed, my dear Sir, I have been more frequently from my house this year in making up your collection than for the whole of the nearly eight years we have lived at Augusta. Even three times before my darling child's Death we went up to the Granite Rock and opposite side for flowers, and I had not been in the boat before for three years. Since then we have returned for the seeds, so that I have spared neither pains or trouble in serving you.

I am desirous to have some flowering shrubs from England, and am almost afraid the seeds would not succeed as well as cuttings. One excellent mode of transporting these is in Tanner's Bark enclosed in a box or Metalic Vessel. Our best Fig trees were slips from the specimens which obtained the Prize from the Horticultural Society at Winchester. These cuttings were inserted in Tanner's Bark, put into an iron camp oven, enclosed in a deal case of various articles, and immediately struck as they were planted, and have since improved every season. But this is accompanied with so much trouble I should be afraid of requesting you to undertake it, and most probably you are acquainted with a better mode. Vines thrive remarkably well, and Captn.

Molloy is desirous to obtain some Purple Grapes of good sorts. We have from necessity raised all our Grapes from Raisin seeds. Although they bear abundantly they are white grapes and there are but very few red ones in the Colony. Our Peaches also were from stones we brought from Cape Town. We have but one sort and that, I am thankful to say, is universally esteemed.

Had Molloy been at home, I doubt not he would have accepted of your kindly offer to send us some good kinds. As it is, I must await his return, lest he should be ruined in freight and other damages, but the shrubs and seeds I subjoin in the list, I have gained his permission for, at the same time telling him he has no Milliner's bill to pay, therefore may very well spare me a little indulgence in what is more beautiful and durable.

You must not imagine from this that Captn. Molloy is at all parsimonious. Quite the reverse, but great prudence in luxuries is required, where heavy and uncontemplated losses have been experienced.

I think I have communicated all that I had to impart relative to this all-engrossing subject, and more than you perhaps deem justly requisite.

With many apologies for this voluminous epistle, permit me to subscribe myself,

<div align="right">Very truly yours,
Georgiana Molloy.[15]</div>

A list of shrubs, seeds and herbs was attached, the herbs asked for being:

Rhubarb for Tarts, Tansy for Puddings, Lemon Thyme, Lavender, Sage, Sorrel, Borage and Melon Seeds, as ours have so long existed near each other, they have very much lost their primitive qualities. I think you are duly imprest with the importance of the seed being quite new. Of course I shall gratefully receive any other seeds you can suggest. I forgot to name Apple and Pear Pips, and Raspberry and Gooseberry seeds. I do not imagine it to be a novelty but send you some Cape Gooseberry seed, the only fruit we have in abundance. All sorts of Medicinal Herbs would be of great service to the community, such as Marsh Mallow etc. etc. but I only remember these *en passant*.

I never thanked you for the very nice and instructive Books you kindly presented to me. *Domesticated Animals* I particularly value, from the strain in which it is written, as references to the Holy Scriptures tend much to impress their importance and indisputable authenticity on the minds of youth. It contains a beautiful Stanza from an Arab to his Steed, which pleases Sabina much to read.* I was delighted to receive a Work on Natural History on her account, although a little too advanced for her early years.

At one time I intended to be scrupulously honest and return your Green Silk, as I have not made any use of it in your behalf, but I am convinced you would be delighted to bestow an article of so much service and scarcity

* Mangles has interpolated, 'My beautiful, my beautiful', by Mrs Norton.

upon me in this alienated Land, and you may judge of the extent of the self-adopted Boon, when I tell you sewing silk is sometimes a shilling a skein, and Black not always to be obtained.

It has frequently been asserted seeds will keep best in their Pods and seed-vessels. This opinion has proved erroneous in all seeds conveyed in this manner from England, and as the seed vessels of this Country are so universally inhabited by insects, one unopened silique might spoil the contents of the Box.[16]

The Molloys had hoped to move to the Vasse during 1838. Owing to the loss of their son, and the illness of Mrs Molloy thereafter, no move was made. The Captain continued to ride over from time to time. He had had a small cottage built, in which he could camp when at the Vasse. He always returned with interesting news of the former Augustans settled there.

At the beginning of 1837, Mr John Bussell had sailed for England. Family financial arrangements had made this imperative, but also John wished to bring back a wife. Miss Mary, Miss Fanny and Vernon had made a visit to Perth, in the course of which Miss Mary's engagement to Mr Patrick Taylor of Albany was announced, and was followed by her marriage to him in September while they were still at the Swan. Mrs Bussell's approval to the match had been sent on from the Vasse: the young man was known to her as he had come out to Swan River on the *James Pattison* with Mary and her mother. After being married at Fremantle, they had sailed almost immediately for King George's Sound, there to make their home. It was the first break in the united Bussell family. Miss Fanny wrote home to let them know that she also had made her conquests while in Perth, and had had a serious 'offer' which she declined: 'I could not strike my colours and your little Fan is still free in hand and heart.' She was not to marry until quite late in life.

During this year there was serious trouble with the natives at the Vasse. They were very fond of potatoes and were constantly trying to steal them. At night they camped at Windelup (the native name for the general area round 'Cattle Chosen').[17] The noise they made was nerve-racking. They knew the district was weakly held and they kept up nightly corroborees to sing the doughty deeds they were about to do.

Miss Bessie Bussell, who was almost alone at 'Cattle Chosen' (Vernon, Mary and Fanny being in Perth, and Lenox and Charles away at Leschenault with Lieutenant Bunbury), noted in her diary:

'The natives really completely beset us. They nearly drive me out of my mind. Evening comes when we used to enjoy ourselves. The noise they make puts conversation out of the question to me now it seems sacrilege to breathe the name of native in an hour of rest, it is so fraught with fatigue, fear and anxiety.'[18]

She mentioned 'old Gaywal' as being a trouble-maker, which later events, culminating in tragedy, were to prove true. In June the Chapman brothers lost a heifer, and Lenox Bussell while helping to search for it, was told by two natives that Gaywal and Kenny had killed the heifer and eaten it. A party of men and two soldiers tried to capture the culprits but there was a skirmish with the natives and nine were killed. Lenox duly reported the affair to the Resident, Captain Molloy. Molloy acknowledged the letter and referred to

> the fatal result of their [the natives'] resistance to the Constable in the execu-
> tion of his office when proceeding with a warrant to apprehend the offenders.
> I am deeply sensible of the unprotected state of some of the settlers in that
> part of the district and I am very sorry I cannot afford you more assistance
> than the two men now detached, nor for a longer period than for four days
> from their arrival at the Vasse.[19]

In July, the constable, Elijah Dawson, who used to plough his land with a rifle slung over his shoulder, was speared in the arm while sitting at breakfast with his wife in their little cottage at Soldier Point. He ran outside and fired three shots which dispersed the natives and brought the Bussells to his assistance. It was decided that the Dawsons should move to one of the servants' cottages at 'Cattle Chosen', as Mrs Dawson was near her time, and in fact gave birth to a son on 31 July 1837.

The Resident received a letter from Corporal Dawson reporting this attack, and sent it together with a report on the killing of the natives in the punitive expedition to capture those concerned in the slaughter of the Chapmans' cow, and the correspondence between himself and Lenox Bussell, to the Colonial Secretary in August.

By the following year, 1838, the situation was a little better. Charles Bussell was of the opinion that only stern measures would hold the natives in check. Since their military protection was small, the soldiers being constantly divided between Augusta and the Vasse, the settlers could not afford to be weak.

It is to be hoped that Captain Molloy did not report too much of

the native trouble to his wife, who was soon to remove to the Vasse.
In June 1838 she gave birth to her third daughter, christened Amelia.

The box for Captain Mangles which Mrs Molloy had been collecting
since the spring of 1837 had still not been sent by the spring of 1838.
No ship had been in, so Georgiana added another page to her letter
of January, dating it 8 September 1838.

I am quite grieved, my dear Sir, that you have not long ere this received
our collection of seeds. I lament every day I have them in my possession, as
their departure has been so unfortunately long delayed owing to the absence
of the Colonial or indeed any other vessel.

I hope that as I was very particular in preserving and taking the best seeds
you may yet not be disappointed, but it is very annoying both to you and
especially to me, who so well know what they might have been. The large
Hortus Siccus has been soldered up since April and I earnestly hope the little
vermin have not made any further havoc. I detected some in each book,
and for want of oil of Petroleum or any other preservative, I made little
bags which contain pepper.

The flowers and shrubs are again beginning to bloom, and when I behold
them I exclaim, 'Poor Captain Mangles, how I wish he had received those
of last year!'

In June Baby was born and she engrossed so much of my time, I have
scarcely leisure to teach Sabina and Mary, of whom I wrote to you some
months since, or rather I should say, of whom I spoke at the commencement
of this Volume. Within this last six weeks Mary has begun to read and I am
unwilling she should escape one day; so between the three and my usual
employments, I know not what to do first.

I am only just recovering from a dangerous illness occasioned by the
mournful event of my darling Boy's awful death, and consequently am
scarcely able to exert myself in either body or mind.

Amelia fortunately is remarkably good. My flower garden has hitherto
been quite neglected, but as the season advances I hope yet to be able to
work in it. Many of the seeds you so kindly bestowed have stood the winter,
and last week I was transplanting some of them. I have enclosed a small
cheque on Captn. Molloy's agent, and would be particularly obliged by your
procuring me a Garden Rake, fit for a Lady's use, as I am obliged to borrow
one of Captn. Molloy's with the most formidable teeth, spreading destruction
and next to annihilation wherever it is applied. The handle I can have affixed
when it arrives. It must not be too fine.

I have heard much of Loddiges' boxes, but am somewhat ignorant of the
principle of preserving the contents. Should you like to try any of them, I
shall feel much pleasure in sending you any Plants you may desire.

No. 1 in your own *Hortus Siccus* is a Variety of *Sollya*, is just ripe, the seed
I mean, and it is of the same pulpy nature as no. 69, there is also another
species of the same now ripening, and if it should be ready I will enclose

it too, but I trust we shall have the long promised visit from the Colonial schooner and that I may hear of an opportunity of some Vessel returning to England.

The Chrysanthemum would do well here, and I should much like to have some. I forgot it in my last I wrote to you in 1837 (in March, I think) and I hope you received my letter, otherwise you must entertain anything but a favorable idea of my civility. But when this arrives I hope it will give you such a pleasing impression of Captn. and Mrs Molloy, but especially the latter, as an active and obliging person, that any derogatory feeling may be removed.

With this assurance I remain, Very cordially your Friend,
Georgiana Molloy.

Since writing the foregoing, my dear Sir, I have received most melancholy news by the *Shepherd*, namely, my poor brother George's Death. He has for some years been suffering, and now at the early age of 25 years has bade adieu to all the painful vicissitudes entailed upon Mortality.

Having named him to you in the course of this letter, I thought it only proper to give you this mournful intelligence. I am now certain you could not have received mine of March 1837, as other letters of the same period have been received and replied to.

If the Box you send me is large enough, a Watering Pot and Rose, (the patent one) would be of the greatest use to us, as ours are worn and destroyed after eight years' service.

I now close your box and letter, of course I cannot but send it away, with many fears and much, very much interest of a manifold nature. So many of its contents were collected under the extremes of joy and acute sorrow; it has beguiled many a moment and I hope you will receive much success and satisfaction in looking over and sowing your seeds.

With every kind wish I finally conclude and remain,
Very sincerely yours,
Georgiana Molloy.[20]

This long letter—for indeed it occupied many pages of her sloping handwriting—Georgiana packed with the seeds she had gathered in the box for Captain Mangles; but more than six weeks passed before the box finally went off, consigned to Lady Stirling at Swan River, to be placed by her on the first ship going to England. Not counting it as a posted letter as it was in the box, Georgiana wrote by mail as well on 1 November 1838.

My dear Sir,—After the silent reception my last of March 1837 met with, I am reluctant again to address you, but am so chagrined at the delay my collection of Flowers and seeds for you has received that I am anxious to acquit myself of a seeming disregard to your requests so handsomely made,

and to inform you that I have had two *Hortus Siccus*, and your box ready to dispatch ever since last March, and in consequence of no vessel being in, it has thus been delayed. For the seeds I tremble, lest after all my particular care, they should fail; and as I write with Baby on my knee and my time is very much absorbed, I should not be able to replace them although the season for collecting has again revolved; but I am endeavouring to obtain those seeds I omitted, from ignorance of the time of their ripening, to gather last year, and sincerely trust they will arrive ere the germinating power be suspended. I have scarcely patience to look at the box as it stands, and know that every hour renders the contents more precarious. I have written a folio, but as it is on the interesting subject of known floral beauties, you will more readily excuse it. Being too bulky, I have defrauded Her Majesty's revenue of its value and enclosed it, illicitly, I believe, in the box.

I cannot describe to you the present brilliancy of the surrounding wilderness, and this year when I ramble out with my little children running like butterflies from flower to flower, everyone I behold is fraught with the association of those I have collected for Captn. Mangles, and then the galling remembrance that the seeds are still at Augusta, makes me quite sad. My own flower Garden is at present in its gayest attire, some of your seeds have survived the winter and are on the 1st November in this heavenly clime in full bloom,—the Tall white Lily, *Lilium Candidum*, the Pink Gladiolus from the Cape, Oleander ditto, single Pinks of every hue, Sweet Peas now fructicose, Captn. Mangles's dark Nasturtium, Mignonette, Geraniums and very many more I have not space to mention—all in full bloom and their colour much heightened by a warmer sun and the dark green of the grass plots which I have interspersed to give a solace to the eye and a contrast to the beds of flowers. Now, my dear Sir, I am inhaling all the sweets of these, whilst I much fear you are enduring the exquisite pain and almost fatal influence of an English winter; but from this pleasant retreat I am soon to be torn, as it is decreed we repair to the Vasse in February next, please the Almighty thus long to spare us, but I look forward to again visiting Augusta in the evening of life, and very much regret all the rest of the world have abandoned it, as this is the cause of our being obliged to do so.

I wish very much both on your account and on ours you had visited us when you were at Swan River, then you could have really condoled with me. Captn. Molloy is at present at the Vasse making preparations for our departure. *En passant*, a marriage is about to take place between Mr Ommaney lately returned from England and Miss Elizabeth Bussell.

I have lately had to bewail the loss of my 'Gardener's Magazine' and 'Transactions of the Horticultural Society for 1827' by White Ants. Since my illness they were laid aside and with them many others of perhaps greater moment; all now completely devastated. Many notices and remarks in the Magazines were highly useful to us in our horticultural labours, to say nothing of their interesting matter. I am anxious to form a quick sort of hedge and observe the *Hibiscus Althea Fontex* is recommended. I wish you would kindly procure me some of the seeds, also those of the Horse Chestnut and *Magnolia conspicua*. I was reading an account of one belonging to

Messrs Loddiges and think it would answer well here. Baby thinks I have written too long a letter, and lest you should form the same opinion I conclude, subscribing myself,

Yours very sincerely,

Georgiana Molloy.[21]

In passing on the little piece of news about the marriage of Mr Ommaney and Miss Bessie Bussell, Mrs Molloy must have been aware that Ommaney and Mangles were acquainted. She may have received the information from Captain Molloy, who was at the Vasse, for Mr Ommaney had only returned from England in August and had gone straight to Port Leschenault and the Vasse.

Henry Ommaney had come out to Swan River in 1830 and was first employed as a clerk in the Surveyor General's Department, on a salary of £50 per annum. He had been made an assistant surveyor with an additional salary by Captain Irwin, acting as Lieutenant Governor while Stirling was in England. On Stirling's return, Ommaney's situation and salary, like several others that Irwin had initiated, was discontinued. Ommaney then wished to become a settler and wrote home in search of the necessary capital. In 1834 he made a trip to the north-west of Perth in the *Monkey* to search for a rumoured lost vessel. On exploring the coast, he did not think much of the prospects there. In 1836 he was in Albany. The following year he returned to England, hoping, after an interview with his uncle, Rear-Admiral Sir John Ommaney, to be encouraged in his desire to become a settler instead of a civil servant. While there, he wrote to Captain Mangles—possibly a friend of his uncle's—sending him some seeds.

All the seeds marked as coming from King George's Sound I gathered myself during my professional excursions in the country, and as opportunity offered, on my return selected as far as I could the various kinds by themselves. The packet which I have distinguished as 'All sorts' was the various remainders after emptying my pockets and assorting the contents.

Ommaney's interview with his uncle was not successful. He managed to obtain a better position for himself as an assistant surveyor, and was back at Swan River in August of 1838. He was at once despatched to survey the districts of Leschenault and the Vasse. At the latter settlement he met the lively and capable Miss Bessie Bussell, and within a matter of months their marriage had taken place.[22]

At length the colonial schooner called in at Augusta, and on 16 November Mrs Molloy was actually able to get her box away. Within a week she took up her pen again to tell Captain Mangles how pleased she was that it had at last gone.

> Untowardly enough, you will receive my first epistle in the box after this my third. Being so much employed in your behalf and having so frequently written to you, I feel much better acquainted with you than you can be with me; therefore I trust you will not be surprised at my throwing aside the garb of formal etiquette usually worn by those not personally known to each other.

There were also a few explanations to be made as to the way some of the seeds were packed:

> In reading the other day I saw it recommended to pack seeds in raw sugar. I accordingly ventured to send the very minute seed of no. 109 in this way, and should be glad to know if this is an approved means . . . they ought decidedly to be enclosed in Tin, but that was in this remote place impracticable. I looked over every package of seeds just four days before the vessel arrived and found notwithstanding all my care a very small fly had got at some of them. This accounts for the quantity of Pepper about them which I hope will be a preservative.
>
> The day on which I sent off the box, I was so unwell as scarcely to be able to pack it, but as the vessel unexpectedly called and had but a few hours to remain, I put in its contents, I fear in a very imperfect manner, rather than lose the quick transport they in all probability would have to England. I was anxious you should first be in possession of what I conceive to be unknown to the floral World, as the specimens from the Vasse are quite new to me, and are not to be met with in this part of the country. I doubt they were not sufficiently dried, as Captn. Molloy only arrived from the Vasse that day week. Some he put between the leaves of his pocket book, which rarely answers but for very fragile plants. . . .
>
> I hope you will gain their proper nomenclature and favor me with it. I am anxious to know through what channel I can send you any future packages as I am always fearful of a want of proper care being shewn to such perishable articles; and now that we are losing our good Governor and your amiable cousin, I can only entrust them to Mr Samson at Swan River, whose taste perhaps would lead him to pay more attention to sugar or Whale oil,— remember, I mean nothing derogatory to him, as I am not personally acquainted with this worthy and useful member of our Society. . . .[23]

Sir James Stirling's administration of the colony ended with the year 1838. By her letters to Captain Mangles, Lady Stirling at first expected to leave Western Australia in September and then in November, but was not able to do so. The *Joshua Carroll* was to sail

direct for England at the end of November, and in this Lady Stirling sent a case of plants 'well-filled with all the Orchis tribe', also a package of seeds from Captain Meares, and the two boxes from Mrs Molloy. These were not glazed cases, as Lady Stirling referred to them as 'boxes, one containing seeds and the other a *Hortus Siccus*'. She also added:

> I understand that Mr Drummond has made a very large collection of seeds for you which I suppose he intends sending by this opportunity. I am not aware what instruction he has received, nor did I inquire when I last saw him, as on a former occasion we had rather a warm argument and I was unwilling to touch upon so tender a subject, but I have no doubt he will charge you for the time he has devoted to your service, and I only hope he may not have exceeded in the execution of the orders you have sent him.[24]

She enclosed a bill of lading for the case of 'Orchis' plants from Meares and the two boxes from Mrs Molloy, and said she had instructed the captain of the vessel that freight for them would be paid in London by Captain Mangles.

In sending the boxes to Lady Stirling to send on for her, Mrs Molloy also wrote a letter of farewell to that lady, whom she had come to regard as a friend. With the letter she sent a small parcel of seed lately come to hand since the packing of the boxes and asked her to take it to Captain Mangles. In an undated letter to Mangles Georgiana mentioned that she had done so:

> The stones of the Vasse Apples I also entrust to your cousin. The shrub grows in the sand close to the Beach about Géographe Bay, and no other soil suits it, nor will it bear removing. The outside is covered with a thin rind and when ripe exactly resembles in shape, colour and size, the Siberian crab, although the colour is a much brighter red, the taste rather acid, and as we are destitute of fruit, it is generally made into a sort of marmalade.

She was to become expert in making Vasse apple jam, and her neighbours were glad to receive little jars of this conserve.*

Sir James and Lady Stirling finally left Western Australia at the beginning of January 1839. They were fêted and farewelled before they left, and they themselves gave a parting ball at Government House on 20 December. 'Dancing was kept up literally till breakfast

* Vasse apple jam is still occasionally made in the neighbourhood of Busselton. It is brownish in colour and requires a good deal of sugar, being rather tart. The plant is botanically known as *Santalum acuminatum* (*Fusanus acuminatus*) and the native name is Quandong.

time next day,' recounted G. F. Moore, and went on to speak of the popularity of the Governor and how sorry the colonists were to lose him. 'We took leave of him publicly on his embarkation at 4 o'clock, and as we raised our voices to cheer him for the last time, he was very much affected.'[25]

Chapter

10

Seeds from an Unknown Land

THE *Joshua Carroll* made quite a fast trip to London, arriving in the early months of 1839, but nevertheless the case of orchid plants did not survive. In May, Lady Stirling, herself just arrived at her old home at Woodbridge, sent her son Andrew up to London with a note to Captain Mangles to inquire how the plants had fared. Her letter bears a disgusted footnote by Mangles: 'All put down in the Hold and Killed!' The *Carroll* also brought from Drummond 'a collection of upwards of 220 sorts of seeds' for Mangles, and for sale, '44 one-pound packages each containing 20 papers of seeds'. Besides these there was 'a very large Bale of specimens of dried plants but for want of paper fit for the purpose I have not been able to divide them into sets'.[1] Faced with a large bale of unspecified dried plants and 44 lb. of seed to market for Drummond, it is small wonder that Mangles had had enough of him. Although in his letters Drummond showed himself a true botanist, one of his worst failings as a collector was that he was careless about labelling plants with their locality, and date of collection. When Mangles prised open the other two boxes brought by the *Carroll* he was therefore probably in no very sanguine mood.

Mangles had begun his gifts of plants, and inquiries for native plants, late in 1835. Owing to the difference in seasons between the two hemispheres, it was September 1836 before spring caused the flowers to bloom in the New World, and December or January before their seeds were ripe. With deficiencies of shipping, it was September 1837 before Lady Stirling was able to write to her cousin that the first lot of seedlings would be ready to send in November, by the *Hero*. They had been grown by Captain Meares and were

'all young, well-rooted and very healthy'. With her letter she en-
closed a list by Meares of what they were. This list whetted Mangles's
appetite. In some excitement he wrote to the Duke of Devonshire
offering him some of the plants when they should arrive, for which
offer the Duke duly thanked him. They were to include eleven
Kingia, some *Nuytsia floribunda*, and 'many other rare and valuable
Desiderata'. Loddiges the nurserymen had had no success in raising
Kingia Australis and *Nuytsia floribunda* from seed, so Mangles keenly
looked forward to having the seedlings from Meares. Drummond
also sent a case of plants, and Lady Stirling had asked to know whether
his box or Meares's arrived in the best condition. The cases were
apparently consigned to Loddiges, for on 14 June 1838, Mangles
received a letter from them which dashed his hopes to the ground:

> We received the two glazed boxes last night, there does not appear to be one
> atom of life in the whole. There are no marks or numbers on either box, but
> the one which contains dead Kingia we suppose is that which Drummond
> intended for us as mentioned in the enclosed letter. . . . The earth in this box
> is moist. The other box appears to have had nothing at all in it but mere
> dusty earth, as dry as if it had been baked in an oven. We have not disturbed
> either of them, as we should like, if it were possible, that you should see them.
> Perhaps you might be induced if well enough, to take a ride over. . . . We
> begin to fear, as Mr Drummond writes, that the plants will not bear
> transplanting.[2]

This was the greatest disappointment to Mangles. Packages of
seed had come by the same ship, and he was obliged to send only that
to the Duke, together with letters from Meares and Drummond
which he thought might be of interest. Paxton, the Duke's Superin-
tendent, wrote to thank him, and to cheer him up for his disappoint-
ment over the plants. During the next few months Mangles sent
packages of seed to various nurserymen and private growers, retaining
the most perfect sets for members of the Horticultural Society and
those whom he regarded as the best nurserymen,[3] while his friend,
Dr Lindley, who as well as being Secretary of the Horticultural
Society, was also Professor of Botany at the University of London,
was interested in the dried specimens. He identified as many of them
as he could, but remarked that many of them were quite new and he
could do no more than name the genera; nevertheless, he would be
glad to see more, as he was anxious for materials for a book he in-
tended publishing, to be called 'A View of the Botany of the Swan

River Colony'. He was very pleased with the *Orchideae* which were nearly all new species.[4]

By the ship *Hero*, which brought the dead plants, had come other disappointments for Mangles. He had received a letter from Sir Richard Spencer, the Government Resident at King George's Sound, saying that that gentleman would be 'most happy to send home any rare bird that may fall in my way. Some malicious person shot a pair of Black Swans that I had quite tame in my pond, or you should have had them. I am sorry to say Lady Spencer is no botanist, and I fear my good girls will never make you any collection of flowers or seeds. . . .'[5] There had been no answer at all to the letter he had addressed to Mrs Molloy at Augusta—her reply of March had somehow gone astray—and the letter from Captain Richard Meares, his first except for a short formal note in the third person expressing his willingness to collect, although interesting and indicating that Captain Meares ('your Life Guardsman', as he used to sign himself to Lady Stirling) was well-read and educated, also indicated that he knew very little about botany, not even the means by which flowers were classified. His letter makes this clear.

He wrote to Mangles in November 1837, from 'The Bower', Guildford:

My dear Sir,
I have had the pleasure to receive your very kind letter and have much to regret that I know so little of Botany as (I fear) to be of little *real* use as a collector of plants or seeds; however, I am extremely interested for this Swan River bantling, & I can only say, that if you will be our tutor, we shall all of us be your pupils. I have myself been always an admirer of lovely Nature, from the most perfect of all her works embodied in the descendants of fair Eve, down to the most humble floweret of the shade. I have however found out a secret by travelling so far; at least it is so at the Antipodes, that *cultivated* Nature is as far above the imagery of wild nature in the wilderness, as the idea of Heaven is from chaos.

For example, and I assure you I am a writer of *facts*, woman, who both in civilized life, in the arts, and all the wisdom of science, has proved to be the most excellent and lovely of creation; we have here, the most *monstrous*, ill-favored, *savage* and inhuman of creatures—I should write human last, in existence; in short we know they are human or we should forget they were ever intended for such. The Forests again are extended over such vast level plains that they lose all the charms of romantic scenery. In this I am woefully disappointed, having a spice of Dr Syntax and the picturesque in all my wanderings.

We have lately sent to Lady Stirling, and I have no doubt ultimately for

you, a collection in the *Hortus Siccus* shape, which however, upon looking over when they were finally arranged and dried, I was disappointed to find had lost all their beauty. . . . In the first few leaves of the brown paper book which Lady Stirling has sent home I arranged that no plant should be sent without the flower, as well as the flower. Now, having lately got hold of a book on Botany, I find that Linnaeus,—who I have no doubt was a lady's man,—has founded his theory of the beautiful, not from the root, but the Roses; the petals, the calyx, and the pistils founding the whole chain of the system in inexplicable nature herself.[6]

Mangles possibly decided that Meares was a well-meaning and likeable fellow (qualities that would recommend him, more than the somewhat churlish Drummond, to Lady Stirling) but not particularly useful as a collector.

Captain Richard Goldsmith Meares was of Irish extraction, an officer who had fought bravely and with distinction in both the Peninsular and Waterloo campaigns. At first in the Royal Fusiliers, he had transferred after Waterloo to the 2nd Life Guards, later resigning his commission. He had come out to Swan River in December 1829 in the same ship as Thomas Peel, and had expected to take up land under Peel's settlement scheme. At first he had lived at Clarence on the coast not far from Fremantle where the ill-fated settlement was to have been, but in 1832 he moved to Guildford, where he built a pleasant home, 'The Bower', to house his large family. His interests were horticulture and sketching. 'The Bower' was to become well-known for its hospitality, and it was from there that he wrote most of his letters to Mangles. Later he was to move to York, where he became Resident Magistrate in 1842. There is a certain similarity between his career and Captain Molloy's. Both were of an age, being born in 1780. Meares was to die in 1862 and Molloy not long after that.

Captain Mangles was evidently impelled to express in a letter to G. F. Moore the disappointment that he had suffered in his quest for plants from Swan River, and the fact that his health was bad in 1837 and '38, for about December 1838, Moore replied: 'I am sorry to find in your letter such a formal announcement of your intention to retire from all concerns about us and our seeds, but I look nevertheless to hear from you frequently, either personally or through Sir James Stirling.'[7]

❧

When Mangles, resigned to disappointment, lifted the lids of the other two boxes that had come by the *Joshua Carroll* early in 1839,

he probably expected the usual hotch-potch from an enthusiastic but unskilled collector. Instead, he drew out of the first box not one *hortus siccus* but two: the one he had sent himself and another larger one. On opening them, they proved to be full of pressed plants mounted and set out with delicacy and precision, and carefully numbered. Practically all were new to him. The second box contained packages of seed numbered to correspond with the *hortus siccus*, showing great evidence of care and cleanliness in the sorting. In this box was a thick letter folded and sealed.

It is possible that Captain Mangles received Mrs Molloy's letter of 1 November 1838 (which would also have travelled by the *Joshua Carroll*) a day or so before the boxes, so he would have a pleasing personality in mind when he opened the 'folio', as Georgiana had called her long letter. 'Being too bulky, I have defrauded Her Majesty's revenue of its value and enclosed it, illicitly, I believe, in the box.' He could not fail to be moved by the account of a tiny child's death, and of a family living on the fringes of a savage and lonely continent, and yet making its minute explorations and discoveries in such a gentle subject as botany; he could not fail to be pleased with the evident freshness of some of the seed, and the care taken in packaging all of it. Here was someone whose interest was not casual, nor was it mercenary. He promised himself the pleasure of procuring all and more of the seeds his fair correspondent asked for in the list she enclosed, and tore up the cheque she annexed. Then he sat down at once to write to Dr Lindley, to send him the *hortus siccus* and the letters.

He received the reply:

My dear Captn., Your friend Mrs Molloy is really the most charming personage in all South Australia, and you the most fortunate man to have such a correspondent. That many of the plants are beautiful you can see for yourself, and I am delighted to add that many of the best are quite new. I have marked many with an X. The seeds we shall be most grateful for. I write in terrible haste, surrounded by people who interrupt me every moment.

Most truly yours,
John Lindley.[8]

This was the academic accolade; next Mangles sent the box on to Joseph Paxton at Chatsworth, who thanked him for 'the deal Box containing the valuable collection of dried plants from S. W. Australia, Port Augusta and Vasse Inlet, with the Map and letters which accompanied them. . . '. Paxton

read the letters with considerable interest. They have been written by one who is devoted to the promotion of Botanical interest in this country and zealously able to fulfil the task of collecting seeds. . . . There are some splendid things in the *Hortus Siccus* of Port Augusta, comprising many new species of *Hovea Chorizema*, Davisia, Boronia, Epacris and Kennedya . . . also many other fine plants which appear to be new, amongst which I particularly noticed nos. 6, 9, 28, 47, & 56; these would greatly add to the richness and beauty of our collections and I hope we may succeed in raising such in particular as promise to be so vastly interesting, indeed the last collection of seeds you were so kind to send us are far superior to any we have received at Chatsworth. . . . The examination of your dried plants has afforded great pleasure and will cast off the gloom which generally is attendant on raising unknown seeds, but now there is a stimulus—we know they are good and from a good quarter. . . .⁹

This was the sort of encouragement that Mangles had been longing for. His health forgotten, he happily made up parcels of seed. 'Mrs Molloy's seeds from Port Augusta and the Vasse Inlet, and Captain Meares's last batch were divided among the following,' he jotted down in his day-book.

1	Loddiges 'perfect set'	9	Mr Young of Epsom
2	Paxton do.	10	Mountjoy of Ealing
3	Lord Orkney do.	11	Henderson of Pine Apple Gate
4	Lord Boston do.	12	Knight of Chelsea
5	The Brothers Bonnamy 'perfect set'	13	Brown of Slough
6	The Horticultural Socy do.	14	Hastings of Regent's Park
7	Robt. Mangles do.	15	Mr Long, Gardener, Zoological
8	Mrs Marryat		Society 'perfect set'.¹⁰

Things were looking better now. In July 1839 Captain Mangles's brother Robert was writing to him: 'I have *Anigozanthus Manglesii* shewing for flower in the open ground where I put it in April.' (*Anigozanthus Manglesii* was the common red and green wildflower, queer rather than beautiful, known as Kangaroo Paw in Western Australia.) Keeping up his bulletins, Robert wrote in August, 'Anigozanthus is progressing fast,' and three weeks later, 'Anigozanthus is now four feet high but has not yet expanded its flower. I am under some apprehension these frosty nights may destroy it.' In September Paxton wrote:

It is with pleasure that I am enabled to communicate so favorable a result from your invaluable collection of seeds. Several hundreds of the two last lots have vegetated, and are now making fine young plants. . . . Amongst them are several Kennedyas, Chorizemas, Anigozanthus, Hoveas, Davisias,

Mimosas, and Everlastings, besides several Epacrideae, and the 'Floral Gem' which the infant Botanist, Sabina Molloy, took so much pains to watch and collect, and which you are anxious should be named after her . . . and in fact the collection is, collectively, the best and contains more good things than I have before received from that interesting part of the World.[11]

Paxton even managed to raise a seedling or two of *Nuytsia floribunda*; but in January of the next year informed Mangles that 'both are dead, the stems not being sufficiently hardened to stand the long damp Autumn'; at the same time, he desired to borrow again Mrs Molloy's *hortus siccus*, to compare with the new plants. 'This is a very desirable object,' he said, 'for when the nomenclature and merit of new Plants is known to those on whom the cultivation devolves, there is much greater chance of success.'

Mr Long of the Zoological Gardens had also raised the Nuytsia, and about the same time as Paxton, was to write to Mangles rather dramatically: 'It is now my painful duty to relate to you the Death of the *Nuytsia floribunda* which I yesterday was called to Witness.' (The *Nuytsia floribunda*, a tree commonly known in Western Australia as Christmas Tree, blooms in November and December in great masses of orange of a painful vividness against the blue summer sky. It is a parasite of the mistletoe family which draws most of its nourishment from surrounding trees and shrubs. Horticulturists still find it difficult to raise from seed.)

The colonists' descriptions of Nuytsia had made English nurserymen keen to grow it, and the struggle still went on, as also with *Kingia Australis*, or Blackgin as it is colloquially known, which with *Xanthorrhea hastilis*, or Blackboy, its kin, is peculiar for its oddity and prehistoric appearance rather than for any beauty, though they have practical uses. Captain Meares goaded them on with his descriptions. Of Nuytsia he said:

> I have found out that it blooms at four years old, and bursts out at the very top with a most gorgeous sun-gilt flame, for it is like nothing else. It is a most glorious and Majestic production of Nature, and in the distance now during the native conflagrations often startles you, and fires the forest. The Kingia I shall select a proud head of, and I really think *entre nous*, it might be introduced as a great novelty, as a new Crown and a sister to the Corinthian order of Architecture.[12]

He was alluding to the pillar-like growth of Kingia, which rises in a single slim column to a height of ten or twelve feet. It is crowned

at the top with its peculiar spiky foliage and at the flowering season
puts out several sticks with round heads, like drum-sticks.

❧

The letters from Mrs Molloy which Captain Mangles received by
the *Joshua Carroll* in 1839 were the last he was to get for over a year,
for in 1839 the much discussed move from Augusta to the Vasse
took place. (Augusta, as it looked at this time, is shown on Plate 4.)

In November 1838, the colonial schooner called at Augusta and a
good many of Captain Molloy's possessions were loaded on to her to
be transferred to the Vasse. This would probably have consisted of the
outdoor and farming gear, for which there would be no more use
at Molloy Island or on the land around the house. In February another
boatload went, and a few days later Captain Molloy went overland
to see it installed. Only the barest necessities of living would be left
at Augusta now, and with little housework to do, Georgiana's main
preoccupation was to see how many of the precious things in the garden
she had so loved and tended could be transplanted at the Vasse.
There were also the two little graves to secure as well as possible
against the wild creatures that might roam over them. With a sad
heart she planted on each a dark crimson China rose of which some-
one had once given her a slip, nor did she know till much later that
it was Captain Mangles who had sent the parent plant to the Swan;
and as she worked, she would realize, now that she was leaving it,
how beautiful this lonely corner of the earth had become to her, and
how she would miss the dark green and silver reaches of the river
and the song of the wind in the tall trees.

While Georgiana was thus engaged in pulling up the roots that
bound her to Augusta, the atmosphere of upheaval had affected the
Turner family. Thomas Turner had struck out on his own again.
In December 1838, he had built himself a cottage at Cape Leeuwin.
Although he lived all alone there, his brothers George and John used
to stay with him from time to time, or go fishing with him, while
his widowed sister Ann McDermott visited him occasionally. It
made a nice walk for her in the company of Mr Green the medico,
who came over increasingly often from the Vasse. His courtship of
the fair Ann was in progress again.

Ann McDermott's diary for 1839 is a most tantalizing document,[13]
for even in this intimate journal she does not allow her real feelings
to appear. At one moment the accent is on home pleasures: 'The

boys . . . brought with them eight swans and three cockatoos, and as
I was making bread they proposed a late dinner and to have swan,
which we did, and danced in the evening'; at the next, ten days
later: 'A party of natives from the Vasse arrived yesterday with letters,
but alas, none for me.' That was in February; a month later Mr Green
was again at Augusta and stayed over Easter, a wet, dull Easter with
little opportunity for walks. Kept indoors, with her mind not on her
work, Ann narrated dismally: 'A failure at distilling the lavender',
but brightened up a day or so later: 'Mr G. tuned my piano just before
tea. When everyone had retired except us girls, I took a stroll down
the garden with *mon cher ami*, as he was going early next morning
to the Vasse.' Twelve days later he was back again, summoned from
the Vasse with Captain Molloy by two soldiers hurriedly sent from
Augusta. Little Mary Molloy was ill, and her mother, although
having little faith in Mr Green, was taking no chances with her
remaining children. However, by the time the party came from the
Vasse—three days after the child took ill—they found her recovered.
This gave the opportunity for more walks with the pretty Ann, and
for her to enjoy herself playing off her English beau with an American.
A whaler, the *America*, was in the bay and her Captain, and his brother
Mr Cole, both took tea at Turner's place. 'Mr G. started for the Vasse
next morning.' Mr Green was to find the Yankee Mr Cole would
have a bad effect on his courtship, less by being a counter-attraction
than by exposing his own weakness.

'Mr G. went on board the *America* with Captain Cole,' said Ann,
and five days later: 'Mr G. came on shore. Sad, sad evening.' American
hospitality had been too much for the doctor: he slept it off through
the week-end. 'We did not see anything of Mr G. since last Saturday
morning till this evening. I became reconciled to him.' But the next
day: 'Mr G. did not behave well, which caused me to quarrel with
him before I went to bed.' Then: 'He made his peace with me this
morning. Spent a pleasant evening.' But the next day the little baggage
was writing: 'The Captains Cole and Butler with their first mates
drank tea with us and spent the evening. Set up dancing till early
in the morning.'

While his daughter was thus amusing herself, Mr Turner was
consumed with wrath and indignation about more serious matters.
Now that Captain Molloy, the last of the solid settlers at Augusta,
was really going, Mr Turner saw his own position becoming untenable.

If the military were removed, as they probably would be on the departure of the Resident, how could he carry on? He had expended several thousand pounds in improvements to his grant, and could not afford to sacrifice it by leaving the place too. He had already written to the Colonial Secretary to this effect the previous year, and had received a long communication from that gentleman in reply:

> The removal or anticipated removal of all the settlers from Augusta to another part of the district, with the exception of your own family, is doubtless the true cause of all the inconveniences alleged. Upon this point the Governor is desirous to point out to you that it is not in his power to prevent individuals from consulting and pressing their own interests and views in that respect. It is equally out of his power to maintain at Augusta those public officers which in the present reduced state of its population are not required. The rule which guides the Govt. in respect of public establishments and outlay is to apportion them strictly to the wants and numbers of the settlers in each district, nor does there appear any reason for the continuance of Officers when they become useless.[14]

Thwarted by Government's reply from Perth, Turner's next step was to appeal to higher authority. ('Writing all day copies of letters to be sent to Lord Glenelg' was Ann McDermott's entry of 21 February 1839.)

> I received a general reply in a letter from the Colonial Secretary of date 9 November last, which has compelled me to make this general statement for your Lordship's consideration, as I think it is evident there has been a plan or at least a desire, for a long time to abandon this place, but I was a main obstacle knowing the great outlay I had made, & without some compensation for the loss I should sustain they could not induce me to remove. In fact I cannot without a total ruin to my property, and now can only maintain ourselves and no return of profit from all outlay and hard labour of nearly nine years. . . .
>
> A plan of the river with some observations as far as they examined it was given to the Govt. in 1834. Also it is there stated as the value of improvements at Augusta at only £2,000. I have expended double that sum myself, and you will perceive that in my application of claim of my land in fee simple, that in May 1833 I have made an outlay on my land to the amount of £1,881 exclusive of stock, implements of Agriculture or moveable property and admitted by our two Resident Magistrates, both of them members of the Agricultural Society and that value much below what had absolutely cost me.
>
> Also in the same report is a statement of the necessity of having an increased Military Force at the old, and of some new-formed, stations and of Govt. Residents or inspectors of the Natives at those places concluding with 'having established these, no new Posts nor sub-detachments should be formed, nor would the administration of civil affairs for some years require a further

extension. All persons residing at a distance from those stations would do so at their own risk.' So that Augusta is there cast out of the pale of protection or encouragement, and settlers must remain there at their own risk, if they will not follow the Govt. Officers and friends to their own recently selected grants, and where I do believe up to this present some have not expended one penny in improvement on their main grant of land.[15]

There was more in this strain and Ann was kept busy copying in her neat handwriting all that her father wished to get off his chest. His protests of the previous year to the Colonial Secretary's office in Perth at least had had one result. They came to the notice of the new Governor, Mr John Hutt.

Governor Hutt had arrived several days before Sir James Stirling sailed, in January 1839. He had previously held the office of Governor of North Arcot in the Madras Presidency. He did not have Sir James Stirling's practical knowledge of colonization and its difficulties, but he had plenty of theories. He had been intensely interested in the Wakefield system of colonization for South Australia. The Western Australian colonists were inclined to view him with suspicion.

Very shortly after he arrived, Governor Hutt instructed the Colonial Secretary to write to the Resident at Augusta to inquire how he was going to fulfil the duties of Resident there when he resided at the Vasse. This letter, which probably arrived at Augusta in the colonial schooner towards the end of February 1839, was not answered by Captain Molloy till 30 March. Whether the delay was caused by Molloy's domestic affairs—he was at the Vasse for most of March—or whether he was put out by the tone of the inquiry cannot be said. There is a note of indignation in the reply which he sent in his own good time.

Sir,—I have to acknowledge the receipt of your letter of 21 January last, wherein H. E. desires to know in what way I propose, as I am about to remove to the Vasse, to perform the duties of Resident at Augusta.

Shortly after the disturbances that had taken place here with the natives, in the course of a conversation with Sir James Stirling at Perth on the subject, he urged the necessity of my removing to this quarter the first convenient opportunity. 'In fact,' he concluded by observing, 'the sooner you are over, the better', and to facilitate my removal, he gave me leave to take advantage of the Colonial Schooner the first favorable occasion that offered. That occasion did not occur from one untoward circumstance or another, until last November, when she was sent for the purpose of removing me and my family to the Vasse. From these circumstances I inferred, in conjunction with the abandonment of Augusta by every family but Mr Turner's and one

individual, Mr Herring, that this was considered at Headquarters as my Post; and this being the most frequented port with the greatest number of settlers, the greatest quantity of livestock and the most numerous native population in the district, would be the point at which I could be the most service to Her Majesty's Govt. But in whatever manner H. E. shall be pleased to direct me, whether by a continued residence at Augusta or by periodical visits, (which latter was the mode I concluded on adopting), I shall be prepared to execute his commands.[16]

Meanwhile he went ahead with his preparations for the removal of his wife and children to the Vasse, and continued to receive protests from Mr Turner about it. Molloy's last letter from Augusta, written to the Colonial Secretary on 4 May, ran:

Sir,—I have the honor to acknowledge the excerpt of your letter of 28 March touching the removal of the Military from Augusta to Albany. The settlement will, if the event takes place, be exposed to the depredations of the numerous tribes of Natives who have every year robbed and destroyed the potatoe [*sic*] Crops. I beg to forward a letter from Mr J. Turner expressive of his apprehensions on the subject.[17]

Mr Turner continued his struggle with Authority for the next six years, even making a voyage to England to go to the Colonial Office in person. After several interviews and examination of local measures and correspondence, the Colonial Office informed him:

It seems that by a general measure which in the year 1837 was sanctioned by the then Lieutenant Governor for enabling the out settlers to obtain land within the settled districts the land of all those who like yourself had obtained extensive grants, was valued at 1s. 6d. an acre and they were allowed a credit at that date for whatever quantity they surrendered to the Crown, in payment for land purchased from the Crown in the ordinary manner. It would therefore have been open for you to avail yourself of that arrangement, had you thought fit to do so, within the time allowed for the purpose to all settlers in similar circumstances, but as you did not take advantage of the privilege thus offered, Lord Grey regrets that he is under the necessity of acquainting you that the Government cannot now, consistently with the Land Sales Act, allow an exchange of land and therefore it is not in his power to afford you any relief.[18]

The Molloys had decided to go overland to the Vasse; it cannot be said whether this was Mrs Molloy's wish, but it is likely that she desired to see for herself the way her husband and the Bussells had so often traversed. The friendly American, Captain Cole, was to take them up the river in his whale boat as far as was practicable. From that point they would ride, Captain and Mrs Molloy on horseback, the

latter carrying the baby Amelia in her arms, and the two little girls on donkeys.

It is to be feared that the sight of her new home came as somewhat of a shock to Mrs Molloy. It was situated certainly upon a bank of the Vasse River and showed possibilities of being a pretty spot when the garden was made, and trees planted; but the Vasse was a narrow and sluggish stream, stagnant in places, and a poor substitute for the magnificent reaches of the Blackwood, while the surrounding country-side was flat, and shut in from the sea with stunted jarrah and banksia trees. The house itself was no bigger than the one at Augusta. It must have seemed to Georgiana that nine years of her life had gone for nothing, so little was the improvement in her lot. The Captain, however, was full of plans for the house they would build when workmen could be procured, and with her customary courage Georgiana set to work to make the most of the home she had.

Very soon after her arrival, she was pleased to make the acquaintance of Mrs John Bussell. When he was in England in 1838, John Bussell had married a young widow, Charlotte Cookworthy, with three children, and had brought her home to 'Cattle Chosen' at the beginning of 1839. No doubt Mrs Bussell had heard a good deal about Mrs Molloy and was interested to see her new neighbour, for 'Cattle Chosen' and 'Fair Lawn', as the Molloys had named their place, were within walking distance of each other, though on different sides of the river. A day was arranged for Mr and Mrs Bussell to call and take tea.

Mrs Bussell wrote later:

A boat was sent for us as there was no bridge in those days. Mrs Molloy, whom I now met for the first time, was standing on the bank when we landed, with her baby in her arms. Her complexion was very fair, and she had a quantity of fair hair. She was dressed in a dark blue print very plainly made. We walked up to the house together. In the parlour was a bright fire. Tea was ready, and on the table was a beautiful bunch of wildflowers, for her garden was not in order and she could not be without flowers in her room. The little girls were seated on each side of the fire on low seats. There was a small piano in the room on which Mrs Molloy played when tea was over, and we spent a pleasant evening.[19]

Mrs Bussell had at once noticed a principal characteristic of Mrs Molloy: 'She could not be without flowers.' Was she echoing some words of her hostess, or did she perceive it to be an essential need?

There was a dignity about the new Mrs Bussell that evidently appealed to Mrs Molloy, for Bussell diaries of the next two years reveal repeated visits, many only a few days apart, and the strained relations between the two families disappeared, to recur only in a smaller degree, as such entries in Mr Ommaney's diary show: '26 December 1839. Accompanied Mr J. Bussell at his request to examine and be prepared to give evidence relative to certain damage done to his wheat by Captain Molloy's cattle.'[20] The little Molloys spent many happy days at 'Cattle Chosen', poling their way down the river as they grew experienced with the boat, and Mrs John and Miss Fanny called, or spent the evening with Mrs Molloy in a neighbourly way very often.

Labour was scarce and only casual at best, nevertheless Captain Molloy made what arrangements he could, for his duties as Resident made great calls on his time and the concerns of his own domain suffered. Soon after his arrival at the Vasse the matter of building a Barracks for the soldiers came up. Governor Stirling in 1837 had fixed the site for it, to Lieutenant Bunbury's disgust, on the marshy land at the entrance of the Vasse and Wonnerup Inlets. It was a desolate place, low and flat, the oozing mud covered with purple samphire, the waters of the inlet a haunt of black swans and cygnets, duck, pelican, grey heron and white crane.

George Layman and the three Chapman brothers had settled at Wonnerup Inlet, and a year or so earlier, after the attempted spearing of himself and his wife at the house at Soldier Point on the Vasse River, Elijah Dawson had removed to Wonnerup to have the protection of the military.[21] A few others had taken up land in a small way near the Sabina River. In 1839 the Resident and Mr John Bussell, with the thought of the Busselton* town-site in mind, and evidently foreseeing that the increasing number of whaling ships in the bay would help to create a town there, had the idea of erecting a proper Barracks near to the land allotted for the town-site. This idea filled the Wonnerup settlers with dismay. George Layman on 17 June wrote a long letter to the Governor stating that as he was unable

* The town-site at the Vasse was given the name of 'Busselton' in honour of its first settlers. The first official mention of the name was on 30 June 1835 when the Colonial Secretary wrote informing the Surveyor General that nine towns, among which was Busselton, were to be considered open for the purchase of allotments.[22] On 4 July 1835, a General Notice to that effect was issued from the Surveyor General's office, Perth.[23] The district continued to be referred to as 'the Vasse', and in general 'the Vasse' and 'Busselton' were equally used as late as the turn of the century, when 'the Vasse' began to be dropped.

to get labour, when he had occasion to be absent from Wonnerup his wife and family of four would be alone and quite unprotected if the military were withdrawn. He added that the Barracks seemed unnecessary at Busselton when 'Mr Bussell has ten men in his establishment and Captain Molloy four, living within gunshot of each other.'[24] Elijah Dawson supported him, and the Chapmans indited a verbose petition of protest to the Colonial Secretary.

On the same day that all these horny hands were grasping the unaccustomed quill, Captain Molloy, accompanied by Mr Ommaney the surveyor, the man Croker and the pack-horse Bob, started for Perth on horseback. The Resident was going to pay his duty call on the new Governor, and put this disputed matter of the Barracks before him.

It took the little party six days to ride up the coast to Perth, and they remained there from 23 June to 6 July. The thought cannot be avoided that Captain Molloy enjoyed these jaunts into comparatively civilized life again. For two weeks, as well as conferring with the Governor, the Colonial Secretary and the Surveyor General, he could meet various congenial brother officers, and, clad in his Rifle jacket, perhaps now a little tight, but still a good enough fit, be 'Handsome Jack' once more as he took tea at one or two of the elegant tea-tables of Perth.

Captain Molloy may have convinced the Governor of the military reasons for placing the Barracks near the town-site, but the Governor, not a military man, was inclined to pay considerable attention to the letters he had received from the various settlers at Wonnerup. The petition of the Chapmans carries a note in Governor Hutt's hand directing the Colonial Secretary to 'inform Messrs Chapman that it is not the intention of the Govr. to remove the Soldiers from Wonnerup. The Resdt. has orders to select a spot for Barracks as near to Town-site as possible. Communicate last paragraph to the Commandant, it involving military details of which the Govr. cannot take Cognizance.' In effect, the Barracks was still to be at Wonnerup but as much towards the town-site as the marshy terrain of the inlets would allow. Captain Molloy and Mr Ommaney journeyed back to Busselton, but as Mr Ommaney arrived with 'bad boils on both legs', it was 25 July before he could note in his diary: 'Accompanied Captn. Molloy to the Sabina River and Wonnerup to arrange eligible position for Barrack site on Sergeant Guerin's land.'[25]

Besides the worry of the Barracks site, the Resident was receiving complaints about the conduct of the surgeon, Mr Green. In August he dashed off a sarcastic letter to that worthy:

> Sir, Understanding from common report that you are about to leave the Vasse to visit Augusta I beg to call your attention to the case of Elijah Dawson, the district Constable, and to urge you as far as regards your professional Character to pay some attention to that individual, whom it would appear has not been surcharged with your medicine or discountenanced by your visits.[26]

Mr Green, it would appear, was going wooing again. Although not young, being now thirty-four, with the spring the surgeon's fancy was lightly turned to thoughts of love.

In August also the Resident received a letter from the Colonial Secretary, to which he felt obliged to reply:

> Sir, I have the honor to acknowledge the receipt of your letter of the 29th ult. directing me to visit the station of Augusta on the 10th and 20th of each month. As it will involve an expense of Horse hire at least 12 days in each month in the summer and sometimes for a longer period during the winter, should it at all times be practicable, I beg you would acquaint me whether it would be more agreeable to the proper authorities to give me a fixed allowance for this service or to pay the common rate of hire.[27]

This matter of his expenses of transit was to become a sore one for the Resident. It kept coming up for the next two years.

He was to inquire testily in 1841:

> I presume it is not expected that I should undertake a Journey to Augusta on foot at my period of Life and with the rank I hold. I must therefore request you will submit to H. E. the justice of my being made some allowance for the performance of this duty either in the permanent allowance of forage for a Horse or the Colonial rate of hire for the time I may be under the necessity of using one.[28]

The answer informed him that he would have to bear the expense himself as when he took up residence at the Vasse he had guaranteed to visit Augusta. 'The Govr. can only refer Captn. Molloy to his own original proposal of visiting Augusta periodically. . . . It was a favor allowing his locating himself at the Vasse,' the Governor's reply reminded him.[29]

In November, Governor Hutt paid the Molloys a visit. Mrs Molloy found him quite interesting to converse with, especially as he was able to tell her about a German naturalist named Ludwig Preiss who

had been at Swan River for nearly a year. 'It is a pity that the Germans should forestall us in our own Colonies,' wrote George Hailes to Captain Mangles, alluding not only to Ludwig Preiss but to the Baron von Huegel, a botanist who had paid a visit to Swan River in 1833. 'Had it not been for your own exertions, we should yet have been ignorant of the many fine Plants we now know to be natives of Western Australia. I trust the day is not distant when a Botanist will be as necessary a part of the fitting up of a Colony as a Governor.'[30]

When the Governor had gone his way, Georgiana at once wrote to Mr Preiss inviting him, if he were interested in the many strange varieties of flowers at the Vasse, to stay at 'Fair Lawn' and examine them at his leisure. He came at once, and as well as the pleasure of having congenial company, Georgiana was delighted to receive at the same time a letter from Captain Mangles—the first since his initial letter of December 1836. She had written so much to him that he now seemed like an old friend.

A day or so after his letter came a box from him, filled with treasures of books, magazines, several new *hortus siccus* to be filled, and many of the necessary materials for putting up seeds—brown holland cloth, brown paper etc.—and some personal presents including skeins of silk and scented soap. Preoccupied as she was with her visitor Mr Preiss, whose visit lasted a month, it was the beginning of the New Year before she could express her appreciation of his gifts to Captain Mangles, and recapitulate for him her departure from Augusta.

She wrote on 31 January 1840:

Dear Captain Mangles, I received your long-wished for letter on the 10th December, and a day or two after, the Box. Words fail me when I attempt to return you my many many grateful thanks and acknowledgements for its useful, beautiful and handsome contents. I stood quite amazed when Captn. Molloy took out the different things, wondering at your disinterested liberality and kindness to those you have never seen, and who are not able to make you any adequate return.

The books are invaluable, and most admirably select, so many of them what I have long wished for, and what we should ourselves have purchased, had opportunity occurred. Uncle Phillips's *Conversations* etc. I saw named in the *Quarterly*, and had set it down with *The Language of Flowers*, Paley's *Conversations*, and some others in a List for Captn. Molloy to get when he performs his long-talked-of visit to England. I saw them there highly recommended among the new publications. *The Greenhouse* I much desired to see, but knew both it and *Keith on Prophecy* were too expensive, therefore abandoned the idea of ever possessing them. By these facts you will be able to

conceive the extent of your bounty on us isolated beings; indeed, I am ashamed to think of my accepting so very much at your hands. Not only to ourselves but to our children and to my Grandchildren will your munificence be perpetuated, and the superiority of feeling that pervades the selection,—to please and gratify the Parents and at the same time be instrumental to the improvement and edification of their children does not pass unnoticed.

In my few stolen moments of leisure I run to the Box of Treasures, and take a Glance at some of the Books with which I am really delighted. The beautifully executed illustrations of *The Greenhouse*, the Language and sentiment of Flowers I could look at repeatedly with unwearied pleasure, not a little increased by calling them my own. I often after a day spent in servile drudgery from the want of Domestics sit down quite exhausted with one of your beautiful presents in my hand, when I receive great refreshment and relaxation. When leave is granted for Captn. Mangles's Books to be looked at, a clean cloth is laid, Sabina and Mary are permitted to regale themselves with the sight.

Captn. Molloy is much pleased with many parts of Australia, and has long wished to read Major Mitchell's Work. He is an old brother officer of Molloy's, and from all accounts is a most zealous and indefatigable person, an excellent draftsman, and on the Peninsula would be absent for weeks together among the hills with his 'Sketch Book', without a companion.

But I must concentrate my many subjects as I have much to say and short space to write it in. 'Imprimis', when I last addressed you it was at dear Augusta. I left it with much regret on the 5th May 1839, having on the previous night taken up all my favorite plants and shrubs I could possibly place in the basket which was hung to my crutch. My feelings on leaving my much loved retreat are best exprest in those beautiful lines of Milton, where he represents Eve driven from her garden in Paradise. At Augusta, as your Cousin well knows, we suffered much in every way, and also enjoyed much undisturbed happiness. I was reluctant to leave it, and would now gladly return, but prudence forbids. We were taken 30 miles up the Blackwood in a Whale Boat belonging to the ship *America*, Captn. Cole, then lying in the Bay. Beautiful our row was up that Magnificent and peaceful River, but it was a great struggle to both of us, not having been so long from my House for nearly ten years.

We stopped at the Governor's Bivouac, and here I must really leave you, and finish my account in my next, or if I thought it was not uninteresting, would commence the little red Book you have sent out,—'Floral Memoranda' —and give you a sketch of our proceedings from that day until the present. Suffice to say we arrived three days after we took leave of Captn. Cole at the Governor's Bivouac, at the Vasse,—a terrible change. After dinner I sought out a moist situation where I might deposit my poor Plants. Torn from their native soil, they seemed to participate in the feelings of their Mistress, trying through the aid of Water to keep up their natural vigour, but evidently had met with some terrible reverse.

We found the Vasse much colder in the nights and mornings and hotter in

the day. June, July and August passed without much interest. The latter end of August the flowers in the Wilderness began to bloom and I was astonished at their loveliness, much finer than at Augusta and many new varieties, some I had never seen there, and vice versa. I had no Book to put specimens in had I dried them, or could not procure even paper to make one, for they must have stiff backs.

The present Governor paid us a visit in November. From him I heard of a Gentleman of the name of Preiss, a German, and one employed by the Austrian and Russian Governments to collect the natural productions of this Country. He is really a Botanist. I thought he might aid me in information respecting the plants of this country, and at the same time benefit himself. I had besides a sinister Motive, I will confess, in which you were not a little considered. I accordingly invited him to 'Fair Lawn' and he staid with us about a month; being so pleased with the Country and its many new Floral productions. He has resolved upon visiting us again. When here he collected many Specimens, and of course tendered me some of his labour, but so rough and ungainly were many, I could not deface the *Hortus Siccuses* with them, so had recourse to fixing them on stiff paper. Of this I was minus, and after asking every probable person, I at last obtained an old Log Book from the Captn. of the *Palestine*, an American Whaler then in Géographe Bay,—and here let me observe that on your account I was particularly sorry on opening your Box that the '16 Quires of Brown Paper' you mention, were not in the Box. To my surprise, the Box had been opened, as the Tin was unsoldered and a vacuity between some of the Parcels, and as there were so many other things than what you specify, I was almost afraid to appropriate them. But if I had had the Brown Paper I should not have sent you the specimens on such as I have been alone able to procure.

I have, I am afraid, been guilty of seizing on both the large *Hortus Siccus*, as also the small one. I know one was addressed to 'Mrs Bull', but I thought it was a mistake, and as coolly as possible appropriated it, until Mr Preiss pointed out to me my error. At all events, they will be returned to you with the tributes of the Spring, and I shall be exonerated from any selfish desire: in the mean time I shall apologize to poor Mrs Bull.

Mr Preiss was in a position to point out the error, for he had stayed at Mrs Bull's place at Picton, Port Leschenault, on his way to the Molloys. He knew that she was one of Mangles's correspondents. She had only just moved to Leschenault from the Swan, and no doubt Captain Mangles included several things for her in the Molloy box, thinking as the two homes were not far apart, these articles might provide an occasion for introducing the two fair botanists. But Mrs Bull's health was bad; she did not like Leschenault: 'Not near so nice a place as the Swan', it 'swarms with Fleas which together with the dirt keeps me in a continual fidget,' she averred, and wrote to Mangles that 'though only twenty five miles from Mrs Molloy,

I have not seen her yet. I have been in too bad health to go to her, as we must sleep one night on the road, it is so bad, and so many rivers to cross; therefore I do not expect to meet her till next year, as she cannot leave home on account of her family.'[31]

Meanwhile Mrs Molloy continued:

Whilst on the subject of Books and Paper, I wish if you honor me any more with being instrumental to your interesting pursuits, you would send me 'seed papers' folded and ready, as your first Box was prepared, also little Paper Bags, they aid me so very much as, my dear Sir, I have everything to do myself, even to the making of the Bags, and searching for the paper, then folding it.

Your name has created a great sensation in this district which you unfortunately avoided. The soldiers who used to pass between this and Augusta unmolested and unencumbered with anything but their knapsacks, are now seen to bring from thence specimens of all sorts of Plants under their arms. The Native Herdsmen are also employed bringing in some desired Plant or Fruit, which until now they have never perhaps looked upon, for they dislike Flowers and will not suffer any one to be placed on their heads,—I think perhaps from the common custom of laying them on the dead. I never knew any but one of the name of Battap who permitted me at Augusta to place a large piece of the crimson Antirrhinum in his Wilgied Locks.*

It would greatly increase the effects of some Plants if in the next *Hortus Siccus* you had different coloured papers put in with the white, especially for Grasses, leaves, and White flowers. I am annoyed at being obliged to apply to you for these different Auxiliaries, but I do not think you will object to the attendant expenditure, and am totally ignorant of any Stationer or Nurseryman in London to whom I could myself apply. Not so in Cumberland, but then the distance from Shipping is too remote.

About the continuation of Numbers I was puzzled, but recommend as my days at Augusta are over, (until I grow old, please God to spare my life to that period) that we commence from the first at the Vasse, and in particular name Augusta to any specimen or number in question. I have accordingly done so, in these last sent. Our field is much wider and in all probability much more extended as to opportunity.

Last Thursday the *America*, Captn. Cole, arrived in the Bay, having (to use a technical term) 'filled up'! She proceeds instantly to America, and I am anxious to send what I have been able of Plants and seeds to obtain for you. Since Saturday last I have been engaged in your service. The children have had a Week's holiday and so have I, although I have necessarily been very assiduous, always working from after Breakfast till 12, and half after 12 at night. This seems incredible, but I had first to fix the specimens, to arrange, then paste on labels to that forbidding old Log Book,—which looks anything but neat and clean; then write attempts on character, make the Bags and cases, and now, Friday night, commence this interminable Epistle.

* Wilgi was a red mud with which the natives used to plaster their hair.

I do not know how the Specimens will arrive, but at least they will afford amusement to your Botanical Friends, and will, I believe, be the first in Britain from this part of the World. My anxiety you should first possess them rouses all my energy to prepare them for embarkation on Monday Feby 3rd, 1840. The seeds have all been gathered the two last months, and so have the specimens, so you cannot have fresher even were you residing here. They have many annoying defects. The papers are motley, and by the bye, do send me some pink tape to tie up the packages with. I cannot bear to put pack thread, it cuts the papers and looks unseemly and inelegant!! and white tape of which I have plenty is too stiff. Again you will see I am perhaps too unceremonious. It is only, however, what I feel towards so kind a Friend.

The Brown Holland you sent me, I really had not the heart to cut it up for seed Bags, for which I presume you meant it, so I substituted some of inferior quality and availed myself of the very excellent and superior material you enclosed. I trust I have not done wrong. You have indeed made me rich in Silk, for which accept my many thanks, which I feel very inefficient in conveying to you a sense of my gratitude. The soap was a fragrant and pleasant acquisition, but am happy to say I did not feel the dearth of that essential article, nor have I ever wanted for any single necessary of life since we have been out in Western Australia. I never use the last of one thing before I gain a fresh supply of the same article. I may have little but still that little will keep, or else we can for a while deny ourselves.

Saturday Feby 1st. I duly received the *Britannia* and *Colonial Gazette*, and think them very well written papers. They are great amusement and edification to Captn. Molloy, who has only this means of knowing what is proceeding in the World, and not leisure to bestow on any reading but what is really useful and interesting.

Three Vessels have arrived at Freemantle from England,—the *Trusty*, *Westmorland*, and *Jean*, but we have no intelligence by them. The latter is gone to Hobart Town for Stock.

In his letter written in the first half of 1839, Captain Mangles must have informed Mrs Molloy of a work of his that was to appear later in the year. This was the *Floral Calendar* (published 1839), a little book urging the beauty and possibility of window and town gardening. Mrs Molloy now touched on this, with a wistful curiosity about its author. He was, though it is likely she did not know it, very little younger than her own husband,* and of a personality that attracted her very much in his letters.

She continued:

I am very anxious to see the 'Floral Calendar'. It appears from what you say to be a desideratum and new in its kind. One embellishment I could suggest, and one which as you mention it is for private circulation, you would be

* James Mangles, born 1786, died 1867.

selfish in refusing, namely,—that a Lithographic Portrait of the Compiler should form the Frontispiece. Then I should see face to face the person whom Fate has so capriciously veiled from sight, but made so instrumental in bestowing kindness and gratification at so remote a part of the Globe. Our Acquaintance is both singular and tantalizing, and somewhat melancholy to me, my dear Sir, to reflect on. We shall never meet in this life. We may mutually smooth and cheer the rugged path of this World's Existence, even in its brightest condition, by strewing Flowers in our Way, but we never can converse with each other, and I am sincere when I say, I never met with any one who so perfectly called forth and could sympathize with me in my prevailing passion for Flowers.

I doubt you are an admirer of Scenery, for I generally find the two sentiments inseparable.

I have just heard that the vessel positively sails on Monday, therefore I must, however reluctantly, shorten this. The seeds Dr Lindley wished for, I have obtained from Augusta, as far as I could, and send you the note respecting them written by a little girl, whom I brought out with me, who, seeing me so deeply interested in Flowers, has imbibed a taste and some information respecting them, being constantly with me when I made your collection in 1837, and who knows the names we ourselves used to distinguish them by.

The little girl to whom Mrs Molloy alluded was Charlotte Heppingstone. She was still living at Augusta with her widowed mother. Her letter to Mrs Molloy, written 28 January 1840, reads:

Madam,—I have obtained all the seeds but the one which is prickly—I do not know it by the description you gave me of it—the seed in a paper without a mark is the seed of the Plant the leaf of which I have sent in the bag. I have been searching all day for them and with great trouble obtained them. The season has been so hot, and the Natives are burning every day, which made it tiresome to get them. If you will send me a description of that seed I will endeavour to get it. I remain, Madam, your Obedt. Hble. Sert.

Charlotte Heppingstone.

In expressing her regrets that Charlotte had not been able to find the particular seed wanted, Mrs Molloy went on to remark: 'I would with all my heart have rode over myself for them and really have liked nothing better, as being in the Bush is to me one of the most delightful states of existence, free from every household care, my husband and children, all I possess on Earth, about me.' This was a change from her former opinions about the Bush and its loneliness. She had Captain Mangles to thank for it.

She continued:

It is to be regretted that the Flowers of this Country are so uncommon in England, as were they imitated in that beautiful work of art, Artificial

flowers, they would create a great rage. They are so well calculated from their size for that work, also the brilliancy of colour could be well imitated in the manufacture of Porcelain and China. They would act as an impetus. Imagine a Dessert set of dead White, with a solitary sprig of the purple Kennedia, the scarlet Kennedia, with the Anigozanthus in the centre, well executed and with all the depth of colouring so beautifully executed as can now be achieved. If it was in my power, I would devote my time to painting some specimens to be imitated in England in Flowers, White Muslins and China, and have strictly according to Nature. I should think many would be glad of the idea, and lovely they would look.

Captn. Molloy proposed this mode of sending via America, thinking it the most expeditious way as the intercourse from thence to England is so rapid, and being anxious you should receive the earliest acknowledgement of your kindness.

Feby. 2nd, 1840. Mrs Bull wrote yesterday and names having many letters from England, also a Box in which she believes is a Book from you to me. Accept my renewed thanks, if it is so, though I am ignorant of what it is.

Another American has just arrived and I shall not close this until the last moment. Captn. Molloy and I are going out this evening for the seeds of the Isopogon to be able to send off tomorrow, Feby. 3rd.

Alas! the Horses have run into the Bush, and after many attempts have not been able to be caught. I must provokingly defer sending the seed. The Vessel sails this evening.

Captn. Molloy desires his best regards, and hoping you have not had any return of indisposition and that I shall shortly hear from you, I remain, my dear Sir,

> Very sincerely your friend,
> Georgiana Molloy.[32]

(This letter is followed in Captain Mangles's volumes by a list of 106 specimens collected by Mrs Molloy at the Vasse between the months of December 1839 and January 1840. These are all identified by genus and species except thirty-nine, which are labelled 'sp. nova', and three, unidentified, being completely unknown.)[33]

Having written her letter of thanks to Captain Mangles by 3 February 1840, Georgiana Molloy was able to pay attention to her own concerns for a while. Captain Molloy was excessively occupied during February and March in overseeing the surveying of the boundaries of his grant by Mr Ommaney. Mrs Ommaney was still living at 'Cattle Chosen' with her family while Mr Ommaney was surveying the Vasse district. She was expecting a child in May, and so was Mrs Molloy. Although the two ladies had reached the stage where they did not go out at all, Mrs John and Miss Fanny were able to exchange

news for them. Mrs Molloy's sister Mary was coming from England on a visit to them and was due to arrive at any time. As the two sisters had not seen each other for ten years, it was natural that Georgiana should wonder what impression would be made, and how her sister would fit into the pioneer life they were leading. It would be great company to have her, for Captain Molloy was away a good deal.

Miss Kennedy duly arrived. The Bussell ladies called and made her acquaintance. Early in April she returned their call, but evidently found the crossing of the little river a trial, for Lenox was set to work to build a bridge for Miss Kennedy. At the beginning of May a domestic crisis occurred. The Molloys' cook left, and went to the Bussell household instead. It could hardly have happened at a worse time, for the next day—8 May—Mrs Molloy was confined. The baby was another little girl, whom she appropriately named Flora. Miss Kennedy was helped through the critical day by the presence of Ann McDermott, who had come over from Augusta and was staying with the Bussells. Five days later Bessie Ommaney's confinement took place. Her child was a son.[34]

In spite of the presence of her sister to help her, Mrs Molloy could not seem to regain her strength. The May weather was fine and warm, and scents of the bushland drifted in through the unglassed window, but still she lay in bed, the books from Captain Mangles piled beside her, and *Tales of a Grandfather* sent over by Miss Fanny, lying idle by her listless hand. The seeds from Captain Mangles were waiting to be sown and she had planned their positions months before. 'I am anxious for creeping plants, as I have just had a small cottage built for myself and I shall make the verandah into a sort of conservatory,' she had written to Captain Mangles in March. This letter was in part a repetition of the one of January, sent by another route in case it should reach him before the one via America. In it, she had added to her remarks on Mr Preiss, the botanist.

He was here at a bad time but is coming down in the Spring. He promised to write and send me particulars respecting seeds etc. but we have heard nothing of him, although he has had excellent opportunities. You would be surprised to see how easily persons in this colony lay aside the common rules of Society. They indicate by the omission that these observances are useless and not intuitive. I have heard Mr Preiss speak of Baron Hughel and have also seen a work of his. I much expect he should have had no rival in his presentation in Britain. I imagine some collector might easily be procured in

England at a moderate expense supported by private subscriptions, and if you were disposed to send such a person here, or to Augusta we should shew him every attention in our power, and a person such as you would select should be welcome to any accommodation as an inmate of our House, so that he might traverse the district yet untrod in these Floral beauties, which have been so long concealed to the rest of the Globe.

Captain Molloy talks of going to England. This has long been in contemplation but his presence there is absolutely necessary. In this case we shall let this place, there being already three in treaty for it, and the children and I will repair to dear Augusta, (this I will delight in).

I have two *Cobea Scandens* up in a box, and intend them for the outside of a new room Molloy is building for me as a dormitory and nursery. The remainder of the seed, if we let the place, I have reserved for Augusta. . . .

The seeds of Kingia and Nuytsia you shall have. This is their precise time of ripening and the last named grows here in great abundance, and splendid it is. It looks so rich among all the sombre Eucalypts of the present season. It presents to my mind the rich and luxurious trees which adorn Paradise. How many, many years must these treasures have blossomed in this Country without one eye to appreciate them. It strikes me so forcibly in riding through the surrounding wilderness that the 'hand of God' is indeed impartial, for the uncultivated parts of the earth are as much loaded with his bounties as are the most frequented parts. I so often regret you should have so devotedly attached yourself to the Swan, and I believe, King George's Sound. If we had only met at Augusta what time we should have redeemed.

At the close of my last I spoke of our disappointment in not enclosing the seeds of the 'Isopogon'. Since then my excellent husband and I took a delightful ride for the same, and I have got a whole bag full. On the same spot which I have described in my last, I found in bloom a bright red species of Verticordia with such rich tufts of flowers. These I carefully affixed for you, a pretty yellow plant of the same class, I imagine, and several others, for which I await Mr Preiss's judgment. These were in a swamp.

I beheld a Tree of great beauty. The flowers are of the purest white and fall in long tresses from the stem. Some of its pendulous blossoms are from three to five fingers in length and these wave in the breeze like snow wreaths. They are of such a downy white feathery appearance, and emit a most delicious perfume resembling the bitter almond; and like all human or rather mortal, delicacies, how quick these lovely flowers fall from the stalk on being collected. I however was able to gather a good many, and on nearer view, found the buds much more beautiful than the full blown flower. I regret they have assumed a yellow hue, but are lovely and elegant even in Death. The native name is 'Danja', and I rather think it will turn out to be a Hakea.[35]

The flowers and scenes of summer seemed very far away as Georgiana lay on her sick bed in May. She received visits from her neighbours and compliments on her baby, but still she lay inert. She heard without much interest that Mr Thomas Turner had left Augusta and had

taken up land at Wonnerup. He had ridden over in March and consulted Mr Ommaney about the country he was surveying. In April he and his brother George took up their abode on Wonnerup Island, where they began to build two 'small wooden huts', one for themselves and the other for their sisters, Ann McDermott and Maria, who were to join them.

On 5 June 1840, Miss Fanny was spending the day at 'Fair Lawn'. It was just as well, for an extra pair of hands was suddenly needed. Mrs Molloy, who had been feverish and restless, began to haemorrhage badly. By night time she was very ill. It was the same pattern of events that had followed the birth of Amelia, only that time she had put down the weakness of her condition to the shock of her son's death from which she had not fully recovered. There was nothing to do now but wait, and rest.

<p style="text-align:center">❦</p>

It was hard to rest when she was obsessed with the need for gathering specimens to send to England. At the height of her illness it preyed on her mind. 'My sister Mary declares that three times out of four when she came to my Bedside I called out, "Oh poor Captn. Mangles! I cannot go on with his collection, and the seeds of the *Nuytsia Floribunda* will all be shed!" and moreover I bewailed the seedling Isopogon I intended procuring for you and sending by some American Whaler when it leaves this Bay,' she wrote to Mangles when she had begun to mend a little.[36] The family could joke with her about it. 'Both Molloy and my sister cannot forbear frequently from smiling at the unparalleled devotion of all my spare moments to this all-engrossing concern, and the very frequent mention made of Captn. Mangles and the specimens'; but it is obvious that this interest had become of major importance in her life. She was lonely, and her few feminine neighbours, though friendly enough, did not approach her in mind at all. It was easier to be friendly with someone she had never seen, with whom she could share an all-absorbing interest in flowers and all to do with them, and who made her feel that she was really contributing by her own efforts to the cause of knowledge. In a letter received while she was ill, Captain Mangles had asked her to write something for his 'Floral Calendar'. It was with sincerity that she replied:

I shall with unfeigned pleasure attempt to gratify you in writing in the 'Floral Calendar', but really feel you have over-rated my poor exertions in a

former description, and now I shall only, I fear, exhibit my impotency. But I will glean all I can, and pray my health may be so recruited as to permit of my making those much enjoyed Floral excursions. When I sally forth on foot or Horseback, I feel quite elastic in mind and step. I feel I am quite at my own work, the real cause that enticed me out to Swan River.

By the end of June the immediate danger had passed. Returning strength made Georgiana anxious to set down her thoughts for Captain Mangles.

In all my illness and real suffering I did not forget you. As Spring approached I lamented not being able to gather the flowers as they came out, and little Mary Dorothea was desired in her rambles with Amelia (not two years old) to bring in all the first flowers, which she did. A very dwarf species of Drosera, just like no. 110, large *Hortus Siccus*, only white instead of orange, and a powerful scent, resembling the snowdrop,—positively no delusion, no association, but bona fide resembling Britain's earliest tribute of Spring. Some at intervals of ease I dried and got the pressure laid on for me, and some Dora.

Once Molloy in Kangaroo Hunting brought me a bouquet of beautiful scarlet flowers, also dried, and which please God I ever get about again, I shall send and mark. I was surprised during my illness to receive a Nosegay from a Native who was aware of my floral passion. These are under preparation for you, and a pretty little white flower with small brown staminae.

I have often exclaimed this was the time I thought of riding out in search of new Plants, and scarcely a day passes I am not thinking of what I can do or how in any way I could promote your cause, especially when I have so many things of an imperative nature to wholly absorb my thoughts and time, and no female servant. I always thought when in low spirits and in much pain, 'Well, this is June and next month I hope and trust Captn. Mangles will have received the Box via America. I have been selfish enough to think much more of the Box and the unexpected pleasure you would have in receiving it than of the safety of the ship and her good and worthy Captain, who will relieve my anxiety by writing and telling me the means used in forwarding it. I know it is not worth freightage, but what am I to do? I seized the opportunity of making it up at Molloy's suggestion and candidly speaking, invited Mr Preiss here only to aid me in your behalf, which he certainly did, but gave me but few specimens in comparison to what he took away. I had, however, some of every kind. Molloy and I cannot leave home at the same time and if Mr Preiss had not rode out with me I must unavoidably have relinquished the pleasing undertaking. You may imagine how ill off I am for a companion when I seized upon an American Captain to accompany me before Mr Preiss came, and made the poor man dismount at every plant and shrub in seed I saw from Horseback on the ground. *He* could *not*, and being prevailed on at length to gather me some pods of Kennedya, asked me if they were good to eat!!

You will perceive this letter is written at various times. Two days have

now elapsed since I wrote the former part*. . . . We have had two American Whalers in since April. They are much pleased with Géographe Bay and say it is the finest Bay on the Coast. Indeed, as a place to land goods nothing can exceed its tranquillity; to use Molloy's phraseology, 'You might land them in a Washing Tub.' But in beauty it is not to be compared to Flinders Bay. The land all around this lies very low, no background, and saving Cape Naturaliste, no points or promontory. Toby's Inlet, which is on our grant, makes no projection and my mountain roving eye looks in vain for a rise or hill. To give you an idea of its good anchorage I will transcribe the different testimonies which the Whalers have borne to its safety.

This place, however, is by no means so healthy as Augusta, but I trust by the aid of Kangaroo soup, Porter and Port wine, soon to be restored.

But, my dear Sir, what really grieves me is that the season is rolling on and there is no ground fenced in and prepared for the reception of those valuable seeds you sent by Mrs Bull. Our having so very many things to attend to, and no hands to be obtained, we are yet without a place worthy the name of a Garden, and this wounds me, when I think of the one I left at Augusta, and how your beauteous gifts were thriving and would have flourished if they could have been here transplanted. Judge of my mortification the other day to hear that my *Cobea Scandens* which were growing so well before I was laid up, and which if ever I forgot, I used to get up in the middle of the night to water, were removed from under my verandah in the Box, and some luckless calves eat them up.

22 June: Thus far had I written, my dear Sir, when on Saturday as I lay but little amended, a party came in from the Swan, via Port Leschenault, with despatches, bringing many letters from England, and amongst the rest, your truly kind and delightfully long letter per *Prima Donna*. How shall I be able to express my gratitude towards you for such uncommon instances of friendship and liberality. We are really overpowered when we think of our impotent and circumscribed exertion in your behalf. Would that I could do more, and as I have before stated, I am particularly grieved that my illness has precluded my going out in quest of specimens which I was prepared to do. I intended giving you each plant as it came out, and flattered myself by the months of August and September, I should have wreathed you one of the richest and rarest coronals Australia could produce.

Dorothea has just brought me in a large bunch of purple Kennedya. The *Champion* having gone to India we have only received letters, but the *Lady Stirling* is soon expected down with the relief Troops and then we shall have the boxes. I only wish you could witness the unbounded pleasure that is evinced in the opening of a Box all the way from England. I assure you old and young are equally anxious and pleased.

About a week after the via America box was dispatched I had a large shallow one made with sliding lids for specimens too large to enclose in the *Hortus Siccus*, and after it was placed in the Dining Room, being 3 feet long,

* This letter was very long. The copy in the Mangles volumes is marked 'Extracts', and further extracts have been made. The letter is in places a little incoherent and repetitive, owing as the writer herself said, to her illness.

8 inches wide and 6 deep, I began to fear the price of freight, which you say you do not mind, but I am the last to put you to unnecessary expenditure, so if it comes I shall endeavour to make it worth freightage.

How unpropitious is my illness! The seeds by the *Prima Donna* could not have arrived at a better season of the year—June 29—and Molloy is fencing in a piece of nice Garden ground, so that by the time the Box and seeds arrive, we shall have a safe place to put them in. My room's windows and those of my sister look on to it. It will be ill off for irrigation in summer but by means of a watering engine, this might be amended. Please God to give me back strength and health to get about again. I can run back and forward from Baby to my garden, now the only pleasure (and that not an uninterrupted one) I can avail myself of. I assure you first and foremost stand you and your cause, both from positive inclination and real feelings of gratitude.[37]

The letter from Captain Mangles which had just arrived had mentioned several of the articles he was sending in the box, so, even before she set eyes on them, Georgiana added her thanks to her letter. There was a gift for Captain Molloy—a telescope which had belonged to Mangles while in the navy. He evidently felt it would be of more use to the settlers on Géographe Bay than to a dweller in London. Captain Molloy was delighted. There were in addition some maps: 'It will be very interesting,' said Georgiana, 'to look over the maps you mention. Nothing can give so good an idea of the country we inhabit as a Map, and I feel so little familiar with our present situation as scarcely to know where we are.' There were microscopes for Mrs Molloy, and a mouth organ for the children. The thanks for this last brought forth a perfect little gem of description:

The children will be quite delighted with the Mouth Organ. We are all passionately fond of Music. I have a little organ, or a sort of instrument like an Organ and Piano united. It is like a Work table in appearance and being a wind instrument has the advantage of not getting out of tune. This the children often dance to, and at dear Augusta, I used to take it on the Grass plot and play till late by Moonlight, the beautiful broad water of the Blackwood gliding by, the roar of the Bar, and ever and anon the wild scream of a flight of Swans going over to the Fresh Water Lakes. The air perfectly redolent with the powerful scent of Vergillia, Stocks, and *Oenothera biennis*, Clove Pinks and never fading Mignonette. We used always to have Tea outside, and for our amusement and interest I had sown the *Oenothera tetraptera* and *Oenothera biennis* profusely in the Borders adjoining this plot, so that we might watch their expanding blossoms.[38]

The box from Mangles duly arrived on 6 July 1840. It got severely wetted during the landing, as the sea was rough and stormy, the season being midwinter. Molloy took it to the house and opened it

at once for the edification of the invalid. Two o'clock dinner was announced while there was still more to take out. One of the things Georgiana could hardly tear herself away from was a small book on the botany of Swan River, with several illustrations, by Dr Lindley, who was known to her through Mangles's letters.

In September 1838 Dr Lindley had written to Mangles: 'I am bent upon publishing "A View of the Botany of the Swan River Colony".' He was anxious for materials. The work finally appeared under the title of *A Sketch of the Vegetation of the Swan River Colony*, in appendix to the first twenty-three volumes of Edward's *Botanical Register*. In December 1839 Lindley wrote to Mangles: 'I should have sent you a Copy of the Swan River Appendix for yourself if it had been complete, but I have deferred doing so till it is all out which will be on the 1st January. You see I have kept my word and described the Plants in good earnest.' His letter then went on to recommend some books for Captain Mangles to send as presents: 'The last edition of Sweet's *Hortus Britannicus* is the best to send, and his New Holland Plants would probably amuse your fair correspondent.'[39]

The materials from which Dr Lindley had drawn up his sketch were derived from a herbarium of about a thousand species formed, he stated, by communications of Mr J. Drummond, Captain J. Mangles, R. Mangles, H. B. Ward, and the gardener of H.R.H. the Duchess of Gloucester. It is more than likely that the contributions from Captain Mangles included Mrs Molloy's two *hortus siccus* which had arrived early in 1839 by the *Joshua Carroll*. Although Lindley does not acknowledge her collections specifically, Captain Mangles must have indicated in his letter that they had been used, for on 8 July 1840, she was writing with much gratification:

> The notices of the Swan River 'Floral Botanical Register' have quite inflamed my ardour, and instigated me to greater exertion, to think how small an aid I have lent your cause. The colour of the Patersonia is too Blue. The natural colour is more of a violet or Amethystine colour. It really is the colour of an Amethyst and there is a yellow species at Augusta, no. 99 large *Hortus Siccus*, with which Mr Preiss was not acquainted, but the seeds are widely different so they may not both be Patersonia. Mr Long shall not long regret his Nuytsias, if my health is reinstated. All Captn. Meares's and Mrs Bull's parcels go up with the *Lady Stirling* this time and I have written to the former to tell him of the numerous seeds you have so kindly sent me and begged me to send him, which I will gladly do when less hurried and stronger in head and hand than I am at this moment.

I am very much pleased with the Floral beauties many [books] contain
that you have written my name in. I send two flowers of the . . . I dare not
say what. Dr Lindley must determine. I shall be very glad if it is found to be
new, but much doubt it.

Still reading hastily this evening while cleaning the Books from Wet and
sand, the notices of the Australian flowers. I have more heart about those I
sent off but they were very coarse and look so un-neat in that horrid Log
Book. I am quite delighted to think I possess so many of the seeds I so much
longed for, as I see I do by Mr Long's list.

Mr Curtis called for letters, will not wait a moment, so *republican* are we
in this Colony. Molloy intended filling up this sheet and thanking you for
all your kind attentions, for the Telescope, Plants etc. etc. but now cannot.

I am glad to see the *Botanical Register*, it will give me a key to these
plants. Pray write immediately. May you have a full share of health and
spirits and every other good. Captn. Molloy and Sabina and Mary send their
best thanks and remembrance, and believe me, Your sincere and attached
friend,
 Georgiana Molloy.[40]

There follows, in Captain Mangles's volumes, a list of persons to
whom were distributed the seeds of the 'Splendid Isopogon' gathered
by Mrs Molloy in February 1840 and received a year later.

By the end of July 1840 Mrs Molloy had so far recovered as to be
able to ride out one Sunday afternoon, escorted by Vernon Bussell.
She had not seen much of the country round the Vasse and was
much interested. With her returning health she also began to take an
interest in the human life around her. Ann McDermott had spent
much time with her during her illness, and had probably talked over
the problem of Mr Green. Although not drawn very much to Mr
Green, Mrs Molloy invited them both several times to spend the
evening at 'Fair Lawn', perhaps to indulge in a little music and singing
at the organ.

During August, Mrs Molloy heard from Miss Fanny that John
Bussell had taken a census of the district, now that Busselton and
Wonnerup were attracting more and more settlers, and had found
that the population consisted of eighty-three souls.[41] Young Hepping-
stone had come over from Augusta and applied for a grant of land at
Wonnerup. In September Captain Molloy and little Mary Molloy
made an expedition to the Capel River on horseback—a long ride for
a little girl. Miss Kennedy began to talk of going back to England.

On 23 September 1840 the *Mentor*, a whaling ship, arrived from
Augusta with a Mrs Bryan and her family on board, who disem-
barked to settle at Busselton. They were almost the last of the

Augustans, the only ones left now being John Herring and the Turners. The *Mentor* was returning to America and it was discussed whether Miss Kennedy should take a passage on her. The Bussell ladies came and went a good deal: they had grown very fond of Miss Kennedy, and were sorry to have to say farewell. After several weeks the *Mentor* was ready to sail, and Miss Kennedy together with some other passengers, went on board. They set sail on 19 October. Conditions could not have been favourable, for four days later the *Mentor* returned to the 'Tub', as the landing place at Busselton was known. Miss Kennedy returned to 'Fair Lawn' for a few days, during which time Mr and Mrs John Bussell and Mrs Molloy were rowed out to the *Mentor* and went on board to see over her. On 27 September, she set sail again, and for the last time Georgiana saw her sister's face as she waved to the little group on the sandy beach gathered about the 'Tub'.

The 'Tub' was a landmark well-known to the whalers and colonial schooners that sailed this part of the coast. It was a barrel at the top of a long pole, and it marked the place on the flat and desolate beach where it was customary to land stores and passengers. Before there were any buildings or roads in the town-site the bullock tracks to 'Fair Lawn' and 'Cattle Chosen' started from here. At a slightly later period a lantern was hung from a yard-arm on the 'Tub's' pole. This improvised beacon was the only one that Géographe Bay could boast for the next thirty years, until in 1873 a small lighthouse was erected about a hundred yards from the site of the 'Tub'. The light-house was mockingly described by a local newswriter as like 'a huge Punch and Judy show on its travels, the outside covering drawn up to a certain height and the legs of the performer sticking through the bottom'. The inhabitants of Busselton, however, were pleased to have it: it represented a step forward from the lantern and the 'Tub'.[42]

⤜⤝

In July Mrs Molloy had received another letter from Captain Mangles. She replied in August:

> I felt very much pleasure, my dear Captain Mangles, in the receipt of your letter of the 25th March per *Chieftain* which I received on the 17th July. I mentioned in my last of the 7th July a severe hurricane which occurred at the time my letters were despatched. The American Whaler, the *Governor Endicott* came ashore in Géographe Bay and the same misfortune happened to the

North American, and *Samuel Wright*, both American whaling ships at Port Leschenault. Fortunately no lives were lost. We were greatly alarmed from the violence of the wind. The storm came on most suddenly about sunset and about two and three the next morning was quite awful.

Today I have been employed in your service. After breakfast the children and I went in search of Flowers. It has been a beautiful day and I have not been so long a walk for many months. I found two sorts of lovely Kennedya, nos. 50, 311. The first I had never seen before in flower altho' I sent you a green specimen and the seed by the Box which certainly must have arrived in the beginning of July. . . .

I was out riding a few days back and the country was assuming its usual garb. Hibbertias and Hoveas thickly covered the ground. I dried two or three specimens but not being able to gather them myself I did not get all I wanted. However, rely on it I will do my best. I have dried some beautiful specimens of Kennedya but by the time you receive them their brilliancy of colour will be fled.

I never ride out that it is not on your account. The other day, when in search for Nuytsia I had most delightful success. We went a very nice ride in a south easterly direction, following a small tributary stream to the Vasse. The banks were thickly studded with Banksia, Accaccia & the She-oak; the ground was adorned with the crimson flower of Kennedya, but not so profusely as it will be a week or two hence. All at once after going through an interminable grove of Jacksonia we came on to an open plain of many acres in extent, scarcely a tree on it and those that grew there were large and fine. I discovered a plant I have been almost panting for, a very small neat white blossom, on a furze looking bush, I do not know the number, it is in the last collection and Mr Preiss could not tell the name, it being peculiar to this Vasse country. We found a large quantity of it. A little further on another enigma was solved. The beautiful white-blossomed tree, the flowers I sent in my last, I found to be the identical Tree which bears those wooden Pears or Nuts. The fruit was hanging on the tree but was too high for us to reach. I was quite happy to make such a discovery. As the shades of night were commencing, we reluctantly turned homewards when other agremens met my eye—what but a grove of *Nuytsia Floribunda*! I thought myself really blest that these desiderata should place themselves before me, and going up to the trees I unhappily found I was too late, I should but for my illness have had the seed. It was too dark to detect seedlings, but these I will repair for. You will think I am romancing when I tell you that out of this Nuytsia swamp we came on one as thickly and universally covered with Kingia, if I understand rightly what Kingia is,—the grass plant with many short heads branching out, whereas the *Xanthorrhea hastile* are very tall and upright. These four things had occupied my mind many a long day. I was quite exhiliated [*sic*] I had found these treasures so unexpectedly. Before this I was working blindfold.

I have received both your delightful boxes per *Chieftain* and am extremely obliged for the many beautiful and valuable contents: Mrs Loudon's *Flower Garden* is beauteous and elegant beyond description. I feel highly indebted

not only to you but to that superior-gifted Lady for the exertions made to strike off an immediate copy.

14 August. I have been out again today for Nuytsia and Kingia, and could only find the former by suckers from the Parent tree, not being enough acquainted with their juvenile appearance to pronounce them young Nuytsia. I have got many roots which I dug up myself, also the fruit of the Xylomelum. I trust I shall be able to send Natives for flowers and seeds, as I have shewed and described several plants to them.

The season is most delightful and inexpressibly inspires me with my pleasant and consonant work. I should like nothing better than to kindle a fire and stay all night as I should be ready for my work early in the morning without again coming so far, or effecting any collection. It was truly enjoyable surrounded by new and refreshing Flowers, some I had never seen in bloom before. I was looking for the Nuytsia,—this was on the 12th,—and was really led to the spot by the different bright colours we saw in the distance. We had to pass through a swamp of Hakea; the sunny evening and perfect stillness which everywhere prevailed with the total absence of other beings besides ourselves & a single Native, and recollecting I was employed in the delightful service of so kind a friend made me really feel singularly happy and free from care.

While thus ruminating I beheld for the very first time a most truly elegant small blue flower which I enclose. I never saw it elsewhere, it is quite new to me, I think its beauty can only be advantageously viewed through a magnifier. . . .

For Shakespeare you have my most grateful thanks. It is a work we did not possess and it is one I have often during my illness wished to refer to, and intended to put it in the List of Books for Molloy to purchase on his visit to England. Everything arrived in excellent order, and I find the Botanical Case very useful. I was cogitating what I should contrive to convey the specimens home in to have them fresh. Molloy and I had been planning three thin boards with leather straps and Buckles and I had given orders to the carpenter, when strange to say we received your Box containing the case that very night.

Time will not permit of my particularizing all your munificent gifts. They really make me ashamed to accept them, and I am impatient to take advantage of this opportunity, viz., the sailing of the *Mentor* from Augusta to America.

I went out yesterday with Captn. Molloy and a Native in order to get seedling Nuytsia and Kingia etc. I rode and Molloy walked so as to be able to gather the different desired plants. I unfortunately could not cross the only Ford which took Kate breast high not in the deepest part. I knew she must swim, and it would not be prudent in me, in my infirm health, to venture. We had to relinquish our intended project and dear Molloy, who was on the other side of the stream, obliged to come over on a fallen tree which took him in parts knee-deep. You would have smiled to see me urging on my horse in the Middle of the River, and the native Calgood calling out, 'Lady Molloa, Mocho too much, Mocho too much!' We returned on Calgood's promising to find a more fordable part which never occurred, however we

did not lose our purpose as I saw that no time must be lost in collecting specimens. . . .

My husband and sister laugh at this all-engrossing theme. They declare it supersedes everything, and I shall be like the poor Maniac described in the *Gardener's Gazette*, who was taken before Mr Barlow of Kensington declaring her children smelt like Pinks![43]

Meanwhile in England Captain Mangles had been assiduous in distributing the seeds that Mrs Molloy had sent via America, which had reached him in June, earlier than she had expected. He also passed round her *hortus siccus* and letter of January 1840. Loddiges the nurserymen thanked him for seed, as did Long of the Zoological Gardens. Paxton wrote from Chatsworth that he was 'very pleased to hear such a charming account of the Vasse, and of Mrs Molloy's success'. Dr Lindley asked for some of Mangles's interesting letters from his correspondents to be published in a weekly garden newspaper, and Mr Hailes from Newcastle wrote at length in reply to Mangles's 'very interesting letter' which must have given some account of his various collectors in Western Australia, for they appear mirrored in Hailes's rather emotional prose:

I sincerely trust, Captain Meares finds his Hut at Swan River affords more real comfort than the gay doings of the Life Guards. I cannot find language to describe my feelings at James Drummond's black ingratitude. These black spots are perhaps of this only use—they set off the clear bright gems of friendship to perfection, and give them a double lustre by the contrast. I have seen something of the fine names given to seeds turning out to be mere fiction—some I suspect of this base fellow's work. It must indeed be a pleasure to hold communication with such as Mrs Molloy and Captn. Meares, especially after having been so treated by the selfish fellow and I sincerely hope they may long enable you to add the splendid Plants of Australia to the Gardens of England.[44]

Life—and Death—at the Vasse

AMERICAN whalers were coming in increasing numbers to Géographe Bay, for it was a good anchorage, there was plentiful wood and water, and with the various small farms becoming more established, the whalers could trade commodities such as molasses, knives and boots with them in exchange for butter, cheese, chickens and vegetables. Unfortunately many of the whalers also traded rum and spirits, as did the coastal vessels too. In April 1840 Georgiana Molloy had remarked: 'We have had six American Whalers in since January and they are charmed with the Bay. They are of great use to us and as yet all have been temperance ships—the greatest qualification they could possess. Indeed, we have no Public House in the district and Heaven grant it may long continue.'[1] But this happy state of temperance did not continue long, for on 1 December 1840, Captain Molloy had written in some dudgeon to the Colonial Secretary:

> Sir, Much irregularity and drunkenness has prevailed in this district since the last visit of the *Champion* at this port, Sergt. Guerin having a large supply of liquor by her. He obtained a License as a retail Dealer from the Collector's office at Perth, which is in this case infinitely more injurious than a Publican's license would have been. May I request that applications of this nature may for the future be rejected unless recommended by the local magistracy?

His request, however, was merely minuted by the Governor: 'The Government have no powers to refuse retail dealers' licenses to anyone. The only remedy in the hands of the authorities is the infliction of the severest penalties on individuals who may be convicted of drunkenness.'[2]

Molloy's next move was to write in February 1841 requesting permission to remove the stocks from Augusta to the Vasse, 'at which

latter place it is hoped they may have a salutary effect'. This brought forth the dry comment, in Hutt's strong black handwriting: 'Why not put up new ones at the Vasse?'[3]

The effect of a dozing drunkard lolling in the stocks was not as salutary as it should have been. Owing to Sergeant Guerin's once having been issued with a licence to sell spirits, he was enabled to re-apply and duly did so. This occasioned a hot letter from Molloy on 12 February.

> Sir, I have the honor to inform you that on the 1st January last I was constrained to issue a License to Roger Guerin as a Retail spirit dealer. This Man's establishment is an inconceivable and almost unbearable nuisance for which the Law seems to have provided no remedy. A few drunken characters had retired to this secluded spot from the Swan district to avoid the temptation that was before them there. An occasional outbreak did take place whenever they could procure the means from any of the visiting vessels, which did not occur often, continue long or press itself upon your notice; but now the interruption to Rural labor is so frequent that I can affirm that in some instances it has amounted to more than one half of the Laborer's time.
>
> The mode, I believe, is for a few of these deluded men to club, as they call it, for a Gallon of spirits, and then retire into some part of the wood adjoining the land of the spirit dealer to consume it, repeating this as long as they are able or have the means of procuring it.
>
> It could never have been contemplated, I should think, to grant a dealer's license where a Public House did not exist, as to me it seems to embrace all the evil of a Public House without any one of its advantages: Inasmuch as the spirit dealer offers neither food nor accommodation to the wayfaring man, can vend on Sundays, is under no penalty for selling to a drunken man. The seamen from the different vessels at times here not being able to obtain any refreshments at this man's house remove to the houses of the neighbouring settlers to consume their purchased liquor, and here arises another source of annoyance both as to example and the seductive invitations to the servants to join them.[4]

His impassioned remarks did not have any noticeable effect. Drunkenness was prevalent throughout the whole colony, and indeed in all of the Australian colonies. It was regarded as a palliative of the hard conditions. Conditions on the whaling ships of the period being pretty hard too, seafaring men regarded their time ashore as one of relaxation to be brought about by liquor. It seemed that a public house or inn would be some sort of a solution of the problem, in limiting to a certain extent the amount of liquor served. Two years later Roger Guerin was issued with a licence for 'The British Fusilier' at Wonnerup, his sureties being Elijah Dawson of Wonnerup and

Jon. Gile of Busselton. He had competition to meet, for at the same time a licence was issued to George Chapman for 'The British Queen', also at Wonnerup, Chapman's sureties being his brother Henry, and C. J. Sholl, both of that district.[5] It was some years later before a public house was opened at Busselton. No trace now remains of the inns at Wonnerup, which would have been no more than low-roofed, wattle-and-daub cottages with a sign hung above the door.

Captain Molloy was on very good terms with the captains of most of the whalers. Occasionally he had to take a strong tone with one or other of them when they and their crew were too undisciplined. To J. Dennison, master of the American whale ship *Hudson*, Molloy wrote on 4 October 1840, giving him three days to leave Busselton:

> Sir, I have peremptorily to forbid your cutting timber or trespassing on the Lands situate in this district under my charge, on pain of being proceeded against according to Law, as in your case in a summary way. I have further to request you will forthwith give the required security for the good conduct of yourself and crew whilst it may be requisite for you to remain in this port for your accommodation. I limit the time for your fulfilling this obligation to the 7th inst.[6]

The crew of the *Hudson* must have been an undesirable lot, for usually wood and water were not grudged to the ships. Many of the captains came from good old New England families. Molloy enjoyed their company, often having them to dine at 'Fair Lawn', and they for their part must have appreciated the glimpse of family life thay got on such occasions. They were lonely men, away from their neat little white New England homes for years at a time. Perhaps they would speak in their slow drawling voices of places they knew, names that to the English settlers in this new land were like an echo of home—Johnnycake Hill in New Bedford, Falmouth (but of Cape Cod, not Devon); Brunswick, Maine. Perhaps in return for their confidences Mrs Molloy would allow something of her enthusiasm for the scenery of this new country to be seen. It may have been to gratify an expressed wish of hers to see Cape Naturaliste that Captain Plaskett of the *Napoleon* invited the whole family to embark on his ship, offering to sail them along the coast to Castle Bay near the Cape.

Mrs Molloy wrote to Captain Mangles on 20 January 1841:

> Since my last, we have all been on an excursion to Cape Naturaliste, Castle Bay and Rock. We spent a week there. We sailed to Castle Rock in the *Napoleon*, Captn. Plaskett, in company with the *Monpelier*, found the *Hibernia*

there, and in the evening—a lovely, beauteous Sabbath evening—two other American ships came to anchor, the *Izette* of Salem and the *Uncas* of Falmouth. I spent almost the whole days off Castle Rock on shore gathering seeds etc. as the flowers were very few. I rode and partly walked one day to Cape Naturaliste, a most bleak and barren headland, a distance of 16 miles. We returned by a boat to Toby's Inlet on our own land, where the *Governor Endicott* was wrecked. There we pitched a Tent and remained two days and returned to 'Fair Lawn', being one week absent. A most delightful trip, this is the clime for such excursions, no apprehension of insecure weather or danger of taking cold.[7]

'*10 January*: The Molloys returned from their expedition to Toby's Inlet', noted Miss Fanny Bussell, who kept a sharp eye on all the comings and goings of her neighbours; and the following day: 'Five ships in the Bay'.[8]

During the whole of January there were seventeen ships, all told, in Géographe Bay, nearly all of which were whalers. Whaling was in its hey-day. Sperm oil was fetching £105 per ton on the London market.[9] Leviathan disporting himself in the waters off Géographe Bay was lending his aid in forming a settlement there.

Mrs Molloy continued in a further passage to Captain Mangles: 'You will perceive how very much pleased we all were with Castle Rock and Bay, and I in particular from its rich soil and resemblance to Augusta.' Unfortunately she did not enlarge on how the four little Molloy girls regarded this exciting, though brief, journey in the whaling vessel with its painted figurehead breasting the waves, and its strong-railed decks. They would be shown the coppers for boiling blubber into oil and the heavy, long-handled iron spoons for stirring it, and the stout casks to contain it. Their little fair heads would be close together to examine the bits of scrimshaw the seamen were carving on whale bone and ivory—designs delicately etched by rough hands with a sailmaker's needle, then rubbed with soot or ink—drawings of sea scenes or pretty girls with ringlets and high-waisted gowns. These the sailors made for presents to take home. Sometimes they made the whale bone into bodkins or tatting shuttles, or corset busks. Such a busk might have scratched on it a verse:

> *This bone once in a sperm whale's jaw did rest.*
> *Now 'tis intended for a woman's breast.*
> *This, my love, I do intend,*
> *For you to wear and not to lend.*

Georgiana, however, was rapt over the scenery. Castle Rock, or Meelup, to give it the native name by which it is known today, is a picturesque spot.

All the American Captns., five in number, concurred in declaring its valuable situation, not only wood and Water, but the position of this. I understand nothing but the beautiful and congenial scenery to me is exquisite and soul-enjoyable in this part of the world, and so pleased was I with this enchanted Valley—a ravine of about 100 acres in extent, with a rapid stream in Winter, then (the first week in the New Year) dried up, that I conjured Molloy, nothing 'en publique', but to apply for it. It would have given us the first choice of all supplies, the first intelligence, and as the Vessel proceeded to Géographe Bay, time and leisure to answer all letters. All vessels pass it for the Swan and Leschenault, whether or not they put in at the 'Tub'. The banks of the richest black mould rise abruptly from the ravine, now studded with your choicest Green House shrubs, Hoveas, Kennedya, of colors Helichrysum, Macrantha, Thysandtis, White Kennedya, and the tall handsome Blackboy, or Grass plant of Augusta. This in the face of the boundless Ocean, for in the Bay you cannot perceive anything of Cape Naturaliste. This dell is confined by high Granite Rocks just as it were poised ready to fall, very high, and extending up this Valley gradually rising from the beach until it attains of much above 400 feet! What a view from a Breakfast room, a cottage with a circular Verandah entwined in this sheltered spot with Nature's choicest flowers and fruit, the land of all others for vines, as the roots would strike rapidly into the bed of this torrent. Then a well-laid-out garden on each slope and the eye to be raised to these beautiful Rocks. Standing in the room or Verandah the summit could not be seen, consequently so much more left to the imagination. Then outside again would be this elegant Cottage in the midst of luxuriant cultivation and opposite would be contrasted these rocky heights. On the left you perceive wild trees in the distance with overhanging branches marking the course of a stream, and on the right, the only present accessible point from the Beach, you see the Bay, now and then the top of a Mast, a bowsprit or part of a flag and sometimes the whole Vessel. Strawberries would thrive admirably and how rejoiced would many of our seafaring brethren be to be able even to get the most ordinary fruit which in this barren land they cannot obtain even at any price in the profusion required. For want of attention and labour neither a Melon or cucumber has this year been grown at the Vasse, and at Augusta where no ships put in, Barrowsful have been given to the pigs. Mr Little at Belvidere, Leschenault, raised an immense quantity from the seed you sent Mrs Bull and speaks most highly of the Persian. But to continue my long story of Castle Bay,—several of the Captains dug wells there and were much pleased as they were close to the Beach. A granite Quarry exists in this dell. There are 7 fathoms of Water close in to the shore at the side of a very large Rock where Captn. Plaskett sent his boat daily to fish, which is there abundant. Captn. Molloy could not at present purchase any land there, but is much inclined from its position.[10]

Being obliged to lay aside her letter, Mrs Molloy continued it at the beginning of February 1841. By this time she had received a letter from Captain Mangles which evidently gave her news of the raising of seedlings in England from the packages she had sent. 'Up in four days,' she noted. 'How very gratifying. Do tell me the numbers and names!' Mangles also must have displayed interest in 'Fair Lawn' and asked for a description of the house, for on 6 February Georgiana continued:

The House is situated about 100 yards from the River Vasse, a very small sluggish stream. We have no Hills or any rising ground as scarcely to be able to see the clouds, unless we look upright. We never see the sunset for the surrounding Forest. Two miles from the sea, a track made by the Bullock cart being the road from thence. I do not think we shall be long at 'Fair Lawn', as I think it by no means well situated, and had I previously seen it, never would have built on that part of Molloy's grant. It is so hot in summer, all the labours of Winter in the garden are burnt up. We intend having a Winter and Summer Garden. The summer one will comprise all the land and gentle slope between the River and Pailing in front of the House. The Flower Garden that is to be, lies on the left and on the very Verge of the River. I intend, please God, to cultivate China Asters according to the Chinese Mode. The rich carpet they present to the eye will be pleasant to look upon from the dwelling house which looks immediately on to it. . . .
Molloy will subjoin a ground plan of what our house is, and is to be, when workmen can be procured.[11]

Unfortunately Mangles did not have this plan copied, if indeed it ever materialized, Molloy at this time being busier than ever before. Georgiana was never to see the house which for more than a century would be known as 'Fair Lawn'. This, a two-storeyed dwelling with a court-room at the side, was not begun to be built until 1853.[12] A visitor describing it in 1856 refers to its

curious architecture—one room thirty feet square—with bedrooms over, separated only by thin deal boards, and numberless unfinished poky places. . . . Large room used for meals, serves also for putting away in the corners harness and saddlery, flour, sacks, seed corn, wool, etc. etc. Adjoining is a nice small room, papered, with calico ceiling, which I suppose I must call the drawing room. Stairs outside, built over. . . . [13]

It is to be feared from this that Captain Molloy was not gifted as an architect. Nevertheless, the building was strongly made of lime-stone, and the large room had as its main beam the huge timber from a ship's keel. It was built to endure, and endure it did, even though a

hundred years later the roof was ripped off, the upstairs walls added on to, and all the piping, tiles and cement of modern plumbing introduced (Plate 8). 'Fair Lawn', when it was first built, with its outbuildings, stone-walled yards, slab fences, and spreading gardens, was indeed a colonial country gentleman's residence.

᚛᚜

As was her custom, Georgiana put her letter by to continue at a suitable opportunity. February with its long hot days, heavy with scent of bushfire smoke, ran on. A native fire had partly destroyed the new bridge over the Capel River. Molloy irritably composed a letter to the Colonial Secretary announcing the fact and presuming that expenses for repairs would be sanctioned. It was hard to wring any expenses from the Treasury: the matter of his horse-hire was still pending, and rankled. He was not at all pleased when he received the reply about the bridge over the Capel. Hutt's minute on his letter reads: 'Sanctioned, but why was not care taken to clear round the bridge and prevent this misfortune happening to it?'[14] The surroundings of the bridge had of course been cleared when it was built in August, but the spring had raised a new crop of undergrowth which was tinder-dry by February; just the place for the blacks to set fire to and start the small game—kangaroo rats, lizards and wallabies.

The natives were being very troublesome again—not only in their usual way, with thefts of potatoes and flour, which was bad enough when such staple foods were still in scant supply—but in more dangerous fashion. The cause of the trouble lay back in the previous year, 1840, when a boy, Henry Campbell, had been speared at Leschenault in May. Two of his murderers had been caught and sentenced but a third had escaped. Seven months later, in December 1840, John Bussell had seen this native, Nugundung, on his way from Leschenault to the Vasse, and had arrested him on the evidence of James Blythe of the 21st Regiment. Bussell had taken the prisoner to the Vasse and from there had sent him to Fremantle to be tried at the Quarter Session. No death sentence had been passed: Nugundung had been sent to a year's imprisonment on Rottnest Island, then a penal settlement for aborigines.[15] This had had two results directly leading up to the events that followed.

The first was that Nugundung's light sentence only convinced the settlers that Governor Hutt's policy towards the natives was too lenient. Five months after his arrival in the State, Hutt had addressed

a despatch to Lord Glenelg on the subject of the aborigines, showing that he had given considerable thought to their position as the original residents in a land that was now subject to British law. In his detached way he had observed that the aborigines, though British subjects, were not tried for their misdemeanours by their peers, but by Europeans, as their own countrymen were incapable of such a task; and that they did not understand the nature of evidence on oath. From this various consequences flowed. Settlers who could not obtain justice for wrongs suffered from the natives for lack of proper evidence and proof, were inclined to take the law into their own hands and deal out their own justice. Hutt therefore recommended that the law should be modified so that both aborigines and settlers could receive justice.[16] He recommended the establishment of the office of Protector of Natives. This was accordingly done. It did not please the settlers, and although in a letter of 'Instructions to Resident Magistrates' Hutt gave them as a rule for their conduct to natives: 'No offence which they [the natives] commit, if declared to be deserving of punishment, should ever be passed over; for however long a period the offender may escape, let the hand of justice reach him at last . . .'[17] nevertheless the settlers found in several cases that the hand of justice lay extremely lightly.

The settlers thought that Nugundung had got off too easily and did not hesitate to say so. In a letter of 10 March 1841 to Governor Hutt, John Bussell, after protesting his right as a magistrate to arrest Nugundung, evidently implied that local opinion thought the Governor too lenient with native murderers, for in reply the Colonial Secretary answered him:

> The last sentence in your letter was wholly unnecessary as the Governor has not the power, were he ever so inclined, to let loose a man charged with murder unless he has been previously tried and found innocent, and that he cannot therefore avoid expressing his astonishment that any idea of the sort should have been conceived and propagated among the settlers in the Vasse district.[18]

However, in spite of the Governor's astonishment, the settlers did hold the idea and in some degree it influenced their subsequent conduct.

Secondly, from the natives' point of view, the seizing of Nugundung was a wrong done to them. Two of their number had already suffered punishment for the death of one white boy. Nugundung's tribal

relatives swore vengeance. Bunny, a native constable, had heard them declare this. 'When at Leschenault he heard Dundap and Guabagood, two of Nugundung's relations, declare they would spear Blythe a man who assisted Mr John Bussell in taking him up. Wobudung, Mamerdung and Mungo have also declared they would kill a white man in this quarter so that there might be one at each place.'[19] Native constables were an idea of Hutt's. They were attached to the Protector of Natives. 'The best behaved, most intelligent and influential individuals are selected for the post,' Hutt reported to Glenelg. 'They cannot be kept very staunchly to their work; but when regularly and actively employed, they receive as pay one pound of flour daily, besides the present occasionally of a woollen shirt.' Bunny was in the employ of Captain Molloy.

Beyond making threats the blacks had not taken any immediate action, but their aggressiveness was growing. A neighbour of Mrs Molloy's, Mrs Bryan, recently arrived from Augusta and living by the New River about three miles from the Molloys, was approached in February by the native Kenny offering fish for sale. She did not want it. She was alone in the house as her husband was working up at Wonnerup for Mr Layman. Kenny appeared to know that her husband was away, and was threatening and abusive. A daring, impudent man,' she called him. She was so upset that she packed a few things and went up to Wonnerup to be with her husband.[20] Whereupon Kenny and some of the others stole stores of rice and goods belonging to her.

The situation was as tinder-dry as the undergrowth around the Capel bridge. It only needed a spark.

On the evening of 22 February 1841—a calm, hot, stifling evening— various natives were gathered round a fire just outside the kitchen of Mr George Layman at Wonnerup. The air was loud with their vociferous noise and the firelight played on their greasy bodies and snaky locks. One of them, Cobbet, had been hunting wallabies all day, and had come up to Mr Layman's house with two opossums, one wallaby and two kangaroo rats. He was loitering about hoping to sell them to Mr Layman. Many of the other natives round the fire had been working for Layman during the day and had received payment in the shape of a certain amount of flour each. They made dampers with it to cook in the ashes—they were very fond of the white man's food. When their dampers were cooked, Gayware, one

of the elders of the tribe, took the damper of one named Milligan. Milligan went into the house and complained to Mr Layman. Cobbet edged over to the door. He saw Mr Layman come out and take Gayware by the beard, saying: 'Why have you stolen Milligan's damper? Give it up.' Gayware replied: 'No. Milligan has done little work. I will give him a little.'

George Layman was young and hot-tempered. He had had about all he could stand of Gayware who was a well-known thief and trouble-maker. He seized the old man by the beard again and shook him. 'Give it up,' he commanded, and thrust him away. As he turned to go back into the house, Gayware snatched up his spear and launched it at him. It struck him in the left side. He pulled it out and staggered toward the kitchen where the servant Elizabeth Barsay and Anne Bryan were preparing supper for the working men. Anne Bryan heard him call for a gun once or twice, then say: 'I am speared!' Then he came in, fell down and died. John Dawson, who had been eating his supper, had rushed to get a gun and when he came back Mr Layman was lying on the floor, blood streaming from his mouth.[21]

Outside, the natives had vanished, melting into the bush like black shadows. Only one person remained in the firelight, a small boy of nine years, John Heppingstone, who had been watching the blacks at their meal. He alone of all the white people at Layman's had seen the whole thing. Next day he told his story upon oath (having had the nature and obligation of an oath explained to him) and the day after added, 'After Gayware threw his spear I saw Woberdung ship his also and throw it but I don't know whether it struck Mr Layman. It however passed between his legs.'[22] Later when the native Cobbet was caught, his description accorded with that of young Heppingstone.

In the Layman household all was activity. John Dawson had picked up the wounded man and carried him gently from the kitchen across to the house, but it was evident he was dead. Someone was sent to fetch the surgeon, Mr Green. Robert Heppingstone flung himself on a horse and galloped to Busselton to inform the Resident and the Bussells.

At daybreak the next day Captain Molloy and the Bussells rode up to Wonnerup. They stopped at the barracks as they passed, to call out the military. The military consisted of Ensign Northey, a corporal, and four privates. Of these, some had to be left to guard

the store with its precious flour, and it was decided to send two to Leschenault to warn them there.*

At Wonnerup the party heard the whole story of the murder and took down the evidence of the eye-witness, little John Heppingstone, and of the household servants. It was decided to assemble as many of the neighbours as they could get, and send out search-parties for the natives who had taken to the bush. But there was first one other duty to be done.

While the piercing noise of the cicadas split the hot air with sudden silences, and every dry stick that cracked in the heat sounded like a gunshot to the taut nerves of the onlookers, while men stood with bowed heads and fanned away the flies with hats held in their hands, Mary Layman, numbed with grief, saw her young husband buried at the foot of a tall tuart tree near the house he had built for her.

It was plain from what the native Bunny had said that the blacks had intended to kill a white man in vengeance for Nugundung. There was also a significant line in the boy Heppingstone's evidence: 'Immediately Gayware and all the natives ran away. I think they knew what was going to be done.' The settlers decided that firm measures had to be taken and Gayware had to be delivered up to justice without delay. For two days parties scoured the bush without a sign of any of the tribe. On the third night, or rather in the early hours of the morning when the stars were beginning to pale and the shapes of trees began to show against the greying sky, the pursuers saw the distant glow of a campfire, and as they crept up, heard the guttural voices of natives chanting the death of Layman. John Bussell could speak a good deal of their language. He whispered to the others that the natives were threatening to kill more whites. Gayware's voice could be heard, boasting of his deed, and imitating the dying man's gurgle. Even to those who did not understand the aboriginal tongue, this was plain. The sound of the death rattle, followed by cries and laughter, revolted the settlers to such an extent that they rushed on the blacks to seize Gayware and his sons. The blacks were quick to launch their spears, guns were fired and in the confusion and half darkness, five natives were shot, but Gayware and the wanted men escaped.[23]

* When he had time, Captain Molloy wrote to complain that the number of troops was inadequate. 'The spirit and activity of the settlers made up this defect,' he declared, 'or we might still have been reduced to the continuity of all evil, the perpetual uncertainty of Life and the destruction of Property.' But he was told the Commandant regretted he could not increase the number. See also Appendix F.

'In the evening,' Miss Fanny Bussell noted in her diary on 26 February, 'John, Captain Molloy and Mr Northey returned. Captain Molloy drank tea here. Seven natives killed. Gayware supposed to be wounded.' Two other natives implicated had been seen and shot while trying to escape, bringing the total to seven. It should be pointed out here that wanted natives when escaping were always exhorted to 'stand and surrender', according to British law. This the natives very rarely did, so that, the requirements of the law being satisfied, they risked the charge of shot that usually followed.

The search still went on. The Bussell and Ommaney diaries show that small parties of four or five went out daily. Nearly two weeks after Layman's death a native by the name of Crocodile offered to give information about Gayware. It was night-time when he volunteered this. Captain Molloy, hurriedly calling together a party consisting of Ensign Northey and his batman, Kelly, John, Charles and Alfred Bussell, Mr Vaughan and Balchin, a labourer, started off at midnight with the native Crocodile who led them to the blacks' hide-out. This time there was no escape for Gayware. He was shot by Mr Northey's servant Kelly, while trying to get away.[24] Now it only remained to take Woberdung, who had also thrown a spear at Layman, and Kenny and Mungo, all three Gayware's sons.

This called for a stratagem. On 8 March 1841, the day after Gayware's death, Captain Molloy wrote to Captain Plaskett of the ship *Napoleon*:

> Sir, I take the liberty in the service of humanity and your natural love of Justice to beg you would interest yourself in the apprehension of these natives whom I am informed are in the neighbourhood of the *Endicott* wreck. Mr Layman, who was known to you and regretted by all who knew him was murdered on the 22nd ultimo by a man named Gayware, his sons Woberdung, Kenny and Mungo are the natives I am desirous to secure for the end of Public Justice. The first named actually threw a spear after the fatal one thrown by his father. The second is an old offender who has been concerned in all of the robberies that have been committed on the property of the settlers or assaults and threats against their lives. Any movements from this quarter would lead to their immediate flight, but as they suppose you are ignorant of their aims, they will not suspect you. I therefore look with confidence to their capture as the result of your co-operation. Any expense you may incur or reasonable reward for the trouble this may occasion your men, I shall be happy as far as lays in my power to accede to.[25]

Captain Plaskett co-operated. He sent out a gunning party to shoot duck. Then he invited the natives on board the ship to dinner, to

feast on the duck. They came. After that it only remained for Captain Molloy to single out Woberdung, Kenny and Mungo, and interview them.

Woberdung said he and Eudine were at a distance, and pleaded not guilty. Kenny said he did not remember having used any threats. Mungo declared he was at Mr Bussell's house with two others when he heard of the murder. This page of statements bears notes by Molloy:

> The last mentioned native Mungo having generally a peaceful character and not having been present at the murder, though the accusation of threats was strong against him, was dismissed in consideration of his youth.
>
> Kenny was generally concerned in all outrages. The spearing of Elijah Dawson and his wife; killing Chapmans' cow, and in the present instance of the whites pursuing the murderers of Mr Layman, sending threats to intimidate the officers of justice, were selected from amongst some others on the charge of robbing Bryan's rice and intimidating his wife, thereby rendering it necessary for her to abandon her house.
>
> Woberdung as a principal in the murder and as an individual concerned in all outrages from the first to the last, we send on the evidence of an eye witness, corroborated by strong circumstantial proof.[26]

Captain Molloy then asked Captain Plaskett to transfer the other two prisoners to the Swan in his ship, and arranged for Plaskett to have the sum of £25 for apprehending and transporting them. He wrote to the Colonial Secretary to that effect, sending also the prisoners' statements and the depositions of witnesses. Woberdung and Kenny, on arrival at the Swan, were charged with an earlier murder—that of Henry Campbell the shepherd boy—and sent to Fremantle gaol.[27]

~⋇~

Captain Molloy had acted throughout the affair according to the rules of law and justice. He had maintained a soldier's discipline over a district where isolated units might have panicked and shot every native on sight. Stern measures had been put into effect and with the apprehension of the ring-leaders, trouble with the natives died down. The Protector of Natives sent in a report of the affair, and Governor Hutt rapped Molloy over the knuckles for promising a reward to Captain Plaskett, and for bringing him into it at all, as he was an American.

The Governor ordered the Colonial Secretary:

> Instruct the Resident Magistrate at the Vasse, that he must be careful hereafter not to offer any rewards when they have not been previously sanctioned by

the Governor. H. E., mistrustful always of offering any remarks on the best plan to be pursued to obtain the capture without bloodshed or violence of native offenders, can not avoid expressing his fears that the apprehension in this stratagem by Captn. Plaskett of these natives with whom he seems to have been living on friendly terms, may lead to various consequences in irritating the aborigines against white men who may live in future on that part of the coast of Géographe Bay where these prisoners were taken.

The Govr. is also extremely doubtful of the policy of employing foreigners to assist us in any occasion of the affairs of the colony. It might give them a pretence for interfering on occasion when their services were not sought, and at no time, whatever they might do, have the Govt. or its officers any control over them.[28]

But beyond that he had no criticism to make of Molloy's handling of the affair, and Hutt was not one to spare criticism when he thought it warranted. In reply to Molloy's two letters of 27 February and 10 March, reporting the murder and the subsequent measures taken, he did, however, draft out a long letter for the Colonial Secretary to send to Molloy. It required considerable thought, for there are many scratchings out and insertions in the margin, but the result was a masterly, though cold, analysis of the whole situation and the events leading up to it. It indicated the attitude of Government to the aborigines who, whatever their behaviour, were nevertheless subjects of the Queen and entitled to a fair trial.

The Governor has been greatly pained by the receipt of this intelligence from the Resident Magistrate at the Vasse. That an industrious and thriving settler, the father of a young family, should have fallen a sacrifice to native vengeance is much to be deplored and what adds to H. E.'s regret on this melancholy occasion is that this crime should have been committed in a settled and located part of the colony where the Aborigines have long been accustomed to the presence of white people and where therefore it might have been hoped that they would be so softened down or subdued as to render the occurrence of any such outrage most unlikely. The whole history, though, of the events which led to this unfortunate transaction shows how careful we ought to be under any circumstances in dealing with these people.

A boy by the name of Henry Pott alias Campbell in the service of Mr Wells residing some few miles up the Collie River maltreated one of the aborigines, who took the first opportunity of indulging his revenge in the only way which a savage understands, and in company with two others of his countrymen he killed Campbell. So soon as Mr Bull, then Rest. Magistrate at Leschenault, became acquainted with this he apprehended the murderers, and having satisfied himself of their guilt he should have sent them up to take their trial at the Quarter Sessions at Perth, instead of which he flogged them and let them go.

On hearing of what Mr Bull had done the Govr. gave immediate directions

for the recapture of the Criminals in order that they might be brought to justice and properly punished. Some delay occurred in consequence of Mr Bull at the time being about to quit the Colony but Mr Elliot having on Mr Bull's departure been appointed in his room, the same instructions were repeated to him. He replied that he would obey the Govr.'s orders, but that the natives would not understand punishment being twice inflicted for the same offence and he was quite sure that the offenders could not be retaken without danger to the lives and properties of the settlers. H. E. considered that this was an extreme case in which he must hazard a dereliction of the law in order to avoid worse consequences. Relying therefore on Mr Elliot's superior local knowledge he instructed that Magistrate that the murderers might be allowed to go free.

How well Mr Elliot judged, the sequel unhappily shows. Mr Bussell, a magistrate of the territory, residing at the Vasse, on meeting one of the accused named Ngukandang* in Mr Elliot's vicinity, without communicating with that gentleman, seized the man, conveyed him to the Vasse and finally sent him up to Fremantle to take his trial.

The aborigines would most likely not have regarded it had even the extremest punishment of the law been visited upon their countrymen in the first instance, but they did not, as Mr Elliot had stated, understand this second act of retributive justice and they vowed vengeance if Ngukandang was not immediately released; and then followed the unhappy scene, the murder of Mr Layman, at whose hands the natives had always received kindness and assistance. His death does not seem to have been premeditated or intentional on their part. Their feelings were roused, their passion excited, and a casual act of his own rendered him their victim.

The dispute respecting the flour or damper related in your letter occurred with Gaywar the Father-in-law of Ngukandang whose imprisonment and absence Gaywar was especially bound to avenge. Gaywar on having been compelled by Mr Layman to restore the damper which he had taken from another man made use of some sullen expression which irritated Mr Layman, it is understood, to shake him by the beard. This to any one would be a grievous insult but to a savage already sulky from supposed wrong it gave the opportunity of displaying his ill will, he seized his spear, and Mr Layman's death was the consequence.

In making these remarks the Govr. desires me to say that he has no wish to extenuate the conduct of the Aborigines but only to show that they had reasons for their conduct, and in their opinion, good and sufficient ones, and that it is by careful forbearance in our conduct towards them that we shall best protect ourselves against their irritability and violence.

The murder of Mr Layman necessitated the Magistrates to take prompt measures against Gaywar who had been guilty of it. The Govr. is aware of

* The spelling of the aborigines' names differs in almost every account. The colonists tried to write them phonetically, but some of the native sounds cannot be reproduced exactly, e.g. words or names starting with ng. Ngukandang, for instance, can be spelt Nugundung, and approximate the same sound. Also, Gayware was sometimes spelt Gaywal, Gaywarl or Gaywar.

the impossibility of capturing any of the aborigines except by an armed party and by stealing upon them unawares. There is always, however, danger in such an expedition involving the innocent with the guilty, and H.E. would earnestly beg of you to be careful whom you entrust with firearms at such times and not to allow them to be used except in the last extremity.

With respect of Gaywar's death I have only finally to remark that the Govr. would have preferred his being taken alive and executed according to the form of civil law. H. E. conceives that such a proceeding would have had a more lasting because a sterner effect; it would have been less of a vindictive character and he would not have fallen apparently contending against his enemies.[29]

The newspapers of the time, the *Inquirer* and the *Perth Gazette*, carried accounts of the murder of Layman and pursuit of Gayware, on 10 and 13 March 1841 respectively, before the news of Gayware's death had reached them. They may fairly be said to reflect the opinion of the colonists at the time, who had to live with the thought that the same thing might happen to them.

After narrating the attempt to capture the natives during which five were shot, the *Perth Gazette* said:

This summary proceeding will, no doubt, bring down upon the recriminating party the cry of unjustifiable homicide. Be it so. Bring any one of the cream-faced objectionists in the same position and see would they not do the same thing were they in the same place. . . .

We have no reason to commend or disparage the acts of those who have found it necessary to follow up the offending parties in this outrage, but from lengthened experience in the colony we are fully satisfied that prompt measures are required in such instances, not alone to avert future injury, but in mercy to the race of blacks who will if unrestrained, carry their lawless violence to such excesses as may lead to a fearful loss of life to repel their aggressions.

The same report said:

Coupled as our conduct has been with acts of kindness, and consideration for their [the natives'] situation, as contrasted with us of civilized life—the benefits we have conferred upon them far outweighing any loss they may have experienced from our occupation of their lands—and the uniform disposition of the whole population to administer to their comforts; these acts combined should at least secure to the distant settler an immunity from unprovoked outrage and security of property. But with the savages of this country, no moral obligation is binding upon them; we state this advisedly, knowing that the greatest acts of kindness—of relief in the hour of necessity—of protection from assailants of a neighbouring tribe—even support in the hour of death is thought of as lightly by them as though they were conferred

from a sense of obligation, or undeserving the simple return of common gratitude. The members of public societies and meetings at home may rant, fume and speechify to their hearts' content, but all this will not avail to unite the link between the savage and the man of civilized habits—this must be wrought by time.

Seen across the lapse of a hundred or more years, the reader of today may think this piece of journalism ironical. But it was written without the background of anthropological and ethnological knowledge that we have today. The study of native races had scarcely begun. It is therefore conceivable that the sentiments expressed in the article were those of sincere indignation based on an assumption that gratitude is an instinctive virtue, and that the natives should have been able to compare the benefits received (for, although it is a debatable question, the evidence seems to show that on the whole they were kindly and considerately treated) with their previous lack of them.

Public opinion in England had been aroused early in the nineteenth century by Wilberforce on the issue of slavery, and thereafter on the treatment of native races. As the *Perth Gazette* had anticipated, the circumstances surrounding the Layman murder were taken up by a certain body of opinion at the time. A letter in the possession of the Layman family shows this. Written to Mrs Molloy by George Layman's sister (then living in England) two years after the murder, it says:

> Dear Madam, In reply to your long and most kind letter which reached me in December, I must first beg that you will accept my very sincere thanks and also present the same to Captain Molloy for his polite attention to my somewhat confused application. At the time I before wrote, my mind was greatly distracted by the shocking intelligence I had been able to obtain. Doubtless the account published in our papers was inserted by an opposite party, as my dearest brother's conduct was represented in a very different light. Although nothing can bring back the lost, or repair the injury sustained, it is a great consolation to me to have had from such authority those most interesting particulars.[30]

The capture of Woberdung and Kenny had shed a blissful state of calm over the whole district. Life resumed its normal course. Mrs Molloy was able to write to Captain Mangles on 9 April 1841:

> Dear Captain Mangles, I have just returned from an attempt to procure more of the *Nuytsia Floribunda* seed. Molloy would not accompany me so I placed myself under the guidance of three of the Natives. I have sent out repeatedly

but without success and this evening obtained the enclosed, as from surrounding Native Fires they have ripened much more quickly than I supposed. I promised you a Bagfull and never could contemplate the murderous circumstances which prevented my obtaining it.[31]

This was Georgiana's only reference to the Layman murder, and yet she must have been very preoccupied with it, for Captain Molloy was made guardian of the four little Layman children, and she herself had written to the family in England giving them the real account of the affair. Molloy did not accompany her on her excursion because he was not feeling well. The worry and strain of the previous weeks may have been too much for him: on 11 April, Miss Fanny noted in her diary, 'Captain Molloy very ill.'

That Georgiana was not afraid to venture out alone with three natives reflects not only her own courage, but also that under ordinary circumstances the natives were not held in dread. Georgiana appreciated their help. 'The Natives are much greater auxiliaries than white people in Flower and seed Hunting,' she assured Captain Mangles. 'They ask no impertinent questions, do not give a sneer at what they do not comprehend, and above all, are implicitly obedient, and from their erratic habits penetrating every recess, can obtain more novelties. The grand desideratum.'

The next day she was writing again:

This is the third Friday three weeks running, my dear Friend, I have been employed in your service partly owing to the influx of vessels. It is a lovely luxurious morning, cloudy and gently-falling showers, the beauteous and gigantic Peppermint trees in front of where I write drooping their graceful form. My windows, or rather calico blinds, the former stitched tight on square frames, down, my doors open, the children playing in the verandah, the songsters of the wood chanting it so merrily. I could not refrain from putting some seed in, and just before I sat down, put in some Mignonette, just sent for winter flowering, and some Lilac and Nasturtium seed.

As always, she was able to depict the scene: the warbling magpies uniting their thrilling notes with the children's voices against a background of peppermint trees, drooping like willows where later a true willow, grown from a slip of the tree that hung over Napoleon's grave at St. Helena, would grow to noble proportions.

Knowing that Captain Mangles would be interested, because of his connexion with the Royal Geographical Society, Georgiana now retailed to him an item of local news.

Dr Carr, who has lately come out with the Australindians,* and is 'il Medico pro tem.', has undertaken to reclaim the Bones of Mons. Vasse, the Gentm. from whom this river takes its Name. Some society in Paris has offered a reward or present for them. These Natives know where they are, in the vicinity of Cape Naturaliste, and are now employed getting them, or for what I know, have got them. This event happened about thirty years since; this unfortunate Gentm. came in shore to explore, was seized, strangled and the spear went in at the right side of the heart. So runs the sequel. However, until enquiry was made by Dr Carr, he was never heard of. They represent him as being tall and thin according to the French Author's description, and when they bring the bones, he will easily be identified as their head and teeth are quite different to ours.[32]

In several of the facts of this paragraph Mrs Molloy was not quite accurate. The doctor who came out with the Australindians was named Carpenter, not Carr; and long before he made his inquiries, G. F. Moore of Swan River, who had visited the Vasse in 1838, had questioned the natives of the district about the French sailor, Vasse.

Vasse, the 'Gentm.' to whom Mrs Molloy referred, was a sailor attached to the French expedition of 1801-04. Two corvettes, the *Géographe* and the *Naturaliste*, under the command of Nicolas Baudin, had reached the shores of New Holland on 27 May 1801. Three days later they anchored in a bay which they called Géographe Bay. Here a party went ashore and later, when being picked up in the ships' boats at night, a sailor, Vasse, a native of Dieppe, was lost in the heavy surf, and as they thought, drowned. Péron, the naturalist of the expedition, gave an account of the incident in his journal, *Voyage de découvertes aux terres Australes*. The expedition then sailed away, having left a record of its visit in the names which exist on the coast-line today—Géographe Bay and Cape Naturaliste, Vasse River, Port Leschenault (after the botanist of the expedition who also gave his name to the sky-blue wildflower, *Leschenaultia biloba*), Point Péron and many others.

Forty years after the expedition there were still natives at Géographe Bay who could remember its visit. G. F. Moore, who had learnt the language of the aborigines and later published *A Descriptive Vocabulary of the Language in Common Use amongst the Aborigines oj Western Australia*, interviewed these aborigines about Vasse in 1838 and noted in his diary that Vasse had not been drowned as thought.

Some natives of that neighbourhood recollect him. They treated him kindly and fed him but he lingered on the seacoast looking for his vessel. He

* See p. 57 n.

gradually became very thin from anxiety, exposure and poor diet. At last the natives were absent for a time on a hunting expedition and on their return they found him dead on the beach, his body much swollen (as they described it)—perhaps dropsical. They offered to conduct me to the spot and show me his bones, but we had not time to go.[33]

However, when he returned to Perth, Moore thought the matter sufficiently interesting to write a letter about it to the *Perth Gazette* of 5 May 1838, giving a long translation from Péron's *Voyage*. Moore's letter in the *Perth Gazette* containing the information of the natives may have reached France and so have prompted the 'society in Paris' three years later to get Dr Carpenter to locate the bones for them. Georgiana wrote on 4 June 1841:

My dear Friend, I wrote to you about the 20th of last month. Captn. Molloy was about to depart to Leschenault to bring our new domestics which he speedily effected without any material inconvenience or delay. He left me on Tuesday and in his absence I applied myself most assiduously to my garden. Got in Anemonies, Peonies, Pinks etc. and in part of my own ground some onions, carrots, Peas etc. These are a sort of Apology for having a preponderance of Flowers, and the consequent absorption of time.

Our Winter has now commenced in good earnest, and I am now sitting before or behind a large fire composed of Peppermint and Jacksonia. My Window shutters are open (Glass windows I do not possess) and Molloy is laying flower beds with geometrical precision. I have sown both Lilacs and Peonies 2 months ago but I grieve to say they have not as yet made their appearance. If you only knew how interesting and useful Marnock's Magazine is to my horticultural pursuits, you would have some remote idea how much I am obliged to you for the book. Other works you have so kindly and considerately sent me are not only valuable but highly edifying in their information, but Marnock's is so universal in its remarks and gives the most approved and Modern culture of the generality of new plants. I take it up as a 'bonne bouche' the last thing at night when the House is in deep repose, and very frequently should I breakfast in my own room I consult it previous to my sowing peculiar seeds in the daytime.

The change of season somewhat perplexes me. At Augusta we were so sheltered and free from Frost, and our Gardens so much on the slope of the Hill, I had nothing to fear even should I be too early in sowing my Gems of the Garden—all sorts of Annuals. Mrs Loudon speaks favorably of sowing Larkspurs early and I cordially can bear testimony to the truth of this remark. In a former letter I asked you for a description of 'Maloa Creeana'. Casually looking over Marnock's yesterday I stumbled on it, and this is frequently the case. On looking over the rich and most select collection of seeds you have so repeatedly sent me, there are innumerable kinds lately introduced I am quite unenlightened about; I have not only the satisfaction of knowing how to cultivate them according to the most approved method, but most

generally through his and Mrs Loudon's beautiful illustrations to see the treasure I am committing to the ground.

I was quite at a loss to know what time to sow the Chinese Primrose, and I perceive from Marnock's Magazine I must not risk it in the open border during our heavy rains. I have now four beds of seedling Anemonies, and but for my last illness might have had roots as you so kindly sent me seed from Westmorland. I cannot get the Heartsease and stock seed to vegetate. I have soaked them, thrown them lightly on the ground, and various other means but without success. The Wallflower is a great favorite of Molloy's and out of a whole paper only six have come up, but these are Jewels bearing the Name of 'Best double German Wallflower'. The seed you sent out per *Chieftain* of Yellow Alyssum will not vegetate, which I regret as it is a great favorite of mine.

My Dairy is finished and I will get Mr Northey to sketch you a view from one of the adjoining rooms which I shall convert into a sitting nook for the Winter, whilst some repairs are going on in the Dining room. It will take in a side view of my room with the Maurandia trained 'en festoon' in my verandah, the shrubbery and flower and Kitchen garden, with the River as the most distant object. In this room I have ordered your most kind remembrance of Bookshelves laden with your manifold gifts to be put up.

I have spoken to several of my acquaintance to procure me the skins of Birds, so hope I shall be able to gratify you. Fortunately I have plenty of Duck shot, which in the season I intend giving to a Native named Bunny. He will shoot the Birds with all the dexterity of a good marksman, and I will get them neatly and carefully skinned and preserved. When Mr Preiss was here, for the use of my preservative soap he promised me many stuffed Birds, but none have as yet arrived. He is still in the Colony surveying on the Canning, I believe. I shall certainly write to him, and what I receive you shall have the whole. How much pleasure should I have had if any one had taken an interest in these things when I first arrived in the Colony. Nothing was heard of but Beef and Pork. The only two persons I met with to take any interest in my pursuits were Dr Johnson of the *Sulphur* who was fond of flowers and curious about collecting seeds, and a Mr Thompson, fond of preserving Birds.

It is clear that Mr Preiss had been somewhat of a disappointment to Mrs Molloy. After her hospitality to him, he had not communicated with her again, or sent her the specimens he had promised. He left the colony on 8 January 1842, by the *Elizabeth*, taking with him a large number of 'natural curiosities', as well as a collection of 2,700 specimens of the flora of the colony. This collection was described by Preiss, in collaboration with several European botanists, and published in Lehman's *Plantae Preissianae* between the years 1844 and 1847. It was to become of great reference value to botanists. The month he had spent with Mrs Molloy collecting specimens of the flowers

of the south-west, had been very profitable to him, as many of the rarest wildflowers were found there.

Georgiana continued:

I shall be at a loss to know what to send you of Novelties in the coming season, I believe I have sent you everything worth sending far and near, therefore what am I to do? Seeds I know I can never go wrong in supplying you with; but they ripen at such a broiling season of the year it is almost Martyrdom to procure them. I have two very pressing invitations to go down to the Sound and nothing would cause me sooner to go there than to be enabled to send you specimens from thence.

I will now give you Captn. Molloy's opinion of our present situation as regards a Port, written to me when absent as every hour we were expecting the *Champion*; nor, my dear Friend, would he have done this but at my earnest solicitude, as he has been so thoroughly disgusted with the Notorious Puffing and Mis-statement of this ill-fated Colony.

He writes, My dear Georgy, You wish me to state my candid opinion of Géographe Bay, and though my mind is overwhelmed with Miscellaneous Matter, I will hurriedly comply with your request. I have a great objection to express an opinion on a matter in which I am so deeply interested, and would rather refer you to what Captains Cole, Coffin and Plaskett have said on the subject. (These letters I venture to swell postage by transcribing.) But to the point. That Géographe Bay, in conjunction with Castle Bay, as forming a connected portion of a whole, will some day be a position of such pre-eminent importance, that the wonder will be, why it had not in the first instance been chosen as the seat of the colonial 'Metropolis'. The loss of the *Governor Endicott*, American Whaler, scarcely detracts from its merits, as it arose from a now evident cause—a foul Anchor, as the cable is now to be seen in the Water with a Turn round the Flue of the Anchor, besides when the Gale was comparatively moderate before it was near its height, she went on shore. Opposed also to her loss it is worthy of remark that the little coasting vessel, the *Lady Stirling* rode out the Gale in security. For eight months of the year I consider it superior to Table Bay. Captn. Coffin says he thinks it available the whole year round. He has lain there in the worst winter months and at all events with the refuge of Castle Bay it offers every security.

But look at their letters and if you like you may send them as the best and most unbiassed evidence that can be afforded on the subject. Toby's Inlet, of which I am possessor, is salt water during the summer months, a flow and ebb of the tide, which from the evenness and clearness of its banks has some resemblance to a Canal; it has always about 7 or 8 feet water within the Bar, ranging from three to four feet. It seems parallel with the Bay for about two miles, where the prevailing highlands about the Cape and the natural accident of the ground give it a course to the south of East. It is between 6 and 7 miles from Castle Bay by Land, and about 5 by water. The general tranquillity of this Bay and the prevailing summer winds being off the land, render the Boat Navigation safe and certain. Indeed its future

destinies may be to afford the pleasing prospect of a shore studded with villages and connected by an occasional isolated residence. Yours etc.

John Molloy.[34]

For the past four years or so, settlers along the coasts of Western Australia had been collecting evidence as to the advantages of their particular regions for ports and anchorage. On 25 May 1838, Thomas Peel wrote to the Editor of the *Perth Gazette* enclosing a letter from the American captain, David S. Adams of the barque *Pioneer*, giving his opinion of Safety Bay as a good harbour. This was followed on 14 July by a letter from H. Bull, Government Resident at Leschenault, enclosing one from J. H. Stackpole, master of the American ship *Harvest*, with a favourable account of Leschenault. Not to be outdone, Captain Molloy had gathered opinions of Géographe Bay from American captains of his acquaintance. 'The Americans come in at all seasons; they know more of this coast than we do and speak well of it,' remarked a diarist. 'If it were better known and English skippers would be more careful and less obstinate, it would be found a safer coast than that of England in bad weather.'[35]

All these accounts, from men of experience in sailing these coasts, were of great value to the Surveyor General. On 14 April 1840, the Surveyor General's office began issuing in the pages of the *Perth Gazette*, 'Sailing Directions for the South West Coasts of Australia'. Captain Mangles must have indicated that he was interested in accounts of good harbours for Georgiana to have asked her husband for this information. Her transcripts of the three American captains, Francis Coffin, ship *Samuel Wright*, William Plaskett, ship *Napoleon*, and T. Cole, ship *America*, followed.

In September 1841, Captain Molloy visited Perth. Although she was sorry to see him go, Mrs Molloy approved the purpose of his visit, for he was to attend a General Meeting of the Trustees of Church Property. Early in February of this year, Captain Molloy had received a letter from the Colonial Secretary informing him that a sum of money had been given towards the erection of a church at Busselton, and that the Governor wished a site to be selected as soon as possible. The Resident and the Assistant Surveyor, Mr Ommaney, accordingly selected a tentative site in the town-site of Busselton.[36] This matter of the church went back a number of years. A cousin of the Bussells,

Miss Capel Carter, to whom many of their earlier letters were addressed, had issued an appeal to friends in England about the year 1833 for funds to establish a church at Augusta. This lady only asked for the sum of sixpence to be contributed, and estimated that £500 would be sufficient.[37] £280 had been collected and had been held by the Society for the Promotion of Christian Knowledge, to be disposed of by Bishop Broughton of Sydney, whose diocese covered the whole of Australia at that time. The money was still held in trust while the migration from Augusta to the Vasse took place.

By 1841 the new settlement at the Vasse seemed firmly on its feet and the Governor wished to see a church established there, as the Colonial Secretary's letter indicated. However, the disturbing events of February and March—the murder of Layman and its consequences—put the matter out of mind for a while. On 2 August 1841, Captain Molloy had convened a meeting of magistrates and inhabitants of the Vasse district to discuss the matter of a church and to select a proper situation for it. The settlers being scattered over a wide area, the meeting had universally agreed that a spot halfway between the proximate boundaries of Busselton and Wonnerup would be the best situation. This spot happened to be on land belonging to the Bussell brothers, who consented to offer the land only on condition that they had the choice of land in the town-site of Busselton in exchange. Captain Molloy had conveyed the decisions of the meeting to the Colonial Secretary.[38] His letter was read by the Governor, who jotted down a minute on it:

> The Govr. cannot agree to this proposal made by Mr Bussell, and if no eligible spot can be obtained for such a desirable object as a church from a landowner at the Vasse without payment or exchange of some kind being offered for it, the Resident Magistrate is directed to make arrangements for the building being erected on the land reserved for this purpose on the town-site of Busselton.

When Captain Molloy reached Perth—on or just before 2 September, as on that date he put in a requisition for stationery consisting of letter paper, six quires; quills, 500 (this struck out and two dozen steel pens written in, which was to make quite a difference to his calligraphy, although he was by no means bad as writers went at that time); letter book, one; sealing wax, six sticks; and wafers, one box—he paid his usual round of calls. The meeting of the Trustees of Church Property was held on 7 September. John Molloy, Esq.,

Resident Magistrate of the Vasse, and J. Bussell, Esq., were nominated
as trustees for the district of the Vasse, and the Colonial Secretary
was informed accordingly.[39] A few days later the secretary of the
Trustees, Mr William Knight, sent in an application made by Captain
Molloy, on behalf of the settlers at the Vasse, for a portion of land for
the erection of a church and for a parsonage glebe, at an eligible spot
on the town-site of Busselton, consisting of about four acres. The
Governor was pleased to grant this, as well as a burial site at the same
place in fee simple.[40] This was the spot on which St. Mary's, Busselton,
was later to be built.

Captain Molloy returned to the Vasse and for the time being
nothing further was done about the church. Early in December 1841,
however, a new and very likeable personality arrived on the scene
in the person of the Reverend John Ramsden Wollaston. He had
migrated to Western Australia at the age of fifty and had taken up
land at Picton, near the new settlement at Australind, Port Leschenault,
in May 1841. From the moment of his arrival in the colony he had kept
a discursive and rather outspoken diary meant for the illumination of
his friends and relatives in England. He had made a brief, uncom-
fortable visit to the Vasse in October. In December (registering
the intention to stay at Captain Molloy's this time, 'where I hope
there is better accommodation') he met Governor Hutt at Bunbury
where they discussed Church matters, and journeyed down together
to see about the building of the church at the Vasse.

Hardly a move could be made in the small world of this colony
without someone jotting it down in his diary, letter or notebook.
The manner in which the Governor set out on such a journey was
described by E. W. Landor, an Englishman visiting Western Australia
at the time, who was later to write a book (*The Bushman*) describing
his experiences. Landor noted that:

The representative of our gracious Sovereign was habited in his bush costume,
—a white hat, bare of beaver, having a green veil twisted round it, a light
shooting coat and plaid trousers, shoes and jean gaiters. His illustrious person
was seated on a pair of broad saddle-bags, which went flap, flap against the
sides of his charger, as he jogged steadily along at the usual travelling pace.
On the pummel of his saddle was strapped a roll of blankets for the night
bivouac, and to one of the straps was attached a tin-pannikin which bumped
incessantly against his horse's mane. . . . Behind us rode his Excellency's man,
no longer the smug gentleman in a black suit, with a visage as prim as his
neck-cloth, but blazing in a red woollen shirt and grinning incessantly with

amazement at his own metamorphosis. Strapped to his waist by a broad belt of leather was a large tin-kettle for the purpose of making His Excellency's tea in the evening. Huge saddle-bags contained provisions, knives and forks, plates and everything necessary for travelling in the Bush in a style of princely magnificence.[41]

After joining forces with the Governor, Mr Wollaston was able to complete the picture. He was a little dismayed to find that the Governor was accompanied by a cart, servant and three soldiers, as this slowed up their progress. After starting from Picton at 7 a.m. he and the Governor had only reached the Capel River by half-past one, and there they had to wait for their dinner till the cart with the supplies came up.

We made a fire ready for our dinner, as well as to keep off the sandflies and His Excellency grew hungry and fidgety. On the arrival of the cart all right, to dinner we went. Some potatoes were immediately put to roast, a cloth was spread on the grass and a famous cold roast fowl which Mr Ommaney had given him, ham and a loaf of bread made their welcome appearance. These creature comforts were washed down with Madeira and water and we wound up with a Segar.

Dinner had a wonderful effect on the Governor's temperament, who I suspect is somewhat choleric. . . . There was however, an interruption to our meal which had nearly proved serious. The Governor himself had made a second fire in a hole behind him to keep off the troublesome flies. This had, unperceived by us, insidiously communicated with the grass, and I was startled at seeing His Excellency all at once jump up, with knife and fork in hand and mouth full of chicken and begin stamping furiously. I then perceived the fire had spread round him. . . . Had it in the eagerness of our repast, escaped notice, in all probability His Excellency would have found it necessary to search his knapsack for another pair of unmentionables.[42]

Wollaston was impatient at their slow rate of travel and made an excuse to push on by himself. He spent the night at Wonnerup, having been offered 'tea and a shake-down' at Mrs Layman's, and pressed on at daybreak the next morning, arriving at the Molloys' 'in time to partake of an excellent early breakfast in company with three American Captains, whose whaling vessels were in the bay. This was out of doors under a sail cloth and very pleasant in the cool of the morning. Hot rolls and a round of beef were indeed to me great dainties.'

The active, though somewhat deaf, little clergyman enjoyed Mrs Molloy's good housekeeping, and 'passed three very pleasant days at the Resident's house'. The Governor also stayed there, and Mrs Molloy's resources must have been strained to the utmost. Wollaston,

an observant man, whose sympathies were the stronger for having
seen his own wife struggle with tasks for which her upbringing had
not fitted her, noted in his journal:

> I could not help remarking to the Governor one morning, as Mrs Molloy
> passed in our view from the house to the kitchen, with the dinner dishes in
> one hand and her youngest daughter without shoes or stockings, in the other,
> how distressing and laborious must be the female emigrant's lot, who has
> in her native country been used even to the common comforts and plain
> cleanliness of genteel life.

Even in this brief time he formed the highest opinion of his host
and hostess, which he was to continue to keep.

> The Molloys are at present without servant of any kind, and if it had not
> been for the loan of the steward of one of the ships in the bay and the Gover-
> nor's servant, they must have done everything for us themselves. As it was,
> Mrs Molloy, assisted by her little girl, only nine years old, attended to every-
> thing in the cooking way. Although the dining room has a clay floor and
> opens into the dairy, the thatch appears overhead and there is not a single
> pane of glass on the premises, (the windows being merely square frames with
> shutters) yet our entertainment, the style of manners of our host and hostess,
> their dress and conversation, all conspired to show that genuine good breed-
> ing and gentlemanly deportment are not always lost sight of among English
> emigrants.[43]

While he was at the Vasse, Wollaston held service twice on Sunday
at the Bussells' house, 'Cattle Chosen'. He was pleased with the size
of the congregation, and pained that the Governor did not stay to
communicate. Mrs Molloy's nineteen-month-old daughter, Flora,
was baptized. In the afternoon, a party of gentlemen walked over
with the Governor and Mr Wollaston to the town-site of Busselton
to see the spot proposed for the church. Wollaston was horrified with
it. 'A more unsuitable spot in the present state of the settlement could
not be; there is not a single settler near it. Two or three ruinous huts
show where abortive attempts have been made to settle. The land is
low and flat; the scene dreary and desolate.' He suggested that the
settlers should unite to erect a church for themselves at a more con-
venient spot, and 'ventured to hint that some endowment would be
necessary to maintain a clergyman, even if the population enabled
him to obtain the £100 a year which the Legislative Council allows
to ministers of all religions.' There was not much enthusiasm for his
ideas and after some talk it was decided to hold another meeting

on the subject in the near future. The next day Wollaston left to return to Picton, and the Governor proceeded to Augusta.

Christmas came and went. In January John Wollaston, the twenty-one year old son of the clergyman, was invited to stay at 'Fair Lawn', since Mrs Molloy had heard from his father that he was interested in botany. They got on well together and were to see more of each other through the coming year. 'He is very thick with Mrs Molloy of the Vasse, who is a perfect botanical dictionary,' his father informed his English relations. At the end of January Wollaston himself went to Perth and was pleased to find that all the five clergymen of Western Australia happened to be there. Enthusiastically he got up a meeting to discuss the state of the Church: 'The Church here is in a most anomalous state and I drew up a letter to our Bishop which we all signed, describing the state of ecclesiastical affairs in the colony and entreating his Lordship to visit us, if possible; consecrate our churches, define our duties; confirm the young and generally "set things in order".'[44] It was Wollaston's idea that each clergyman should append to this general letter a separate account of church matters in his district. Unfortunately he had to leave for home in three days and through carelessness the letter to the Bishop was not sent for several months, and then without the letters describing each district. Wollaston reminded himself that it was said to take eighteen months to get a reply from the Bishop in Sydney, and true enough, he did not receive his reply till the end of June 1843. The Bishop's reply was encouraging, but he feared there was little hope of his visiting them. He asked for information which it was obvious he should have been furnished with long before, and without which he could not act.

Before 1836, Australia had been included in the Bishopric of Calcutta. From 1836 until 1847, Bishop Broughton, residing in Sydney, was called Bishop of Australia. For nearly a decade after this, Western Australia was included in the Bishopric of Adelaide. In 1848 Bishop Short of Adelaide paid a visit to Western Australia, bringing with him his Archdeacon, Matthew Hale, who in 1857 was to be consecrated first Bishop of Perth. By that time Hale was Captain Molloy's son-in-law.

The matter of the Busselton church hung fire for two more years. Wollaston, though he made periodic visits to the Vasse and was very popular there—'the people of the Vasse have been most kindly anxious that I should go and live there'—was busy with his sons

building with their own hands the little wooden church at Picton which was to serve the settlers at Bunbury, Australind and round about. Until he had it built and held services in it, the Government would not pay his stipend of £100 a year, and this he badly needed. The Vasse people raised a subscription towards his church. On Sunday, 18 September 1842, it was formally opened. Built of wood and thatched with rushes, with a cement floor and windows made of oiled calico, painted in cross stripes, it represented the hope and zeal of a truly good pastor of his flock, who not only put his energies into developing the future of the Church in Western Australia, but also the future of the country itself. Wollaston was a pioneer of vision and enterprise.

The opening of the Picton church was enjoyed by everyone. It was fixed for 11 o'clock in the morning—'this was to give time for the gathering of the settlers from a distance, as well as to have the shorter service. I omitted to have the numbers counted but about a hundred I am told assembled.' The service began with a Collect and then an address by Wollaston. He noted in his diary at the end of a tiring, but satisfying day:

> Altogether the service was most impressive and gratifying. As my case was peculiar and such as no clergyman within reach of his Bishop is ever placed in; considering too that it was very desirable a proper Church impression, if I may so express myself, should at first starting be made upon the people, many of whom have evidently quite forgotten Church usages, I hope I shall not be considered as having taken too much upon myself.

The service was followed by a repast for

all of the better sort who chose to come to our house. It may satisfy the curious to be told how in this land of short commons such a thing could be done. I will describe therefore our shifts and contrivances. . . . We were materially assisted by our neighbours, the Ommaneys, and Miss Bussell who is staying with them and who made all our cakes for us. My object was to provide enough luncheon and yet not set the company down to table which indeed would have been impossible. So I bought a ham at Australind (about 1/6 per lb.) and a hind quarter of mutton at Bunbury. These were all cut into sandwiches. I procured butter and cheese from Mrs Scott. Cakes we had in abundance and variety. Mrs John Bussell sent us some rich pound cakes from the Vasse, of her own making, and plenty of good coffee. I had secured also with some difficulty 1 doz. bottles of English ale. This with a few bottles of Teneriffe wine, one of Port (a very scarce article) and a little Cherry Brandy we had left and plenty of pure water served to wash down the solids. Of course, a little tasty arrangement must be imagined at the side table, with

native flowers, geraniums and mignonette. All went off well. There was plenty for everyone in parlour and kitchen. All seemed pleased and we parted in the best possible spirits. Thus ended the proceedings of the day. I went to bed early, for I was very tired, with a thankful heart.[45]

The pride in work well done might indeed soothe Wollaston to sleep. He had brought his efforts to a conclusion: the church at Picton was to serve generation after generation of settlers, and is in use today. The opening of the church at Busselton was to be delayed for several years, Captain Molloy being preoccupied during the next year with the state of his wife's health, and John Bussell being sunk in a state of apathy—'the matter might easily be arranged independently of the Government, if Tully's college chum, John Bussell, were to exert himself properly,' said Wollaston in 1841. In 1843 the postponed meeting was held. It was decided to erect the church at Busselton using the money already collected and to petition the Government to build a foot bridge across the Vasse in order to make the church accessible. It was also decided to attempt to build another church at Wonnerup in due course.[46] Wollaston was asked to have plans prepared for both churches, as he knew of a young architect in Bunbury named Forsayth, who was willing to do the work. Arrangements were made between Wollaston and Forsayth, 'of which more another time', Wollaston remarked tantalizingly, and ended his journal.

The foundation stone of the Busselton church was eventually laid on 4 March 1844 with some ceremony, and a report of the proceedings was sent to the *Inquirer*, appearing in its pages on 13 March. The settlers, to the number of about sixty, assembled at the new bridge at 1 o'clock, and formed into a procession. The order was: Architect and Mason; the settlers, male and female, bearing boughs; the three local Trustees, bearing wands—viz. Mr John Bussell, Captain Molloy and Mr Henry Chapman; Officiating Minister and Mrs Bussell senior. They moved onwards to the church site, the Reverend Mr Wollaston reciting the *Te Deum*. The lacy peppermint trees made a welcome shade for the settlers to stand in while Mr Wollaston addressed them at some length. Then Mrs Bussell senior laid the stone, and afterwards everyone partook of cakes and wine donated by the family at 'Cattle Chosen'.[47]

Now that the church was actually started, all the settlers had a hand in the building of it, from John Bussell down to the lowliest labourer. Limestone was quarried and laid for the walls, and jarrah sawed in

sawpits in the near forest for beams for the roof and boards for the floor. It was opened thirteen months later, though not quite finished, on 11 April 1845, but it was not consecrated until Bishop Short visited the state in 1848.

While plans were going forward, albeit slowly, for the building of the church another move was taken which was to set Busselton one more step on the way to becoming a town. In February 1842, John Bussell tendered for the delivery of the mail, quoting £1 10s. per week for conveying the post between Bunbury and Busselton, or £2 per fortnight.⁴⁸ Governor Hutt minuted this offer: 'Cannot be accepted. Tender too high.' However, Mr Herring, the Postmaster at Augusta, being desirous of moving to Busselton, 'assumed the duties of his office' in December 1842, and six months later was named Tide-waiter* as well. In writing to the Colonial Secretary about this appointment, Captain Molloy said of Herring: 'He feels duly thankful for the opinion entertained of his qualifications for the office of Tide-waiter whose incumbent duties he would discharge with his best zeal. He will take the most prompt measures to have a house erected on the town-site in a convenient situation with the understanding you have expressed that a part of it would be rented for a public office.' With the number of American ships anchoring in Géographe Bay— they preferred Géographe and Flinders Bays because they were not obliged to pay harbour dues as at Port Leschenault—the office of Tide-waiter became necessary. For this, Herring was to be paid £35 per annum with a £15 allowance for Postmaster. The rent of part of his house was to be determined later.⁴⁹ Herring built his house about a hundred yards from the sea front on the corner of Adelaide and Queen Streets. It was a low wooden cottage that can still be seen unchanged today. He was not particularly prompt about its building, for it was March 1845 before the Resident could inform the Colonial Secretary that Mr Herring was offering 'his premises near the beach to be used as an office for the Resident Magistrate, or Custom House, at the following rates. If unfurnished, for the sum of £17 10s.; if supplied with chairs, tables and shelves, twenty pounds per annum. Room with fireplace, composition floor 12 feet by 14, mahogany plank ditto, 12½ feet by 12.'⁵⁰ A dry note on a further letter of Molloy's

* Tide-waiter: a customs officer who boarded ships on arrival to enforce customs regulations.

says, 'The Resident Magistrate does not seem to have understood that not only the rent of the house but the £35 p.a. salary is also dependent on the revenue collected in the district.' Hutt was ensuring that the Tide-waiter was zealous.

An earlier appointment than that of Postmaster was that of Captain Molloy as Sub-Registrar for superintending and keeping a Register of all births, deaths and marriages in the district of the Vasse.[51] Molloy held this office from 30 November 1841 until March 1861, when increasing age made him relinquish it: he recommended John Bussell in his place.

❧

Mrs Molloy's letter to Captain Mangles begun in January 1841 and finished in June was the last long letter he was to have from her. She sent with it a parcel of seeds consisting of a hundred different species. Mangles received these in January 1842, and distributed them to his brother Robert Mangles; to the Earl of Orkney; to Dr Lindley of Chiswick; to Mr Knight of the Exotic Nursery, Chelsea; to Messrs Loddiges of Hackney, and to Mr Henderson of Maida Hill. In June 1842, Mangles had the pleasure of hearing from Mr George Hailes of Newcastle that that gentleman had 'flowered the first novelty to our Gardens which the seeds from Swan River you so kindly sent me two years ago have produced with me.' He enclosed a sketch of it, remarking that it was impossible to do justice to a blue flower, especially one such as this, which had a transparent appearance like the flowers of *Agapanthus umbellatus*.

Hailes went on:

> I had hoped that it was new, and intended to ask my friend Sir William Hooker to figure it with my name of 'Caesia Molloyae', as a fitting memorial of the fair lady to whose exertions we owe so much and who has been so very ungallantly overlooked by all the describers of her collections, but on examining Lindley's sketch I found it was described as 'Caesia hirsuta'. It is, however, the first of the Genus yet bloomed in Britain, and though the flowers are very fugacious, it well deserves cultivation.[52]

Mr Hailes was quite right in remarking that Mrs Molloy had been 'ungallantly overlooked'. Mangles's various correspondents all acknowledge the pre-eminence of her collections, among which were many unknown and un-named specimens, yet none was named after her. Meissner, a German botanist who collaborated in making from Ludwig Preiss's collection the two-volume *Plantae Preissianae* (Hamburg,

1844-47) proposed the name 'Molloya' in honour of Mrs Molloy for a plant now known as *Grevillea cynanchicarpa*. Ironically enough, he described it not from one of her specimens but from one collected by Drummond.[53] He was under the impression that it was a distinct genus, but in later years when George Bentham was compiling his *Flora Australiensis*, the major work on Australian flora, he included this species in the genus Grevillea. Mrs Molloy thus a second time lost any recognition. Her name occurs in a work of reference, *A Biographical Index of deceased British and Irish Botanists* by Britten and Boulger, which appeared at first month by month in the *Journal of Botany* (vols. xxvi—xxlx) from 1888 to 1891. In 1891 this appeared in book form, and a second edition appeared in 1931. So little is known of her that she appears in it as flourishing from 1840 to 1855 at Swan River colony, although by 1855 she had been dead twelve years. She was, however, of sufficient importance as a collector to be included in the work, which indicates that some specimens of her collecting are at Kew herbarium.

It is hard to estimate her importance to botany. George Bentham sometimes mentions Mrs Molloy as a collector; but Bentham wrote twenty to thirty years after her time, when other botanists, whose collections were fresher and who had more botanical knowledge, had appeared in the field and had covered the same ground that she did. It is possible that her main contribution was to the progress of horticulture. In the years before Kew Gardens came to the fore again, all the growers acknowledged the freshness and viability of the seed she sent; but here again it is likely that Mangles, rather than Georgiana, received the credit—he it was who distributed the seed, and he reaped the thanks. Only in one field did she come into her own: no one wrote such letters as she did, painting in words the unknown flowers as they appeared for the first time to the European eye.

Mr Hailes continued: 'I hope you have good news of Mrs Molloy, and when you next write to her pray inform her of the beautiful plant her seeds have produced; they were marked "Vasse Grass-like plant, Blue".' While in a further letter a month later he said:

> The sketch of Caesia is a mere ten minutes work, but if you are at Kew and will ask Sir William Hooker he will shew you a finished drawing by one of my sisters. It does not flower in masses but with a large plant will furnish a pretty fair lot of colour. I find that you have mentioned it to Dr

Lindley. There must, as you observe, be many things yet at and near the Vasse to introduce, and if you are writing to Mrs Molloy, pray urge her to collect the Verticordia, and the splendid *Chrysorrhoe nitens*, for we really must not rest until they are in our Gardens.[54]

Even before he had written this Mrs Molloy had made her last collection. On 11 April 1842, she had penned her last lines to Captain Mangles.

I have been four times out in quest of Nuytsia and send you the small, small harvest. They are very difficult to obtain, if not there the very day they ripen. Again I have had four sacks of capsula (or seed-bearing branches, more properly speaking) put gently into a bag, a cloth spread under the tree, and I shall not be able ever to find more than two, rarely, in the capsule, and many which I take to be male flowers. The quantity sent speaks for itself. I have twice sent natives, once a man and native, gone four times out myself, twice with a servant, and twice with Molloy, and yet you see the results. I have put some slips into Ward's glazed box,* which brought my indian plants, ready for embarkation at a good opportunity.[55]

Georgiana's excursions stopped because about this time she knew that she was to have another child. She had been so ill after the birth of the last baby, the little Flora, and with Amelia, the one before her, that who knows with what dread she looked forward to the coming summer. No more letters from her, and only one more from Captain Meares, appear in the Mangles letter-books.

It is evident from this time that Mangles's interests were swinging from the propagating of rare seeds from the colonies to the collecting of birds, and the improving of London parks and gardens—Kensington Gardens in particular. The letters he received in 1842 allude to the different kinds of ducks that he was presenting to Kensington—black swans were unfortunately £15 a pair and hard to procure—to improvements to the Round Pond, and to the suggestions he made from observations during his daily walks in the Gardens. 'The Public ought to know how much they are indebted to you,'[56] wrote Dr Lindley. A list of plants and cuttings presented to the Gardens by Mangles up to September 1843 totalled 7,995 plants, while 49 birds were also given by him. 'In the Round Pond in Kensington Gardens, by patience and perseverance, I have collected a very choice assortment of Waterfowl amounting to nearly 50,' Mangles wrote to the Earl of Lincoln

* Nathaniel Bagshaw Ward about 1836 invented a nearly air-tight case with glass sides and top, used for transporting growing plants on long sea voyages. The 'Glazed boxes' that Mangles had been sending to Captain Meares and Lady Stirling were probably 'Ward's boxes'.

in December 1843,[57] petitioning him to order a small enclosure of rhododendron bushes to be made where the birds could nest undisturbed. His interests were now thus completely absorbed.

For her part, Georgiana was concerned with improvements to her house and garden. During the winter months she had John Dawson working for her, doing odd jobs and bits of carpentering. She would follow him about, telling him what she wanted done, in her sweet tones, and saying laughingly: 'Now, Dawson, you do the work, and *I'll* carry the nails,'[58] alluding to a feat of strength of Dawson's which had become a local byword. As a young man, during the eighteen-thirties, he had walked the sixty miles between Augusta and the Vasse carrying eighty pounds of nails on his back.

Spring came to find 'Fair Lawn' justifying its name: the grass was planted to the river's edge, and the gardens were bright with colour; vines had been planted, also a row of purple fig trees down by the river where the girls would bathe in coming summers.

In November Mary Layman, widow of the murdered George, married young Robert Heppingstone. She was some eight years older than he, but a very agreeable woman of whom everyone spoke well. She had found it almost impossible to carry on her late husband's holding, with a very young family and labour hard to get. They spent some sixteen years in happiness, and then in 1858, Robert Heppingstone met the death at Castle Rock that his father had met at Augusta—he was drowned while fishing.[59]

Georgiana's fifth living daughter was born on 7 December 1842, and was named after her mother. The birth was difficult, ('the doctor at the Vasse being drunk', as Wollaston said angrily) and left Mrs Molloy very weak. Soon after it she was 'seized with shiverings and other dangerous symptoms', and Alfred Bussell was despatched on horseback to Leschenault to get another doctor. Unfortunately two doctors there were engaged on a difficult birth which they could not leave, and the only other good doctor—Dr Allen—was not to be found. John Wollaston, full of fears for his well-liked hostess and friend, rode everywhere looking for him. Dr Allen was located the next day by Mr Ommaney and taken down to Busselton by him. He was just in time to resuscitate the sinking Mrs Molloy, and for a while it seemed that she was out of danger. The heat of summer was upon them, however, and more than anything she needed good nursing. She was spent and thin from loss of blood, and unable to take much

nourishment. Mr Wollaston came to see her in January, and was much distressed at the condition she was in. 'I am very anxious to do something towards alleviating the great distress of mind under which she labours,' he wrote in his journal on returning to Picton, 'but it is extremely difficult without any knowledge of previous character to suggest suitable reflections. I have written to her and shall write again, but this does not seem to draw her out. . . .'

Mrs Molloy may not have revealed her Presbyterianism to the Church of England clergyman, and in her depressed frame of mind the world to come was looming close. What was ordained for her? Who could give her comfort? Had her faith been sufficient? How would the friends of her youth have counselled her to think?

Turning her thoughts back from the world to come to the world that she knew she was leaving, who would look after her young family, her little girls—the serious Sabina, lovely Mary Dorothea, dark-browed Amelia, and dimpled Flora; the baby Georgiana, who would rear her? She thought of Mary Layman, now Heppingstone, and begged Captain Molloy to take the baby to her after her death.

February passed and the heat grew worse. Her wasted form developed bed sores, and she asked could they make her a hydrostatic bed, of which she had read in the newspapers. Captain Molloy, who had found a description of this contrivance in the *Penny Magazine*, tried spreading a mackintosh cloak over a trough of water, but the cloak was not big enough and let the water through. A more successful attempt was made with a new mackintosh of Wollaston's which was bigger, and for a little while it brought some relief to the sick woman. Watching the concern for her comfort with which it was made must have caused her to reflect on Molloy's care for her, on the years of affection spent with her 'excellent husband' as she had called him. A later generation may opine that it was to him that she owed her present situation: she should never have had her last two children. But this thought would never have occurred to her. She would see only the years of struggle and happiness, the mingling of mutual interests, the love and respect that makes mere existence a minor detail when life has been lived to the full. With him she had created her posterity; with his help she had pursued her interest in the flowers and plants of her chosen country. In both she had fulfilled herself. 'I believe I have sent you everything worth sending,' she had written to her friend Captain Mangles. She was content. Thirty-seven years

she had spent in this 'Vale of Tears', as she had called it in her youth, but they had not been unhappy.

She had not left her bedroom now for three months. A small, close room, it looked out over the garden and the river. Had its window opened towards the sea, the breeze might have relieved the heat, and at night she might have seen the strange light in the sky that had begun to cause wonder among the settlers. A long stream of light had appeared slanting up from the horizon on 5 March 1843. Some had guessed it to be a comet, though it was not fully to be seen. Wollaston described it in his journal on 8 March as of immense size, with the head just visible. It came more into sight as the nights passed and remained in the sky for about ten days, magnificently brilliant, striking awe into the natives, and causing wonder not unmixed with awe to the whites. In ancient days it would have been regarded as a portent, and so it was to prove to Mrs Molloy. Each night fleeting onwards into space it left the world a little further behind, and so did she. At the end of March, Mr Wollaston was sent for, and administered the Lord's Supper. She was now in such pain and unease that opiates had to be given. She lingered on until 8 April, and then she died.[60]

She was buried two days later in a field near the house, her grave surrounded by a square of spiky yucca lilies that she had brought with her from Augusta.[61] The church of St. Mary was not yet built. Later her body would be re-interred beneath it, with the two little dead children from Augusta, and her name commemorated on a brass tablet. At Augusta the pink gladioli from the Cape that she planted in her garden will not die, but come up anew each year: at the Vasse the *Yucca gloriosa* she brought with her to the colony grow thickly still in the field where she was buried.

Strangely enough, it was not Captain Mangles, to whom she had written from her very heart, who set down the final epitaph on Georgiana Molloy. He merely noted an extract from a letter of Lady Stirling's announcing her death in his letter-book. It remained for George Hailes of Newcastle, who had had the greatest success in growing the seeds she had sent from Australia, to write to Mangles of a rare and gentle lady: 'Not one in ten thousand who go out into distant lands has done what she did for the Gardens of her Native Country, and we have indeed as regards her specially to lament, that "From Life's rosy Chaplet, the Gems drop away." '[62]

Chapter

12

The Years After

CAPTAIN MOLLOY survived his wife for nearly a quarter of a century. Of the people she had known, some soon followed her to the grave; others established families and lived to a good old age, leaving names that are still borne in the district; and some again, losing faith in the place, left for further fields. One of these was Thomas Turner.

By the end of 1843, Thomas and his brother George were tiring of living at Wonnerup. For eighteen months or more Thomas had been negotiating with the Colonial Secretary for a remission for his five thousand acres of land at Augusta.[1] With the price he duly received he was able in May 1844 to purchase 900 acres of land at Dunsborough—location 13; and 600 acres, location 12, at £1 per acre. This was the new minimum price for land bought from the Crown. At Dunsborough, he built a slab 'tenement', as he called it, to which he gave the name of 'Cometville', probably after the phenomenon of the year before. His sister Ann McDermott came to live with him there, and in August 1844 she at last made up her mind to marry Mr Green. The marriage took place at 'Cometville', and they returned to Green's house at Wonnerup to live. Two years later, Thomas Turner married seventeen-year-old Elizabeth Heppingstone and took her to 'Cometville'. In this year, 1846, Turner sold location 12 to Elijah Dawson for £120. Eight years later, he sold location 13 to Captain Molloy, whose land it marched with, for £300.[2] It will be perceived that he lost money on both deals. Tired of the West, he departed to try his luck in Victoria. His father several years afterwards gave up the relentless struggle with the bush at Augusta and retired to Perth.

Elijah Dawson, although he had had some success with growing

wheat at Wonnerup, removed to the 600 acre block he had bought
from Thomas Turner. Here he built a house and called it 'Westbrook'.
His family grew up there. He became a man of substance and was
able to take up other land. When he grew too old to farm, his son
carried it on, the old man living there still. His neighbour Captain
Molloy would sometimes ride over to celebrate Waterloo Day—
18 June—with him.

Captain Molloy was to have the usual experience of those who
live to a great age. They see those they knew and lived with, some-
times even their own children, die before them, their vague feeling
of triumph at their own survival yielding slowly to a sense of the
deepest loneliness—that of having outlived their own world. In 1845
Lenox Bussell died, and in the same year, Mrs Bussell senior. Charles
Bussell was the next to go in 1856, followed by others of the
Augustans—Robert Heppingstone aged 30, Henry Chapman aged
54, Vernon Bussell aged 47, and John Herring aged 87.[3] Fortunately
Molloy, having married late in life, had a young family to link him
with the present. Sabina, his eldest daughter, eleven years old when
her mother died, was of a serious and responsible turn of mind. She
ran the household, with the aid of whatever female servants Captain
Molloy was able to engage. She saw that her little sisters were brought
up as her mother would have wished. Prayers were read each day to
the assembled household, and in due course she and her sisters were
prepared for their communion by Mr Wollaston.

In November 1848, the Vasse was visited by Bishop Short who
came from Adelaide with his good-looking Archdeacon, Matthew
Hale. Hale was tremendously impressed with the family at 'Fair
Lawn', but particularly with Sabina. The personality of Captain
Molloy struck him first.

Hale set down in his diary:

There is something peculiarly striking and interesting in the position of this
veteran officer. He came out here as a settler and as unfortunately the case
has been with a large majority of the settlers in this Colony, seems to have
known very little of the way to go to work in settling, and has probably
gone back in his affairs rather than forward. He is quite the old soldier, full
of anecdotes and incidents and with a most striking countenance. Indeed, it
is said, that amongst his companions in arms in former days he went by the
name of 'Handsome Jack'. But however much one's interest may be excited
with respect to himself, it is called forth a hundred times more with respect
to his family. This family consists of five daughters, who, although living in

the most complete seclusion, possess a grace and dignity and ease of manner which would do honour to the most refined society, to say nothing of their being, both great and small, strikingly handsome. . . .

It pleased God to deprive them of their mother some four or five years ago. Of this lady everyone speaks in terms of the most unbounded praise. The Colonial Chaplain, when he speaks of her, seems scarcely able to find words to describe her excellences. I have heard him more than once declare his belief that she was the best-informed, the most accomplished, the most elegant, the most lady-like woman that ever came into this Colony.[4]

The Bishop and Archdeacon spent some three days in Busselton and then went on to Perth. It was long enough, however, for Matthew Hale to decide that Sabina Molloy must be his wife. Sabina was only seventeen, and was much younger than the Archdeacon, who was a widower with two daughters of five and three years. It is not known whether he spoke to her father then or wrote from Perth. Bishop Short's stay in Western Australia was brief: he left Fremantle on 27 December 1848 for Adelaide, the vessel calling at Bunbury, the Vasse, and Albany. A letter from the Archdeacon invited Sabina to be ready to be married as soon as the *Champion* stood in at Géographe Bay, so she had little time to prepare her wedding finery. Sabina also had to see to the clothing of her younger sisters, for they were all to leave by the *Champion* when she did, Mr Hale having offered to care for his young wife's sisters while Captain Molloy made a voyage to England.

This voyage, so often spoken of during the past twenty years, did not take place as soon as his family had departed. For some reason or other, it was delayed until March 1850.[5] When Captain Molloy finally reached London he renewed his acquaintance with some of his companions in arms. As one of them said: 'The last enemy has done his worst on very many of our Peninsular companions. . . . Some Riflemen still remain to dine together sometimes. . . . Johnny Bell cultivates dahlias at Staines, Will Napier misgoverns the Guernsey-men, Johnny Kincaid regulates the secrets of a prison-house, Jonathan Leach writes histories.'[6]

One visit was paramount. Captain Molloy wished very much to see his old Commander-in-Chief. He called on the Duke of Wellington at Apsley House. He was kindly received, the Duke being 'very civil', and asking him where he had been and if he had made a fortune. There were also calls to be paid on Captain Stirling, lately made Rear-Admiral, and, no doubt, on Captain Mangles.

It may have been shortly before his departure for England or even after his arrival there that Molloy received his Peninsular Medal. This medal, awarded to veterans of the Peninsular War with bars engraved with the names of the particular battles in which they had fought, on a purple ribbon, was not granted until 1847, after an incredible delay of thirty-three years from the end of the Peninsular War. Molloy was very proud of his medal, which had eight bars, and photographs of him taken from this time on always show him wearing it, together with his Waterloo Medal (Plate 2).[7]

When he left England he took ship direct to Adelaide in order to escort his daughters back to the West. Mary Dorothea was the eldest daughter now at home, and was the next to marry.

When Captain Molloy returned to Western Australia he found a great change. In 1841 the price of land had been raised to £1 per acre; prospective immigrants lost interest and immigration practically ceased. Labour, which had always been scarce, became almost impossible to procure. A depression set in, and the question of admitting convicts as labourers was raised, as it had been raised by a few bold spirits since the inception of the colony. The pros and cons of the question cannot be given here; suffice it to say that in May 1849, Western Australia, whose proud boast it had been that it was a free settlement, was nominated as a place to which convicts could be sent. In June 1850 the first shipload arrived.*

Their presence was just beginning to be felt when Captain Molloy returned in 1852. The way in which it affected him was twofold. As Resident Magistrate he had taken great pride in the peaceful running of the district under his control. In 1855 he felt obliged to write to the Colonial Secretary to claim the allowance granted to visiting magistrates as 'the duties of my office have increased both daily and hourly since the accession of convicts in the colony and their general employment in this district.' He also had to draw the attention of the Colonial Secretary to the need for a larger gaol. 'The Conditionals and Ticket of leave men exceed the grown-up male population, and the presence of foreigners so much adds to the number of idlers.'[8] The 'absence of moral discipline' worried him, and it is evident from two warrants issued by him, which are still extant, that he tried to keep a strict hold on the morals of the little township that was growing up under his care.

* Transportation ceased in 1868.

The second way in which the situation affected him was through his daughter Mary. A young Englishman named Edmund DuCane was employed in connexion with the Convict Department in Western Australia, being a magistrate of the colony, and visiting magistrate of Convict Stations. In the course of his work he visited Busselton, and saw the lovely Mary Molloy. From all accounts she was the most beautiful of the five sisters: 'Tall, handsome, with a blooming complexion, the clearest blue eyes I have ever seen, and coils of silken fair hair. She looked especially well on horseback,' said little Amy Hale, Archdeacon Hale's elder daughter by his first marriage, who visited 'Fair Lawn' in 1854. Mary was a good mimic, and little Miss Hale remembered meeting her later on in England when 'she would amuse us by enacting a corroborree with a walking stick . . . the strange-sounding native words rolled out in various tones and accompanied by appropriate movements of her graceful and commanding figure'⁹—a bizarre effect in a crinoline!

Mary was married to Edmund DuCane in July 1856 at Fremantle. Captain Molloy drove up from Busselton in his 'Cape carriage' drawn by a strong pair of horses. Amelia, who was to be bridesmaid, was with him and the journey took three or four days. Some eight months later Mary departed for England with her husband, who was to have a distinguished career, and was to be knighted for his services to the Crown.

This left Amelia as the eldest at home, and as housekeeper for her father. She was a notable housekeeper and had inherited her mother's gift for gardening. She 'had an oval face, very regular features, and low wide forehead, clear grey eyes, and perfectly pale, creamy clear complexion. She was very original and amusing in a quiet manner,' said Amy Hale. Amy was entranced with her visit to 'Fair Lawn'. Clear in her memory when she wrote her reminiscences were dances in the big room decorated with wildflowers and branches of orange Nuytsia, and parties at 'Cattle Chosen', with Mrs John Bussell and Captain Molloy leading the quadrille.

Amelia was to make a good match too. In 1857, at the little church in Busselton she was married to Mr William Richardson Bunbury, a son of Lady Richardson Bunbury who came out to the Leschenault district from Ireland in the early eighteen-forties with her family. Amelia was the only one not to desert the Vasse. She lived at 'Beechlands' about three miles from Busselton, and her descendants live on

at the Vasse today at a property named 'Marybrook', formerly part of Captain Molloy's holding.

Although he was pleased that his daughters were making good marriages, Captain Molloy was rapidly losing all his girls. Flora— the 'laughing girl', as Archdeacon Hale called her when writing to describe their new young aunts to his little daughters—who loved practical jokes and whose freckles disturbed her peace of mind, was the next to wed. She married Mr William Brockman, son of one of the first emigrants to Western Australia. This left only Georgiana at home with her father. Unlike her sisters, her love affair ended in tragedy, and she died unmarried in 1874. She had been engaged to Mr J. K. Panter, a nephew of the Governor at that time, a fine young man who was killed by natives during an exploring expedition from Roebuck Bay in 1864.[10]

In his old age, Molloy was to see his grandchildren about him. Sabina with her young son Matthew, and her step-daughter Amy Hale, paid 'Fair Lawn' a visit from Adelaide in 1854, and again in 1856. In 1859 Mervyn Corry, the eldest of a large family, was born to Amelia and William Richardson Bunbury. An old photograph of 'Fair Lawn', taken about 1865, shows young Mervyn, Mrs Bunbury, a nurse holding a baby, Miss Georgiana on horseback, a Miss Turner and Captain Molloy, old and white-haired, seated in front of the house (Plate 5).

Whatever Matthew Hale may have thought of his future father-in-law's affairs in 1848, by 1865 the availability of labour had made a difference to 'Fair Lawn'. A photograph of about 1870 (Plate 8) shows it as a prosperous collection of solid stone buildings, well-fenced with jarrah slabs, and a shingled cottage standing at right-angles to the main house, which had been built to house the young Hales when they came from Perth to visit their grandfather. Matthew Hale had been made Bishop of Western Australia in 1856, consecrated in 1857, and among the donors of land to endow such a bishopric was his father-in-law, Captain Molloy, who had put his name down for 250 acres, 'or one half of Molloy Island on the Blackwood', when the idea was first suggested. Later he increased his offer to 500 acres.[11]

At the beginning of the eighteen-sixties, Captain Molloy turned the management of 'Fair Lawn' over to Mr Richard Gale, a young Englishman who had been recommended to him by Mr Brockman. In the quiet of his last years, the old man saw Busselton develop into

a sleepy little township (Plate 7). From time to time when whaling ships were in, it would wake up and become loud with Yankee voices whose owners were visiting the several public houses, or marketing their 'Yankee notions'—wooden clocks, nutmeg graters, hairpins, bolts of gaily figured cotton and such like—to the housewives of the Vasse. Sometimes the old man would drive out in his carriage (he was too old now to mount his tall, elderly horse, Duke)—and would visit the few shops, the shopkeepers coming out respectfully to the road to take his orders as he sat in the carriage.

In the last years of his life he had been gazetted a Brevet Lieutenant Colonel, and was known thenceforth as Colonel Molloy. He died full of years and honour, on 6 October 1867, aged 87. He was buried in the churchyard of St. Mary's, the little church in whose building he had been so interested. His tombstone, under the shady peppermint trees of his adopted country, rings with the names of ancient battles he helped to win for England, but the battle with the Australian bush, which he also won, is not among them. It is implicit in the final inscription on the stone which reads:

> *I have fought a good fight,*
> *I have finished my course.*
> *I have kept the faith.*

APPENDIX A

LIST OF PASSENGERS IN THE 'WARRIOR'

As there is no record of an official passenger list for the *Warrior*, this list has been made from Applications for Land by persons stating that they arrived on that ship, and from allusions in diaries.

Mrs Molloy's age, as given by her husband in his application, is twenty-two. It should have been twenty-four, if checked against the Registration of her death, in the Titles Office, Perth.

Alfred Bussell's age, as given by John Bussell in his application, is sixteen. A tablet in Busselton church gives the date of his birth as 1816, which would make him fourteen in 1830.

Captain John Molloy		
Georgiana Molloy	22	Wife
Robert Heppingstone	32	Servant
Ann Heppingstone	26	Wife
Robert	9	Child
Charlotte	7	
Ann	11 mths	
Elijah Dawson	34	Servant
Anne Dawson	25	Wife
James Staples	35	Servant
John Thurstan Koller	23	Surgeon
Mary Emily Koller	20	Wife
John Thurstan	18 mths	Child
Mary Peronne	18	Servant
Alfred Green	25	Assistant surgeon
George Best	36	Agriculturist
Sally Best	34	Wife
Sarah	1	Child

David Bell (who did not disembark at Fremantle)

William Burges	22	Applicant
Samuel Burges	20	Brother
Lockier Burges	16	Brother
Michael Connors	20	Farming servant
John Byrne	25	Farming servant
Judith Kearney	20	Servant woman

William Proctor and family (who did not disembark at Fremantle)

John Wood	26	Mechanic

James Woodward Turner	50	Agriculturist
Maria Turner	39	Wife
Ann Turner	18	
Thomas	16	
George	14	
Selina	11	
John	9	
Maria	8	
James	3	
John Dewar	46	General servant
Mary Dewar	40	
Ann	17	
Alexander	15	
Jesse	13	
Robert	10	
Ralph	9	
Mary	5	
John	3	
William	1	
Andrew Smith	36	
Mary Smith	36	
William	3	
James	1	
Thomas Willy	32	
Susan Willy	21	
Ann Smith	40	
Thomas Salkild	24	
Henry Longmate	21	
Henry Postans	18	
Thomas Robinson	16	
John Garrett Bussell	25	Agriculturist
Charles Bussell	20	Brother
Vernon Bussell	17	Brother
Alfred Bussell	16	Brother
Edward Pearce	14	Servant
William Habgood	24	Agriculturist
Charles Gillingham	20	Labourer
Francis Henry Byrne	31	Captain in the Army
Anna Matilda Byrne	22	Wife
John Handcock	50	Carpenter and Farmer
Grace Handcock	48	Servant
George	21	Labourer
James	20	Carpenter and Labourer
Jesse Cherville	22	Shepherd and Labourer
Elizabeth Cherville	20	Servant
Charlotte Cherville	1	
Frances Eliza Byrne	3	Deceased
Selina Jane Byrne	1	Deceased
William Temple Graham		Captain in H.M. Royal African Corps
Mrs Graham		
Joseph Cooper		
Elizabeth Cooper	35	
Elizabeth	7	
Rebecca	5	
Joseph	3	
Mary Ann	6 mths	

Also on board the *Warrior*, mentioned in various diaries, were the following:—

Mr Northcote
Mr Brown
Mr Cummings
Mr De Burgh (who was put off the ship at St. Jago)
John Herring
Mr H. C. Sempill and family (who did not disembark at Fremantle)

This list only accounts for about 90 of the *Warrior's* 166 passengers. The remainder probably continued on to Hobart or Sydney.

CAPTAIN JOHN MOLLOY. Description of Quantity of Property imported by Applicant in the ship *Warrior*. (WAA36/6, p 104.)

Live Stock

2 cows	£40	5	0
12 sheep, Merinos			
5 Lambs			
1 horse			
1 Mare	£76	10	0
12 ducks	1	7	0
14 fowls	1	12	0
12 pigs	14	9	0
Public	2/	113 18	0
Private		56 19	0
Mare		45 0	0
		101 19	0

10 sheep died on the Passage
6 pigs do.
⅓ of each Captn. Molloy

Machinery and Ironmongery

2 ploughs
2 Harrows
Scarifier
1 cart
1 truck
1 wheelbarrow
Wheat Mill, bin, stones
Tools of various descriptions for Carpenters, Sawyers and Bricklayers
Horse Shoes, Iron Hoops
2 bundles 48 bars of Iron
10 cwt Hardware and Cooking Utensils, Nails, etc.

Barnes	£49	6	7
Brown	13	5	6
Jackson	87	1	3
Eddy	85	4	3
Ryan	5	13	0
Public	2/	240 10	7
		120 5	3½

Provisions not Luxuries

10¾ cwt beef	2 „ raisins
9 „ pork	1 „ Hams
7 „ flour	1 „ Pearl barley
7 „ soap	2 „ Loaf Sugar
65 lb. Green Tea	2 cwt 3.19 lb. coffee
121 lb. Black Tea	2 cwt fine biscuit
6¾ cwt Sugar	1 Oatmeal
30 „ Biscuit	5 cwt salt
3 „ Butter	233 gallons brandy
4 „ Split peas	25 gallons Vinegar
3 „ rice	50 doz. Wine

Sempill's bill		
Provisions	£315	11 10
Gamble & Co.	77	16 10
Sempill	25	10 7
Public 2/	418	19 4
	209	9 8

Seeds and Plants

Garden seeds various
Tobacco seed
Wheat 2 bags 6 bushell
Oats 3 „
Barley 3 „
Indian Corn
12 Fruit Trees

Half Pay or Pension £127 per annum as Captain in the Army

Nash	£2	3	1
Noble	2	11	4
Syned	1	2	10
Nash & Co.	2	13	0
	8	10	3
Potatoes	1	12	0
Public 2/	10	2	3
	5	1	1½
Legge	1	1	3
	6	2	4½
Seeds from Cape	7	17	6
	13	19	10½

Miscellaneous

Guns. Yokes, milk pails and sundry coopersware. Saddlery. Two boats. Cordage. Grindstones. Clothing for servants. Shoes. Furniture. Medicine. Pewterware for kitchen. Stationery. Earthenware. Gunpowder. Shot. Paints, corks, 50 gross. Itemized, this amounts to £213 10 1.

APPENDIX C

A NOTE ABOUT CAPTAIN MOLLOY

It is the opinion of the author that if Captain Molloy was descended from any Royal person, that person was most likely to have been Frederick, Duke of York, second and favourite son of George III. The authority, quoted on p.7, for the story of Molloy's youth, was Horace Stirling, whose newspaper article in the *Sunday Times* (Perth), 22 May 1921, entitled 'Links with the Past' ended with the assertion that it was a tradition of the early days that Molloy was of royal parentage. Horace Stirling's father, Edmund Stirling (no relation to Governor Stirling) arrived in the colony in 1830 as a boy of fifteen; by 1840 he was associated with the founding of the newspaper the *Inquirer*, and by 1847 was its sole proprietor. He was reputed to have had a good journalist's ear for a story. The author has talked with several people who knew the Stirlings, father and son, and had heard them talk about early notabilities. They were inclined to relate Captain Molloy to George IV. When the facts are taken into consideration, however, at the time of Molloy's birth, (September 1780) George, Prince of Wales, was entangled with Mrs Robinson (Perdita). They had no issue. In 1780, on the other hand, Prince Frederick, only a year and a day younger than Prince George, that is to say 17 years old, and full of life, is known to have had an affair with a girl at Kew which caused him, when news of it reached his august parents' ears in December, to be sent off to Germany to complete his military education, which he received from his uncle the Duke of Brunswick. The girl showed signs of wishing to join Prince Frederick in Hanover but was successfully put off, and he did not return to England till 1787. (cf. *The Noble Duke of York*, by Lieutenant Colonel Alfred H. Burne, D.S.O. London, 1949.)

Prince Frederick, as well as being Duke of York and Albany, was created Bishop of Osnaburg before he was one year old by his father King George III. Osnaburg was a tiny German principality. It provided several thousands a year of income, in addition to the Parliamentary grant of £12,000 a year which Prince Frederick had as Duke of York. During his minority his father accumulated the income of the bishopric till he came of age. This is important, because it meant that the Duke of York, unlike the Prince of Wales who was always without money, would have had the funds to provide for his natural son, as Molloy is said to have been provided for. It is possible that the amount of £20,000 to which allusion has been made, was exaggerated.

Again, it is possible to trace a likeness between portraits of the Duke of York

and John Molloy. Both had the same high-bridged nose and autocratic stare, whereas the Prince of Wales had a small nose and rather bulbous eyes.

The above facts are only pointers, not proof. There is a further pointer in the fact that Molloy, when a lieutenant, was able to do a course at Great Marlow, the military college founded by the Duke of York who was then Commander-in-Chief of the Army, at a time when he was over age, and there was a long waiting list. What clinches the matter for the author is the naming of the streets at Augusta. There was no other reason for choosing all the titles of the Duke of York. He was then dead and forgotten.

DETAILS OF JOHN MOLLOY'S MILITARY CAREER, SUPPLIED BY
THE WAR OFFICE

Educated at Harrow			
2nd Lieutenant, 95th Foot		17 December	1807
1st Lieutenant, ,, ,,		5 June	1809
Captain (Promotion)		5 August	1824
Brevet Major (Half Pay)		28 May	1829
		28 June	1838
,, ,,			1851
,, Lieut. Colonel			
Captain (Brevet Lieut. Colonel) 9th Foot		April	1859
(He sold out the same day)			

Served in the Peninsula:

2/95	August 1808-January 1809	
1/95	June	1809-April 1810
	July	1812-April 1814

Present at: Roliça, Vimiera, Vigo, Salamanca, San Millan, Vittoria, Pyrenees, Vera, Bidassoa, Nivelle, Nive, Tarbes, Toulouse.

Received General Service Medal with bars for the following battles: Roliça, Vimiera, Salamanca, Vittoria, Pyrenees, Nivelle, Nive, Toulouse.

Also served at Waterloo. Severely wounded.

APPENDIX D

It will be the Duty of the Government Resident to exercise a general superintendence over all the Civil Officers of the District or Town committed to his care, with the exception of such Departments of the Public Service as may not be placed specifically under his control. Should he require the Assistance or Co-operation of any such department he is to make application to the Persons in Charge of it to that effect, and instructions will be given to such Persons to attend to the Suggestions, but he is not to interfere authoritatively with the general course of proceedings in such departments.

In the event of a Detachment of His Majesty's troops occupying any Part of his District, the Resident is to afford the Officer Commanding all the aid in his power to the furtherance of the Service. Should it be necessary to apply to the Commanding Officer for Military Protection, and the circumstances be such as to admit of no Delay, the Resident is to do so, but in general it is desirable that no official Communication be made on such subjects except through the Commandant of the Forces in this Settlement.

The Preservation of the Peace and the Administration of such Laws as are usually entrusted to Justices of the Peace will not necessarily form Branches of the Resident's Duty. But whether he may or may not be included in the Commission of the Peace he is to lend his readiest Co-operation with the Magistrates in the maintenance of Order, and in cases where his Absence from the Bench may be unattended by Inconvenience to Public Benefit, it will be desirable that he aid them rather in his official Capacity as Resident, than as one of their number. In distant districts where there may be no Magistrate except himself it will be of course requisite for him to act.

The Guardianship of the Aborigines and the Cultivation of a Friendly Understanding with them are points to which the Resident's constant attention must be given. He is to consider himself the Curator of all Descriptions of Public Property in his District. Roads, Buildings and other works which may be sanctioned and directed to be undertaken, are to be inspected by him, and he is to report to the Government if he should observe any Imperfection or objectionable proceeding. He is not to undertake any Public Works without Sanction, but his suggestions relative to the Improvement and Welfare of his District will meet with due attention.

* P.R.O.: C.O. 18/8-9-10, Folio 87.

Should there be no Officer on the Spot in charge of the Duties of the Surveyor General's Department the Resident is to afford all necessary Information to Applicants on the Subject of Land and to receive and forward all Requests for Grants. But he is not to give even Temporary Permission to occupy any Land nor to hold out any Prospect of Land being assigned to any applicant until the case shall have been submitted for the Lieutenant Governor's Sanction by the Surveyor General. The Resident is to keep salary and Cash accounts in the usual Forms and transmit them as early as possible after the close of each month. He is not permitted to incur any expense except such as may have been previously warranted in writing by the Lieutenant Governor.

He is to communicate as fully and frequently with the Colonial Secretary as Circumstances may admit on the Subject of his Charge. He is to keep an account of all the Persons resident in his District, specifying their pursuits, Progress and Condition so far as may be requisite for conveying full information on such Matters, and on this Subject as well as on the qualities of the Country in his vicinity, he is to render an accurate Report at the Close of each year.

Everything which may tend to the Prosperity and Tranquillity of a District it will be the Duty of all its Residents to forward as far as his means may permit and the best Proof of his Zeal and good Management will be its Advancement and Welfare.

JAMES STIRLING

APPENDIX E

LIST OF BOTANICAL GARDENS IN BRITAIN CIRCA 1840*

The letter-books of Captain Mangles contain (interspersed among letters from his correspondents from all over the world) lists of nurserymen in business in the London of 1835-1844; foreign nurserymen; and a short list of American nurserymen. There are lists of 'Persons of Celebrity for their Gardens'. One of these lists is made by Mr J. Sabine, Secretary of the Horticultural Society in 1830; another by Mr J. C. Loudon, Editor of the *Gardener's Magazine*; and another by Mr Page, nurseryman of Southampton.

Captain Mangles seems to have collected these lists of persons, and the following list (undated) of Botanical Gardens in Britain, with their gardeners, for the purpose of making a tour of inspection. He had a very beautiful garden of his own, referred to by correspondents as an 'Elysium' and a 'Paradisiaho'.

BOTANICAL GARDENS IN BRITAIN

Chiswick	Horticultural Society Gardens	Thompson
Kew	Royal Gardens	Aiton
Chelsea	Physic do.	Anderson
Edinburgh	Royal Botanic do.	W. McNab
	Caledonian Horticultural Society	I. McNab
Glasgow	Botanic do.	S. Murray
Dublin	College Botanic do.	Mackay
	Glassnevin Botanic do.	Nevin
Belfast	Botanic Gardens	
Liverpool		
Manchester	„ „	
Birmingham	„ „	
Cambridge	„ „	
Sheffield	„ „	
Bury St. Edmunds	„ „	
Oxford	„ „	
Hull	„ „	
	„ „	

There is also a list of some thirty-four names of 'Persons gratuitously supplied by Captain Mangles with Seeds, Bulbs, Roots, Plants etc'. This includes the gardeners of various noblemen, other people living in England, and at Swan River—Mrs Stirling, Mr Drummond, G. F. Moore Esqr., Captain Meares, and Mrs Molloy, of Port Augusta.

* WAA479, I, pp. 136-40.

APPENDIX F

THE LAYMAN MURDER

A very misleading account of the Layman affair is contained in J. S. Battye's *History of Western Australia*, Oxford University Press, 1924, p. 161. It says:

> In 1841 there occurred an incident which, if true, can only be described as an act of atrocious cruelty and savagery on the part of some of the settlers in the south-west. Early in the year a settler at Wonnerup, George Layman, offered some indignity to a native, in return for which he was on the first convenient opportunity speared through the heart. An avenging party under Captain Molloy set out and, it is said, ultimately succeeded in surrounding the whole body of natives on an open sandpatch, whereupon they proceeded to shoot the unfortunate aborigines in cold blood, not stopping till the adult males had all been accounted for. Colour is lent to the story by the fact that there is a sandpatch near Minninup where skulls and bones are still to be seen, and near which even present-day natives will not go. No records of the encounter exist, and it is more than likely that it has been built up to account for the collection of bones which in all probability represents an aboriginal burial-ground, which would be 'wintych' or sacred to the boolyas or spirits of the departed, and therefore to be avoided by all natives. All that is definitely known is that the murderer of Layman was shot by a soldier later in the year.

No reference is given by Battye for the above statement, except '*Perth Gazette*, 14 March'. This should be '13 March', and the account contained therein states the incident as set out in the pages of the present book. Battye appears to have founded his statement on an account found in an earlier *History of Western Australia*, by W. B. Kimberly (F. W. Niven & Co., Melbourne, 1898). This account, which presents the whole affair as taking place on a much larger scale and over a longer period of time than was actually the case, states that no records exist of the affair and that it is drawn from 'the evanescent memory of pioneers and the statements of several surviving natives of that period . . .' (*History of Western Australia*, W. B. Kimberly, p. 115-16).

Plenty of records of the murder of Layman exist in the shape of properly attested depositions of pioneers of the time contained in the Colonial Secretary's Office files, (WAA36/100) and in diaries and letters of the Bussell family (WAA139).

Records of the encounter with the natives are confined to the accounts in the *Perth Gazette* and *Inquirer*, and to the 'Summary of Transactions relative to the Natives for the Quarter ending March 1841' (WAA36/95) supplied by the Protector of Natives, Charles Symmons. Symmons had left Perth on a routine visit to Leschenault and the Vasse on 20 February 1841. He reached the Vasse shortly after the encounter which took place on 25 February. He returned to Perth on 8 March, leaving before hearing of the death of Gayware. The fullest reports of the encounter and Gayware's death would have been

261

S

those made by Captain Molloy, in his capacity as Resident, to Governor Hutt. That they were made is certain, for in the margin of Hutt's rough draft of his letter of 1 April he has noted: 'In reply to Captn. Molloy's two letters, 27 Feby. and 10 March'. These two letters are not to be found in the Colonial Secretary's files, although they are listed in the Index as 'Replied to'. From the nature of the Governor's reply of 1 April, and of a further letter on the subject on 23 April—both of which show that he accepted the Resident's reports— it would appear that Molloy had said who actually shot the natives: 'H. E. would earnestly beg of you to be careful whom you entrust with firearms at such times'; and that Molloy himself may not have been with the party that had the encounter: 'The Govr. therefore considers it to be his duty to instruct you that no armed force can be again directed against the aborigines unless under the conduct of a Magistrate who has good ground for supposing the information he has obtained will lead him directly to the haunts of the offender.'

Whatever Molloy did say, his reports have disappeared, and the relevant page in the Bussell diary of 1840-41 has been torn out. There are, however, letters from Molloy of 10 March and 3 April stating that the number of troops in the district was inadequate for the performance of the duties required of them, and that the troops consisted of a corporal and four privates, under the command of an ensign. Referring to the Layman murder as an example of the need for more troops, Molloy said that on this occasion two soldiers had to go to Leschenault and a guard had to be left at the store. Consequently action against the natives depended on 'the spirit and activity of the settlers' (letter, 3 April 1841. WAA36/100). Kimberly's account which says: 'Captain Molloy ordered his soldiers to prepare to march and he took command of them etc.' is incorrect, as there were no troops available. A soldier himself, Molloy would doubtless have preferred the safety of the district to rest on soldiers obedient to orders than on settlers not under the same control.

The sandpatch at Minninup referred to by Dr Battye may well have been an aboriginal burial-ground, as he was careful to point out. Not far away, at Wonnerup—a name meaning 'the Place of the Wonna', the wonna being the digging stick or weapon of aboriginal women—when the ground was being trenched for vines a great many women's skulls were found, indicating that a battle of women fought with wonnas had taken place there. This battle of women was known of by natives of the district, but not how long ago it had taken place, as the primitive aborigine has no way of indicating time.* No one has yet inferred that a massacre of native women by settlers took place there.

Dr Battye's account roused a good deal of protest at the time his book appeared, in the form of letters to the *West Australian* from May to August 1925, written by Mrs G. C. Bisdee, a grand-daughter of Captain Molloy; by Mr Walter Gale, husband of another grand-daughter; by Professor E. O. G.

* Information supplied by Miss Layman of 'Wonnerup House'.

Shann, whose book *Cattle Chosen*, the story of the Bussell family, was published in 1926 (by the Oxford University Press); and by Mr A. G. Layman, a grandson of the murdered man. Dr Battye made several replies to these, showing that he had since looked up records of the affair. Unfortunately his *History*, containing the above loose account, is often used for reference.

The author hopes that this book will make it clear that no wholesale massacre of natives was ordered, nor would it have been in the character of Captain Molloy to do so.

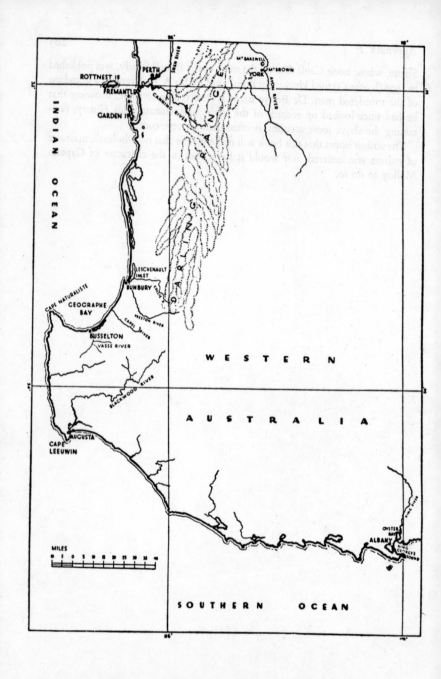

Map of part of Western Australia (reproduced by permission from *The Hentys* by Marnie Bassett, Oxford University Press, 1954).

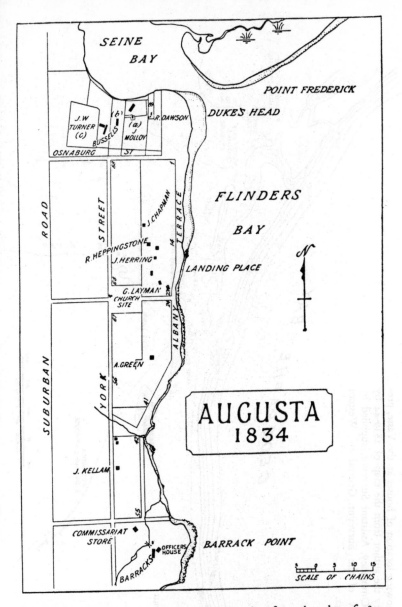

SEINE BAY

POINT FREDERICK

DUKE'S HEAD

J.W TURNER (c)

BUSSELL'S

(b)

(a) MOLLOY

R. DAWSON

OSNABURG ST

ROAD

R. STREET

R.HEPPINGSTONE

J.HERRING

J. CHAPMAN

14 TERRACE

FLINDERS BAY

LANDING PLACE

N

G. LAYMAN CHURCH SITE

ALBANY

A. GREEN

YORK

AUGUSTA 1834

J. KELLAM

SUBURBAN

COMMISSARIAT STORE

OFFICERS HOUSE

BARRACKS

BARRACK POINT

SCALE OF CHAINS

The town site of Augusta: prepared by the author from the plan of 1834 by Alfred Hillman, Assistant Surveyor, supplied by courtesy of the Surveyor General of Western Australia. Buildings marked on the original plan have been reproduced, and occasional allotment numbers given. The full list of numbers with owners' names is contained in Nathaniel Ogle's *Colony of Western Australia*, p.xli.

Plan showing location of houses at the Vasse, prepared by the author from the map of 1839-44 by H. M. Ommaney, Assistant Surveyor, supplied by courtesy of the Surveyor General of Western Australia.

REFERENCES

Abbreviations used in this list of references are:

WAA—Western Australian Archives.
WAHS—Western Australian Historical Society.
WAHSJ—*Western Australian Historical Society Journal*.
P.R.O.: C.O.—Public Record Office: Colonial Office.

CHAPTER I

1 Ashton, J.: *Dawn of the 19th Century in England*, p. 81. Patriotic Handbills of 1803.
2 The day and month of Georgiana's birth, 23 May, are to be found in her diary of 1833 (WAHS/79), but not the year. The year 1805 is given on the brass tablet in St. Mary's Church, Busselton, and can be derived from the registration of her death in April 1843 at the age of 37 (Titles Office, Perth).
3 Letter, 7 November 1829. WAA501.
4 Letter, 12 September 1829. WAA501.
5 Letter, 11 December 1828. WAA501.
6 The day, month and year of Molloy's birth, 5 September 1780, are contained in a letter of a grand-daughter, Mrs G. C. Bisdee of Bridgewater, Tasmania, dated 21 July 1925, together with other particulars about him. This letter was published in the *West Australian*, 1 August 1925. The date given in the letter agrees with the registration of his death in October 1867 at the age of 87 (Busselton Court-house).
7 The copy of Charles Dalton's *Waterloo Roll Call* in the War Office Library gives this information. It was annotated by a man who had tried to find out from what schools the officers at Waterloo had come. The author regrets that she cannot add to this information: repeated letters to Harrow have produced no answer.
8 Article entitled 'Links with the Past', by H. (Horace Stirling), *Sunday Times*, Perth, 22 May 1921.
9 Letter of a grand-daughter, Mrs G. C. Bisdee, 21 July 1925.
10 'The Peninsula and Waterloo: Memories of an old Rifleman'. By Lieutenant General Sir Edmund DuCane. *Cornhill Magazine*, 1897. Volume III.
11 Fitchett, W. H.: *Wellington's Men*, p. 227.
12 Ibid., p. 154.
13 Ibid., p. 227.
14 Smith, Lieutenant General Sir Harry: *Autobiography*, Volume I, p. 73.
15 Fitchett, W. H.: *Wellington's Men*, p. 50.
16 'The Peninsula and Waterloo: Memories of an old Rifleman'. By Lieutenant General Sir Edmund DuCane. *Cornhill Magazine*, 1897. Volume III.
17 Smith, Lieutenant General Sir Harry: *Autobiography*, Volume I, p. 255.
18 Ibid., p. 258.
19 Letter, 23 March 1823. WAA501.

CHAPTER 2

1 Battye, J. S.: *History of Western Australia*, pp. 75-76.
2 P.R.O.: C.O. 18/5 & 6, Folios 237 & 299.
3 P.R.O.: C.O. 18/4 & 5, Folio 237.
4 Powell, J. G.: *Narrative of a Voyage to the Swan River*, p. 287.
5 P.R.O.: C.O. 18/5 & 6, Folios 237 & 299.

CHAPTER 3

1 MacDermott, M.: *A Brief Sketch of the Long and Varied Career of Marshall MacDermott*, p. 35.
2 P.R.O.: C.O. 18/5, Folio 299.
3 Ibid.
4 Letters, 7 June, 15 September, 19 October 1831. WAA36/16, 17, 18.
5 Letter, 7 November 1832. WAA501.
6 Letter, 31 August 1829. WAA501.
7 Ibid.
8 Letter, 12 September 1829. WAA501.
9 Letter, 31 August 1829. WAA501.
10 Ibid.
11 Letter, 12 September 1829. WAA501.
12 Ibid.
13 Diary, Bussell Papers. WAA139.

CHAPTER 4

1 Letter, 12 September 1829. WAA501.
2 Diary, Turner Papers, WAHS450.
3 Ibid.
4 WAHS644.
5 Diary, Bussell Papers. WAA139. Charles Bussell was offering advice to his brother Lenox who was to emigrate in 1833.
6 P.R.O.: C.O. 18/6, Folio 299.
7 Parliamentary Papers: Returns Relative to Swan River. WAA88, also WAA36/5/130.
8 Diary, Bussell Papers. WAA139.
9 Turner Papers. WAHS450.
10 Bussell Papers. WAA139.
11 Turner Papers. WAHS450.
12 WAA36/6.
13 Bussell Papers. WAA139.
14 Letter, 22 January 1838. WAA139.
15 Diary, Bussell Papers. WAA139.
16 Ibid.
17 Turner Papers. WAHS450.
18 Bussell Papers. WAA139.
19 Ibid.
20 Ibid.
21 Turner Papers. WAHS450.
22 Ibid.
23 Ibid.
24 Ibid.
25 Ibid.
26 Ibid.
27 WAA501.
28 Letter, 28 August 1830. WAA58/8/115.

CHAPTER 5

1 Shipping Report, WAA36/5/130.
2 Letter, March 1831. WAHS450.
3 Diary of Mary Ann Friend. WAHSJ, Volume I, x, 2.
4 Moore, G. F.: *Ten Years in Western Australia*, p. 150.
5 WAA58/8/115.
6 Thomas Turner's book of drawings of houses. WAA603B.
7 Letter, March 1831. WAHS450.

8 Letter, December 1832. WAA139.
9 Letter. WAA58/8/115.
10 Wilson, T. B.: *Narrative of a Voyage round the World*, p. 224.
11 P.R.O.: C.O. 18/4, Folio 237.
12 Bunbury, Lieutenant H. W.: *Early Days in Western Australia*, p. 139.
13 Ogle, N.: *The Colony of Western Australia*, p. xlv.
14 WAA 49/2.
15 Wilson, T. B.: *Narrative of a Voyage round the World*, p. 196.
16 Ibid., p. 188.
17 WAA36/4.
18 Powell, J. G.: *Narrative of a Voyage to the Swan River*, p. 22.
19 Letter, August 1834. WAA139.
20 Bryan, C.: *West Australia in the Making*, Part 7, p. 8.
21 WAHSJ, Volume I, x, 11.
22 Letter from J. Sabine, Secretary, Horticultural Society, London to R. W. Hay. WAA58/3/86-87.
23 Moore, G. F.: *Ten Years in Western Australia*, p. 46.
24 Ibid., p. 59.
25 Cross, J.: *Journals of Several Expeditions made in Western Australia*, p. 87.
26 Letter, 30 September 1835. WAA36/41. A copy of this was forwarded by Molloy to the Colonial Secretary in 1835, with an application to be allowed remission of purchase money on land in right of military service.
27 Wilson, T. B.: *Narrative of a Voyage round the World*, p. 229.
28 Letter, September 1838. WAHS450.
29 Bunbury, Lieutenant H. W.: *Early Days in Western Australia*, p. 140.
30 WAA36/7/183.
31 Letter, 5 March 1830. WAA49/2.
32 WAA36/6.
33 WAA36/5.
34 WAA49/2.
35 WAA36/6.
36 WAA79.
37 WAA49/2.
38 WAA58/8/115.
39 P.R.O.: C.O. 18/12, Folio 230.
40 WAA223.
41 WAA36/6/102. See Appendix B.
42 Cross, J.: *Journals of Several Expeditions in Western Australia*, p. 89.

CHAPTER 6

1 Turner Papers. WAHS450.
2 Letter, 1 October 1833. WAA501.
3 Official Correspondence, Resident Magistrate. WAA309.
4 Map of Alfred Hillman, 1834. Augusta 28 & 28B, Lands Department, Perth.
5 Quarterly Report on Public Works. P.R.O.: C.O. 18/10 & 12, Folios 87 & 230.
6 Letter, October 1833. WAA501.
7 Ibid.
8 Official Correspondence, Resident Magistrate. WAA309.
9 WAA53/J1.
10 Letter, December 1831. WAA139.
11 Bussell Papers. WAA139.
12 Official Correspondence, Resident Magistrate. WAA309.
13 Letter, April 1833. WAA139.
14 Letter, 7 November 1832. WAA501.
15 Letter, 12 January 1833. WAA501.
16 Hanson, Lieutenant Colonel J.: *Letter on the Swan River Settlement*.
17 Official Correspondence, Resident Magistrate. WAA309.

18 Government Resident Letters relating to lands and surveys. WAA223.
19 Ibid.
20 C.O. Despatches, 28 April 1831. WAA391.
21 Diary of R. V. Edwards. WAA223.
22 WAA223.
23 Ibid.
24 Ibid.
25 Cross, J.: *Journals of Several Expeditions in Western Australia*, p. 186.
26 See Appendix C.
27 WAA309.
28 Letter, 8 December 1834. WAA139.
29 WAA36/21/136.
30 Moore, G. F.: *Ten Years in Western Australia*, p. 103.
31 Letter, 30 May 1832. WAA139.
32 Turner Papers. WAHS450.
33 Ibid.
34 Letter, 28 August 1830. WAA58/8/115.
35 WAA223.
36 Letter, 14 November 1832. WAA223.
37 Turner Papers. WAHS450.
38 Ibid.
39 Appendix D. P.R.O.: C.O. 18/8-9-10, Folio 87.
40 Official Correspondence, Resident Magistrate. 20 November 1838. WAA309.
41 The 'blue vine' was probably *Hardenbergia Comptoniana*, sometimes known as
sarsaparilla or blue Kennedya, though both names are inappropriate. The generic name
commemorates the sister of Baron von Huegel who, at the beginning of 1833, was the
first botanist to visit Swan River and King George's Sound after settlement. The other
two purple pea flowers mentioned were probably *Hovea chorizemifolia* and *Hovea trisperma*.
42 Cholera morbus, or 'Asiatic cholera', moving across Europe from India, had reached
England in June 1831, and struck at London in February 1832. A circular from Lord
Goderich was issued from Downing Street on 31 March 1832, on the subject of quarantine
with reference to cholera. It had been drawn up by the Central Board of Health, London,
and was sent to the colonies for their information. WAA36/21/134.

CHAPTER 7

1 WAA501.
2 Letter, 21 April 1833. WAA139.
3 Ibid.
4 Letter, 1 October 1833. WAA501.
5 This diary is the only known piece of Mrs Molloy's handwriting. Although it is
not dated, internal evidence shows that it belongs to the year 1833. It was presented to
the Western Australian Historical Society in July 1929 by Mrs Walter Gale, a grand-
daughter of Mrs Molloy.
6 Letter, 1 October 1833. WAA501.
7 Letter, December 1833. WAA139.
8 Shann, E. O. G.: *Cattle Chosen*, p. 132.
9 WAA 501.
10 Despatch, 10 April 1833. P.R.O.: C.O. 18/13 & 14, Folio 119.
11 Letter, 8 December 1834. WAA501.
12 *Perth Gazette*, 26 January 1833.
13 *Perth Gazette*, 15 June 1833.
14 WAA223.
15 Letter, 8 December 1834. WAA501.
16 Letter, 16 October 1830. WAA139.
17 Letter, 8 December 1834. WAA501.
18 Ibid.
19 Ibid.

20 Ibid.
21 Turner Papers. WAHS450.

CHAPTER 8

1 Letter, 8 December 1834. WAA501.
2 Letter, 25 May 1834. WAA139.
3 WAA501.
4 Letter, 6 February 1835. WAA139.
5 Letter, February 1835. WAA139.
6 Letter, undated. WAA139.
7 Bussell Papers. WAA139.
8 Ogle, N.: *The Colony of Western Australia*, p. lxiv.
9 Map by H. Ommaney, 1839-44. Busselton, no. 27, Lands Department, Perth. This shows the position of the first cottages.
10 Letter, 25 December 1835. WAA139.
11 P.R.O.: C.O. 18/9. Folio 87.
12 P.R.O.: C.O. 18/12. Folio 230.
13 Gravestone, Busselton churchyard. This reads, 'Elizabeth Herring, arrived in Australia, 1853. Died March 31, 1857, at 73 years. Also John Herring, husband of above, arrived in Australia 1830. Died April 16, 1866, aged 87 years'.
14 Letter, 18 May 1834. WAA501.
15 Bunbury, Lieutenant H. W.: *Early Days in Western Australia*, p. 98.
16 Letter, June 1837. WAA139.
17 WAA139.
18 Official Correspondence, Resident Magistrate. WAA309.

CHAPTER 9

1 WAA479, I, p. 67.
2 Moore, G. F.: *Ten Years in Western Australia*, p. 39.
3 WAA479. Entitled, 'Letters &c., Botany, Gardening, Seeds, Horticulture, the Parks'.
4 Ibid., I, p. 111.
5 Ibid., I, p. 11.
6 Ibid., I, p. 57.
7 Ibid., I, p. 19.
8 Ibid., I, p. 19.
9 Ibid., I, p. 2.
10 Ibid., I, p. 49.
11 Pamphlet: 'The Royal Horticultural Society and its Work Past and Present'. Issued by the Society.
12 Moore, G. F.: *Ten Years in Western Australia*, p. 288.
13 WAA479, I, p. 268.
14 Ibid., I, p. 364.
15 Ibid., I, pp. 301-320.
16 Ibid., I, p. 321. Supplementary to letter of 25 January 1838.
17 The native name for Augusta was 'Tarlemup'. This information was given by Mr Edward Dawson of Busselton, son of John Dawson of Augusta.
18 Diary, 1837. WAA139.
19 Official Correspondence, Resident Magistrate. WAA309.
20 WAA479, I, pp. 322-325.
21 Ibid., I, p. 287.
22 From letters and diaries of 1837-42, in the possession of a descendant, Dr Guy Elkington, of Perth.
23 WAA479, I, p. 293.
24 Ibid., I, p. 291.
25 Moore, G. F.: *Ten Years in Western Australia*, pp. 368, 372.

CHAPTER 10

1 WAA479, I, p. 326.
2 Ibid., I, p. 184.
3 See Appendix E.
4 WAA479, I, p. 220.
5 Ibid., I, p. 175.
6 Ibid., I, p. 168.
7 Ibid., I, p. 332.
8 Ibid., I, p. 297.
9 Ibid., I, pp. 342-345.
10 Ibid., I, p. 361.
11 Ibid., I, p. 373.
12 Ibid., I, p. 363.
13 Turner Papers. WAHS450. This diary is printed in the *Western Australian Historical Society Journal*, Volume I, iv, 17, but the date is given as 1833 which is a misprint. It should be 1839, as internal evidence shows.
14 Ibid.
15 Ibid.
16 Official Correspondence, Resident Magistrate. WAA309.
17 Ibid.
18 Turner Papers. WAHS450.
19 WAHSJ, Volume I, iv, 68. Original letter in the possession of Mrs Piers Brockman, Busselton.
20 Diary, in the possession of Dr Elkington, Perth.
21 Letter, E. Dawson to Governor Hutt, 16 June 1839. WAA36/66.
22 WAA49/7.
23 WAA525/1.
24 Letter, G. Layman to Governor Hutt, 17 June 1839. WAA36/66.
25 Diary in the possession of Dr Elkington, Perth.
26 Official Correspondence, Resident Magistrate. WAA309.
27 Ibid.
28 Ibid.
29 WAA36/1000.
30 WAA479, II, p. 28.
31 Ibid., p. 55.
32 Ibid., pp. 11-23.
33 Ibid., pp. 23-25.
34 Diary, 1840-41. WAA139.
35 WAA479, II, pp. 67-71.
36 Ibid., p. 87.
37 Ibid., pp. 82-87.
38 Ibid., p. 93.
39 Ibid., I, p. 398.
40 Ibid, II, pp. 97-98.
41 Diary, 1840-41. WAA139.
42 WAA36/488, and *The Herald*, Fremantle, 22 March 1873.
43 WAA479, II, pp. 110-117.
44 Ibid., p. 59.

CHAPTER 11

1 WAA479, II, p. 72.
2 WAA36/85.
3 WAA36/100.
4 Official Correspondence, Resident Magistrate. WAA309.
5 Letter, 7 April 1843. WAA36/121.
6 Official Correspondence, Resident Magistrate. WAA309.
7 WAA479, II, pp. 123-124.
8 Diary, 1840-41. WAA139.

9 The *Inquirer*, Perth, 9 June 1841.
10 WAA479, II, pp. 128-131.
11 Ibid., p. 125.
12 Wollaston, J. R.: *Albany Journals*, p. 192.
13 Ibid., p. 237.
14 Letter, 10 February 1841. WAA36/100.
15 House of Commons Paper 627 (printed 9 August 1844) relative to the Aborigines, Australian Colonies. Report of Protector of Natives, p. 455.
16 House of Commons Paper 627. Hutt to Glenelg, 3 May 1839, p. 363.
17 House of Commons Paper 627. Extract from Instructions to Government Residents, p. 386.
18 Letter, 25 March 1841. WAA49/13.
19 Deposition of Alfred Bussell, interpreting for the native Bunny. 24 February 1841. WAA36/100.
20 WAA36/100.
21 Depositions of Cobbet, a native, 20 March; Elizabeth Barsay, 8 March; Anne Bryan, 8 March and 23 February; John Dawson, 23 February; Martin Welch, 23 February 1841. WAA36/100.
22 Depositions of John Heppingstone, 23 and 24 February 1841. WAA36/100.
23 Quarterly Report of Protector of Natives. 31 March 1841. WAA36/95.
24 Diary, 1840-41. WAA139.
25 Letter, 8 March 1841. WAA36/100.
26 20 March 1841. WAA36/100.
27 Diary of Native Transactions for the Quarter ending 30 June 1841. WAA36/95.
28 Letter, 25 March 1841. WAA36/100.
29 Rough copy in incoming C.S.O., WAA36/97. Fair copy, C.S.F., WAA49/13.
30 Letter of Mrs Barber, 15 February 1843. In the possession of Miss Layman, 'Wonnerup House'.
31 Letter, WAA479, II, p. 127.
32 Ibid.
33 Moore, G. F.: *Ten Years in Western Australia*, p. 340.
34 WAA479, II, pp. 132-137.
35 Wollaston, J. R.: *Picton Journal*, p. 88.
36 Official Correspondence, Resident Magistrate. WAA309.
37 Irwin, F. C.: *State and Position of Western Australia*, Appendix VI
38 Letter, 2 August 1841. WAA36/100.
39 Letter, 8 September 1841. WAA36/97.
40 Letter, 13 September 1841. WAA36/97.
41 Landor, E. W.: *The Bushman*, p. 404.
42 Wollaston, J. R.: *Picton Journal*, p. 34.
43 Ibid., p. 36.
44 Ibid., p. 58.
45 Ibid., pp. 113-114.
46 Ibid., p. 280.
47 The *Inquirer*, Perth, 13 March 1844.
48 Letter, 6 February 1842. WAA36/105.
49 Letters, 2 January and 26 May 1843. WAA36/121.
50 Letter, 25 March 1845. WAA36/140.
51 Letter, 2 February 1842. WAA36/105.
52 WAA479, II, p. 159.
53 Information supplied by the Director, Royal Botanic Gardens, Kew.
54 WAA479, II, p. 164.
55 Ibid., p. 162.
56 Ibid, p. 186.
57 Ibid., p. 200.
58 Narrated to the author by Mr Edward Dawson of Busselton, son of John Dawson. A paper entitled, 'The two Dawson families of Augusta and Busselton' by the author is contained in the *Western Australian Historical Society Journal*, Volume V, 4.

59 Registration of death, Busselton Court-house.
60 Registration of death, Titles Office, Perth.
61 Conversation with Miss Prinsep of Busselton.
62 WAA479, II, p. 222.

CHAPTER 12

1 Letter, 21 February 1842, referring to earlier correspondence.
2 Land deeds of 'Cometville' (Sussex location 13) shown to the author by permission of the present owner, Mr Martin. History of Sussex location 12 from the Lands Department, Perth, by permission of the Surveyor General, Mr W. V. Fyfe.
3 Respectively, 1856, 1858, 1859, 1860, 1866. Registration of death, Busselton Court-house.
4 WAHSJ, Volume II, xvii, p. 26.
5 Letter, 12 February 1850.
6 Smith, Lieutenant General Sir Harry: *Autobiography*. Volume II, p. 211.
7 These two medals are in the possession of Mrs V. M. R. Bunbury, Marybrook.
8 Letter-book. WAA580.
9 Hale, Amy: *Reminiscences of visits to W.A. in 1854 and 1856*. WAA157.
10 WAAP.R.7.
11 WAA580.

BIBLIOGRAPHY

This book is based on research among original documents, including official records at the Archives Branch of the Perth Public Library; at the Lands Department, Perth, and at the Busselton Courthouse. Reference was made to microfilm copies of Colonial Office Records at the National Library, Canberra, to private correspondence and other papers held by the Archives branch of the Perth Public Library, by the Western Australian Historical Society and by old residents of Busselton. Frequent reference was also made to the files of early colonial newspapers. This research was supplemented by conversations with old inhabitants of Perth and Busselton, and numerous visits to the scenes of the story. Some notes made by my husband in 1928 recorded other conversations with old colonists.

OFFICIAL DOCUMENTS

Colonial Secretary's Office Records:
 Inward Correspondence. (Accession number, WAA36/vol. number. Some of these volumes are not page-numbered. In that case, dates have been given.)
 Copies of Outward Correspondence. (Accession number WAA49/vol. number.)
Official Correspondence of Resident Magistrate, Augusta and Vasse. (WAA309)
Government Resident's letters relating to lands and surveys, Augusta and Vasse. (WAA223)
Letter-Book of Resident Magistrate, Busselton. 1855. (WAA580)
Letters from Assistant Surveyors. (WAA223)
Microfilm of Public Record Office documents. (References to these are made by their Public Record Office numbering.)

MANUSCRIPTS

Brockman, Mrs E. R.: Reminiscences of the wedding of Mary Molloy and Lieutenant DuCane. (WAA164)
Bussell Papers: Original letters and diaries of members of the Bussell family. (WAA139)
Currie, Mrs M. J.: Diary, 1829-1832. (WAA79)
Hale, Amy: Reminiscences of Visits to W.A. in 1854 and 1856. (WAA157)
Mangles, Captain James, R.N.: Letter-Books, 1837-1844. (WAA479)
Molloy, Georgiana and John: Letters. Microfilm copies. (WAA501)
Molloy, Georgiana: Diary, 1833. (WAHS79)

275

Molloy, John: Notes from his Diary on board the *Warrior*. (WAHS664)

Ommaney, H. M.: Original diary and letters. Private possession.

Turner, J. W.: Original letter-book, 1830-1853. (WAA29)

Turner Papers: Typescript. (WAHS450)

Turner, Thomas: Book of paintings of Augusta, and maps. (WAA602 B, & 78 B)

——Book of drawings of houses he lived in. (WAA603 B)

PRINTED WORKS

Battye, J. S.: *Western Australia, a history from its discovery to the inauguration of the Commonwealth*. London, 1924.

Bentham, G.: *Flora Australiensis*. London, 1863-78 (7 vols.).

Bryan, Cyril: *West Australia in the Making*. Perth (circa 1939).

Bunbury, Lieutenant H. W.: *Early Days in Western Australia*. London, 1930.

Cross, J. (compiler): *Journals of several Expeditions made in Western Australia during the years 1829, 1830, 1831, and 1832*. London, 1833.

Hanson, Lieutenant Colonel J.: *Letter on the Swan River Settlement, Jan. 9. 1832*.

Hasluck, P.: *Black Australians*. Melbourne, 1942.

Irwin, Captain F. C.: *The State and Position of Western Australia commonly called the Swan River Settlement*. London, 1835.

Landor, E. W.: *The Bushman, or, Life in a New Colony*. London, 1847.

Lindley, J.: *Sketch of the Vegetation of the Swan River Colony*. Appendix to the first twenty-three volumes of Edward's *Botanical Register*. London, 1839.

MacDermott, M.: *A Brief Sketch of the Long and Varied Career of Marshall MacDermott, Esq., J.P.* Adelaide, 1874. (Written for private distribution amongst relatives and special friends.)

Moore, G. F.: *Diary of Ten Years of an Early Settler in Western Australia*. London, 1884.

Ogle, N.: *The Colony of Western Australia*. London, 1839.

Powell, the Reverend J. G.: *Narrative of a Voyage to the Swan River*. London, 1831.

Roberts, Jane: *Two Years at Sea, being the Narrative of a Voyage to Swan River, Van Diemen's Land etc.* London, 1837.

Shann, E. O. G.: *Cattle Chosen*. London, 1926.

Stokes, J. Lort.: *Discoveries in Australia . . . during the visit of H.M.S. Beagle, 1837-42*. London, 1846.

Wilson, T. B.: *Narrative of a Voyage Round the World*. London, 1835.

Wollaston, the Reverend J. R.: *Picton Journal, 1841-1844*. Perth, 1948.

——*Albany Journals, 1848-1856*. Perth, 1954.

Journal of the Western Australian Historical Society, Volumes I, II and IV. *Early Days*, published by the Western Australian Historical Society.

Pamphlet: 'The Royal Horticultural Society and its work past and present.'

SECONDARY SOURCES USED FOR BACKGROUND

Aldington, Richard: *The Duke*. New York, 1946 (reprint).

Ashton, John: *Dawn of the 19th Century in England*. London, 1906 (fifth edition).

Bryant, Arthur: *The Years of Victory*. London, 1944.

——*The Age of Elegance*. London, 1950.

Burne, Lt. Col. A. H., D.S.O.: *The Noble Duke of York*. London, 1949.

Cameron, H. C.: *Joseph Banks*. London, 1952.

Carlyle, Thomas: 'Edward Irving'. *Frazer's Magazine*, January 1853.

Cope, Sir William H.: *History of the Rifle Brigade*. London, 1877.

Dictionary of National Biography.

DuCane, Lt. Gen. Sir Edmund: 'The Peninsula and Waterloo: Memories of an old Rifleman'. *Cornhill Magazine*, 1897. Vol. III.

Emden, Paul H.: *Regency Pageant*. London, 1936.

Encyclopaedia Britannica: 'Church of Scotland'.

Fitchett, W. H.: *Wellington's Men*. London, 1900. Extracts from Kincaid's *Adventures in the Rifle Brigade* (published 1830), *Rifleman Harris* (published 1848), Anton's *Military Life* (published 1841), Mercer's *Journal of the Waterloo Campaign* (published 1870).

Hawks, Ellison: *Pioneers of Plant Study*. London, 1928.

Oliphant, Mrs.: *Edward Irving*. circa 1864.

Principal Story: By his daughters. Glasgow, 1909.

Smith, Lt. Gen. Sir Harry: *Autobiography*. Edited by G. C. Moore Smith, 1902. 2 vols.

Story, Robert Herbert: *Memoir of the Life of the Reverend Robert Story*. London, 1862.

Symons, Julian: *Thomas Carlyle*. London, 1952.

Wynne Diaries: Vol. III, 1798-1820. London, 1940.

Young, G. M. (ed.): *Early Victorian England*. London, 1934. 2 vols.

Index